Teaching Art: Academies and Schools from Vasari to Albers is the first book to examine the history of art training from the Renaissance to the present. Addressing the question of whether art can be taught, Carl Goldstein describes how the secrets of such masters as the Carracci, Rembrandt, and David were passed on from generation to generation. He also analyzes the conceptual framework for teaching in the great academies, such as those in Rome, Paris, and London. This book treats the academic tradition from the point of view of the artist, and thus practice – the making of art – is the focus throughout. Also considered in this ground-breaking study is the training of women, who were excluded from traditional academies and treated as inferior in the modern schools. Goldstein concludes with an overview of current methods for the teaching of art at the university level and their impact on contemporary art.

TEACHING ART

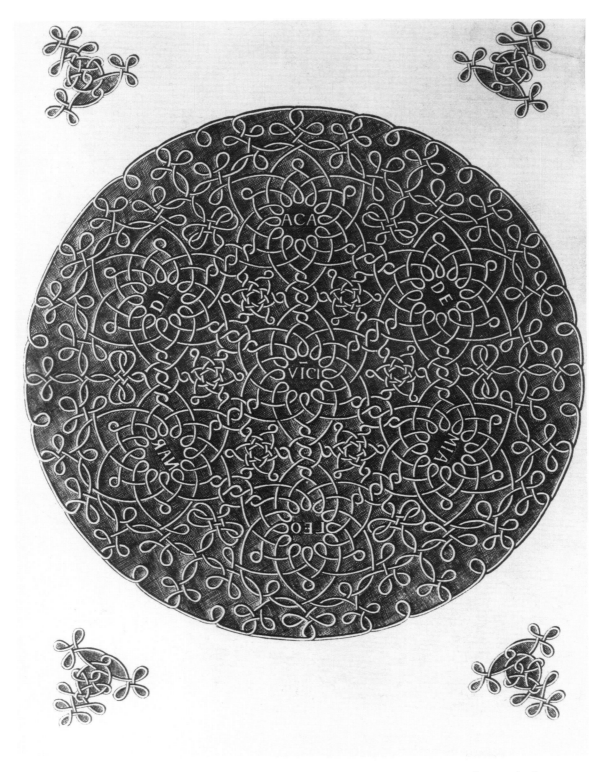

Frontispiece. The Academy of Leonardo. Engraving. Providence, Museum of Art, Rhode Island School of Design. (Photo: Museum of Art, Rhode Island School of Design)

TEACHING ART

ACADEMIES AND SCHOOLS FROM VASARI TO ALBERS

Carl Goldstein

University of North Carolina, Greensboro

CAMBRIDGE
UNIVERSITY PRESS

Published by the Press Syndicate of the University of Cambridge
The Pitt Building, Trumpington Street, Cambridge CB2 1RP
40 West 20th Street, New York, NY 10011-4211, USA
10 Stamford Road, Oakleigh, Melbourne 3166, Australia

© Cambridge University Press 1996

First published 1996

Printed in the United States of America

Library of Congress Cataloging-in-Publication Data
Goldstein, Carl.
 Teaching art : academies and schools from Vasari to Albers / Carl
Goldstein.
 p. cm.
 Includes bibliographical references and index.
 ISBN 0-521-48099-X (hc)
 1. Art – Study and teaching. 2. Art – Historiography. 3. Art
schools – Curricula. I. Title.
 N85.G62 1996
 707 – dc20 95-5991
 CIP

A catalog record for this book is available from the British Library.

ISBN 0-521-48099-X hardback

For Alicia

CONTENTS

ILLUSTRATIONS

PREFACE AND ACKNOWLEDGMENTS

This study had its beginnings nearly thirty years ago in a dissertation on teaching in the seventeenth-century French Academy of Painting and Sculpture written under the direction of the late Rudolf Wittkower. The issues with which the dissertation was concerned being restricted neither to France nor the seventeenth century, I spent the years after its completion studying teaching in other countries and other periods, working my way up to teaching in modern times. By 1970 it seemed to me that I had amassed enough material for a book on the subject, and I began to write one. I also thought it would be desirable to be directly involved with such teaching and had the opportunity to so be, accepting an offer to teach in an art department dominated by studio concerns. Teaching art history and criticism to artists – one of the courses regularly taught bears the title of this book – and discussing this teaching with colleagues who were artists themselves, gave me a whole new perspective on the subject and, indeed, made me change many of the ideas with which I had begun – or, perhaps more accurately, led me to ask different kinds of questions from those in the literature, my early articles included. These were very large questions, my colleagues and students contributing toward my own education.

A book written over such a long period of time obviously was helped along by so many people that it would be impossible to name them all, and I apologize to those inadvertently omitted. My first debt is to the late Rudolf

Wittkower, to whom I owe not only my early interest in this subject but also, more importantly, a training in art history that I have drawn upon throughout my career. An equal debt is owed to the late Peter Agostini, with whom I discussed the issues of this book, in his sculpture studio and in galleries and museums, during the course of a friendship of more than twenty years. Among other friends and colleagues who have been helpful, special thanks must go to Albert Boime, Jerrold Lanes, Jennifer Montagu, and Melvin Zabarsky. My interest in teaching having from time to time flagged, it was revived by commissions for papers on aspects of the subject from Sabine Schulze and Herbert Beck of the Liebieghaus, Frankfurt am Main, and Edouard Pommier of the Musée du Louvre. K. Porter Aichele, Paul Barolsky, Donald Posner, and Trevor Richardson read all or parts of the text in manuscript and made suggestions that greatly improved it.

I am grateful for the kindnesses of those entrusted with the care of the legacy of teaching institutions, particularly Philippe Grunchec, Sidney Hutchison, and the late Luigi Pirotta. For help with the increasingly difficult task of obtaining photographs, I wish particularly to thank Barbra Brady, Angela Cipriani, John Elderfield, Anna Harwell, Timothy Riggs, Paul Taylor, and Olga S. F. de Sanchez de la Vega.

An early attempt to write this book was made with the aid of a Howard Foundation Fellowship. Some of the materials were collected through the assistance of two grants from the Penrose Fund of the American Philosophical Society. A substantial portion of the text was written, and momentum generated to complete it, during a research leave from my university, the University of North Carolina at Greensboro. I am particularly grateful to Dean Walter H. Beale and Provost Donald V. DeRosa for supporting this leave during a period of considerable financial constraint. I am also indebted to my colleagues on the university's Research Grants Committee for an award that helped cover the cost of the illustrations.

A portion of Chapter 4 has appeared in *Les Musées en Europe à la veille de l'ouverture du Louvre* (Paris, 1995). Parts of Chapters 7, 9, and 13 are much revised versions of papers published, respectively, in *Antikenrezeption im Hochbarock*, ed. H. Beck and S. Schulze (Berlin, 1989); in A. W. A. Boschloo et al., eds., *Academies of Art between Renaissance and Romanticism* (*Leids Kunsthistorisch Jaarboek* 5–6, 1986–7, Leiden, 1989); and *Arts Magazine*.

A commitment to this project notwithstanding, mine might very well have remained a Pisgah view if not for my wife, Alicia Creus. Her sympathetic but always rigorous review of my ideas, whether in conversations or on paper, encouraged me to forge ahead. The dedication is offered in love and appreciation and also in acknowledgment of her indispensable role.

INTRODUCTION:
ACADEMIC QUESTIONS

This is a book about teaching visual art in the Renaissance tradition and, more particularly, what this teaching was meant to achieve. It also examines a range of questions raised during the course of the reaction against this teaching tradition beginning in the nineteenth century, with attention to alternative methods, particularly those grounded in the theory and practice of modernism.

A book about teaching in the Renaissance tradition and the modernist subversion of this tradition is a study, above all else, of the ups and downs of academies of art, the institutions in which virtually all artists were trained, beginning in the later Renaissance and particularly from the seventeenth century until the early modern period. And there is just one existing study of this subject: Nicolaus Pevsner's *Academies of Art, Past and Present* (1940).[1] This book begins with Leonardo and the Italian Renaissance, touches on all the major institutions of the following centuries, and concludes with a discussion of schools in modern England. Pevsner's book has been, and will remain, a work of indispensable reference, an extraordinary achievement that must seem all the more so for having been undertaken in the 1930s, when academies were under a cloud, the word "academic" having become a term of abuse as a result of the modernist rejection of the nineteenth-century academy. If academies were unfashionable, however, they clearly were major historical phenomena and were so approached by Pevsner who, a historicist by inclination, conceived of the study of academies as an essential contribution to a social history of art.[2] His book is extremely ambitious, placing academies within the context of social and political developments during four centuries; but it is also severely limited. Concentrating on questions of

institutional history and administration, the one thing it leaves out entirely is the art of the academy: nowhere is a work of art made in or for an academy discussed or illustrated.

When Pevsner wrote a foreword to a reprint of the book in 1969, he was able to state that nothing published on the subject since 1940 would lead him significantly to alter his text; he thought it sufficient to list a few recent titles for "further reading." He would not have so done a short time later. For the whole approach to academies was changed in 1971, with the publication of Albert Boime's *The Academy and French Painting in the Nineteenth Century*.

Boime showed the sketchiness of Pevsner's factual material and the limitations of his historicist neglect of style; he filled the gap of Pevsner's discussion by publishing drawings and paintings produced in the nineteenth-century academy, demonstrating the importance of the academy for all the artists of the period, avant-garde as well as traditionalist. In a subsequent book, *Thomas Couture and the Eclectic Vision* (1980), and many articles and catalogue essays, Boime enlarged upon this discussion, to which an increasing number of scholars contributed during the next years in what became a major reassessment or revision of the canon of nineteenth-century art history, to mention only one further and more recent example, H. Barbara Weinberg, *The Lure of Paris: Nineteenth-Century American Painters and their French Teachers* (1991).

Although this revival of interest in academies during the last two decades has been most conspicuous in nineteenth-century art history, it has been in evidence in the study of other periods as well, the interest, indeed, being discipline-wide. There has been a major monograph on the key academy founded in Renaissance Florence by Vasari and associated with Michelangelo, Z. Waźbiński's *l'Accademia Medicea del disegno a Firenze nel cinquecento: idea e istituzione* (1987). I published a detailed study of the near-mythical Carracci academy: *Visual Fact over Verbal Fiction: A Study of the Carracci and the Criticism, Theory, and Practice of Art in Renaissance and Baroque Italy* (1988). The French academy from the seventeenth to the nineteenth century has been studied in three of the most widely discussed books of the "new" art history: Norman Bryson, *Word and Image: French Painting of the Ancien Regime* (1981) and *Tradition and Desire, from David to Delacroix* (1984), and Michael Fried, *Absorption and Theatricality: Painting and Beholder in the Age of Diderot* (1980). And many articles have been published clarifying the histories or practices of specific academies. One collection of such articles, commissioned to mark the fiftieth anniversary of the publication of Pevsner's book, brings together studies of academies throughout Italy, France, Spain, The Netherlands, Germany, Austria, Poland, England, Ireland, and Denmark.[3]

Study of the most important of the modern schools, the Bauhaus, in recent

years and especially since the absorption into the Federal Republic of Germany of the former East German states of Saxony and Thuringia in which it was born and reached its early maturity, has assumed the proportions of a major academic industry.4 (I say "school" here to postpone a discussion of the status of the Bauhaus, to which I shall return shortly.)

Despite all this attention, the academy as a teaching institution has remained highly elusive, in good part because of the negative connotations of the word; merely to utter the term "academy" is to continue to evoke an image created for the nineteenth-century academy by such anti-academicians as Gauguin and Cézanne, an image projected back into the history of academies from the Renaissance on.

The difficulty of bringing the academy into focus was demonstrated some years ago by Thomas B. Hess, in remarks that are worth quoting in some detail – the subheading of this introduction quotes Hess as well:

> To discover what it ["academic"] means, we must begin with the accepted connotations and attempt to refine them.
>
> Academic implies a worship of the past. But all artists have been in love with their ancestors: Matisse with Cézanne, Cézanne with Rubens, Rubens with Michelangelo, Michelangelo with the Master of the Belvedere Torso. Art comes out of art and artists have been hero-worshippers ever since the hero was invented. . . .
>
> Another indictment of the academy is based upon its insistence on a doctrinaire, systematic esthetic. But this has characterized many other approaches too. Off-hand, one can cite Piero della Francesca, Alberti, Poussin, and Mondrian as non-Academic artists who were involved in elaborating philosophical and technical systems, and one could add Seurat, Kandinsky and, in his own eccentric way, William Blake. . . .
>
> Finally, the Academic is often confused with imitation, derivation and the arts of disciples. But almost every master, Academic or not, has had his following. Consider the crowds of minor Pointillists and Cubists, of the excellent and now largely forgotten school-artists around El Greco and Poussin. The issue of influence (and of misunderstood influence) applies to every kind of art.5

Hess was convinced of fundamental differences between these seemingly similar visual practices and teaching methods. If all artists tended to look to the past, academic artists must have done so in a peculiar way; if many artists have relied on doctrines, that of the academy must have been of a "special, metaphysical nature," and so on – observations that have some truth to them, as shall be shown in the following pages. There is a more important point to be made at this time, however, and it is about Hess's ironic review of the "accepted connotations" of "academic."

Writing at a time of more or less universal agreement as to the failure of academic art and of the teaching behind it, Hess was concerned with identifying the root causes of this failure. What he found was that failure was barely distinguishable from success, that the artists of the academy thought and acted in substantially the same ways as the "great" artists of their own and

other times. Or so it seemed. (From the seventeenth century on, the "greats" were as likely to be academically trained as the not-so-greats.) It was clear, at the very least, that the academy, far from existing on the margins of the art world, was at the very center of it, so that to pose questions about academic art was to enter directly into the artistic life of the Western world, questions that were far more basic than those about whether academic art is as bad as had been thought or has redeeming qualities.

Hess did not attempt to answer his own questions. Pevsner had not posed them; nor have the authors of the specialized studies mentioned above done so. They are examined in this book, particularly two of them: the relation of practice to theory and of the present to the past.

The first concerns the interrelatedness of visual art and speech in academies and the question of a "language" of visual art. For language did indeed, as Hess indicated, play a central role in academies – in two senses, one may add. The first: artists in academies, as in the Renaissance tradition more generally, were consciously and profoundly concerned with visual art as a means of communication, which they often discussed, analogically, in relation to language. The second: that, in academies, language in the literal sense of discourse accompanied artistic production. The second point concerns the literary source materials not only of academies but more broadly of the Renaissance tradition, the literature of art articulated from the early Renaissance, resonating in academic discussions. These materials typically have been regarded as verbalizations of works of art, as though differences between visual works and speech were strictly formal. They will not be so regarded in this study, in which the relationship of the visual to the verbal, theory to practice is assumed to be problematical.

Another, closely related, theme is that of the equally problematical relationship of the present to the past. If we can understand present-day art because it expresses the ideas of our time, how can we respond to the art of earlier historical epochs, the dominant ideologies of which were significantly different from our own? And if we are indeed moved by earlier art, whether that of Raphael and Michelangelo produced in papal Rome, or that of Jacques-Louis David addressed first to the king and court, then to the "people," and finally to the emperor of France, by the art of Rembrandt's Protestant Holland as much as that of Velasquez's Catholic Spain, what does this tell us about the relation of art to religious, social, and political institutions? What, in sum, does all of this tell those responsible for teaching about what can and should be taught?[6]

The artists of the academy, itself a preeminently political and social institution, were far from blind to these questions, which they made central to their project. The single question that has haunted the history of teaching art from the Renaissance to the twentieth century is precisely what should be taught

and whether the essence of art can be taught, or can *art* be taught? It is in examining these problematics that this study most differs from earlier investigations of academies and teaching such as Pevsner's. To say it as clearly as possible, this book, though concerned with Pevsner's subject and much of his material, which it enlarges upon and brings up-to-date, is not the encyclopedic study of his design but rather an investigation of the teaching of art for the light it may throw on basic issues, both art-historical and aesthetic. It is at the same time a visual history of teaching, as distinct from a collection of examples illustrating the arguments of the text, and as such the most comprehensive of its kind yet to appear in print.

The discussion up to this point has been principally concerned with academies and schools in the Western tradition. They were bound to change with the tradition and did so change when, in the nineteenth century, much of what the tradition cherished was called into question: the role of the figure and the handling of traditional materials. A new mode of artistic production was needed, it was argued, reflecting changes in industrial production. To fill this need, craft schools were founded, followed by a school that merged art and craft: the Bauhaus.

The most influential art school of the modern period, the Bauhaus displaced the older academies and played the role that they formerly had played. Was it not, then, itself an academy or was it, rather, a workshop or school?[7] If an academy, it was the only one to forgo the name, having been designated simply the State Bauhaus of Weimar (Staatliches Bauhaus in Weimar). Let us for the moment agree to think of it as a school. Is there justification for regarding it as an art school? Proclamations regularly issued from the Bauhaus to the effect that art cannot be taught, for which reason its program was organized around the crafts. And yet we can see that the Bauhaus did teach art, responsibility for the program having been entrusted chiefly to artists, Kandinsky, Klee, Albers, and others. To the mind of its founder, Walter Gropius, the principal mission of the Bauhaus was to train a new generation of architects, not artists. But the one subject that the Bauhaus did not teach when it was founded and taught only intermittently later was architecture.

The contradictions of the Bauhaus bring out the complexity of the history of teaching institutions. It cannot be assumed that a particular school or academy was precisely the kind of place described in its literature, much less that it was like other establishments calling themselves by the same name; not every school was like every other school, nor every academy like every other academy. A school need not have been different from an academy. At the same time these terms are so freighted with ideological preconceptions that to use either one of them is to conjure up an image of an organization with a definite program, conceived with particular goals in view.

To return to the question asked earlier as to whether the Bauhaus was

a workshop, school, or academy, the answer would follow from our understanding of the meaning of each of these terms. A designation having been decided upon, the Bauhaus would become in our minds that kind of institution – a democratic school versus an authoritarian academy, and so on.

Simply to ask questions about the impact of the university art departments that have displaced the older academies as well as studios, departments through which the majority of North American artists now pass, has seemed, inevitably, to imply that the art of university-trained artists – that is, those of an institution commonly called an "academy" – is "academic" and, therefore, fatally compromised.

It is the aim of this book to avoid such preconceptions by concentrating on the evidence of teaching. Nor will a hard-and-fast line be drawn between different kinds of schools and academies. The whole point is to approach visual art from the perspective of artist-teachers and art students, in whichever institutions they congregated.

The first three chapters set the stage by locating academies within the history of teaching in the Renaissance tradition. Chapter 1 examines the various teaching establishments of the Renaissance – workshop, school, club, and academy – and asks how an academy would have differed from the other types. It asks, in other words, a question of definition: what was an "academy" in Renaissance Italy, what would have entitled artists to use the term? The evidence of teaching in the first official academy, the Florentine Accademia del Disegno, is reviewed in relation to Renaissance theory and an observation made that is a principal thread weaving through the book, namely, of the contradictions between theory and practice.

Chapters 2 and 3 follow the evolution of the academy as an institution. The most detailed treatment is given to the academies of Rome, Paris, and London, the most successful and influential and the ones in which issues of the means and ends of teaching were most directly addressed, though other institutions are also discussed, among them the academies of the Americas. If readers who miss such detail about other academies were to compare the teaching practices in them with teaching in the institutions here most fully discussed, they would find, I suggest, a fundamental sameness of approach; all the major features of academic programs throughout the world can be traced back to the programs of the academies of Rome, Paris, and London, which were also the training grounds for artists and future teachers from all parts of the world. Thus, to detail the teaching of the other national academies would have been to describe little more than other artists subscribing to the same doctrine of imitation, drawing from the antique and from the live model, and so on. The aim of this study, in any case, is not simply to describe the academy's practices but to focalize the reasons for them.

It is recognized throughout this study that the history of teaching in the Western tradition cannot be subsumed into a unilinear history only of those organizations calling themselves "academies." In these early chapters independent schools and alternative courses are considered, both for what they have to tell us about conceptions of art and teaching and also to clarify the method of academies: the famous school of Rembrandt, the "academy" of Matisse, and the schooling of women, who were excluded from formal academies.

Chapters 4 and 5 initiate a discussion of the doctrine of the academy. This doctrine typically has been presented as having two components: theory and study of the best masters. But what art, as Thomas Hess has reminded us, has not had some kind of theory behind it and submitted to the authority of one or more masters of the past? It is here argued that what was distinctive about the doctrine of the academy was not its theory as such, nor its version of art history, but rather its opening up of a dialectic between theory and practice. The unfolding of academic doctrine as described in these and later chapters is, then, the story of how the many contradictions that emerged from this dialectic were resolved into a unity.

The discussion of visual art and language initiated in Chapter 2 is resumed in Chapter 5. In question is the appropriateness of the application of the paradigm of language to the study of works of art or, in simpler terms, whether and to what extent images are like texts. That the model is applicable – and images textlike – has been a widely accepted assumption of modern linguistics. It is here argued, to the contrary, that despite a penchant for discourse, academies aimed to liberate images from the tyranny of texts. The artists of academies, as no doubt those operating within the broader framework of the Renaissance tradition, did indeed conceive of art as a "language," but one learned from and constantly referring back to other works of art: a language of visual images understood as different from verbal signs.

Each of Chapters 6 through 8 examines one facet of academic training: copying the masters, drawing after the antique and from the live model. Some overlapping with the previous two chapters was, of course, unavoidable. But here the emphasis is on the practical engagement with art that was, after all, what teaching was all about. In each of these chapters practices within academies are examined in relation to those by independent artists and members of the modern avant-garde.

It is argued in Chapter 6 that although copying always had been part of the training of artists, academies blurred the distinction between original and copy, going so far as to encourage their artists to regard virtual copies as originals. The modernist Manet was implicated in this practice, and so, in their own ways, were Van Gogh and Cézanne, who, as though taking academies at their word, produced "original" copies.

Chapter 7 shows that whereas the study of the antique had been central to the Renaissance tradition it was turned by academies into the imitation of a surprisingly small group of models. Just how restricted a group this was early-twentieth-century classicists demonstrated. Rejecting the academy's canon while drawing inspiration, nevertheless, from classical models, artists such as Picasso, Léger, and Severini, opened up a whole new chapter in the story of art in the classical tradition.

Chapter 8 addresses the extremely complex issues of life drawing in the Renaissance tradition, the academy, and among modern artists. It suggests answers to such questions as how artists went about forming an idea of the beautiful and "selecting" the best features of live models, familiarized themselves with the female form when nude female models until fairly recent times were banned from academies and schools, and were able to draw from the nude that was so central to academic training and yet not produce "academic" nudes.

Chapter 9 is concerned with the relation of art to science, which, like that of art to language, is a recurrent theme in the literature of art from the Renaissance on. According to the most widely held view, the "science" of art is theory, without which it would be aimless and "dumb." On the basis of case studies, it is here proposed that science, like theory itself, was placed in the service of visual precedent; it was not to science that the exalted status of art was owed but to the practice of the masters.

Chapter 10 is devoted to a question asked intermittently from the first pages of this study and particularly in Chapter 4, a question of art history or of art *in* history. How did artists reconcile the present with the past, all the while looking to the future? Specifically, the question is one of the academy's understanding of style, which is examined in relation to modern stylistic terms and categories. These proving inadequate – the categories of early-twentieth-century art history as well as recent revisions of them – an alternative model is proposed.

The principal threads of the first ten chapters are woven together in the eleventh, in which the workings of the academy's "language" are examined in detail with regard to both sculpture and painting, to clarify the meanings of "imitation" and "originality." Revisions and rejections of the academic method from Jacques-Louis David to Courbet and Picasso are examined, recognizing the impossibility of closure so long as the institutions themselves continued to exist.

With Chapter 12, the discussion shifts, almost literally, from the Renaissance tradition to the modern age of the machine and examines the new awareness of something up to that time overlooked, when not denigrated: the human hand, which had been considered inferior to the intellect. To elevate the status of the first, design or craft schools were founded; to harmo-

nize art and craft, a new type of school was created: the Bauhaus. Although incorporating an academy of art and counting leading artists among its staff, the Bauhaus insisted, as was noted above, that art cannot be taught, all the while, it will be argued in this and the following chapter, that something we would call art was being taught. This was only one of the contradictions of an institution in principle committed to the crafts yet capable of treating one of them – weaving, as is shown – as a lowly "women's" occupation.

Chapter 13 carries the discussion of Bauhaus teaching into the present-day university and art-world, examining the teaching of Josef Albers and responses to it by his former students. The spectre of a new "academicism" conjured up in connection with this work is confronted. The real question, it is suggested, is not that of "academic" art as such, because, for one thing, the term has been understood differently in the modern world from the way it was formerly, but that of the role of a *tradition* and whether teaching can take place in the absence of one. This discussion forms the basis for the reflections of the Epilogue.

THE PROBLEM OF THE FIRST ACADEMY

To write the early history of academies is to come face-to-face with a question both of definition and of difference. What was an academy and how did it differ from a workshop or school? The question calls attention to these other organizations, asking about the state of our knowledge of the training of artists early in the Renaissance tradition and whether or not academies caused a rupture in this training. It is an important question because of the temptation to project back into the early organizations, be they workshops, schools, or academies, the practices of such organizations in later periods.

WORKSHOP, CLUB, SCHOOL, AND ACADEMY

The most famous of the early academies and certainly the first public one was the Accademia del Disegno founded in Florence in 1563. It was preceded by other "academies," however, one or another of which would seem to qualify as the first academy of art. One such "academy" is associated with Leonardo, principally on the basis of a series of engravings that carry the inscription: ACADEMIA LEONARDI VINCI (Frontispiece). Another was presided over by the sculptor Baccio Bandinelli in Rome in the 1530s and moved to Florence, perhaps around 1550 (Fig. 1).[1]

Appearing at about the same time as academies, and existing alongside of them, were artists' "clubs." Writing about the Roman art world of the 1520s, Benvenuto Cellini mentions "a club of painters, sculptors, and goldsmiths, the best that there were in Rome. . . . We often came together, at the very least twice a week." The time was spent, he says, composing and reading poetry, and enjoying musical concerts.[2]

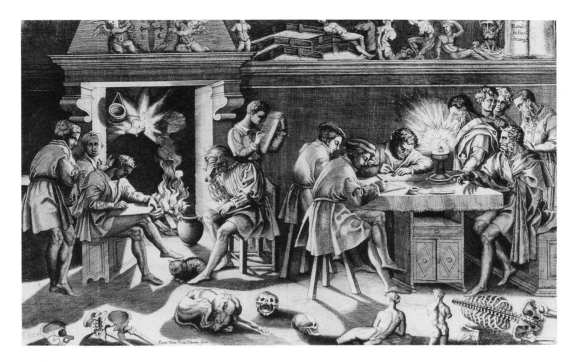

Figure 1. Enea Vico, *Bandinelli's Academy in Florence,* 1550. Engraving. (Photo: Warburg Institute)

Vasari, too, reports regular meetings of artists' clubs in the early sixteenth century. One, in the workshop of Baccio d'Agnolo, sponsored "marvelous lectures and debates" ("bellissimi discorsi e dispute d'importanza") with the participation of such artists as Granacci, Raphael, Sansovino, Antonio and Giuliano da Sangallo and, at times, Michelangelo. Giovanni Francesco Rustici also was host, according to Vasari, to a club ("una brigata di galantuomini") that organized festivities attended by painters, sculptors, musicians, and members of the Florentine upper classes, among the first, Andrea del Sarto and Puligo.[3]

A club using a workshop as its meeting place obviously is not the same as that workshop. And the preoccupations of these clubs were altogether different from those of workshops: literature, poetry, and music rather than drawing, painting, and sculpture. A workshop, by contrast, was organized around a whole range of strictly manual as well as technical procedures, from the grinding of pigments and preparation of panels to the practice of drawing, the skill basic to visual representation, whether in painting, sculpture, or architecture, taught alike to students preparing for careers in any of the three disciplines.[4] Drawing instruction was based above all on copying, of works by the masters and also sculptures or casts of them – that is, on copying

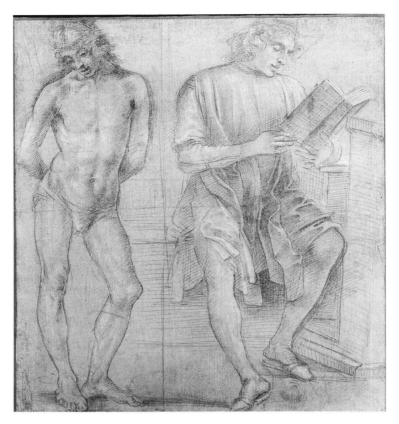

Figure 2. Filippino Lippi. *Standing Youth, Seated Youth*. Silverpoint heightened with white, on pink prepared paper. New York, The Metropolitan Museum of Art, Harris Brisbane Dick Fund, 1936 (36.101.1 recto). (Photo: The Metropolitan Museum of Art, New York)

works first in two dimensions and then three – so copying was a regular part of the workshop routine. These were copies of representations of the human figure, which was the focus of the Renaissance tradition. Other workshop exercises, involving the more advanced students and members of the profession, confronted the figure directly, typical studies being of the figure itself (Fig. 2) or, nearly as common since figures were usually represented clothed, of drapery (Fig. 3).[5]

One of the drawing practices of the workshop was associated by Vasari with "schools," namely copying. He speaks of how Michelangelo's cartoon for the *Battle of Cascina* was a "school" for young artists; and he says the same of Michelangelo's Medici Chapel.[6] Michelangelo was among the artists said to have studied in the school in the garden of San Marco referred to by Vasari as "Bertoldo's School," which specialized in copying from ancient sculptures.[7]

Drawing is the activity represented in the engraving of Bandinelli's acad-

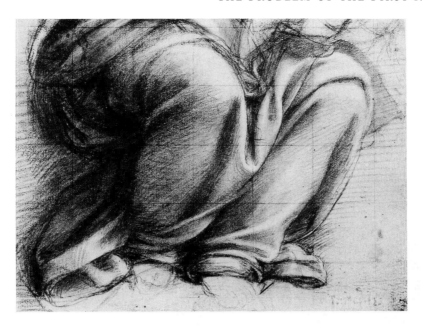

Figure 3. Fra Bartolomeo (?). *Study of Drapery over the Knees of a Seated Figure.* Black chalk heightened with white. New York, The Metropolitan Museum of Art, Bequest of Walter C. Baker, 1971 (1972.118.240). (Photo: The Metropolitan Museum of Art, New York)

emy (Fig. 1). But this is neither the drawing of the workshop nor of Vasari's "schools," namely, copying from other works of art or from nature. Nor is it the kind of drawing we would expect in an academy. For the academy as we know it from later in the Renaissance tradition placed a stress on figure drawing at least equal to that of earlier organizations. The importance of the figure not having diminished, figure drawing remained the foundation of academic training; the public image and institutional identity of the academy were inextricably interwoven with drawing from the nude model.

There is neither a nude nor a clothed model posing in Bandinelli's academy, however; altogether lacking are live models of any kind. Nor are the artists represented attending to the various objects strewn around the room — skeletons, antique sculptures, models or reductions of Bandinelli's own sculptures. Drawing (or writing) takes place on a darkened stage, more conducive to introspection than observation, as exemplified in the melancholic figure in the center and the figures raptly attending to the demonstration at the right. Only artificial light shines on these labors, the light understood as the visible sign of a surge of intellectual illumination.[8]

The sense of this image is confirmed by Bandinelli's own words. For he stated that his academy was dedicated to a special kind of drawing. He

declared, that is to say, that his was an "accademia particolare del disegno."⁹ And the term *disegno* was laden with arcane meaning in the Renaissance. Usually rendered in English as "drawing," its connotations were broader than that, and more abstract. It was understood to comprise the common foundation of all the visual arts – painting, sculpture, and architecture – to be the "father" of the arts and principally responsible for distinguishing them from the crafts. In Vasari's words: "*Disegno* is an apparent expression and declaration of the *concetto* [or judgment] that is held in the mind and of that which, to say the same thing, has been imagined in the intellect and fabricated in the *idea*."¹⁰ *Disegno,* then, is an ineluctably intellectualizing activity far different from, and not to be confused with, descriptive drawing.

Stressing the philosophical foundations of visual art, Bandinelli was active in other fields of intellectual endeavor. A writer and poet identifying with Petrarch, he was admitted to the literary Accademia Fiorentina in 1545; he joined art to literature in theoretical speculations.¹¹ A self-portrait recapitulates his view of the artist and of the centrality of *disegno* (Fig. 4). One would never guess that this was an artist who, as a sculptor, engaged in manual activity of the most strenuous kind; entirely detached from such activity, here we see a gentleman and intellectual whose only connection with the visual arts is the drawing (*disegno*) of Hercules and Cacus.

Such, evidently, was the conception of visual art underlying Bandinelli's academy, the line of demarcation separating the intellectual from the manual side of the activity that entitled him to use the term. For not just any organization could be so called. Before the word "academy" was used in connection with visual art, it was associated with the school of Plato and, in the Renaissance, with the Platonizing philosophy of Marcilio Ficino, who was thought to have founded the first academy since the end of classical antiquity.¹² In the years after word of Ficino's academy spread, others were created, until by 1500 academies were as numerous as they were fashionable.

Ficino may not actually have founded an academy in the physical sense, for the term in Renaissance usage is ambiguous and need not refer to an institution. It had at least seven meanings: (1) the grove of the hero Academus that gave its name to Plato's nearby school; by extension, (2) the school of thought associated with Plato, (3) a private humanist school, (4) a classicizing substitute for the medieval university; more loosely, (5) any regular gathering of literary men, (6) a house, villa, or chamber used for literary or philosophical studies; metonymically, (7) the Platonic corpus.¹³

Bandinelli was well versed in Platonism, the connection with which his use of the term "academy" may have been intended to convey.¹⁴ Such a connection would have been strengthened, too, by coupling "academy" with *disegno,* which was defined at the time within the framework of Platonic metaphysics. If he was not stating a strict philosophical position, it is certain,

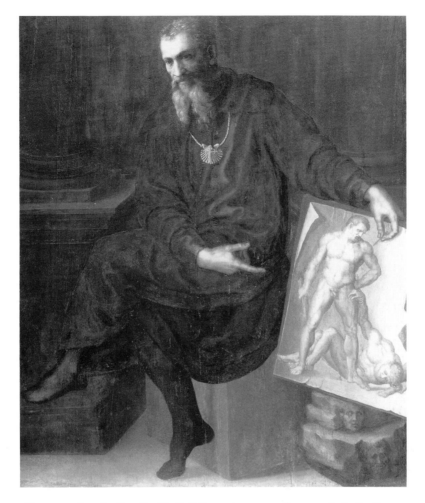

Figure 4. Baccio Bandinelli, *Self-Portrait,* 1540s. Boston, Isabella Stewart Gardner Museum. (Photo: Isabella Stewart Gardner Museum, Boston)

nevertheless, that he was declaring a commitment to intellectual activity. For if "academy" did not necessarily designate a particular school of philosophy, the term could only be used for a group dedicated to the study of humanistic subjects, such as literature and philosophy.

An artists "club" devoted to composing and reading poetry could conceivably have called itself an academy, as the term was sometimes used to refer to regular gatherings of literary men. Artists meeting as a "school" for the purpose of copying works of art or otherwise engaging in the process of drawing from observation would not, however, have constituted an "academy": one thing an academy could not be until sometime late in the sixteenth century was a center for drawing, either from works of art or from a model.

THE FLORENTINE INITIATIVE

All this changed, or so it would seem, in 1563, with the foundation of the Florentine Accademia del Disegno.[15] This was an academy created, to Pevsner's mind, out of a "belief in certain teachable dogmas and certain canons discovered by a few divine artists of the past," an academy more recently represented as teaching drawing and fostering the creation of an "academic" drawing style.[16] If it had done only, or even principally, the latter, the Florentine academy would have been a drawing "school" masquerading as an academy; had it joined "dogmas and canons" to drawing instruction, on the other hand, it would have been an academy of a whole new type, the Ur-academy of the Renaissance tradition. To determine which, the history and structure of this academy must be examined in some detail.

The historical facts are quickly recounted. Upon returning to Florence in 1560, the sculptor Montorsoli had the idea of creating a special burial place for himself and for other painters, sculptors, and architects. With the aid of his friend Father Zaccaria Faldossi, he obtained a chapel – the former Benizi Chapel – in the cloister of the Santissima Annunziata. Montorsoli and Faldossi then let Vasari in on their plan and approached other artists as well – Bronzino, Francesco da Sangallo, Ammanati, Vincenzo de' Rossi, and Michele Ghirlandaio, among others.

Thinking first of a funerary chapel, the artists soon turned their attention to the possibility of reviving their old guild or confraternity, the Compagnia di San Luca, which had declined and no longer had a fixed meeting place. In a ceremony on May 24, 1562, the assembled Compagnia formally thanked Montorsoli for donating the chapel and solemnly transferred the remains of Pontormo to their new resting place.

No sooner had this been done, however, than Vasari called for a meeting the following Sunday to create a new kind of organization, consisting of artists drawn from the confraternity but superior to it: an academy that he had discussed with Duke Cosimo de' Medici. The duke earlier had made himself protector of the Accademia Fiorentina, which was devoted to linguistic questions, and was receptive to Vasari's initiative. With the duke as protector of the academy its success was assured. In January 1563 statutes were drawn up and, after they were approved by Cosimo, a foundation meeting was fixed. Vincenzo Borghini, connoisseur, writer, and good friend of Vasari, was made *luogotenente* (vice president). Duke Cosimo and Michelangelo were made *capi* (honorary presidents).

When Michelangelo died the following year, the academy staged a large-scale spectacle in support of its claim to a place of honor within Florentine culture.[17] The church of San Lorenzo was filled with paintings and sculptures contributed by its members, dominated by a giant catafalque trumpeting the

fame and glory of this sculptor-painter and, by implication, of the academy to which he had lent his name. The author of a pamphlet commemorating the service wrote:

It was the intention of the academicians to relate in the stories that have been, and will be, described some of the more outstanding events which happened to Michelangelo, and because of the infinite number they showed only those which were deemed noteworthy for their profession, such as gaining fame, esteem, benevolence, honours, and other similar distinctions from the princes of the church as well as the realm, and which truly contributed to the advancement of the arts.[18]

A permanent monument to Michelangelo, for Santa Croce, was begun in the same year. A second monument, to the academy itself as it were, was undertaken in 1565 with a contract to complete the decoration of its chapel, the Cappella di San Luca, in the church of the Santissima Annunziata, begun by Montorsoli but left unfinished at his death in 1563.[19] Here the academy was boldly asserting the claim of painting itself to a position of preeminence despite the drudgery that it entailed. For in one of the principal frescoes Saint Luke is represented painting the Virgin in the way a painter would, with brush and painting stick (*mahlstick*), while assistants grind pigments in the background (Fig. 5). The painting, while consistent enough with the iconography of Saint Luke, is in marked contrast to many representations of the saint precisely in its glorification of the craft of painting, which, in this context, would seem to place the Florentine academy at the confluence of workshop and academy.[20] That this position had behind it the highest public sanction is confirmed by the nearby statue of Duke Cosimo, grimly signifying his approval.

The academy had attempted to distance itself from the guilds of the workshop tradition, however, the contrast being encapsulated in its name: Accademia del Disegno. For, as I have observed, an academy was a center of humanist learning, *disegno* a shorthand alluding to intellectual, not manual, activity. And one of the first concerns of the academy, shortly after it was created, was the matching of its name with a seal or device proclaiming its high intellectual purpose.

Of the surviving designs for the seal, one by Benvenuto Cellini is a representation of *disegno* in all its plenitude of esoteric meaning, the unraveling of which surely would be thwarted but for the accompanying explanation addressed to the academicians ("voi Artefici nobilissimi"; Fig. 6). The central figure is a traditional personification of Nature, who nourishes all things and in whom originate the true and perfect ideas of *disegno*. The rays of light emanating from the crown on her head are shed on the worthy academy, resulting in its fame, symbolized by wings and trumpets. The serpent and lion refer to Prudence and Fortitude, the twin virtues promoted by the academy, and also have meanings on another level, for the lion is a sign of Florence and

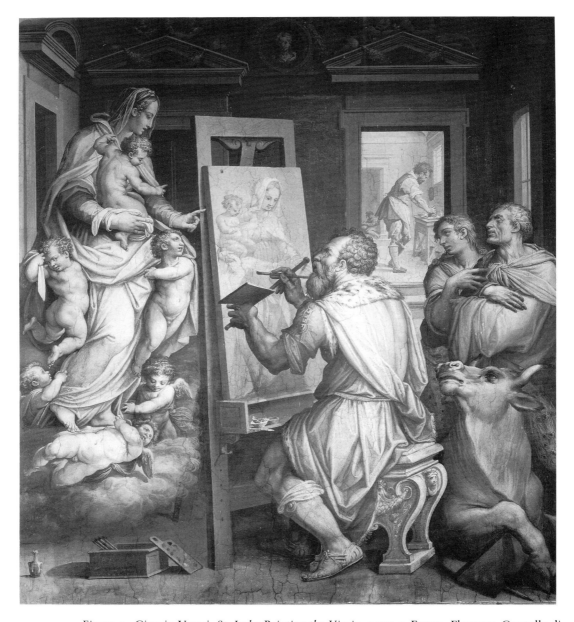

Figure 5. Giorgio Vasari, *St. Luke Painting the Virgin*. 1570-1. Fresco. Florence, Cappella di San Luca, Santissima Annunziata. (Photo: Soprintendenza alle Gallerie, Florence)

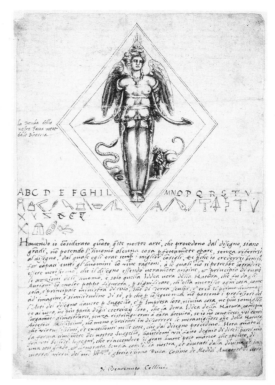

Figure 6. Benvenuto Cellini, *Design for the Seal of the Florentine Academy.* Pen and brown ink and wash. London, The British Museum. (Photo: Courtesy Trustees of the British Museum)

the serpent one of the insignias of Duke Cosimo. To the sides are Roman letters, together with an "alphabet" of the visual arts, represented in the form of instruments used by artists of different kinds, painters, sculptors, and architects. Just as there are alphabets as different from one another as the Egyptian, Hebrew, and Greek, so there is an alphabet of the visual arts, Cellini declares, recalling both Plato's argument for God as writer (of Nature) and Socrates' "picture theory" of language in which words resemble that which they represent – or in this case are, literally, the "instruments" of representation.[21] The clear aim is to harness the intellectual energy and prestige of the literary academies.

That the Florentine academy viewed itself as an agent of professional advancement is made clear, then, by its name and deeds; the whole concept of an academy of *disegno* is inimical to a guild workshop. What was the role in it, then, of workshop practice? Was it perhaps a drawing center, augmented by theoretical instruction as a result of which the drawing styles of its members became "academic"? In terms of this discussion, how was the gap between the painter of Vasari's representation (Fig. 5) and the personification of Cellini's seal (Fig. 6) bridged? The place to begin to look for answers are the statutes drawn up by the academy articulating its mission.[22]

A NEW KIND OF TEACHING?

The statutes contain many passages and provisions that point to Vasari. The first article, for example, begins with an account of the legendary origins in Florence, during the "prima rinovatione" of the arts, of the artists' confraternity, the Compagnia di San Luca. This soon becomes a panegyric to Duke Cosimo, who is credited with recovering this glorious heritage through his creation of an institution in which beginners would learn the arts of *disegno* ("Academia et Studio a utilità d'i giovani che imparono queste tre arti . . ."). The teaching function of the academy having thus been enunciated in the first article, surprisingly little is said about it in those that follow.

funeral rites

Almost half the articles are concerned with administration: the election, duties, and conduct of officers; the frequency of meetings; keeping peace in the academy; the maintenance and embellishment of its meeting place. The next largest group deals with religious services and celebrations, exequies, and charitable works. Among the other articles, two point again most directly to Vasari: upon their deaths, academicians and members of the confraternity were to have their names inscribed in specially kept books, with a list of their works and a record of their places of burial; a frieze was to be created from portraits of the most excellent artists, beginning with Cimabue and including, upon their deaths, the best artists of the academy — the kind of documentation of Italian art that Vasari pursued in his *Lives*, the second edition of which was in preparation during these years and contains woodcut "portraits" of the artists, and in his own collection of drawings.[23] Several extremely important articles make the academy the supreme authority on artistic matters in Florence.

After article 1, no mention is made of students until article 31: a library was to be created as a repository for drawings, models, and plans that members were urged to will to the academy for the benefit that its students would derive from studying them. The next two articles were devoted to educational procedures: each year three masters — one painter, one sculptor, and one architect — were to be elected as *visitatori* (supervisors) to teach a select number of boys either in the academy or in their own workshops; they were to visit the shops in which the boys ordinarily worked to call their attention to errors they were falling into. This was to be done gently ("con amorevolezza"), considering the particular talent and experience of the boy. When they considered the boy sufficiently advanced, they were to propose him for membership in the *Compagnia*, a decision then being taken on the basis of a drawing (or model or plan) that he would submit.

These last articles make plain a key difference between this academy and that of Bandinelli or the literary and philosophical academies; for it had to accommodate a painters' guild – its complete name was the Accademia e Compagnia del Disegno – which it proposed to do by having its members augment the regular instruction and supervision of students in the workshops. This being an academy, the omissions of its statutes are, nevertheless, astonishing. There were no plans to facilitate drawing either from the antique or from the live model, such key features of the programs of later academies. (From 1644 on, records show that nude models did pose in the academy, though by this time the practice was common in schools and academies throughout Europe.)[24] Nor, what seems the most resonating silence, was there a theoretical program, a body of "dogma." True, there is a provision in the statutes of January 1563 for lectures on geometry, though they only began in 1569. The emended regulations of July of that year provided for lectures on anatomy ("una Anathomia"), which were held in the Hospital of Santa Maria Nuova.[25] But no other theoretical studies were contemplated. This is surprising, indeed shocking, for from the early Renaissance it was theory that was relied upon to set the visual arts on an equal footing with the intellectual or humanistic disciplines. And in the present context, this is the kind of program that one would have expected Vasari and Borghini to formulate in order to justify the use of the term "academy" and make the Accademia del Disegno the true equal of such academies as the Accademia Fiorentina.

It has been difficult to accept the academy on the evidence of its statutes as an organization devoted to *disegno* and designated a *studio*, that is, a place of learning, and yet without an intellectual dimension. For a true academy would have been a center of humanist discourse, and so Charles Dempsey has imagined the Florentine academy necessarily to have been, an "academic phenomenon" that raises the question of "what it is that could have prepared artists to implement formally in academic institutions the training of the arts of *disegno* as a liberal profession on the model of the sister arts of letters." It could only have been a complete humanist education that they themselves received, he suggests, allowing them to found institutions of higher education in which art was taught according to a system of rules.[26] The whole notion of "academic" art turns on the centrality of rules, so that what is suggested is that, this early in the history of academies, a course was charted from which later institutions did not deviate.

Karen-edis Barzman has argued similarly that, as this was an academy of *disegno,* its founders must have viewed the visual arts as liberal activities, understanding practice to be based on theory. It would follow, therefore, that they promoted the study of those subjects considered essential to a

liberal education: mathematics, anatomy, life drawing [*sic*], and natural philosophy. In evidence of such teaching, she enters not the contents of the statutes or records of the academy but, rather, the principles of Renaissance art theory, particularly that of Alberti, "echoed by art theorists in the circle of the Academy," that is, voiced in art treatises. That the substance of this theory – "history" (*istoria*), elevating the more technical procedures in Alberti's program – was not reiterated in the academy receives only passing mention.[27]

But that it was not is the essential point. To state it once again: the teaching of mathematics, stipulated by the statutes, was desultory, that of anatomy equally sporadic – if taught at all; there was no provision for teaching any other "liberal" subject or for posing nude models. The one further mention of an instructional initiative is a decree of 1571 according to which sculptors were to prepare clay models to be used for drapery studies.[28] Was this, one of the most elementary of workshop exercises (Fig. 3), a proper "academic" activity? There were members of the academy who believed it was not, that the academy was not appropriately discharging its educational function. One of them was Federico Zuccaro, who, around 1578, wrote a letter pleading for reform.[29]

Zuccaro writes about how study has been neglected and needs to be recuperated ("rimettere in piedi li studii") if the academy is to survive. (The lectures on mathematics and anatomy were, in fact, the only ones given earlier and that could, therefore, have been resumed.) His program of reform is of an inflection, however, in comparison with which the vagueness of the original statutes is thrown into relief. He demands that the academicians accept responsibility for teaching, which is to take place in all the regular meetings. Teaching would be of an organic unity, showing equal attention to theory and to practice. The actual practices of the masters would be discussed and drawing facilitated by setting aside a room for working from life ("ritrarre dal naturale") – the first such mention in connection with this academy; examinations of student works would be used as occasions for communicating the rules and science ("regole et scienza") of art, measure and proportion, among others, and regular lectures on such subjects as mathematics would be offered. A record of the discourses would be preserved, as would the drawings of the best students, whose conformity to the teaching of the academy would be rewarded with prizes.

Zuccaro was a commanding figure in the later Roman Accademia di San Luca, in which he had an opportunity to implement his program. Apparently nothing was done about it in Florence, for several years later we hear again about the academy neglecting teaching in a letter by the sculptor Ammanati demanding that it institute regular lectures on such subjects as composition and proportion.[30] This summons, too, seems to have been ignored.

THEORY AND PRACTICE

It certainly is surprising that the academy should have dismissed the claims of theory, for the period of its birth and the formulation of its statutes witnessed the proliferation of theoretical utterances. It was at this time that the legacy of Alberti, whose landmark treatises on painting and sculpture apply to the visual arts the language of early Florentine humanism, was both cherished and transfigured, art theory and criticism turned into a full-scale humanist endeavor. Writers such as Varchi (1546), Vasari (1550 and 1568), and Borghini (1584), adumbrated a program for visual activity as a harmonious totality of the liberal disciplines, advocating for art what had been claimed for such subjects as literature, history, or ethics. They argued, that is to say, as Alberti had done, for the antiquity, nobility, and superiority of the visual arts, but with a greater range and subtlety, by more fully modulating the tropes and figures of classical rhetoric.[31] It is difficult to understand how the academy could have refused to teach subjects the importance of which these writers so persuasively argued; the more enduring paradox is that these arguments were put forward by the very leaders of the academy.

To say that the language of Florentine theory was that of classical rhetoric is to state that the theorists respected, and exploited, the discipline regarded as most essential to a liberal education, the skill regarded as quintessentially humanist: eloquence. Scholars long ago became aware of the centrality of classical rhetoric to an understanding of Renaissance literature and historiography; in recent times this research has intensified and established the even greater importance of classical rhetoric to these disciplines than had been thought. Art historians, too, have been reading classical rhetoric; from Panofsky and Gombrich to Baxandall and Summers, they have traced the influence of classical rhetoric on the writing of art history and criticism in the Italian Renaissance tradition, on Alberti and the theorists who followed him — all of whom drew upon the same rhetorical tradition.[32]

Rhetoric in a broader sense, that of literary production, has been a specific topic of discussion among poststructuralists. Rhetoric here refers to the way a discourse is structured to engage an audience; such a study of rhetoric is, then, an investigation of the *tropological* strategies of *any* discursive practice.[33] It proceeds by means of an analysis of the narrative prose discourse utilized for purposes of explanation; rejecting the old distinction between the actual and the fictive, it regards all texts as *representations* drawing on available literary capital. Any text is created out of other texts, of which it is a reworking; a text is, before anything else, "about" the use of language, writing and reading processes of responding to traces of other texts.[34] Florentine art theory and criticism not only speak the language of classical rhetoric but are replete with textual traces — to the rhetorical handbooks of Cicero

and Quintilian, as well as other ancient texts. These borrowings generally have been understood as evidence of the influence of the ancient authors, to whom the Renaissance writers are imagined as having turned for help in fashioning more stylish arguments. This is precisely the kind of assumption that now must be regarded as questionable.

That the Renaissance writers applied to visual art the categories and processes of classical rhetoric was no doubt inevitable given the importance of rhetoric within the humanist agenda and the fact that these books were written for an audience accustomed to humanist discourse. The language of the art treatises was continuous with that of other works in the humanist corpus, a language read in relation to that of other humanist texts. The treatises were judged according to certain standards of eloquence – in other words, as to whether and to what extent they were suasive in humanist terms, rather than whether what they said was "true." To argue that they were also intended for artists, articulating their innermost convictions and desires, is to assume that artists, too, thought in terms of humanist concepts, regarding eloquence and visual representation as coterminous. And such an assumption would, at the very least, have to be supported with corroborating evidence. The silence of the records of the Florentine academy is eloquent testimony to the opposite: indifference or hostility to the theory harnessed to liberal education and to all but the most elementary teaching.

Rather than try to argue away this silence, as some scholars have done, we must accept the evidence for the reluctance of the academy to formulate a comprehensive program of instruction. Teaching was to remain the domain of the workshop, with the academy playing an almost exclusively religious and social role. Here, it would seem, are the distant roots of the Bauhaus conviction that craft alone can be taught, not art. And the story of the formation of a uniquely academic doctrine, a species of Renaissance theory that is nonetheless distinct from it, between the periods of the Florentine academy and the Bauhaus, is a narrative first of the problematizing of the relationship between theory and practice, and then of a "deconstruction" of theory in a resolutely dialectical engagement with it as something demonstrably different from practice.

That the Florentine academy should have broken the bond between theory and practice cemented in the Renaissance literature of art may, moreover, be understood in light of discussions of practice in treatises and letters. To enter these discussions in evidence of views of art after having earlier rejected their evidentiary status may seem to be an attempt to have it both ways. But there are indications that at times the theorists wrote out of an engagement with art itself rather than with humanist discourse, in such discussions taking a whole different approach to practice than to theory and to such learned questions as that of the relation of the visual arts to other disciplines. The

writers acknowledge, that is to say, the elusiveness of art and of the natural talent that an artist either has or does not have, and of the potential harmfulness of intervention in the activity of artists of the first kind and the futility of study for the second. Vasari, for example, warns that too much study and effort can undermine artistic performance, as it did in the fifteenth century, when artists were too scrupulous in their applications of the rules of anatomy and perspective, too mechanical in applying rules. He stresses the need to go beyond the rules, for the sake of a "facility" and "grace" refracted by them.[35]

see also, p. 44

When Vasari uses Christian terms, he intends them, I have elsewhere suggested, in their theological senses; he understands grace, that is to say, as God-given, so that greatness in painting is a sign of God's favor, evidence that this was someone in a state of grace.[36] An artist in such a state has no need of instruction; not so favored, he will benefit little from it. Paolo Uccello is one of Vasari's examples of an artist who believed that he could achieve greatness through study. "If he lacks the ability," Vasari states, "whatever his efforts he will never be able to achieve what another painter, with the help of nature, can take in his stride." His principal example of the artist of the second type is Michelangelo, "whom God and nature have made so gifted that [his] work seems almost miraculous."[37] This same view is traceable to Michelangelo himself. "A good judgement and an exact eye are better than compasses," he had declared in an aphorism paraphrased by Vasari: "the eye must give the final judgement."[38]

Borghini also stressed the importance of the eye and the danger of relying on "compasses." Commenting on a debate among artists over the *paragone,* the most obviously rhetorical of all the topics of Renaissance art theory, declaring the superiority of one of the arts by praising it at the expense of another, he criticizes the participants for putting aside their proper concerns as artists to impersonate philosophers and rhetoricians. All the arts are equal, he states, and there should be no dispute among them. Rather, artists should concentrate on what they do best and strive to do excellent work in their own disciplines – by working and not talking ("di FARE et non di RAGIONARE"). This was not only the opinion of Michelangelo but a clear echo of his own *paragone* letter of 1548, which closes with a similar emphasis on making, not speculating.[39]

The early Florentine academy would seem, then, to have been an "academy" principally in name, neither offering comprehensive drawing instruction nor espousing a doctrine consisting of rules to be implemented by all its members alike. This is the conclusion I reached after a detailed examination of the evidence in my book on the sixteenth-century academies. And the same conclusion was reached by Waźbiński in his study of the Accademia del Disegno; the idea in the sense of Renaissance theory far outstripped the reality of the academy, he stated.[40] Certain of its procedures may nevertheless

Figure 7. Cosimo Gamberucci, *Resurrection of Lazarus.* 1613–14. Pen and brown ink, brown wash, traces of black chalk, squared with red chalk. Paris, Musée du Louvre, Cabinet des Dessins. (Photo: © Réunion des Musées Nationaux)

have encouraged the production of "academic" works, measures of the kinds taken in many later academies, and they were written into the first statutes.

STYLE AND THE FLORENTINE ACADEMY

In question are articles 30, 31, and 34;[41] article 30 provides for an exhibition space in which works by the masters of the academy would be displayed; article 31 calls, similarly, for the creation of a study collection of drawings, models, and plans made by its members; and article 34 states that, four times every year, each artist of the academy had to submit one work – a drawing

Figure 8. Gregorio Pagani, *Madonna of the Rosary,* c. 1594–8. Pen and brown ink, brown wash with white heightening, on gray-blue paper. Paris, Musée du Louvre, Cabinet des Dessins. (Photo: © Réunion des Musées Nationaux)

by the painters, a relief by the sculptors – to be inspected by the consuls, who would decide on the basis of these submissions which of the artists were to be given a share of the festival decorations, the best of the artists to be additionally rewarded. And there are, indeed, records of exhibitions of paintings made for funerals and festivals.[42]

What these articles evidently are about is the setting of a standard, bodied forth by masterworks and applied by the consuls; young artists were to be helped to develop their visual skills, the further honing of which was to be stimulated by commissions and prizes. And the students may have been spurred to develop skills of a special kind. For the process of selection stipu-

lated could have been tantamount to the definition of a stylistic norm, the "correct" style of modern Florence to which all the young artists were expected to conform; works by the older artists of the academy would have constituted the models exemplifying that norm. The articles in the statutes providing for exhibitions and making the consuls judges of the maturity of the young artists may be understood, in other words, as designating the consuls as arbiters of style, effectively centralizing control over artistic production and thereby fostering stylistic uniformity.

Works by students in the academy are indeed characterized by an unusually high degree of conceptual, as well as technical, uniformity. Consider two drawings by artists whose names were inscribed in the academy's register, a *Resurrection of Lazarus* (Fig. 7) by Cosimo Gamberucci, a student from 1580, and a *Madonna of the Rosary* (Fig. 8) by Gregorio Pagani, mentioned in 1576.[43] The two share a static equilibrium, resulting from the strict counterbalancing of elements, figures, and architecture; in both, too, the figures, though looming large in the foreground, are tightly drawn and have little credible volume and little movement – astonishingly little for works in the "school" of Michelangelo. The same could be said, too, of works by the founders of the academy that, under articles 30 and 31 of the statutes, would have been placed before the students for purposes of emulation, works that reflect the same basic interpretation of the art of the High Renaissance (Fig. 5).[44] The uniformity of works produced in and around the academy was that of Florentine art at this time, in other words, the painting by Vasari no less than the drawings by Gamberucci and Pagani projecting this uniformity, and the question raised is of the responsibility of the academy: how much of this sameness is traceable to specifically "academic" practices. Pevsner implied that responsibility for it should be assigned to the academy, and Ward agreed, recognizing its expectations behind the art of the time.[45] But to suggest the possibility of the academy playing such a role is merely to note the continuity of Late Renaissance art in Florence; the role of the academy was in no way different from that of the studios to which the teachers and pupils were attached. There is no reason to believe that the academy in any way altered the course of Florentine art; nor is there any reason to believe that it was the intention of its founders to do so.

Their clear intention was to create an instrument of access to the world of the great and the powerful, nothing more – as though this were not enough. An academy was eminently suited to provide such access, its very name severing the connection of the visual arts with manual activity and forging a link with bodies of learning at the higher reaches of society. With Cosimo de' Medici's sponsorship, the academy was indeed able to share in the aura of Medici power, making it the envy of artists all over Italy and Europe; Medici

largesse, real or imaginary, made it doubly enviable. When the artists of Paris, in 1652, drew up new plans for their academy, they addressed a plea to the king asking that he pay the expenses of this academy as the Medici had that of the Florentine ("à l'instar de celle du Grand Duc de Florence").[46] And other academies had been founded, after the Florentine and before the French, inspired as well by stories of the Medici academy in Florence. The history of these academies constitutes the narrative of the first stage of the academic tradition.

A TRADITION IN THE MAKING

When Federico Zuccaro was elected president (*principe*) of the Roman Accademia di San Luca in 1593, he was in a position to act on the plan he had presented to the Florentine academy some fifteen years earlier. The Roman academy had been founded not long after the Florentine, in 1577, for the stated purpose of teaching young artists.[1] But however such instruction may originally have been conceived, it seems that nothing was done about it during the first period of the academy's history. With the election of Zuccaro a new phase began in which attention was focused on instruction.

FROM FLORENCE TO ROME

Rules drawn up in 1593 and 1596 commit the academy to education, "in word and deed," and adumbrate a whole series of exercises, organized into a graduated course designed for students at all levels. Novices would begin by drawing from drawings, from reliefs, and with the "alphabet" of drawing, the ABCs of heads, feet, hands, and so on, all drawn from casts; they would go on to draw from the antique, and from the nude model. The *principe* was to participate in the drawing course and reward the best students, which Zuccaro was quick to do, immediately after the rules were formulated announcing a contest in which prizes would be awarded to the authors of the best drawings of parts of the body.[2] An engraving by Pierfrancesco Alberti pictures an academy structured according to these regulations – though omitting the nude model – in an idealized image of an improved facility for teaching the young, identified by him as "academia d' pitori" (Fig. 9).

Practical instruction was, however, only one part of the program; the

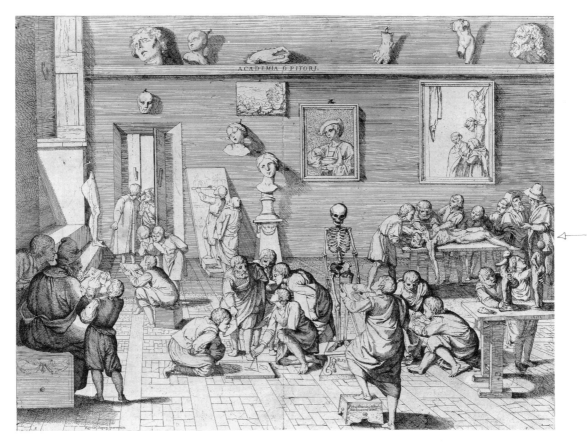

ACADEMIA D PITORI.

Figure 9. Pierfrancesco Alberti, *A Painter's Academy in Rome*. Engraving. New York, The Metropolitan Museum of Art, The Elisha Whittelsey Fund, 1949 (49.95.181). (Photo: The Metropolitan Museum of Art, New York)

other was theory, to which Zuccaro gave equal attention.[3] After having awarded prizes in the first contest, he called on one of the academicians to speak on *disegno*. The ensuing lecture was an explication of *disegno* in a practical sense, the speaker outlining the various manners and functions of drawing. This was an artist, in other words, with a view of *disegno* as a unity of graphic activity. Zuccaro made it clear, however, that this was not the type of discourse he had in mind, commissioning another member to lecture on the same subject at the next meeting, but "intellectually, as a painter and philosopher." This lecture, too, disappointed Zuccaro, who was begged by the assembled artists to explain what he had in mind. What followed was an oration explicitly addressed to the literati present, discussing *disegno* in the way they understood the term.

In Zuccaro's exposition, *disegno* is the original image present in the mind of God and in the heavenly bodies He created, the first of which is the sun; as

an internal principle, *disegno interno,* it enters the mind of man as a spark of the divine mind, like the sun, illuminating his worldly activities, of which artistic representation is one, but as *disegno esterno,* which is secondary and necessarily inferior. Vasari committed the egregious error of conflating the two types of *disegno,* Zuccaro says, and Armenini, in his treatise on painting, also failed properly to differentiate the two, which are entirely separate and independent intelligences, one universal and the other particular.[4]

see also. p. 46

In developing his argument, Zuccaro drew on the writings of Saint Thomas Aquinas as well as on the Platonic corpus, against which he juxtaposed the "false" interpretations of modern authors.[5] He constructed his discourse – that is to say, in the prescribed manner of humanist rhetoric, "discovered" his argument – by consulting standard reference works, and intensified it with utterances of blame such as were required by the genre of the epideictic, the leading form of rhetoric in the Renaissance. This was the discourse of the educated elite and the literary and philosophical academies over which they presided. It is what the learned would have expected of an exposition of *disegno,* as of discourse in an "academy," whether in Florence or Rome. Just what it had to do with visual art, as distinct from philosophy, is an open question. Apparently, this is the theory the lack of which in the Florentine academy Zuccaro had lamented.

After Zuccaro's performance, scarcely an artist in the academy dared to speak. When the sculptors were pressured to prepare a lecture, one of them remarked that it was easier to make a pair of marble figures than a speech.[6] And the few who did eventually speak expressed an understanding of theory different in kind from Zuccaro's. *Disegno* as it appears in one such lecture, for example, is not a spark of the divine but simply an arrangement of figures or objects in a composition.[7] Zuccaro had difficulty filling the lecture schedule, and with his departure it quickly succumbed to the indifference of the members.

After having reviewed the evidence of theory in the early Roman academy, Denis Mahon wrote as follows:

We get the impression that Zuccaro was a flash in the pan, the exception among his fellow members, who were somewhat perplexed by his abstract aesthetics, and seem to have sickened of theory for some time after the dose he gave them. His conception was primarily philosophical and speculative in character, and above all seemed to have no very direct or close relation to the practical job of painting. It was this unfeasibility of application in practice which rendered his theories quite unsuitable for adoption as the doctrine or programme of an academy of working artists.[8]

One would have to say, conversely, that since to the minds of the majority of the working artists of the academy there was a direct passage from image to word, their "theory" was nothing but a description of their manual activity. In terms of Renaissance theory this is no theory at all; and in terms of the

evolution of an academic doctrine or program it is an impasse that in no way would distinguish such an academy from a workshop.

Drawing instruction of some kind seems to have been offered during these years, for the emended regulations of 1596 expressly forbid students from holding private meetings or arranging life classes, meaning, presumably, that such sessions continued to be organized by the academy.[9] And in the rules of 1607 instruction is described as earlier, with no indication that it had been neglected. The passage reads: "The studies of the academy will be of drawing, painting, anatomy, sculpture, architecture, perspective, and everything else of concern to the profession."[10]

The records are sparse for the next years in the academy's history, as noted by Missirini, who thought that there may have been little to record.[11] That drawing was taught, however, we have learned from more recently discovered documents that mention classes held, for example, during the presidency of Vouet, in 1624.[12] And the drawing contests stipulated in the first statutes seem to have been revived during the presidency of Pietro da Cortona (1634–6), who awarded prizes, we are told, not to the best drawings of parts of the body as Zuccaro did, but rather to the best "histories," "following a precedent of the Carracci," commissioning a painting of the same subject from the winner of the first prize.[13]

THE TEACHING OF THE CARRACCI

To speak of the Carracci is to evoke an academy of great renown and also another part of the academic tradition: the private academy. For although the Carracci academy was one of the first directly inspired by the Florentine Accademia del Disegno – the other was the Perugian Accademia del Disegno founded in 1573 – it more properly belongs to the tradition tracing its origins to the academies of Leonardo and Bandinelli and including Bernardo Baldi's Accademia degli Indifferenti, which the Carracci are said to have frequented before establishing an academy of their own.[14] Founded in Bologna around 1582 by three members of the Carracci family, Ludovico and his cousins Annibale and Agostino, and usually called the Accademia degli Incamminati or, simply, the Accademia de' Carracci, its influence was felt in public and private academies alike.

Modern discussions of this academy have been unusually varied and contradictory, with scholars differing not only as to what sort of organization it was but whether it existed at all. That it did unquestionably exist I have shown in a detailed study of the visual, as well as textual, evidence.[15] It is clear enough from the funeral service arranged after the death of Agostino Carracci, for example, that the academy was a fact and that it was used, similarly to the Florentine Accademia del Disegno, for purposes of profes-

sional advancement. The monument erected in celebration of Agostino's achievement, like the one fabricated by the Florentine academy in honor of Michelangelo, heaped emblem upon hieroglyph – all designed to establish the intellectual credentials and high social standing of a visual artist.

At the same time, the images most closely associated with teaching in this academy suggest anything but ideation and dogma. In one, students of all ages are shown drawing from casts while the masters paint at their easels (Fig. 10). And other engravings in this same collection teach drawing with an equal stress on practice. The first consists of a step-by-step demonstration of how lines are configured into eyes (Fig. 11); the following plates are covered with anatomical units, to be mastered through careful and constant repetition.[16] This is the kind of practice, it is to be recalled, adumbrated in the statutes of Zuccaro's academy and represented in Alberti's engraving (Fig. 9). In that academy, it was coupled with theory, however problematical that theory may have been. And debates over the nature of the Carracci academy have turned on the question of the role theory played in it.

The grounds for these disputes are statements by seventeenth-century writers, the majority of them biographers of the artists, about the importance of theory to the Carracci and in their academy. Agostino, the one most specifically associated with theoretical concerns, is said to have been at home in all liberal studies – philosophy, history, poetry, mathematics, and so on – and to have been predisposed to theoretical discourse. In the Carracci academy, hours were devoted, we are told, to such theorizing, to lectures and discussions of history, mythology, poetry, and music; there were anatomical lectures and studies of bones and muscles in addition to the by now familiar drawing exercises of ears, feet, and other parts of the body. The drawing course involved, too, drawing from plaster models and casts and culminated in contests. As for this course, stress was laid on one key feature: the Carracci are said to have originated a particular kind of life-study that came to be called an "academy."[17]

On the basis of these reports some scholars have concluded that this academy was a new kind of setting in which visual art was taught analytically and programmatically. Others have read the same reports, however, as eulogistic hyperbole misrepresenting what was in actuality only an especially well-organized studio or workshop.[18] Those who have held the second view have understood the question to be not merely one of how much teaching was done but whether or not the Carracci advocated the selective imitation of the works of artists of the past in a theory of "eclecticism" imputed to them; to argue that they taught programmatically would seem to support the notion that teaching in their academy was harnessed to such a doctrine of "eclecticism."

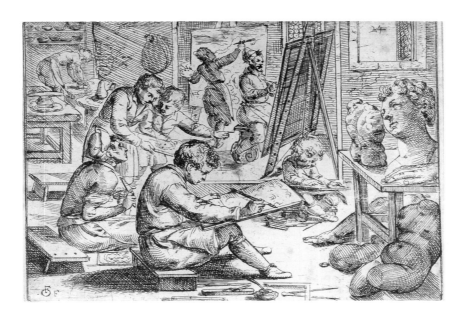

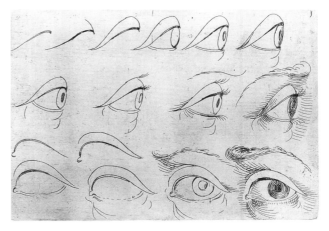

Figure 10 (above). Odoardo Fialetti, *The Artist's Studio.* Etching from *Il vero modo et ordine per disegnar tutte le parti et membra del corpo humano,* 1608. (Photo: Warburg Institute)

Figure 11 (right). Odoardo Fialetti, *Drawing an Eye.* Engraving from *Il vero modo et ordine per disegnar tutte le parti et membra del corpo humano,* 1608. (Photo: Warburg Institute)

There is evidence of Carracci practices and teaching other than the early texts – namely, drawings and paintings. Having examined this evidence, I have suggested that the Carracci did indeed conduct investigations of the kinds mentioned by the writers and may have taught these same procedures: they drew after the antique and after works by a variety of Renaissance masters; they reflected upon anatomy and studied systems of proportion; they learned the rules of perspective. But they mobilized these rules, as the data of anatomy and principles of proportion, in strategies that were different from those described, or implied, by the writers. Those taking the

35

seventeenth-century writers at their word have assumed, that is to say, that these studies would have been undertaken by the Carracci both rigorously and systematically (not to say pedantically), channeling the results into rules that they translated in their own works and taught to pupils. What the visual evidence shows, to the contrary, is that their study was unsystematic and often skewed out of context, considerations of theory interpenetrating with those of practice. Such studies could hardly have formed the basis of a formal doctrine of the kind that could justifiably be called "academic."[19]

The visual evidence also shows that the Carracci did indeed mine the works of the masters of the Renaissance, regarding such works as sources of images at least equal to nature, which is to say that their practice was demonstrably "eclectic," and eclecticism is a doctrine residing in the innermost sanctum of the academic tradition. About Carracci eclecticism two points must be made: first, that it was bound up with a whole Renaissance notion of "imitation" that is not well understood today, and second, that their practice is characterized by a level of improvisation betraying an individual sensibility rather than an institutional system. That later academies may have been influenced by reports of Carracci "eclecticism" is, nevertheless, conceivable and will be discussed in Chapters 4 and 5.

One part of the Carracci program definitely did make a major impact within the history of academies, and it was the role they assigned to drawing from the live model – the "academy." Posing nude models had been, in fact, a far less usual practice in Renaissance workshops and studios than has been imagined. The Carracci are said to have originated a particular kind of life-study, in any case, and just what this means will be examined in Chapter 8. Of interest at this point is the effect this study had on other artists during this early stage of the academic institution. For as the fame of the Carracci academy spread, other organizations were created in its image stressing, as it did, drawing from the nude model.[20]

Academies proliferated during the following decades that were often said to have been founded specifically for drawing from the model ("dal nudo"); one, for example, was frequented by Borzone in Genoa in 1610, and another was founded by Guercino in Cento in 1616.[21] And the term "academy" itself, when used in connection with artists from the end of the sixteenth-century on, was defined more broadly. Having earlier been reserved for meetings conforming to certain elite requirements of learning, it came also to designate a group of artists assembled for no other purpose than to draw from the nude model. As such, perhaps the most noteworthy academy of the first half of the seventeenth century lay outside Italy: the "academy" of Rembrandt.

REMBRANDT AND THE MODEL

Rembrandt's establishment, usually called a workshop, is nowhere referred to in the early literature as an "academy," it should be said at once, though Baldinucci uses the word in writing about Rembrandt's participation in "la famosa Accademia de Eeulemborg."[22] A Uylenburgh academy may, in turn, have been modeled after the academy said to have been founded in Haarlem by Karel van Mander, Cornelis Cornelisz van Haarlem, and Hendrick Goltzius, the first academy of the Netherlands, "in order to study from life" ("een Academie om nae't leven te stud eeren").[23] However, this academy was founded in 1583, and van Mander had left Italy in 1577, before the Carracci academy would have been operational. There also seems to have been an "academy" in which pupils drew from live models in Utrecht during the first half of the seventeenth century.[24] In any case, posing the model became a far more widespread practice in the wake of the Carracci, and the place in which this was done was called, in Italy and by Italophiles, an "accademia dal nudo."[25]

In none of the Italian academies did the nude model play so dominant a role as it did in Rembrandt's teaching. Its importance is established by the unusually large number of extant figure studies by Rembrandt and his pupils as well as by the many images of the life class.[26] In one etching, Rembrandt makes the role of the nude model in the drawing program visually palpable (Fig. 12).[27] Two male models, drawn as observed in life in poses found in other drawings from the studio, are frankly represented as studio models, while more faintly etched in the background is a small child in a walker with a nurse. The sense, emblematically communicated in the child's attempt to walk, is that learning to draw is a slow and difficult process requiring regular and constant exertion. Whereas the artists of the Italian Renaissance tradition would have agreed in principle with this conceit, for this reason having their students commence drawing with the elementary exercises of copying drawings, prints, and casts – which not only simplified the figure but also introduced them to an ideal – Rembrandt, by contrast, would have his pupils go directly to life: the "flat" figures of the etching were apparently intended to serve as models for inexperienced artists, preliminary to drawing from the nude model as observed posing in the studio.

That Rembrandt should have bypassed the more basic exercises is all the more remarkable given their importance in the northern European workshop tradition. Artists assembled large collections of prints, drawings, and casts for the instruction of students, and these were also conveniently arranged in drawing books that appeared throughout the seventeenth century.[28] It is well known, too, that Rembrandt had formed one of the largest and most impres-

Figure 12. Rembrandt Harmensz van Rijn, *Two Male Nudes and a Mother and Child* ("Het Rolwagentje"). C. 1646. Etching. Berlin, Staatliche Museen zu Berlin, Preussischer Kulturbesitz, Kupferstichkabinett. (Photo: Jörg P. Anders)

sive collections of any artist in the Netherlands of prints, drawings, and other works of art by the Italian and northern masters. But he did not, it would seem, use them in teaching. There are almost no copies by Rembrandt's pupils, Svetlana Alpers has noted, of works in his collection. His students did a great deal of copying, to be sure, but it was after his works or works that he corrected. "The major example that Rembrandt put forth in his studio," she remarks, "seems to have been his own way of practice itself."[29]

In addition to having his students work from the nude model, Rembrandt had them make narrative compositions. These were regular exercises in the studio, reviewed and corrected by the master. There are many student drawings that show evidence of his intervention, usually in a few sure pen lines emphatically altering the relations of figures to one another (Fig. 13). And copies that students made after corrected drawings show their desire to learn these lessons. It evidently would have been more difficult for them to

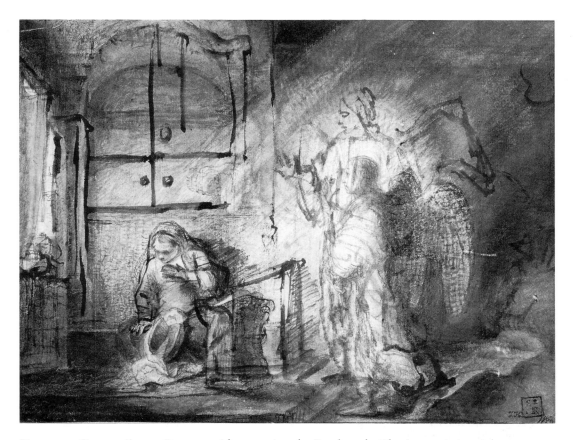

Figure 13. Constantijn van Renesse, with corrections by Rembrandt, *The Annunciation*. Ink and wash. Staatliche Museen zu Berlin – Preussischer Kulturbesitz, Kupferstichkabinett. (Photo: Jörg P. Anders)

do so, however, in the absence of an actual correction. For, as Samuel van Hoogstraten learned after pestering Rembrandt with questions about how to proceed, there were no rules to follow; make use of what you already know, Rembrandt told him.[30]

Rembrandt's students came to him at an age when other young Dutch artists were going to Rome to confront the Renaissance tradition at its source. Those who made the trip in the 1630s would have found an educational environment very different from that of Rembrandt's studio. There were, to be sure, academies of the type of Rembrandt's, academies of the nude model; such academies apparently were common and met in various locales.[31] But they would have found, too, an active Accademia di San Luca, sponsoring not only drawing contests but also discussions in which a substantial portion of the membership seems to have participated.

The most intense of these discussions probably was held in 1636 and gave

rise to a debate over whether narrative compositions should be organized with few or many figures. This subject was lodged in art theory from the early Renaissance on – Alberti advises not more than nine or ten figures – and, like so much else in that theory, was imported from literary criticism, particularly Aristotle's argument of the unities. Whereas some of the artists in the academy echoed the traditional ("classic") view, others – the majority, we are told – headed by Pietro da Cortona, argued to the contrary for compositions with many figures; theirs was an argument, in other words, in favor of "baroque" richness and variety.[32] Not much more than this is known, the only report of the debate being Missirini's tantalizingly brief summary of documents that have not since his time been located. But there is independent testimony of debates in the Roman academy from which it would appear that they were ongoing and, indeed, of some seriousness.

The report is by the French artist Hilaire Pader, who was in Rome through the early 1630s, at least until 1638. The academies of Rome, he tells us, are rife with opinions about art, its artists divided into factions, some arguing the virtues of the Venetians and northern Italians, others of the Florentines, some of Guido Reni, others of Guercino, with the art of Michelangelo and that of Raphael hovering over the discussions as the two poles toward one or the other of which art naturally gravitates. Such open discussions of styles and stylistic alternatives, undertaken with the apparent approval of the pope and under the protection of his nephew, Cardinal Francesco Barberini, created a new awareness of the academy as a professional association promoting the interests of artists.[33] The foreign artists in Rome must have regarded it with envy, wishing for one of their own. The next chapter in the history of the academy is the story of the fulfillment of this wish by artists, first in France and then England and the rest of the world.

PARIS, CAPITAL OF THE ACADEMIC TRADITION

Although founded in Paris in 1648 by a diverse group of artists, including miniaturists, flower painters, landscapists, and portraitists, this academy from its earliest period was dominated by younger artists in the Renaissance tradition of "history" painting, most of them veterans of the Roman art world, one the newly returned Charles LeBrun. Their styles were on the whole compatible, the majority speaking the classic language of Roman painting in the wake of the Carracci and of Poussin, though individually inflected, with differences as considerable as that between the "atticism" of Laurent de La Hyre and the "baroque classicism" of Le Brun.[34] These differences have been stressed in recent discussions, as this academy, more than most others, has long been embedded in the popular imagination as an authoritarian institution with a clear and fixed notion of stylistic unity.[35]

Theirs evidently was not a shared notion of style so much as of the value of an official institution, protected and supported by the king, reserved for and promoting the interests of visual artists. As a precedent, they could cite the recently established Académie française founded in 1635 as the official linguistic institution, and they had, of course, the academies of Florence and Rome as models. (L'Académie française, it should be noted, was in no sense a school but was devoted to the study of the French language and the production of a dictionary and grammar, as well as the drawing up of "rules" of literary composition.)[36] In the event, the earlier academy cited by the visual artists was that of Athens, though their principal argument was not based on historical precedent alone. An academy was urgently needed, they declared, to provide for the teaching of art as a liberal discipline.

Their claim was that of Renaissance art theory, more or less audibly echoed in earlier academies, for the liberal status of the visual arts, amplified in the usual way with a list of studies: geometry, perspective, music, astronomy, anatomy, history, and poetry. And one of the first acts of the newly created academy was the appointing of specialists to teach several of these subjects: Quatroulx for anatomy, Chauveau for geometry, and Bosse for perspective.[37] This instruction, however, was to constitute only one part of the program.

As in the Roman academy, theoretical studies were to be joined to the more practical business of drawing, to which the academy declared its devotion. The core of the drawing course was to be a life class supervised by the twelve-man governing board, each responsible for posing the model for one month. The rules say, too, in words recalling those uttered in the Florentine Accademia del Disegno, that young artists would benefit from the experience of their elders, who would freely aid and advise them.[38]

That access to the nude model was the principal attraction of the academy to many artists is proven by what followed. For the envious artists of the old guild responded to the challenge of the academy by transforming the guild, making it into an academy, that is, "an academy of the model," which it called the Académie de Saint-Luc (Academy of St. Luke); this academy posed not one model but two, and had twice the number of teachers.[39] There followed a period of conflict between the two organizations, ending with a truce in the form of a nominal amalgamation in 1651. The artists who had drawn up the petition in 1647 had had something more than a drawing academy in mind, however, and to show that they had, they proposed to implement the educational ideal written into the statutes.

The members were asked to submit statements outlining a course of instruction, which they duly brought to a meeting in 1653. Only three members complied, however: the perspective teacher Abraham Bosse and the Brothers Testelin. From this poor response, as well as the contents of these

statements, it would seem that the general membership no more believed in the redemptive potential of philosophy than had that of Zuccaro's Accademia di San Luca. Bosse's proposal was the more unified: students were to begin by copying engravings after the Renaissance masters and the antique, then drawings and paintings by modern masters and the actual sculptures or casts after them, graduating to the live model; theoretical instruction would accompany these exercises, in proportion and perspective, invention, and expression. The recommendation of the Testelin brothers was more general: that the academy define the "four principal parts of painting," line, light and shade, color, and expression.[40]

The members endorsed the proposal of the Testelins but postponed discussions, drawing up instead new rules governing them. One that, as shall be shown in Chapter 5, opened the floodgates of controversy, embodied a trust in Renaissance theory that was unusually deep for an assembly of artists: disputes among the members would be settled by consulting one of the art treatises "approved" by the academy.[41] Before anything was done, however, the academy again reviewed its rules, clarifying and enlarging upon them, still more explicitly modeling them after the rules of the Accademia di San Luca.

As registered in 1655, these statutes provide for a royal subvention in place of the former voluntary contributions, and also for rooms on crown property; the academy was given a monopoly on life drawing, posing the model anywhere else being expressly forbidden; there would be monthly lectures and annual competitions; the members were to have the privileges conferred upon those of the Académie française. The line between this academy and a guild or life-drawing academy was now more clearly scored; the rupture with the guild's Académie de Saint-Luc was complete.[42]

During the following years, the artists of the new academy posed the model as required but did little by way of implementing the other measures, thereby inviting renewed complaints from the artists of the Académie de Saint-Luc, soon led by Pierre Mignard – who was, nevertheless, no less a classicist than the artists of the Académie royale. What was needed, Colbert thought upon becoming vice protector in 1661, was a still more hierarchical structure. A new and definitive constitution, approved in 1663, established such a structure, administrative and educational. What this constitution makes clear is that the academy was never conceived as a replacement for the workshop. A student learned neither to paint nor to model in the academy but did so, rather, in the workshop or studio of his master, with whom he still lived as before the age of the academy. The rules of 1663 allowed each academician to teach six pupils.

These rules divided the drawing course into lower and higher classes, the first for copying, the second for life drawing. A student who wished to

become a member (*agréé*) had to submit a specimen of his work (*morceau de réception*) for the examination of the academicians. Competitions were planned in two parts: a drawing competition in which prizes were awarded to the best treatment of a given subject, and a more advanced painting contest held a short time afterward, on the same subject, with students competing for a grand prize that soon became the famous Prix de Rome. While the entries were on display in the academy, their authors were expected to explain and defend them, as the academicians were expected to articulate their responses to the reception pieces.[43]

The academy would seem, then, to have been well on its way toward formulating a doctrine far more detailed than any yet enunciated in an academy. But simply stating that the academicians were to do so was not enough; for what the records show is that the members were at a loss as to how to proceed. And when Colbert paid a visit in 1666 expecting to savor a morsel of doctrine, he was served instead stale Italian art theory, warmed-over in a so-called treatise by Leonardo. Colbert let it be known that far more was expected of an academy that was the acknowledged repository of the artistic capital of the nation. What he proposed, no doubt following the counsel of Le Brun, was the renovation of the monthly lecture program: henceforth discussions would be of works of art in the royal collection. Each month, one of the academicians would lecture on a specific work; a discussion would follow, with differences mediated and decisions reached as to the right and wrong of that work. The cumulative wisdom of this prolonged dialectic, scrutinizing the dictates of theory while upholding the precedence of practice, was to be recorded in the form of rules.[44]

On May 7, 1667, the first series of these *Conférences* opened with a lecture by Le Brun on Raphael's *St. Michael,* followed by a lecture on that artist's *Holy Family of François I;* other lectures were on Titian's *Entombment of Christ,* Veronese's *Christ at Emmaus,* Poussin's *The Israelites Gathering the Manna* (Fig. 34) and *Christ and the Blind Men of Jericho,* and the *Laocoön.* Responsibility for distilling the rules was delegated to André Félibien, who published them in 1668 in the preface to a complete transcription of the proceedings.[45] A still better-known tabulation is Henri Testelin's 1680 *Sentimens des plus habiles peintres sur la pratique de la peinture et sculpture, mis en tables de préceptes.* These precepts, then, set down as a specific set of conventions reflecting the consensus of the academicians, herald the emergence of an academic doctrine. This is the doctrine conspicuously lacking in earlier academies and a constant feature of those during the next phase of the academic tradition. The principal expression of academic philosophy, it will be discussed in Chapters 4 and 5.

Although the *Conférences* were designed to confront actual works of art, a few exceptional lectures were devoted to more general problems. The most

remarkable in this series was an illustrated lecture delivered by Le Brun on the "passions of the soul" (Fig. 104).[46] Elaborating on themes he had introduced from 1668 on, Le Brun gave the lecture in 1688, the illustrations eventually being engraved and published. This was done, though, only after his death, the many editions, in English and German as well as French, ensuring the availability of these models to students during the next two centuries.

These images, discussed in Chapter 9, are more highly developed instances of a phenomenon that has seemed uniquely academic and that does indeed attach itself to a thread running through the history of academies, namely, that of adumbrating a "language" of art. Cellini argued such an analogy, it is to be recalled, in the Florentine academy (Fig. 6), and so did the artists of Zuccaro's Accademia di San Luca (Fig. 9), in which drawing from casts of parts of the body was a regular feature of the program; an "alphabet" is suggested by the drawing system associated with the Carracci academy (Fig. 10), a system demonstrating the capacity of configured lines to *signify*.[47] This is an extremely rudimentary system, however, compared with Le Brun's "language" of expression. And Le Brun's program has been the one singled out for discussion in the ongoing debate over the possibility of a semiology of images.[48]

What is so remarkable about Le Brun's "language" is that it outlived Louis XIV and the court at Versailles, circulating in academies from monarchy to Enlightenment, from the "Age of Despotism" to the "Triumph of Democracy." It continued to be used long after facial expressions had changed their meanings, sometimes in bewildering ways, after they had lost their capacity to signify in the sense of Le Brun's original system. Why would the academy have wished to perpetuate a dead "language" that had behind it only an exhausted cultural/behavioral code? And having so desired, how would it have succeeded in doing so?

Conventional wisdom would have it, of course, that the academy ultimately failed precisely because of its refusal to accept change. But it was not alone in this. The whole Renaissance tradition turns on the aura of the masterpiece, a work, literally, of transcendent value that never goes "out of style." From the time of Vasari on, artists of all kinds — whether in the newly formed academies or not — channeled traditional visual means into the creation of works that they hoped would be deserving of inclusion within the Renaissance corpus. And this was the ambition of the academy: to articulate visual art like a language, but one, unlike speech itself, of timeless universality. The ideal was one of art as extralinguistic — despite the academy's penchant for discourse — and transcultural, even if the world into which it would pass was neither.

Before ending this account of teaching in the French academy, two further

developments must be mentioned. Once the competitions had become part of the routine of student life, they were made still more formal. Painters and sculptors were divided into three classes according to their standing. Competing by class in stages, they gained access to the higher stages only if judged worthy at the end of each exercise. The first was a drawing of the live model; the second, a drawing of the prescribed subject; and the final test, the execution of a painting of still another subject, in a locked room in the academy. The grand prize was a scholarship to study, usually for four years, at the French academy in Rome, which had been inaugurated in 1666.[49]

In addition to displaying competition works and the *morceaux de réception,* the academy organized exhibitions of works by its members. The first was held in 1667, but they became regular events – the famous Salons – only after 1737.

example of work for admission

ROME STILL THE SOURCE

It was in the 1660s, too, while the French academy was thus strengthening its position, that the Roman Accademia di San Luca was revitalized. Teaching as mandated by the original statutes was done only intermittently, it was noted, from early in the century through the 1630s. From 1663 on, however, the educational program as originally defined was fully implemented. Drawing was taught from drawings and casts, followed by drawing from the live model; anatomy, architecture, and perspective were taught; a drawing contest was held every three months, by class, with prizes awarded to the best entries in each class; the award ceremony was to serve as the occasion for a theoretical discourse.[50] The program, traceable to the original statutes of the Roman academy, was similar, in sum, to that of the academy in Paris in the 1660s, not coincidentally, as the French had modeled their program after the one originally envisaged in Rome. And because of this similarity members of the one institution felt at home in the other, the two drawing increasingly close to one another.

The young French artists in Rome, seasoned veterans of the contests of the academy in Paris, were the first to gravitate toward the sister program of the Roman academy. For this outpost of the French academy was only a place of residence for its pensioners, who were put to work copying the great works of the past and would have had little opportunity to do anything else.[51] By presenting themselves to the Roman academy they were able to draw from the model and compete in the contests.

Cooperation between the two academies was increased in 1672, when Charles Errard, director of the French academy in Rome, was elected president of the Accademia di San Luca, to be followed in 1676 and 1677 by Le Brun, with Errard acting as his deputy in Rome, before being elected in his

own right once more for 1678. In 1677 there had been a formal amalgamation of the two academies.[52]

These signs of concord have been seen, however, as only surface displays masking fundamentally different philosophies of art. The Accademia, despite its close administrative ties to the French academy, could not "altogether swallow that accentuation of the rational which was so characteristic of theory in the latter," Denis Mahon has stated.[53] And he has cautioned, "We may sum up by saying that though the academic name may remain constant, Academies and their influence differ widely at different periods and places, and so do the theories which from time to time find a home within them."[54]

The theory of the Roman academy in question is that of Giovanni Pietro Bellori, whose *Idea* discourse was composed as an oration for the prize ceremony of 1664 before being published in 1672 and becoming one of the most influential statements of classic or "academic" art theory (academic classicism); Bellori was also the speaker when the prizes were distributed in 1677.[55] About his theory the first thing that must be said is that it is still another statement of the Neoplatonic philosophy that had implanted itself in Renaissance culture and had come to fruition in academies from the time of Zuccaro on. This is the *Idea* originating in the mind of God and expressed in eternal purity by the heavenly bodies before passing into unstable terrestrial objects, the necessarily imperfect human figure among them; the task of the artist is to "imitate the highest artist" by finding within himself a notion of that perfect beauty by means of which nature can be perfected.[56]

This is metaphysical speculation of the kind, it is to be recalled, that baffled the members of Zuccaro's academy, for whom theory was interwoven with practice; placing art in the ephemeral embrace of God is, rather, to render it contingent to a God-given grace that is gifted rather than acquired. This is the message, too, of an image of an academy by Bellori's friend Carlo Maratta, who served in various capacities in the Roman academy and was also advisor to the French academy (Fig. 14). The essential requirement of excellence, he tells us with figures of the Three Graces at the upper right, is a God-given gift for the lack of which no amount of study will compensate.[57] And when, in 1681, a copy of Félibien's publication of the *Conférences* held in 1667 was brought out for discussion in the Roman academy, one of its members, G. M. Morandi, raised the objection that they left out that which was most important: an undefinable grace appealing to the heart rather than the mind ("una parte dell'arte, ch'è forse la più bella, cioè la grazia").[58]

On the basis of such testimony it has been concluded, by Mahon and other students of Bellori and the Roman academy, that this academy was altogether different from the French, that it was not an "academy" in the same

Figure 14. N. Dorigny, after Carlo Maratta, *An Academy of Painting*. Engraving. London, The British Museum. (Photo: Courtesy Trustees of the British Museum)

sense or perhaps was an academy in name only.[59] This conclusion is contradicted, however, by the evidence of teaching in the academy. Student drawings made in the contests that will be discussed in detail in Chapter 10 show the Italian artists working under the influence of a "doctrine" different in some ways from the French but nevertheless compatible with it.[60]

During the last quarter of the seventeenth century, then, artists in Rome, as in Paris, had succumbed to the temptation of academic ideology. They

learned the lessons the academy had to teach, trusting that this was the pulse of the Renaissance tradition and the foundation of a new art of lasting value. Distilling the essence of the art of the past and projecting it into the future, Rome with its academies held out the promise of an eternal art that would be a beacon to the artists of the world. The Florentines were only the first to join the movement to Rome, opening the Academy of the Grand Duke of Tuscany, an outpost of the institution to which this entire tradition owed its existence, in 1673.[61] As academies sprang up in the nations of the world, they put down roots, at the same time, in Roman soil.

THE TRIUMPH OF THE ACADEMY, LEADING TO THE REACTION OF THE AVANT-GARDE

During the 1700s academies became the principal centers of art instruction, so that to entertain the notion of becoming an artist was to prepare for entry into an academy. The French again took the lead: from 1738 on, academies opened in virtually every large city in France, academies modeled after the one in Paris and sustained by relations with Rome. The axis of the French academy that extended from Paris to Rome was intersected by others, Orléans–Rome, Toulouse–Rome, and so on.[1]

Inspired, too, by events in Paris and Rome, the rulers and artists of Europe created academies of their own. Thus, in 1697 an art academy was founded in Berlin that was conceived as "a high school of art or university of art like the academies in Rome and Paris."[2] The Royal Danish Academy of Painting, Sculpture, and Architecture in Copenhagen was established in 1754.[3] An academy in Vienna, originally founded principally for the purpose of drawing from the model, was transformed in the 1720s following the French example, which was the model as well for the Russian Imperial Academy, established in St. Petersburg in 1757.[4] The Spanish Academia de San Fernando, founded in Madrid in 1744, was similarly dependent on the French, as were the academies created in Spanish America, in Mexico City, Buenos Aires, and other capitals.[5] And there were many others, academies that, like the institutions in Paris and Rome, stressed drawing from the masters, the antique, and the live model, and organized competitions and lectures, typically under the guidance of artists, some of them French nationals, trained in the academies of Paris and Rome.

Consider the outline of the program of the Vienna academy shortly after 1800 (from a letter about the recently arrived Friedrich Overbeck):

From the studies which he had brought with him, I saw however that he had up to now no opportunity to study from actual painterly or academic drawings. Of these there are a great number here, and from those he must first exercise his hand and become fluent in the mechanism of the various kinds of drawing, before he can proceed with painting and the more difficult parts of it. These preliminary studies may well take several years, and will indicate the definite direction which his art is taking, and from which one can judge the degree of ability of a pupil. I have given him a place in the department of elementary historical drawing, where one works the whole day from the best academic drawings. In the morning from 6 to 8 he draws from nature [i.e., plaster casts] in the rooms with antique statues, skeletons and later from the large anatomical statue, the work of our Professor of Sculpture and Artistic Anatomy Martin Fischer, with which all our pupils begin in order to become thoroughly familiar with the inner construction of the human figure. By this method they become knowledgeable draughtsmen if they have talent, and will not be led astray by dark phantasies of mere untaught sentiment and look with disdain on this after all easy scientific knowledge, which is so necessary for the performance of the arts. — Steady application and the example of so many other students will help him to step higher and higher.[6]

CONTINUITY RATHER THAN CRISIS

It may seem paradoxical that the academy should have become a European phenomenon at a time when the academy in Paris, the wellspring of academic teaching and doctrine, was in disarray. For if there was disagreement in the academy during its heyday, by the last quarter of the seventeenth century and into the eighteenth, we have been told, it was rent by dissension. Already in the 1670s a quarrel had broken out over color, which is to say over its neglect in academic doctrine, proving that "in fact there was not *one* academic doctrine."[7] And in histories of French art, the early 1700s are said to have witnessed a shift from the classic style of the academy to a rococo style, "uninhibited by classicistic dogma."[8]

About these assertions two points need to be made. The first is that all the major artists of France, whether "classic" or rococo, were trained in, and accepted by, the academy. And the second, more important point is that the "classicistic dogma" of the seventeenth-century academy was upheld by artists who were in fact among the most successful and famous of the early to mid-eighteenth century, such artists as Louis de Boullogne le Jeune, Antoine Coypel, François Lemoine, Carle Vanloo, Noël Hallé, and many others.[9] Most scholars agree, in any case, that before mid-century, there was a reaction against the rococo and a return to the principles of the seventeenth-century academy.[10]

This reaction is associated with a reform of the academy in 1747, which, whatever its immediate cause, was only another fine-tuning of teaching in an institution whose history was in fact punctuated, as we have seen, by such periodic adjustments.[11] This time, the aim was to confirm the high serious-

Figure 15. Charles-Nicolas Cochin, *The "Prix d'expression."* Black and white chalk on gray paper. Paris, Musée du Louvre, Cabinet des Dessins. (Photo: © Réunion des Musées Nationaux)

_{taste}

ness and preeminent singularity of history painting ("le grand goût, la grande manière") by more narrowly channeling the energies of the students qualified to enter the advanced competitions. To begin with, the prizes for the history subjects were increased. Later, additional prizes were established: a prize for the study of the expressive head by the Comte de Caylus in 1760 and a La Tour prize in 1784 for the study of the half-length figure ("Prix de torse"). A related adjustment was the creation in 1748 of the Ecole des Elèves Protégés, better to prepare the Grand Prix winners for their study in Rome.

The "Prix d'expression" evidently was conceived to promote the study of the "passions" in the tradition of Le Brun but, significantly, augmenting his treatise with live models (Fig. 15). The idea was to expand Le Brun's repertory and modulate the conventionality of his images by returning to the source of all expression in nature. What surviving studies show, however, is that even when confronted by the model the students produced highly con-

Figure 16. Jacques-Louis David, *La Douleur.* 1773. Black and colored chalk on brown paper. Paris, Ecole nationale supérieure des Beaux-Arts. (Photo: Ecole des Beaux-Arts)

ventional images, as though glancing sideways at Le Brun's illustrations (Figs. 16, 104). These studies attest to the continued authority of Le Brun, as also to an attitude toward the live model that remained unchanged so long as the academy endured.[12]

Of lasting importance, too, was the formalization of art exhibitions and the attendant diffusion of art criticism. The academy had sponsored exhibitions of works by its members in the later seventeenth century; these became annual events in 1737 and biennial from 1751 to 1791. After 1755 they were held in the Salon Carré of the Louvre – hence the name by which they have since been known: *Salons,* dazzling spectacles, with pictures hung on green cloth from eye level to ceiling (Fig. 17). These exhibitions were open to the public, and so, beginning in 1673, a *livret,* or catalogue listing all the exhibited works, was published.[13] "In some ways," Michael Levey has commented, "those exhibitions represent the chief advance of the visual arts in France during the ancien régime. They helped to create general public interest among a class of people no longer necessarily patrons or connoisseurs but simply spectators – going to look at the assembled pictures and sculpture as they might go to look at a firework display or a festive procession."[14]

Addressed to the public, too, were exhibition reviews belonging to a literary genre of increasing importance, that of art criticism. The most famous of the eighteenth-century critics was Denis Diderot, who reviewed Salons held between 1759 and 1781.[15] He was followed in the next century by such luminaries of the literary world as Baudelaire and Zola.

The reviews of the Salons, unlike the *livrets,* took on a life of their own, which is to say that in reading them it was necessary to recall images seen months before or not seen at all, as was the case with Diderot's reviews, published in a private newsletter that circulated in manuscript to royal

Figure 17. Gabriel-Jacques de Saint-Aubin, *The Salon of 1765.* Watercolor over black chalk, and black and brown ink. Paris, Musée du Louvre, Cabinet des Dessins. (Photo: © Réunion des Musées Nationaux)

houses outside of France, in Russia, Poland, Sweden, and a few other nations, and read by an audience that had not and would not see the works themselves.[16] What was required, therefore, was a verbal description rendering visibly palpable something only vaguely remembered if seen at all, a description of an evocativeness beyond the reach of academic theorists, more completely erasing the line between art writing and literature. But if this erasure helped to open up art criticism as we think of it today, it was founded on a long and intricate history tracing its origins back to the beginnings of the literature of art. The practice originated with the ancient one of *ekphrasis,* the description of real or imaginary works of art as part of a rhetorical composition, out of the belief that sight is the sense by means of which listeners are most likely to be moved. They would be moved, of course, only in proportion to the emotional effectiveness of the figures portrayed, without an appreciation of which no *ekphrasis* could be complete; "looks truly alive and seems to breathe," or "so true to life that everyone who saw it trembled," were among the standard phrases.[17]

Such conventional phrases were used by the reviewers of the Salons, among them Diderot, who brought to the discussion of works of visual art the same criteria as inform his writings on the theater.[18] These criteria were not coincident, moreover, with those promoted by the academy or, as stated more emphatically by Michael Fried, "stood in implicit opposition to Academic practice."[19] The question raised by these writings is, then, related to

that of the more obviously theoretical art literature, though perhaps more readily addressed. What do the requirements of dramaturgy or of rhetorical and literary composition have to do with creating works of visual art? A partial answer is that all the arts, visual as well as literary, were to some degree influenced by literary and rhetorical theory. This is far from proof, however, of the sway of theory. The proof, if it is to be found, must be sought in the works of art themselves. Instead of arguing from theory to practice – in other words, arresting the dialectic – movement in the opposite direction must also be gauged, the possibility of the unique or contrary priorities of practice acknowledged. What all of this means is that while the reviews of the Salons rightfully belong to the literary corpus of art history, they are not to be confused with the doctrine of the academy, and will not be when this doctrine is examined further in Chapters 5 and 11.

DISCOURSE IN THE ROYAL ACADEMY

In none of the academies inspired by the French did doctrine take so strong a hold or play so central a role as it did in the Royal Academy officially established in London in 1768. This academy had been preceded by one or more studio academies, organized for the purpose of drawing from the live model and counting among their members French artists familiar with the routines of the academies of both Paris and Rome; the most well known of these were the studio academies with which Hogarth was associated first as student and then as master, the first the Chéron and Vanderbanck Academy in St. Martin's Lane, the second Hogarth's own in the same street.[20] The Royal Academy, by contrast, was created for "two principal objects": "the establishing [of] a well-regulated School or Academy of Design, for the use of students in the Arts, and an Annual Exhibition, open to all artists of distinguished merit."[21] This was to be an academy of "design," then, in the tradition of the Florentine academy, with an exhibition schedule modeled after the French academy. (This was the model Hogarth earlier had emphatically rejected.)[22]

The statutes, too, were patterned after those of the academy in Paris, though they were not identical to them. There were to be forty academicians, painters, sculptors, and, unlike in Paris, architects. Vacancies were to be filled from among the exhibitors, a new member being required to deposit an example of his or her work before receiving a letter of admission or diploma signed by the king. Lectures were to be offered on anatomy, geometry and perspective, architecture, and painting; a library and collection were to be formed. The drawing course was articulated by stages, from casts to life. That this course was the centerpiece of the program is made clear in Zoffany's early group portrait of the academicians (Fig. 18), imagining the

Figure 18. Johann Zoffany, *The Life Class at the Royal Academy.* 1772. Windsor Castle. (Photo: The Royal Collection © Her Majesty Queen Elizabeth II)

members assembled in the life-class, surrounded by casts and an anatomical statue (*écorché*), while the academician in charge poses the model. The male members are so assembled, that is to say; the two female members are represented in the form of portraits hanging on the wall at the right. As this is the first representation of a studio or academy including women in any form it is worth lingering over it.

In her landmark article "Why Have There Been No Great Women Artists?" Linda Nochlin noted that the two female academicians were so represented because women were expressly forbidden to draw from the nude model. She observed that the taboo of nudity was a principal motive for excluding women from the teaching establishments of the Renaissance tradition and, as this was above all a tradition of the nude figure, a principal cause of their near invisibility. "The fault lies not in our stars," she stated in answer to the question of her title, "but in our institutions and our education."[23] I shall return to the question of the training of women later in this chapter.

The final stage of the drawing course, accessible only to those who had successfully negotiated the nude model, was an annual competition, capped

by the awarding of gold medals. This contest, too, was in stages; after submitting an entry, the contestant had to undergo a further test, namely, a drawing to be made in the academy in two hours.

As in Paris, the academy announced the subject for the contest, in painting and sculpture always a "history." The subject of the first painting contest was "Time Discovering Truth"; among those of succeeding competitions: "Hercules and Antaeus" (1770), "Venus Entreating Vulcan to Forge the Arms of Achilles," and "Timolean Ordering His Brother's Death" (1771).[24] Such were the subjects of the academies in Paris and Rome. Beginning in 1780, however, "modern" subjects of a uniquely English character, drawn from Shakespeare and Milton, were chosen: 1780, "any" scene from *Macbeth* and the same for *Paradise Lost;* 1782, *King Lear;* 1784, *The Tempest.*[25] Such subjects never entered the repertory of the academy in Paris, despite the admiration for Shakespeare first on the part of Diderot and later, in the early nineteenth century, the Romantics.[26]

If all this seems to be more or less what one would have expected of an academy with the example of the French to follow and yet resolutely English, these initiatives are nonetheless surprising because of the unique circumstance in which English painting found itself. For in accepting the supremacy of history painting, the Royal Academy had taken upon itself the promotion of a type of painting without a history in England, where support had been found for only one type: portrait or face painting. When the creation of an academy had been mooted earlier in the century, Hogarth had observed: "Portrait painting ever has, and ever will, succeed better in this country than in any other. The demand will be as constant as new faces arise; and with this we must be contented, for it will be vain to attempt to force what can never be accomplished; or at least can never be accomplished by such institutions as Royal Academies, on the system now in agitation."[27]

The founders of the Royal Academy would not heed such a warning; they were determined to accomplish what to a Hogarth seemed impossible. Led by Joshua Reynolds, a successful portrait painter who nevertheless identified not with earlier English portraitists but with no less an artist of the Great Tradition than Michelangelo – whose bust he placed behind his own self-image (Fig. 19) – the academy articulated a twofold mission: to promote history painting and to reconcile the demands of portrait painting with the virtues of histories. Its mission, then, involved changing the course of English painting by making history painting the principal focus for the energies of English artists; its educational program was the means for making that focus effective. Within that program the by now venerable form of academic education, the lecture, was to play a leading role.

On January 2, 1769, Reynolds read an appropriately effusive inaugural address that included general remarks on history painting together with

Figure 19. Sir Joshua
Reynolds, *Self-Portrait.*
1780. London, Royal
Academy of Arts. (Photo:
Royal Academy of Arts,
London)

advice to the students. At the end of the year, having been called upon to
present the prizes, Reynolds thought that the occasion required more than
words of praise, that praise should be accompanied by observations on art,
"to animate and guide [the students] in their future attempts."[28] Thus origi-
nated a second *Discourse,* for which Reynolds was thanked by the academi-
cians for "recommending to the students a method to be pursued in the
course of their future study."[29] By the time of the *Third Discourse,* he evi-
dently was thinking in terms of a series giving consideration to the different
methods and problems of visual representation, the *Discourses* for which he
is famous.[30] These lectures were delivered regularly at the awards ceremonies
until December 1790.

When other academicians lectured, Barry and Fuseli, for example, or
West, who succeeded Reynolds as president, their observations were in sub-
stantial agreement with those of Reynolds, confirming the centrality of the

Discourses and testifying to a consensus in the Royal Academy, as though the members had entered into a pact as to the means and ends of visual art.[31] This pact was articulated by a doctrine of a kind fundamentally similar to that of the French academy, though, being still more clear and systematic, it also illuminates that doctrine. To speak of academic doctrine is to refer, then, above all else, to the utterances of these two academies, conjoined to facilitate the wide dissemination of the academic method.

DOWN WITH THE ACADEMY, LONG LIVE THE ACADEMIC TRADITION

After reigning supreme for more than a century, the French academy ceased to exist. It was abolished by law during the Revolution, in 1793, on the recommendation of a former pupil and rising academician, Jacques-Louis David. Thus began the most confused chapter in the history of the academy, for though the academy as an institution of that name was banned, academic teaching was only briefly interrupted.

Opposition to the academy by David and his club of revolutionary artists (Commune des Arts) evidently had to do more with questions of politics than with aesthetics – academic rank, access to the Salons, and so on. For even though the academy was officially closed, its courses continued to meet under the protection of organizations of different names until it found a new home in 1795, as part of the Institut de France.[32] As reconstituted, the academy was in two parts: an Académie des Beaux-Arts, as it came to be called, for administration and an Ecole des Beaux-Arts for teaching. The academy proper recruited professors for the Ecole and supervised the minor competitions and the Prix de Rome and examined the works sent from Rome by the pensioners at the French academy. Teaching was the sole responsibility of the Ecole.[33]

The curriculum was much as before, drawing from casts and from life and courses in anatomy and perspective, but with an even sharper focus on the competitions – including, after 1816, prizes for painted sketches and historiated landscapes, the latter in the tradition of Annibale Carracci and Poussin.[34] The Ecole was a school for "advanced" study, that is to say, it admitted students who already had the competitions in view, after having received basic training in the private ateliers of the academicians. In so relying on the ateliers, the Ecole was reconfirming a symbiotic relationship that had grown up after the old academy had been abolished. For it was then that the private ateliers had burgeoned and assumed the importance that they never again lost. David's atelier had been the most famous, because of its large size and stress on drawing from the live model – it was, in fact, an "academy" of the

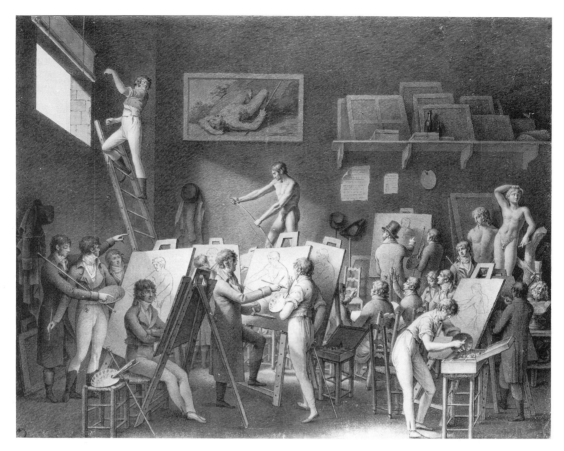

Figure 20. Jean-Henri Cless, *David's Studio*. Black chalk. Paris, Musée de la Ville de Paris, Musée Carnavalet. (Photo: Lauros-Giraudon)

model (Fig. 20) – and, more importantly, because of the success of his pupils in the Prix de Rome competitions.[35] Among the larger and more important ateliers that followed were those of David's pupil Drölling, of Delaroche, Gleyre, and Couture.[36] The passage from atelier to Ecole was more rigorously controlled than earlier, students entering a more hierarchical program than that of the old academy. Entrance examinations (*concours des places*) were given semiannually and began with questions in anatomy, perspective, and world history, leading up to the most important test: a drawing from the antique or from life. Those accepted – perhaps one-third of the entrants – were allowed to attend the life-drawing sessions and lecture courses and to enter one of the minor competitions, such as that of the expressive head (Fig. 21) or the half-length figure (Fig. 22). Only after having won a medal in one of these competitions would he have been allowed to compete for the Prix de Rome, which he could enter annually until the age of thirty.

Figure 21. William-Adolphe Bouguereau. *Disdain.* 1850. Paris, Ecole nationale supérieure des Beaux-Arts. (Photo: Ecole des Beaux-Arts)

Figure 22. William-Adolphe Bouguereau. *Half-length figure.* 1850. Paris, Ecole nationale supérieure des Beaux-Arts. (Photo: Ecole des Beaux-Arts)

All of these adjustments concerned the organization and form of teaching, the content of which was barely distinguishable from that of the academy at its inception almost two centuries earlier; changes in the program were external, leaving that which was intrinsic to the doctrine intact despite the momentous changes that had occurred in French society during the intervening period. As if to take these changed circumstances into account, another reform was undertaken in 1863, but this, too, so far as the doctrine was concerned, was largely external.[37]

This is not to say that the reform of 1863 was not important. It represents, in fact, a watershed in the history of the academy. For it eliminated the mediating role of the ateliers by installing workshops in painting, sculpture, and architecture on the premises of the Ecole, finally renouncing a prejudice against craft deeply rooted in the Renaissance tradition. By so doing, it made of the Ecole a unity that until then had been only imaginary, as practical instruction had always been left up to independent workshops.

As a result of the reform the doors of the academy were also opened to more students. Instruction was free and students were able to enroll with the consent of the chief of the workshop, without having to pass an official examination. This made it possible for foreign students, who had been excluded because they were ineligible for the Prix de Rome but, from the time of David, were to be found in large numbers in the private ateliers, to gain access, intensifying the spread of the academic method beyond the borders of France. Enrollment in the Ecole itself, carrying with it the right to compete for the Rome prize, was at the same time controlled by a semiannual life-drawing competition; other competitions, in perspective, anatomy, history, and archaeology, were open to students of the Ecole and ateliers alike.[38]

The method itself, as taught by a Gérôme or Cabanel or Pils, had changed little, still conforming to the same basic philosophy weaving through the history of the academy from the later seventeenth century on. In other words, the teaching of the Ecole after 1863, no less than before, recapitulated the motifs of the academic tradition: the copy, the antique, the live model, and history painting in a Renaissance mold. The ideology of the academy remained substantially unaffected by reform at this time, and indeed well into the next century.

TEACHING WOMEN: ALTERNATIVES TO THE ACADEMY

My use of "he" in this discussion has been conscious; for women continued to be excluded from the academy. They benefited from neither the "open-door" policy nor the liberalization of requirements for foreign students. It was first in 1896 that women were permitted to enroll in the Ecole; they had to wait until 1903 to be allowed to compete for the Prix de Rome.[39] Until the

end of the nineteenth century women were prevented, to say it once again, from receiving the training considered essential for a career in the visual arts, the kind of training that all male artists received as a matter of course (or gender). This brings us back to the question asked by Linda Nochlin about women artists and greatness and to her answer citing the exclusionary policies of academies; it also raises the whole question of where and what sort of art training women did receive. For it has become abundantly clear that being excluded from academies did not prevent women from embarking on careers in the art world, which they entered, we now know, in substantial numbers.

Provoked by Nochlin's essay, feminist art historians began to identify women artists and document their lives and careers. Aiming, like Nochlin, to prove that women are equally capable as men of "greatness," they proposed an expanded list of Western artists or an alternative canon of great female artists, beginning with such legendary Greek and Roman figures as Eirene and Marcia and including, for the Renaissance and Baroque, Sofonisba Anguissola, Artemisia Gentileschi, and Judith Leyster, and for the eighteenth century, Rosalba Carriera, Elizabeth Vigée-Lebrun, and Angelica Kauffmann.[40]

As was to be expected, none of these women had the benefit of an academic education with its access to the nude model, neither those of the Renaissance and Baroque, when academies were first consolidating their positions, nor those of the seventeenth and eighteenth centuries, when the art world was dominated by academies. Even Angelica Kauffmann, a founding member of the Royal Academy, was denied such access; one of the two women members, she is included in Zoffany's painting as one of the portraits hanging on the wall at the right (the other is the flower painter Mary Moser) (Fig. 18).[41] The training women did receive took place in private studios, at times those of their fathers, as in the cases of Artemisia and Angelica, or of local artists, Sofonisba with an artist of Cremona, or in their homes, Vigée-Lebrun receiving such instruction from Doyen, Vernet, and Greuze. These studios, whether of fathers or strangers, were the principal sites of art instruction, it is to be recalled, before the advent of academies, and they remained the sources of technical training alongside the academy;[42] the academy's students came from, and remained attached to, private studios during the entire period of their training.

Works by women artists are testimony to the soundness of this training, proving that an academic education was not essential for a career as a visual artist. There can be no question today that Artemisia (Fig. 23) was at least as "great" as her father and other male artists of the early Baroque, or that Angelica Kauffmann was the equal of her Neoclassical male contemporaries. And these accomplishments were, in fact, acknowledged by the academies of

the day. Artemisia Gentileschi was made a member, exceptionally, of the Florentine Accademia del Disegno in 1616; Angelica Kauffmann was highly enough regarded to have been accorded a place among the founders of the Royal Academy; Rosalba Carriera was made an honorary member of the academies in Rome, Bologna, and Paris; and Vigée-Lebrun also was accepted as a member of the academy in Paris.[43]

It must be stressed, however, that the successes of women artists were exceptional and, for the most part, of a lesser kind than those of men. For the tradition within which women had to be accommodated was preeminently narrative: a tradition of history painting requiring detailed knowledge of the nude figure. Denied access to the models on which such knowledge was based, and most likely believing in the unseemliness of a female depiction of male nudity, women artists had to accept their lot as practitioners of the "lesser" arts. Carriera and Vigée-Lebrun, for all their fame, were portraitists and not history painters. And a disproportionate number of the women artists rediscovered by feminist art historians were still-life painters, in the hierarchy not only of the academy but of the Renaissance tradition the lowest of the genres (Fig. 24).[44]

This is a tradition the values of which feminist scholars ultimately began to call into question. Given the social and institutional restraints on women artists, the interesting question is not of their relative accomplishment, their greatness or lack of such, Rozsika Parker and Griselda Pollock have observed, but of "how they worked despite these restraints. Furthermore, in many cases women have produced really interesting work as much because of as despite their different relation to the structures that officially excluded them."[45] The question is not simply of history, then, but of ideology.

Women's exclusion from the academies did not only mean reduced access to exhibition, professional status and recognition. It signified their exclusion from power to participate in and determine differently the production of the languages of art, the meanings, ideologies, and views of the world and social relations of the dominant culture.[46]

That women were "lowly" portraitists or still-life painters is, in these terms, not as noteworthy as society's low regard for these genres and the fact that they were open to women. Even more remarkable from this perspective is the position in the social and economic hierarchy of the crafts in which women specialized, such activities as lace-making or weaving, whose inferior status contributed to the "politics of exclusion."

The career of Berthe Morisot may serve as a case in point.[47] The time was the later nineteenth century, when many traditional institutions were under attack. One that was not was the home, a space reserved for, and under the sway of, virgin and mother. It was not at all uncommon for middle-class

Figure 23. Artemisia Gentileschi, *Judith and Holofernes*. Naples, Museo e Gallerie Nazionali di Capodimonte. (Photo: Author)

families to engage a drawing master to instruct young women in their homes as part of their general education, but strictly as part of a regime including music and deportment and, most of all, sewing – all understood as "arts" of domestic harmony. Or, no less respectable, such instruction might take place at designated times in the artist's studio. Artists no less eminent than David and Ingres had taught women pupils by arrangement, though Morisot's first teacher, Geoffrey-Alphonse Chocarne, was not of this rank. The thinking was that these were suitable diversions for young women until marriage, when art, piano-playing, and singing would be put aside for the sake of more important domestic responsibilities and, of course, child-rearing. For women determined to make art a profession, the principal alternative was training in such occupations as embroidery-pattern design or miniature painting. Morisot had no interest in the latter, which, too, was beneath the social position of her family,

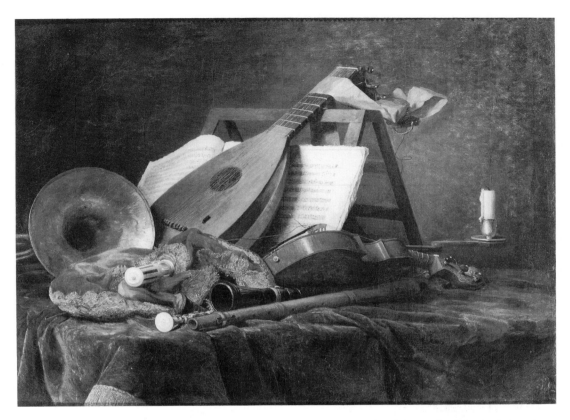

Figure 24. Anne Vallayer-Coster, *Musical Instruments*. 1770. Paris, Musée du Louvre. (Photo: © Réunion des Musées Nationaux)

at the same time that her interest obviously went deeper than that of an amateur.

Having outstripped her first teacher, she went on to a second; her third was Corot, who taught her, like the others, on a private basis. Despite her evident seriousness, Morisot was expected to pursue art only as a hobby whose future status would be determined by the pragmatics of home and husband. In the event, these helped her to pursue a career as a "professional" artist; her upbringing, social relations, and marriage, exceptionally, all carried her toward a destiny written for few women of the time. The point of recent feminist criticism would be that all these questions of culture and ideology are more important than the mere fact that the odds were against Morisot's becoming an artist. That she succeeded where her sister failed – after marriage and the birth of a child – would require an engagement with other questions, perhaps those of psychoanalysis. These are all questions of Morisot's performance as a woman in a patriarchal society and one who, obviously not coincidentally, most often chose to represent women. To pose

such questions involves far more than exposing the values of a male-dominated academy; it is to ask not only about connections between art and gender but also about the role of art in society. Such questions increasingly have been raised, and not only by feminist scholars.[48]

OTHER PEOPLES, OTHER CULTURES

Questions of privilege and of power also have been asked of the teaching of academies in countries under colonial rule. For, as was mentioned at the opening of this chapter, academies were created in the capital cities of Spanish America – and eventually the Middle East and Asia. And their teaching was the ordinary academic routine, the same as that of the academies of the European capitals. Art students in academies throughout the New World, whether in Mexico City, Havana, or Buenos Aires, copied works by the Renaissance and Baroque masters, drew from casts of ancient sculptures and from the live model, and in other ways were expected to make a commitment to the art of the academy – an art, as should by now be clear, based on the ideal Western figure and depicting subjects drawn from the ancient and Christian classics of western European literary culture. This was the art of the colonial academy as well, to reiterate, an art privileging the ideal Western figure and "history" painting in the Renaissance tradition.[49] Paintings produced and exhibited in the academies of Spanish America could just as well have been made in the academies of Europe.[50] It could hardly have been otherwise, as the directors and teachers of the New World academies had been trained in those of the Old, to which their students typically returned to complete their education.

To note that colonial artists gravitated toward the academies of the European capitals is to observe that their behavior was typical of artists on the periphery. For the artists of Buenos Aires and Mexico City were not the only ones looking to Rome or Paris; artists raised and educated throughout Europe did so, as though reflexively drawn to the centers of their tradition. This was the tradition, too, of the New World, settled by the peoples of Europe, with whose cultures they continued to identify. What, then, could have been more natural than for colonial artists to follow the lead of the principal academies of Europe? And is the art of the New World academies not testimony to both the talent and the resolve of their artists and the strength of the academic tradition?

The questions are deliberately provocative. For we all know that settlers of European origin and culture were not the only inhabitants of the regions of the New World; these regions had indigenous populations that were displaced and dominated, when not annihilated, by Europeans. Only the pace of subjugation – or extermination – differed throughout the various areas. Writ-

ing of the River Plate region of Argentina and Uruguay, Jorge Luis Borges noted, "The conquest and colonization of these kingdoms was such an ephemeral operation that one of my ancestors, in 1872, led the last important battle against the Indians, thereby realizing, after the middle of the nineteenth century, the work of conquest begun in the sixteenth."[51]

The work of pictorial conquest had begun in Buenos Aires in 1789 with the creation of an Academia de Dibujo that stressed drawing the parts of the body and copying engravings after Michelangelo, Raphael, Titian, the Carracci, and other masters of the Renaissance tradition.[52] The artists of Argentina were members of European families, sent to the academies of Rome, Florence, and Paris to complete their training; their "native" styles were imprinted with those of the European academies, to which they owed the handling of their subjects as well: the uniquely Argentine is invested with the aura of a classical or biblical narrative (Fig. 25), the gaucho, a quasi-allegorical figure in the tradition of the European military hero, signifies the virtues of the conqueror (Fig. 26). In other regions of the New World, the process in question was begun and completed much earlier; in Mexico, in the sixteenth century.

What was brought out with particular clarity by the teachings of these academies, then, was the bond between art and power, how the educational and cultural apparatus of the country belonged to the people or class that had succeeded in imposing its hegemony. If proof were needed, consider the following description of life in the Mexican Academia de San Carlos:

every night, in these spacious halls, well illuminated by Argand lamps, hundreds of young men were assembled, some sketching from plaster-casts, or from life, and others copying designs of furniture . . . and that here all classes, colours and races were mingled together; the Indian beside the white boy, and the son of the poorest mechanic beside that of the richest lord . . . one of the principal objects being to propagate amongst the artists a general taste for elegance and beauty of form, and to enliven the national industry. Plaster-casts, to the amount of forty thousand dollars, were sent out by the king of Spain, and as they possess in the Academy various colossal statues of basalt and porphyry, it would have been curious . . . to have collected these monuments in the courtyard of the Academy, and compared the remains of Mexican sculpture, monuments of a semi-barbarous people, with the graceful creations of Greece and Rome.[53]

That the indigenous peoples of Mexico created monumental sculptures in stone did not mean that they were "civilized"; nor were their cities to be taken as evidence of highly developed cultures. The only true culture is that of Europe, to be imposed on, and presented as a gift to, the Other.[54]

The art of the academy was fatally compromised in the New World, then, by its association with an imperialist ideology. It was bound to be rejected along with this ideology, and was so rejected with the rise of nationalist movements in the early twentieth century. This rejection is especially closely

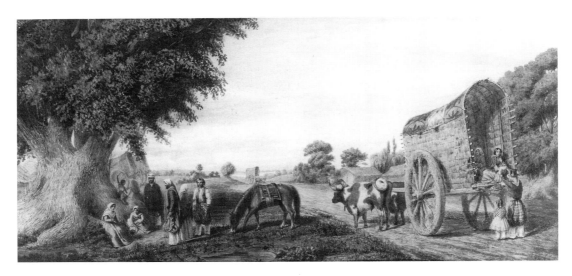

Figure 25. P. Pueyrredon, *A Sunday in the Suburbs of San Isidro (Un Domingo en los suburbios de San Isidro).* Buenos Aires, Museo Nacional de Bellas Artes. (Photo: Museo Nacional de Bellas Artes)

Figure 26. A. Della Valle, *Paisanos.* Buenos Aires, Museo Nacional de Bellas Artes. (Photo: Museo Nacional de Bellas Artes)

identified with the Mexican Revolution and its artists, Rivera, Orozco, and Siquieros, artists imagined to have replaced European academicism with something more genuine and uniquely Mexican. As Octavio Paz has insisted, however, this rejection itself signified a shift in European aesthetics:

We can now view precortesian art with clean eyes, because for more than a century we have been taught to look at Gothic and Oriental art, and later at the art of Africa and the South Seas. These conquests have not only enriched our sensitivity, but they have influenced the work of all great contemporary artists. Remember what Negro masks have meant for Cubism, Egyptian art for Klee, Sumerian sculpture for Picasso. The work of the Mexican painters is part of this tradition which Romanticism began. Without it Rivera would be inexplicable. Our painting is a chapter in modern art.[55]

This is not to say that Mexican art was the same as modern European art. "It is, at the same time," Paz continues, "the painting of a people which has just discovered itself and which, not content with recognizing itself in the past, is searching for a historical project to become inserted in contemporary civilization."[56] In presaging the rejection of implanted academicism by Mexican artists, early modernism is indeed the beginning of a larger story, as Paz suggests — that of a growing tension between the past and the present which was felt in academies throughout the world. This tension resulted in the steady erosion of their authority until, by the early twentieth century, they had become the embattled institutions we have known them to be.

A CROSSROADS

One whose experience of this tension eventually caused him to call the academy's values into question was another artist on the periphery, the North American Thomas Eakins, who began his training by drawing from antique casts and from the live model in the Pennsylvania Academy of the Fine Arts, and then, taking advantage of the 1863 reform, entered the Ecole des Beaux-Arts, enrolling in the atelier of Gérôme in 1866. Indeed, Eakins's early career exemplifies the cross-fertilizations of academies characteristic of this period in the academic tradition. His later relations with the academy are marked, however, by a crystallization of the dissatisfaction with academic teaching that increasingly was being voiced and that is most closely associated with the antiacademicism of the avant-garde.

The Pennsylvania Academy, in which Eakins enrolled in 1861, was the first academy of art in North America, founded in 1805 on the model of the Royal Academy and, like it, stressing study and exhibitions. Even though originally inspired by the Royal Academy, the Pennsylvania Academy from early in its history oriented itself toward Paris, to which it owed its philosophy and also its staff, the instructors typically being French nationals trained in the ateliers and Ecole of Paris.[57]

Study in the Pennsylvania Academy involved principally, as one would expect, drawing from casts and from the model. (The casts had been imported from Paris.) Eakins drew from both and also attended lectures on anatomy.[58] But these lectures, like the drawing instruction, must have seemed poor substitutes for the legendary teaching of the Ecole, on which Eakins soon set his sights.

Under Gérôme, Eakins found the same insistence on beginning with the antique as existed in Pennsylvania, but he was allowed, from the first, to draw from the nude model. After some months of such drawing, he received Gérôme's permission to paint and proceeded to paint the motifs he formerly had drawn, ancient sculptures and the nude model. After almost three years of painting under Gérôme, Eakins worked briefly in the private ateliers of the portraitist Léon Bonnat and the sculptor Augustin Dumont. The method thus implanted having come to fruition, his paintings were accepted for the Salon of 1875.[59]

The circuit of this academic itinerary was completed in 1876, when Eakins was appointed to teach drawing and painting in the Pennsylvania Academy; he also assisted in the anatomy course, instructing the advanced students in dissection. On the evidence of representations of the anatomy course during these years, it would seem to have been conducted in much the same way as the one in the Ecole, joining the study of the skeleton and muscles to the superficial anatomy of the live model. Images of the life class also show a scene familiar from other academies, with one exception: the women's life class (Fig. 27). The Pennsylvania Academy was unusual for admitting women under the same conditions as men, Mary Cassatt having been one of the women students so admitted; and, during Eakins's time, females and males were enrolled in about equal numbers. Eakins's innovation consisted in having male models pose in the women's class. During Eakins's time, too, the academy admitted Henry Ossawa Tanner, the first African American to enter an academy in North America.[60]

These studies, of the live model and of anatomy, constituting the foundation of training in the nineteenth-century academy, had formed the basis of Eakins's education and remained of unquestioned importance to him. However, Eakins did begin to question the philosophy underlying them in the academy: the necessity or desirability of a long study of casts; the assumption that drawing must precede painting; and, most important of all, the academy's notion of "imitation."[61] What he was calling into question, in sum, was the doctrine to which this academy, like all others, subscribed. And, not surprisingly, in 1886 the directors called for his resignation. Just what it was that Eakins objected to will be clarified in the following chapters discussing, first, the doctrine of the academy, and then the constituent parts of the

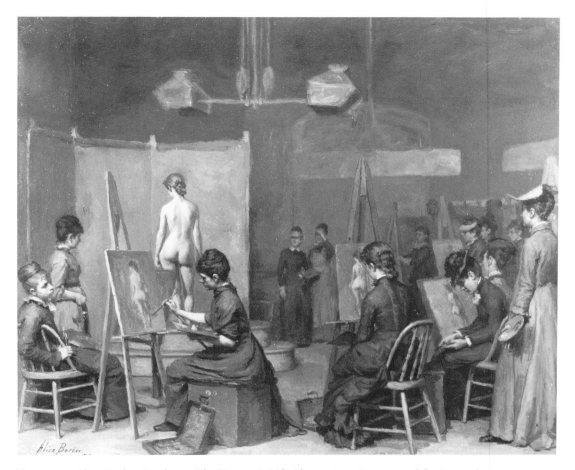

Figure 27. Alice Barber Stephens, *The Women's Life Class*, 1879. Courtesy of the Pennsylvania Academy of the Fine Arts, Philadelphia. Gift of the Artist. (Photo: Pennsylvania Academy of the Fine Arts)

program. The point to be made at this time is that Eakins was far from alone in his discontent with the academic method.

To be sure, the academy as an idea and institution was criticized before the late nineteenth century. William Blake, for example, wrote in his copy of Reynolds's *Discourses,* next to a discussion analyzing imitation: "The Man who on Examining his own Mind finds nothing of Inspiration ought not to dare to be an Artist."[62] And when a reform of the Academia de San Fernando was undertaken, Goya, then deputy director, proposed a complete overhaul of the curriculum on the ground that the rules on which the academy hitherto had relied were illusory.[63] Criticisms such as these echoed throughout the later nineteenth century, but with a far greater intensity than before. What

should be stressed is that these criticisms came from artists who, having received training in the academy, nevertheless took a stand against it – which is to say once more that to study art at that time meant to attend one of the organizations, whether atelier or Ecole or academy proper, that was part of the academic network. And because virtually all male artists were trained in the academic tradition, to speak of criticism of this tradition in the later nineteenth century is to refer, above all, to the ideology behind a form of art more radical than that of Eakins: the art of the avant-garde.

The early careers of the avant-gardists are, indeed, indices of the popularity of the academy's ateliers: Couture's in the 1850s, which attracted Manet and Puvis de Chavannes; Gleyre's in the 1860s, with Monet and Renoir; and so on. Degas enrolled in the Ecole and also worked in the private atelier of Louis Lamothe, a pupil of Ingres; having undertaken a tour of Italy, he gravitated toward the French academy in Rome, in which he drew from the model. Enrolled in the Ecole, Seurat worked in the atelier of Lehmann.[64] And the same was true of other members of the avant-garde – all artists who began their careers in the Ecole and ateliers of the academic tradition before rejecting much of what that tradition held most dear.

One of the principal issues in revisionist art history has had to do with just how much these artists did reject. The line of demarcation neatly separating the avant-garde from the traditionalists of the academy in the older literature more recently has become blurred. Avant-gardists, we are told, continued to apply the lessons they had learned in the academy in their mature works. One such lesson was the "aesthetics of the sketch," to which Albert Boime has traced the technique of Impressionist painting.[65] And Boime has argued, too, for the lasting importance to the avant-garde of drawing from casts and from the model. In his words:

All the major artists of the 19th century studied in academies. Significantly, painters like Degas, van Gogh, Seurat, and Matisse extended their life drawing practice into their mature work, and the traditional exclusion of their academic products drastically alters our understanding of the nature of their achievement. Van Gogh said early in his career: "The key to *many* things is the thorough knowledge of the human body," and he developed a rigorous habit of drawing the human figure as the basis for understanding the formal complexities of the natural world. . . . If we recall the animated forms which pervade his landscapes, then we cannot take these statements too lightly. Indeed, as we shall see, van Gogh was a true heir of the academic tradition.[66]

The artists mentioned by Boime are among those who did indeed remain committed to the human figure, which is to say to a phenomenon experienced by means of direct observation. Working from the live model was, therefore, as essential to them late in their careers as it was when they were just starting out. However, this in itself is not evidence that they continued to

regard the figure in the way it was taught in the academy. A discussion of how it was taught and of the relations of figures by members of the avant-garde to this teaching must be postponed until Chapter 8. Before concluding this chapter, however, it seems appropriate to examine the context of figure drawing in the one school established by a modernist mentioned by Boime: Matisse.

THE ACADEMY OF MATISSE

Matisse, like Degas and the others mentioned above, first learned to draw in the ateliers of the academic tradition, beginning in Bouguereau's and moving on to Moreau's in the Ecole. This was a tradition, however, that he would seem later in his life to have repudiated, in word as well as deed. Having distanced himself from the academy with an art of unprecedented "wildness," Matisse dismissed the system that relegated this art to a zone of taboo. Consider the following statement: "There is no such thing as teaching painting. At the Ecole des Beaux-Arts one learns what not to do. It is the perfect example of what to avoid . . . L'Ecole des Beaux-Arts? A machine for making Prix de Rome scholars . . . it only exists in its own surroundings. It will die a lonely death."[67]

This was a view that the painter of such canvases as the *Joy of Life* (1905–6) and *Blue Nude* (1907) would have been expected to hold. And it was apparently one taken for granted by the young artists who entered his atelier when it opened in 1908; for they threw themselves into their work with a frenzy that they must have imagined approximated his working state. When Matisse appeared for his first critique, however, he was confronted by work that he did not recognize as related to his own. He immediately left, only to return a short time later with a cast of a Greek head. Admonishing his students, he told them to start over again, drawing from the antique.[68]

To this head Matisse added a cast of the Greek *Apollo Piombino*, and he may also have had the students copy Michelangelo's *Dying Slave* (Fig. 28). He had them draw and paint from the nude model. Study in his class, it would seem, was a recapitulation of the course of the academy that he had regularly dismissed as "deadly for young artists."[69] Or was it? Here is another statement by him:

The few exhibitions that I have had the opportunity of seeing during these last years, makes me fear that the young painters are avoiding the slow and painful preparation which is necessary for the education of any contemporary painter who claims to construct by color alone. . . .

An artist must possess Nature. He must identify himself with her rhythms, by efforts that will prepare the mastery which will later enable him to express himself in

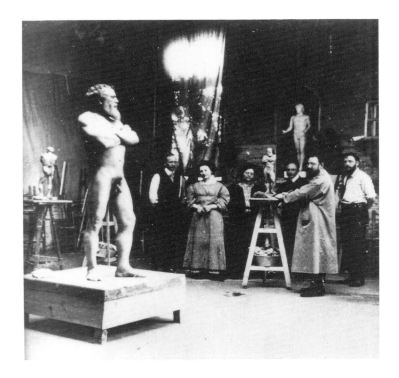

Figure 28. Sculpture Class at the Académie Matisse, Hôtel Biron, Paris, 1909. (Photo: © 1994 The Museum of Modern Art, New York)

his own language. The future painter must feel what is useful for his development – drawing or even sculpture – everything that will let him become one with Nature, identifying himself with her, by entering into the things – which is what I call Nature – that arouse his feelings. I believe study by means of drawing is most essential. . . .[70]

Must this not have been the understanding that led Matisse to stress the traditional drawing disciplines? It is clear at the same time that his teaching of these disciplines was not at all traditional. In his class criticism as recorded by Sarah Stein, we read the following:

The model must not be made to agree with a preconceived theory or effect. It must impress you, awaken in you an emotion, which in turn you seek to express. You must forget all your theories, all your ideas before the subject. What part of these is really your own will be expressed in your expression of the emotion awakened in you by the subject.[71]

Forget all your theories! Express an emotion! It would be difficult to conceive of sentiments more repugnant to the academic mentality. Drawing in the academic tradition obviously involved far more than simply describing masses of plaster or flesh-covered bones. It was based on a whole enabling structure that teaching such as Matisse's threatened to erode. It is time to examine this structure, beginning with the academy's overhanging doctrine.

DOCTRINE 1: ART HISTORY

In organizing exhibitions, the academy took upon itself one of the functions of a modern museum, which it prefigured in two other ways as well[1] – one in forming a collection and the other in using this collection for purposes of instruction in the history of art. This history itself was, in a sense, the property of the academy. For modern art history emerged shortly before the creation of the influential Florentine Accademia del Disegno, and in the same environment, and was most often revised thereafter at the behest, and under the aegis, of one academy or another. This was art history as a story revolving around the lives and works of the idols of the academy such as Michelangelo, Raphael, and Poussin; the collection documenting this history was to be a gathering together of their masterpieces, which were to serve as models for the students of the academy.

In question, then, are the works of the masters that will figure prominently in the discussions of the following chapters, works at the center of the academy's doctrine of imitation. What precisely was there in the academy to imitate? Did its models adequately convey the qualities of masterpieces? Was the academy's Michelangelo, Raphael, or Titian the same as ours? The reason for asking these questions is that the collections formed by academies rarely included any of the original works repeatedly cited in academic discourse.

THE "GREATS"

Let us begin with the art history behind the collecting, which is to say, with a narrative fundamentally Vasarian. Vasari's "rebirth" of art, it is to be recalled, was an evolutionary process, unfolding in three phases or ages, the

first two of which witnessed "progress" but were nevertheless imperfect.[2] Perfection was achieved in a third age by artists who had the advantage of the rediscovery of the great works of classical art until then known only from Pliny's text, the *Laocoön, Hercules,* and others. These were the great artists of the High Renaissance: Leonardo, Raphael, and, above all, Michelangelo. The works most clearly exemplifying this perfection are the incomparable Sistine Ceiling ("it is scarcely possible even to imitate what Michelangelo accomplished")[3] and the *Last Judgment,* in which Michelangelo outstripped not only all others but also himself.[4]

In Vasari's schema, Raphael's perfection exists in an ironic or antithetical relationship to that of Michelangelo, whom he first imitated and then, realizing the futility of such imitation in the realm of the figure, "resolved to emulate and perhaps surpass . . . in other respects."[5] This late style, a course steered between Michelangelo and other painters, is entirely his own and "will always be the object of tremendous admiration."[6] The sibyls and prophets in Santa Maria della Pace exemplify this perfection.

To write such a history of Renaissance art from Cimabue to Michelangelo was to narrate the story of Florentine *disegno,* which is precisely what Vasari states his intention to have been at the outset of the book. Such a unilinear history, modeled after classical rhetoric, is dismissive of forms of art based on alternative principles or simply produced in other cities. And Vasari was dismissive of art outside of Florence: the art of Venice was, in his schema, inferior to that of Florence, Titian's *colore* no match for Michelangelo's *disegno;* Lombardy's Correggio went as far as was possible at a remove from central Italy, but obviously that was not far enough. As for art outside of Italy, that of "Germans" and "Flemings" was not to be compared with Italian.[7]

With this canon, comprising the great artists of antiquity and select artists of the Florentine High Renaissance, Leonardo, Raphael, and, above all, Michelangelo, who equalled and even surpassed the ancients, Vasari laid the foundation for the history of art of the academy. To be sure, his rhetoric had to be adjusted to new settings and his hierarchy to some degree shuffled. But his was the basic "history" taught in academies, astonishingly, for some three hundred years and more.[8] It was the history of art of the Florentine Accademia del Disegno after its founding in 1563, an academy created in the image of Vasari's *Lives,* with Michelangelo as honorary president.[9] Preserving Vasari's heritage also became a preoccupation of this academy, which encouraged the republication and expansion of the *Lives,* resulting, ultimately, in a new compendium advocating the cause of Florentine art by a "second Vasari," Filippo Baldinucci's *Notices on the Professors of Design* of 1681.[10]

Before this expanded *Lives* had appeared, however, Vasari's hierarchies

had come under attack. Painting was reborn not in Florence but in Venice, whose *colore* was superior to Florentine *disegno,* countered Carlo Ridolfi in 1648, amplifying an argument put forward by Venetian polemicists shortly after the publication of Vasari's text; the most universal painter was neither Raphael nor Michelangelo but Titian.[11] Malvasia argued similarly (1678), depressing the reputations of the artists of Florence and all other cities in order to elevate those of Bologna: the Carracci and, most of all, Guido Reni.[12]

For the art history of academies, however, the most important revision of the *Lives* had to do with neither Titian nor the Bolognese, not with repudiating Vasari's argument but with reversing the positions of Michelangelo and Raphael in his hierarchy. This was a reversal that took full advantage of the Vasarian model and is most closely associated with the collection of artists' lives published by Bellori in 1672.[13] A member of the Accademia di San Luca and an honorary member of the French Académie Royale, Bellori seems at first to have thought about updating Vasari's collection.[14] In the end he wrote an entirely new work, containing biographies of only twelve carefully selected post-Renaissance artists but, significantly, substituting Raphael for Michelangelo as the most perfect. After Raphael, art degenerated to the point of needing a new "rebirth" or restoration, which was entrusted to Annibale Carracci, who was followed by another artist, similarly incarnating the ideal of Raphael: Nicolas Poussin. This modified Vasarian schema formed the core of academic art history from this time on – to say it once again, a history beginning with the ancients and positing a Renaissance revival culminating in Raphael's art, which in turn was revived and deepened, first by Annibale Carracci and then Poussin.

Such was the schema of the seventeenth-century French academicians, Bosse (1649) and Félibien (1679); the *Conférences* (1667) began, it is to be recalled, with a lecture by Le Brun on Raphael's *St. Michael* and highlighted his *Holy Family of François I* as well, before proceeding to analyses of paintings by Poussin.[15] Raphael was the idol of the Accademia di San Luca of Maratta (1663–1706) and later of Mengs and Winckelmann; his cause was promoted in the Royal Academy by Reynolds – though somewhat reluctantly because of his admiration of, and even identification with, Michelangelo.[16] In the nineteenth century, Quatremère de Quincy was only one of those who celebrated the life and work of Raphael.[17] The hierarchical relations behind this advocacy are expressed, literally, in Ingres's *Apotheosis of Homer,* 1827 (Fig. 29), in which Raphael appears prominently to Homer's right, with Apelles, directly above Poussin, whereas Michelangelo is a shadowy figure relegated to the background on the inferior left side.

To be sure, Raphael and the other Florentines, along with Annibale and Poussin, were not the only artists in the academy's pantheon. Reynolds, for

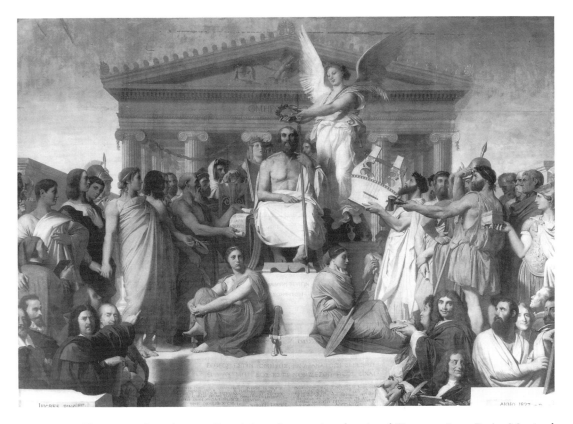

Figure 29. Jean-Auguste-Dominique Ingres, *Apotheosis of Homer.* 1827. Paris, Musée du Louvre. (Photo: © Réunion des Musées Nationaux)

example, strongly recommended Ludovico Carracci, had words of praise for Rubens and Rembrandt – and reservations about Poussin.[18] And Roger de Piles, during the Quarrel of Drawing and Color, went so far as to find fault not only with Poussin but with Raphael.[19] These were only momentary desertions, however, from the camp of Raphael, to whose authority, in the long term, the theorists of the academy inexorably submitted.

One further reinterpretation of Vasari must be mentioned, for it concerns a procedure that has been imagined as quintessentially academic: eclecticism. In question here is neither the hierarchy nor the schema, both of which are evaded in a strategy of synthesis. The best art, according to such an argument, will be the most broadly encompassing, joining the drawing of Michelangelo to the invention of Raphael and the color of Titian. In the literature of art, the Carracci academy has been the most closely linked to such a strategy, and much ink has been spilled in modern times attempting to prove the contrary.[20] I have recently suggested that although the argument itself is

clearly rhetorical, there is visual evidence of eclectic practices in the Carracci academy, different, however, from the programmatic borrowing associated with the term.[21] What I attempted to show is that the Carracci ranged widely over works in the Renaissance tradition in developing their own inventions, which do not thereby "unite" the color of Venice to the drawing of Florence, and so on. And when a seemingly "eclectic" method was advocated in the later academies, when Reynolds, for example, spoke of imitating the "excellences . . . distributed amongst the various schools," a similar procedure is recommended: to borrow freely from the art of the tradition.[22] No academy actually taught an eclectic method in the sense of incorporating the best features of the different schools.[23]

To write the history of art in academies, then, was to sing the praises of the works of Michelangelo, Raphael, Annibale Carracci, and Poussin – as well as of the ancients. In the histories themselves, this was done by means of verbal *ekphrasis*, the translation of an image into words, whether by a Vasari or a Bellori, whose *Lives* consist largely of such detailed descriptions of seminal works: the *Farnese Vault* of Annibale, the *Seven Sacraments* of Poussin, and so on.[24] For teaching artists, however, words were not enough. To be effective, academic art history had to be visual history, and such were the histories envisioned from early in the academic tradition.

ILLUSTRATING ART HISTORY

It seemed quite natural to Vasari to form a collection of drawings by the artists of the *Lives* – his famous *Libro* – showing the excellences otherwise left up to the visual imagination.[25] And the statutes of the academy that he helped to write call both for a space in which to exhibit works by the masters and students and for the formation of a study collection consisting of drawings, models, and plans donated by the masters.[26]

Such collections henceforth were formed in every academy, collections consisting of drawings and models by the teachers, and also drawings, paintings, bas-reliefs, and sculptures in the round made by the students in competitions and as their reception pieces.[27] These are the kinds of works that typically appear in images of academies, their walls adorned with student works and paintings by their members.[28] What we see is far from an illustrated history of art of the academy, however. Essential works of ancient art are usually included, it is true, among them the *Laocoön* and *Hercules*, casts of which eventually were acquired by virtually every academy. And such casts were tantamount to the originals from which they were directly taken. But the presence of such ancient exemplars only renders more conspicuous the absence of works by the moderns. Where are the Raphaels and Michelangelos, Annibales and Poussins, the works of the Great Tradition central to the

academy's whole notion of excellence and quality in art? Where are the works figuring so prominently in academic discourse that we know the academy in fact had at its disposal? In Reynolds's words:

The principal advantage of an Academy is, that, beside furnishing able men to direct the Student, it will be a repository for the great examples of the art. These are the materials on which Genius is to work, and without which the strongest intellect may be fruitlessly or deviously employed. By studying these authentick models, that idea of excellence which is the result of the accumulated experience of past ages, may be at once acquired; and the tardy and obstructed progress of our predecessors may teach us a shorter and easier way.[29]

The importance of gathering together these "authentick models" was, of course, that they were not otherwise available. The artists of Florence had their Medici Chapel and those of Rome the Sistine Ceiling, Vatican Stanze, and Farnese Gallery. The artists of London and Paris, or Vienna and Copenhagen, had access neither to these monuments nor to the great altarpieces of the masters. Nor did they have available to them the museum collections that eventually played so important a role in the education of artists. Public museums only began to appear in Europe toward the middle of the eighteenth century with the Musée du Louvre created first in 1793 and the National Gallery in London in 1824. Before the opening of public museums, the peregrinations of the great works of the Renaissance tradition ended in princely collections to which artists had access rarely, if at all.[30] Eventually students might get to Rome, passing through the other great Italian art centers on the way, but only after having proven themselves artists of the stamp of the masters. How, then, were they to begin learning from the masters? Of what did the academy's collection of "authentick models" consist? The answer is that, during a substantial portion of the academic tradition, before the founding of public museums and beyond, the works of the masters were experienced through the medium of reproductive engraving.

MUSEUM WITHOUT WALLS

To be sure, the artists of academies were not the first to study masterpieces through engravings; they were in fact continuing a practice of the Renaissance workshop described above. In their hands, however, this study had surprising and hitherto unnoticed consequences. The art history of the academy was, in short, an early form of a modern art history textbook, with words and images, the latter being engravings of the works referred to in academic discourse. As in a textbook, these works were displaced from their original contexts and assigned new identities; it mattered little that one image was of an altarpiece, another of a wall decoration, that one was sacred and

the other profane. Disencumbered of their original significance, they all reveal the same truth: the timeless universality of art.

The pitfalls of such a history of art were inventoried by André Malraux in a publication of 1947 from which the title of this section is borrowed.[31] In the "museum without walls," a religious icon becomes simply a picture or a statue, he noted, even portraits losing their social and historical significance to become only so many "pictures." These pictures and statues are brought together, moreover, from the most widely disparate sources. Writing toward the middle of the twentieth century, Malraux chose examples from all the traditions and periods of world art, not only those of the classical tradition; in his book we see a Greek torso together with an Indian one, a Scythian plaque with a Romanesque sculpture.[32] But his observations apply equally to collections of reproduced images from the classical tradition. He observes, for example, that such images are all about the same size, a miniature appearing to be as large as an altarpiece, a plaque the same size as an architectural relief.[33] By falsifying the scale of objects, reproduction even creates what he calls "fictitious" arts, particularly the fragment or detail, which creates a wholly different impression from the original in its entirety. And color, when used – it was just "coming into its own" – merely evokes, and does not do justice to the original.[34] The works of art thus reproduced, Malraux notes, have undergone a "strange and subtle transformation," conjuring up worlds of art that never existed.[35]

The reproductions of Malraux's discussion were, of course, photographs, which, to his mind, had brought about a complete disruption of aesthetic consciousness by erasing the one work that the Renaissance tradition could not do without: the masterpiece. This may seem paradoxical, as photography places a profusion of masterpieces before the public. But these photographic reproductions have an effect, he suggested, opposite to that of the masterpiece "in itself"; from having been absolute and incomparable, the masterpiece has become merely one work among others of that style and period and by that artist.[36]

What the masterpiece thus has lost as a result of photographic reproduction is, in Walter Benjamin's formulation, its "aura."[37] Like Malraux, Benjamin, in 1936, identified photographic reproduction with a disarticulation of the masterpiece. Interfering with its "authenticity," such reproduction calls its authority into question. In sum:

the technique of reproduction detaches the reproduced object from the domain of tradition. By making many reproductions it substitutes a plurality of copies for a unique existence. And in permitting the reproduction to meet the beholder or listener in his own particular situation it reactivates the object reproduced. These two processes lead to a tremendous shattering of tradition which is the obverse of the contemporary crisis and renewal of mankind.[38]

This "crisis and renewal" is the materialist transformation – or commodification – of the modern world in which art, by means of photographic reproduction, participates, this participation in turn resulting in further mutations in the art of the tradition. Although not uncontested, this argument has become something of a commonplace in recent discussions of art history and contemporary art.[39] But much of what Malraux and Benjamin had to say about photographs mass-producing what had been unique images applies as well to traditional reproductive engravings, which circulated widely and in great numbers long before the advent of photography. Is it possible that photographic reproduction was not the momentous intervention in art history that has been claimed?

The answer would seem to be that the claim has not been exaggerated, but for reasons only touched on in passing by Malraux and Benjamin. Having drawn a neat line between photography and the tradition, Malraux nevertheless noted that originally photographic reproduction had been conceived of in a similar way to engraving: as improved and cheaper reproduction.[40] Benjamin, too, referred to forms of reproduction before photography, but suggested more complex relationships between these reproductions, the originals, and photographs. "Confronted with its manual reproduction," he stated, "which was usually branded a forgery, the original preserved its authority; not so *vis à vis* technical reproduction . . . process reproduction is more independent of the original than manual reproduction."[41] If we replace "forgery" with "copy," an important difference between engravings and photographs emerges, a difference between types of reproduction that would need further investigation. And there are other differences as well, not remarked upon by Malraux or Benjamin.

Some of these differences were noted by William M. Ivins, Jr., in a book of capital importance for the history of art not only in academies but more generally in the Renaissance tradition before photography.

THE WORK OF ART IN THE AGE OF MANUAL REPRODUCTION

Prints and Visual Communication is the story of "printed pictures" from their first appearance in medieval times to the triumph of photography.[42] Concerned as much with science and technology as with visual art, Ivins stressed the importance of "repeatable" pictures for the dissemination of information in all fields, an importance not less, he argued, than that of printed texts. He described the origins and development of the various reproductive techniques, through the displacement of these techniques by photography, which he understood similarly to, though independently of, Malraux and Benjamin as having revolutionized reproduction.[43]

Of concern here is the "prerevolutionary" phase of reproductive printing

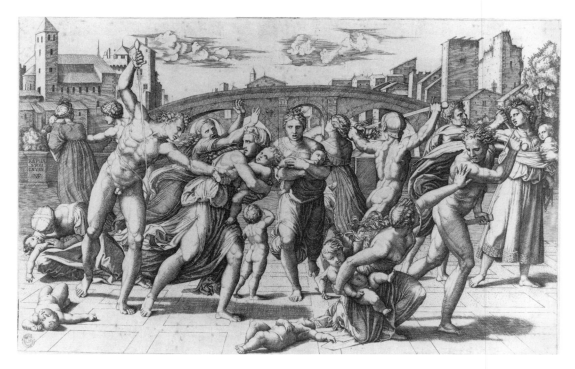

Figure 30. Marcantonio Raimondi, after Raphael, *Massacre of the Innocents*, c. 1513–15. Engraving. Paris, Musée du Petit Palais (Photo: Bulloz)

that Ivins examined and described in detail. For paintings and sculptures, what would have been expected, he suggested, was a means of translation capable of recording the characteristic features of that particular work in two or three dimensions. Before the days of photography, however, such an expectation was unrealistic. The most that could be expected was "a first-hand statement by a competent observer and honest recorder."[44] As competent and honest as this recorder might have been, he was restricted to a particular way of seeing and working, so that "when it came to copying a picture, that is to making a visual statement about a visual statement, the copyist felt under no obligation to be faithful to either the particular forms or the linear syntax of the . . . [work] . . . he was copying."[45] Whatever that syntax, in other words, it could only be reproduced as a web of lines, series of dashes, or cluster of dots, which German engravers would deploy in one way, Italian printmakers in another. Of the latter, the example of Marcantonio Raimondi was cited as particularly instructive (Fig. 30).

Marcantonio is best known for engravings after works by Raphael, particularly drawings, which, Ivins noted, consisted of broken outlines, with no regular system of shading and yet strongly illusioned volumes. In Mar-

cantonio's engravings these volumes are translated into linear schemes describing the "bosses and hollows made in a surface by what is under it" akin to the terrain in a geodetic survey.[46] This method was widely adopted by engravers, for it had the advantage that it could be applied to works in different materials. Its strength, however, was also its weakness, as "it was impossible for the engraver who used it to catch and hold the particular characteristics that gave the originals their unique qualities."[47]

It is no exaggeration to say that Raphael was known throughout Europe principally through Vasari's narrative and engravings made by Marcantonio, his followers and imitators, of works mentioned in that narrative.[48] Among the works especially widely circulated and studied, certainly in academies, were *The Judgment of Paris* and *Massacre of the Innocents* (Fig. 30), both engraved by Marcantonio after drawings by Raphael, according to his schematized linear practice. This is the same scheme of crosshatching and swelling and tapering lines that he used in engraving Raphael's paintings and also ancient sculptures.[49] Works by Raphael are united, of course, by a style that, in turn, was formed in response to classical sculpture. But in Marcantonio's engravings the unity of drawing, painting, and sculpture is far greater, and of a different kind, from that of the originals: the inexorable unity of the same reproductive technique.

That these works were experienced in the form of engraved copies made them no less admirable, however; from the frequency and intensity with which they were studied it seems reasonable to conclude that they were accepted in place of the originals, which is to say that they were regarded as images of masterpieces. Benjamin was surely correct in suggesting that the originals of works reproduced manually, in contrast to those reproduced photographically, preserve all of their authority. (In the engraved reproduction the "aura" still clings to the original.)[50] Why this should have been so he may have thought self-evident and, in any case, did not attempt to explain.[51] Several reasons come to mind. First, that an engraved reproduction consists of marks or units that, if not identical with those of the original, nevertheless require a similar density of reading; this is a reading in time, as opposed to the instantaneous registering of a photograph. Second, from the obviousness of the marks it is clear that this is only a translation or copy of an absent painting or sculpture, which preserves its uniqueness as something existing in another space. But if for such reasons the originals of engraved reproductions were perceived differently from those of photographs, in other respects engravings and photographs performed similarly. Much of what Malraux and Benjamin claimed for the photographic reproduction applies to the engraved reproduction as well.

Like photographs, engravings remove works from their original contexts and arbitrarily reduce or enlarge their scale so that they all end up being

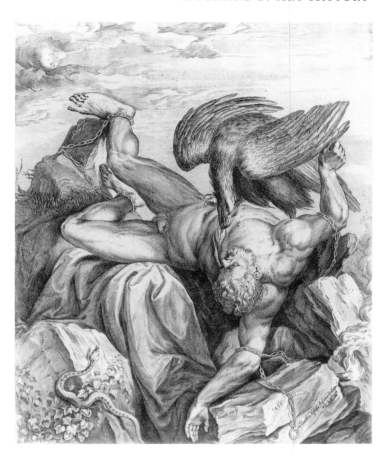

Figure 31. Cornelis Cort, after Titian, *Prometheus.* 1566. Engraving. Ackland Art Museum, The University of North Carolina at Chapel Hill, Ackland Fund, 68.14.1. (Photo: Ackland Art Museum)

about the same size; they bring up close what ordinarily might be seen only from a distance; they deprive paintings of their color. The last is perhaps the most striking transformation of the original. For if the color photograph does not do justice to the original, as Malraux complained, the reproductive engraving eliminated color entirely: all paintings in the Renaissance and academic traditions were reproduced in black and white.[52]

In engravings, the conceptions of Veronese or Titian (Fig. 31) are not markedly different from those by Raphael or Michelangelo (Fig. 32); all are translated according to the same linear code, color, as light and shade, being conveyed by means of parallel lines and hatching. Works by all these artists appear so similar, in fact, as to render Vasari's remarks about Venetian color contrasting with Florentine drawing unintelligible.[53] That the linearity of the images is that of engraving, and specifically of a technique first perfected by Marcantonio, may not have been lost on the academicians; but even so, they were confined to visual models that problematized the categories of Renaissance art history. Mediating the conflicts created by these categories, repro-

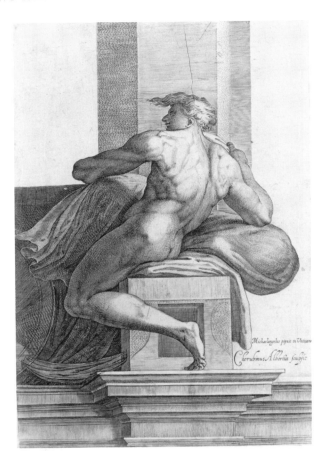

Figure 32. Cherubino Alberti, after Michelangelo, *Ignudo from the Sistine Ceiling.* Engraving. Ackland Art Museum, The University of North Carolina at Chapel Hill, Burton Emmett Collection, 58.1.606. (Photo: Ackland Art Museum)

ductive engraving, at the very least, produced a "history" of a hitherto un-known homogeneity.

And not only history. With time, nature too was translated by means of the vocabulary of engraving. This was especially true of the nineteenth century, when teaching in the academy had become so completely bound up with the study of engravings that the live model, and even the landscape, often were rendered with well-defined contours and hatching, as though with an engraving tool.[54]

The artists of academies were not alone, as noted, in using engravings reproducing the inventions of the masters. Such engravings played a major role – for one, Kenneth Clark has suggested – in the development of Rembrandt's art. Although he never went to Italy, Rembrandt regularly quoted and interpreted works by the Italian masters that "were always present in [his] mind like rough molds into which he could pour his immediate sensations."[55] That these "rough molds" originated with engravings is made clear

by an inventory of Rembrandt's possessions. Included were: engravings after Mantegna, a book "full of the work of Michelangelo Buonarroti," "almost all the work of Titian," and four volumes of engravings after Raphael."[56] And the use of such reproductive engravings is documented for other artists as well, Poussin and Rubens, among others.[57]

To note the prevalence of the practice is, however, not to deny its importance in academies. Nowhere else, moreover, were engravings studied so intensely or so limited a repertory of images copied so systematically – Raphael's above all others. With the history of art thus at their fingertips, the artists of the academy were ready to compete with the masters, whose inventions, already displaced out of context and experienced as so many "great examples," were further drained of their original meanings and then imbued with whatever meanings the academicians decided to give them. The creation of new masterpieces was, of course, the goal. But the works thus engendered often seemed to fall far short of that goal. Roger de Piles was one of the first to express misgivings about the uses to which engraved reproductions were put, complaints that were echoed throughout the nineteenth century. "One can only find feebly disguised reminiscences of Giulio Romano's sketches and Marcantonio's engravings," remarked one critic of the paintings in the Salon of 1866.[58]

By the time these words were written, studying works in the Grand Manner was no longer confined, of course, to engravings. It was in the 1860s that Adolphe Braun began photographing works of art, carrying reproduction into the phase analyzed by Malraux and Benjamin. These were photographic reproductions of works in the Louvre and other public museums.[59] And this brings us to the more important phenomenon – namely, that of the museum. With the creation of the Musée du Louvre in 1793, followed by public museums in other capitals, access was provided to original works by the masters, indeed, to a large number and wide range of such works. To visit the museum was to confront the tradition with all the force of immediate experience. Can there be any doubt that such confrontations, shifting emphasis from engraved copy to painted original, provided a primary impulse behind the successive transformations of art in the nineteenth and twentieth centuries?[60]

DOCTRINE 2: THEORY AND PRACTICE

By definition, the academy's doctrine would be everything that it taught, not only art history, but copying the masters, drawing after the antique and the live model, and also anatomy, geometry, and perspective – theory and practice conjoint. In general usage, by contrast, the term "doctrine" has tended to be most closely associated with that part of academic ideology involving a hierarchy of genres privileging "history" painting. While there is some truth to these readings, as teaching in the academy had comprised theory as well as practice and been permeated with an ideology declaring the supremacy of history painting, they both leave out that which was most unique about academic doctrine: the academy's recognition of the fundamentally pragmatic context in which its ideal was to be articulated. The point of doctrine, so to speak, was to open up a new dialectic between theory and practice that frankly acknowledged the contingencies of the second.

THE HUMANISTIC THEORY OF ART

The motifs of this dialectic emerged from a long and intricate history; they traced their origins to discussions of art in Greece and Rome and threaded their way through the literature of art in the Renaissance tradition from Alberti on. This is the tradition of Renaissance humanism referred to in Chapters 1 and 2, visual art in this tradition being treated as a humanistic subject. As humanism had been a dominantly literary movement, humanistic art theory, not surprisingly, as Rensselaer Lee has noted, applied to art a system "for which it was not originally intended."[1] These same criteria were brought to bear in academic discussions, which typically would begin with

the central trope of this literary tradition, a comparison of painting to poetry (*ut pictura poesis*).[2]

Academies were not content, however, with reiterating existing statements of humanistic theory. For one thing, these statements were found too vague, unsystematic, and contradictory; thus the academy took upon itself the task of deducing more consistent and definite rules to be duly recorded. Such was the task assigned, we recall, to André Félibien and Henri Testelin in the seventeenth-century French academy and was the role played by Reynolds in the Royal Academy.

Consider the content of humanistic theory with which the deliberations of the academicians began. The crux of this theory is the notion of mimesis, founded on the presumption of a representative interrelation between a work of art and the world of appearances.[3] And some of the best known and most often repeated topoi of the literature of art bring home the importance of imitating nature well and convincingly: the stories told first by Pliny about Zeuxis and his grapes, Apelles and his horse, anecdotes about artists making people believe in the "reality" of pictures.[4] These stories were repeated in the Italian Renaissance, when artists were advised to do what the literature said the ancient artists had done. "Painting strives to represent things seen," declared Alberti.[5] And Leonardo reiterated this view: "Painting is most praiseworthy that has the most similarity to the thing reproduced, and I say this to refute such painters as want to improve on nature."[6]

Already in the ancient literature another kind of relation between artists and the facts of nature was mooted, however – one involving a process of selection that generalizes or perfects nature. The topos exemplifying this relationship is the one about how Zeuxis, in order to depict a perfectly beautiful woman, selected the best features of each of five virgins.[7] The Renaissance writers, too, urged such a process of selection, coupling it, as though perversely, with their admonitions to imitate nature exactly. "It is very rarely granted even to Nature herself," declared Alberti, "to produce anything absolutely perfect in every part," citing in support of his argument for the inadequacy of mere imitation the ancient painter Demetrius, "who failed to obtain the highest praise, because he was more devoted to repre- senting the likeness of things than to beauty."[8] To be devoted to likenesses was, in the words of Kenneth Clark, to dwell on the "wrinkles, pouches and other small imperfections" invariably encountered in the live model.[9] Required, therefore, was a process of selection of the kind associated with Zeuxis: "[the painter should] not only render a true likeness but also add beauty. . . . For this it will help to take from all beautiful bodies each praiseworthy part, and one must always exert himself with study and skill to learn great loveliness."[10]

This was the kind of contradiction – the body and not-the-body – that

was to be adjudicated in the academy's rules, which dryly state that painting should imitate nature, but selectively, "correcting" nature's faults. (The rules were most fully developed for painting but also apply to sculpture.)[11]

These rules, derived from the theory and practice of the Renaissance tradition, are not radically divergent from the one or the other; the basic principles already were stated in Alberti's treatise, which in turn articulated the method employed by artists from the time of Giotto on. As Reynolds wrote on the scroll that he placed in the hands of a figure representing theory: "THEORY is the knowledge of what is truly NATURE" (Fig. 33).[12] Had the doctrine of the academy consisted of nothing more than such assertions it would be difficult to distinguish it from the theory of the Renaissance tradition, with which it was, understandably, viewed as continuous by Lee. (He placed Reynolds at the end of that tradition.)[13] Academic doctrine is, nonetheless, original, its originality consisting in its conduct of a dialectic that forced theory to a crisis. The narrative of this crisis begins with the academy's confrontation with theory during the early stages of its history.

THEORY CONTRADICTED

When, in 1653, the members of the French academy reviewed the role of theory, they agreed that, should disputes arise during the course of their future deliberations, these would be settled by consulting the classic texts of the art theoretical tradition; and if a lecture on a given topic had not been prepared, the suitable chapter of an art treatise might be read in its place.[14] In keeping with this decision, Le Brun brought in a copy of the recently translated "treatise" of Leonardo for the edification of the academicians. Among the precepts in this text is one of the kind mentioned above: that art is the exact imitation of nature ("de tout copier d'après nature"), along with similar, equally random observations.[15] Because of such statements, the text was challenged by the perspective teacher, Abraham Bosse, leading to a controversy eventually involving Poussin, whose name appeared on the engravings illustrating the "treatise" but who nevertheless agreed with Bosse that it was neither well organized nor well considered ("ni en bon ordre, ni assez bien digéré").[16] Despite these objections, when Colbert visited the academy in 1666, Leonardo's text was brought out and used as the basis for a discussion of theory. By this time, however, more serious questions had been raised about the relevance of Renaissance theory, rendering still more problematical theory's relation to practice.

This conflict involved far more than a theoretical lapse of the kinds of which Leonardo had been accused and revolved around one of the academy's subjects: perspective. At its center, again, was Bosse, joined by Roland Fréart, Sieur de Chambray. Both Bosse and Chambray viewed geometry, for

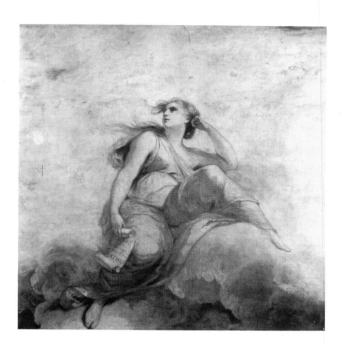

Figure 33. Sir Joshua Reynolds, *Theory.* 1776–9. London, Royal Academy of Arts. (Photo: Royal Academy of Arts, London)

reasons to be discussed in Chapter 9, as a paradigm for visual art, geometrical perspective as the necessary foundation of pictorial composition. This view was encouraged by Renaissance theory, which, from Alberti on, stressed the importance of perspective.[17]

Accepting the word of the theorists, Chambray assumed that Renaissance compositions were developed according to the rules of perspective and claimed as much for works by Raphael; Raphael's practice, he declared, proved the importance of perspective and should therefore guide the artists of his time. Bosse, however, more knowledgeable in perspective than Chambray, pointed out that Raphael's compositions do not in fact converge on a single vanishing point. For him it was a question, not of what painters had or had not done, but rather of what it is "reasonable" to do. He warned at the same time against following the example of any painter, even the preeminently singular Raphael, who had ignored perspective in practice.[18]

But how could one admire Raphael, as he was universally adored in France throughout the academic tradition, and fault him at the same time? "If there is a work by Raphael deficient in perspective, is he for that reason to lose his reputation?" was Félibien's ironic rejoinder.[19] If one continued to admire him despite the clear evidence of his neglect of so important a theoretical discipline, thereby acknowledging the dispensability of theory, was this not tantamount to a repudiation of the claims of theory? Such questions returned to haunt the academy as it proceeded to formulate its doctrine.

Academic doctrine emerged, we remember, from the *Conférences* inaugurated in 1667.[20] Each *Conférence* consisted of a lecture delivered by an academician charged with unlocking the secrets of a specific work in the royal collection, followed by a critique by the members and guests. This was, then, a dual interrogation, first of the work of art itself and second of the discourse engendered by that work. Of the seven *Conférences* held during the first year, the last two – Poussin's *The Israelites Gathering the Manna* (Fig. 34) and *Christ and the Blind Men of Jericho* – originally intended to recapitulate the earlier discussions, gave rise to heated debates over the relation of practice to theory, and so are worth considering in some detail.[21]

Le Brun opened the *Conférence* on Poussin's *Manna* (Fig. 34) by rehearsing the critical trope whereby an artist is praised for bringing together all the "parts" of painting otherwise dispersed among many different artists. In this work Poussin is said to have united the drawing of Raphael, the color of Titian, and the facility and composition of Veronese. For this reason, Le Brun explained, and so as not to be redundant, four things were to be stressed: (1) the disposition in general and of each figure in particular; (2) the drawing and proportions of the figures; (3) the expression of the passions; (4) the perspective and harmony of colors.

His main points were that the desperation of the Jews is perfectly expressed by the barren setting ("un désert affreux") and that the melancholy feeling thus created is reinforced by the dim lighting ("une lumière si pâle et si foible qu'elle imprime de la tristesse"); that the figures are gathered into groups and the groups judiciously related to give prominence to the central figures, Moses and Aaron ("cette unité d'action et cette belle harmonie"); that the drawing is admirable, as are the proportions, which he traced to specific models, the *Laocoön*, the *Niobid, Seneca,* and so on; that the expressions of the figures communicate both the misery of the Jews and their recent deliverance; the clothes, he noted, too, were carefully designed with regard to the quality of the person represented.

Perspective, the theory and practice of which was so hotly disputed in the academy, was remarked upon as follows: it was perfectly observed, Le Brun noted, as can be seen from Poussin's division of the landscape into terraces on which he was able to dispose a multitude of figures ("terrasses les plus elevées pour y placer ses figures"), diminishing in size as consistent with the morning mist enshrouding them. And the lights and shadows, as well as the values, are all appropriate to the figures, given their positions and the quality of the light in the landscape space.[22]

In the ensuing discussion, exception was taken to Le Brun's unqualified praise for the painting. Poussin erred, this person declared, in showing the manna falling like snow during the day, in full view, when Scripture clearly states that it was found around the camp in the morning, like dew. And

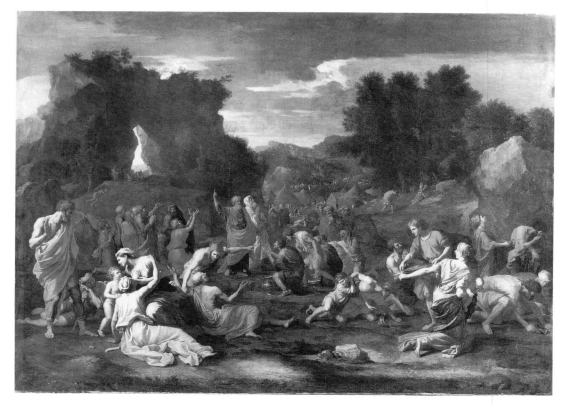

Figure 34. Nicolas Poussin, *The Israelites Gathering the Manna,* 1637–9. Paris, Musée du Louvre. (Photo: © Réunion des Musées Nationaux)

Poussin made the mistake, too, of showing a young woman suckling her aged mother instead of her child when, according to Scripture, the evening before the manna was sent, quail were provided for the Jews, whose immediate need would thus have been satisfied.[23]

In question was whether Poussin's representation was "true," whether it conformed to the text. For the theoretical precept of decorum (*vraisemblance*) required both that nothing improbable be shown and that the representation adhere to the *letter* of the text. It was in terms of the second that Poussin was criticized. And this was criticism that Le Brun was unable to countenance. Faced with a choice between the reality of a painting he admired and the abstraction of a theoretical precept, he opted for the first. A painter, he said, is not like a historian who uses words to narrate a progressive action; a painting, by contrast, is taken in at a glance, and must at times, therefore, gather together several different incidents to be effective. This distinction between painting and history is not in itself remarkable in the long history of the *ut pictura poesis* doctrine. What is noteworthy, however,

is the context – namely, that of the perceived opposition of practice to theory in the academy during the 1660s. For Le Brun was saying two things: first, a painting is not the same as a verbal text; and second, considerations of practice outweigh those of theory.[24] The discourse of the academy, by foregrounding an auratic image, is at one and the same time irrevocably theoretical and irredeemably antitheoretical, the second whenever further speculation threatens to undermine the authority of that image.

In the *Conférence* on Poussin's *Christ and the Blind Men of Jericho* a similar dispute arose. After a lecture – by Sébastien Bourdon – that followed the general outline of Le Brun's talk, though making light the most important of the six principal parts ("six parties principales"), one of the auditors criticized the painting for containing few figures when Scripture states that a multitude was present. Still another member, perhaps Le Brun himself, quickly defended Poussin on the ground that many figures would have detracted from the principal characters, in this case few figures being more effective. (The most famous of these disputes took place the following year and has seemed the most ridiculous: why did Poussin omit the camels prescribed by the text from his *Eliezer and Rebecca* (Fig. 35) when they would have enhanced the beauty of the young girls? Le Brun's explanation in defense of Poussin: he wanted greater concentration on the essentials of the subject and its expression.)[25]

The questions posed in the later 1660s can be related, as was noted, to a quarrel that had broken out a decade earlier. Nor were such quarrels restricted to the academy of painting and sculpture.

THE CONTRADICTION UNRESOLVED

When an academy of architecture was created by Colbert in 1671, it too was charged with formulating rules, and the academicians decided that these should be derived from a joint study of ancient buildings and the architectural theory of the classical tradition. ("selon l'estude [des] ouvrages antiques et sur les éscrits de ceux qui en ont traité.")[26] The problem, as already made known in 1650 by Chambray, was that the buildings tell a different story from the treatises, which themselves contain widely divergent measurements of the same structures.[27] And already in the fourth meeting there was disagreement as to whether proportion was governed by an absolute rule or was simply a question of usage.[28]

The academicians spent much of their time reading Vitruvius and Vignola, Serlio, Palladio, and the other writers of the Renaissance tradition. No matter how often they read the treatises, however, the numbers remained divergent. In an attempt to arbitrate differences, requests would be sent to the

academy in Rome for measurements of key ancient monuments, but these agreed neither with one another nor with the texts. The conclusion seemed inescapable: the architectural practice of the classical tradition cannot be reduced to a set of rules. Accepting this conclusion, however, would have meant abandoning the quest for rules that was the academy's stated and sole purpose, and it adamantly refused to do so.

Its strategy, as reflected in the *Cours d'architecture* of François Blondel, its director, was to put its trust in theory, pondering the different measurements of the treatises without worrying about whether or to what extent these measurements agreed with the buildings themselves.[29] One resolution of the contradictions of the texts was so bizarre as to seem a parody. Like the majority of the academicians, Claude Perrault believed in the efficacy of Vitruvius's "rules" ("les véritables règles du beau & du parfait dans les Edifices").[30] If there are problems with the *Ten Books,* he states in his edition, they were created by copyists incorrectly transcribing the numbers. His solution: change the numbers. And he proceeded to do the same for Vignola and the Italian authors, "rectifying" their figures to create whole numbers and clear relationships.[31]

In principle, the academy was concerned with practice as well as theory and seemed to encourage the taking of accurate measurements of the key monuments. Such measurements were made, for example, by Antoine Desgodets and published in 1682 in his *Les Edifices antiques de Rome,* a book that eventually became the standard work on Roman buildings.[32] When the academy was presented with Desgodets's evidence of practice contradicting theory, however, its response was to ignore the evidence. The members returned to the impasse of the theoretical treatises.

An edifice such as it was the task of the academicians and their students to design obviously consists of more, or something other than, words. And, despite the inability of the academicians to agree about the relative importance of architectural theory and practice, buildings were designed. In design, practice, not surprisingly, played the leading role, with far less respect for Vitruvius and the other theorists than the reverence of the academicians might have led one to expect. Architectural practice drew upon the actual buildings of the esteemed French architects of the seventeenth century, such as Mansart, and upon the churches and palaces of Italian architects from Vignola to Palladio and Michelangelo and, eventually, Juvarra and Piranesi; intermingled with these were the forms of ancient Roman buildings such as the Pantheon, which the students, like those in the Academy of Painting and Sculpture, were sent to Rome to study firsthand after succeeding in their own Prix de Rome competitions. The gap between the two kinds of evidence could not be bridged, and the academicians found themselves suspended in it again in the nineteenth century. To Quatremère de Quincy, the texts consti-

tuted the primary evidence, whereas his successor as secretary, Désiré Raoul-Rochette, placed his faith in the monuments; the evidence of the monuments ("La témoinage de ces monuments") is decisive, he declared, advocating the rejection of any texts conflicting with them. The arguments echoed through the rest of the century. At stake, it is to be stressed, was not a question of beauty – whether this or that evocation of a building or actual structure was the more beautiful – but nothing less than the aesthetic and ontological status of architecture itself.[33]

A REVOLUTION IN THOUGHT

It is not unusual to link the programs of the French academies and to view their preoccupation with rules as symptomatic of a desire for orthodoxy imposed on them by Colbert. To be sure, Colbert was a powerful influence in both the academy of painting and sculpture and the academy of architecture and was the instigator of theoretical discussions that he expected to result in the formulation of rules. But if it is possible to trace the emphasis on discourse to Colbert, he can hardly be credited – or blamed – with the different outcomes of the dialectic that ensued in each of these academies. The discussions he was instrumental in initiating touched on a conflict, in fact, with roots running deep in the intellectual and cultural life of the time.

It is no exaggeration to say that this conflict was a turning point not only in theories and philosophies of art but in the culture that was the context for such speculation. A convulsion of truly monumental proportions, it has been identified with revolution itself, the scientific revolution of the modern world that began with a questioning of received opinion in the Renaissance and culminated in the Battle of the Books of the seventeenth century, pitting the moderns against the ancients.

To side with the ancients was to respond to the heritage of Greco-Roman culture in a way that was only partially aesthetic. Such a response embodied a deep trust in the achievement of the ancients in all fields of human endeavor, in ancient philosophy (including science) and literature as well as art, a belief that the legacy of the ancients was a repository of higher and ultimate truths. Antique artifacts were regarded as having about them something of the "aura" of the sacred, and ancient texts were approached with an awe reserved for the truly holy; they were to be deciphered, translated, and ritually annotated, but not criticized. To study logic or ethics or natural philosophy was to absorb Aristotle and his commentators; to study medicine, to digest Galen; and so on. To question the correctness of these texts would have been to challenge learning itself; learning, it was agreed, meant submitting to the authority of texts.

The modern revolution in thought began with an abrogation of this agree-

ment. Books exist, it was decided, to be engaged, tested, and, if necessary, "rewritten." This attitude is most closely associated with Francis Bacon, who, in his *Novum Organum* of 1620, proposed the object of knowledge to be not a theory about something but rather its "firm and true definition." The state of human knowledge, he explains in a prefatory note to the *Great Instauration,* is dismal: "That the state of knowledge is not prosperous nor greatly advancing; and that a way must be opened for the human understanding entirely different from any hitherto known, and other helps provided, in order that the mind may exercise over the nature of things the authority which properly belongs to it."[34] Renegotiating this authority entailed, to begin with, the displacement of conventional learning, which, to Bacon's mind, was excessively rational and theoretical:

There are two ways, and can only be two, of seeking and finding truth. The one, from sense and reason, takes a flight to the most general axioms, and from these principles and their truth, settles once and for all, invents and judges all intermediate axioms. The other method collects axioms from sense and particulars, ascending continuously and by degrees so that in the end it arrives at the most general axioms. The latter is the only true one, but never hitherto tried.[35]

The "true" method is, then, inductive, as opposed to the deductive method of traditional philosophy; and the inductive method is that of experimental investigation. It is for this stress on observation and experimentation ("collecting axioms from sense and particulars") that Bacon has seemed the philosopher who, more than any other, anticipated the characteristic method that resulted in the preeminence of modern natural science.

[margin, handwritten: Plato vs. Aristotle]

Bacon's call for a new methodology was echoed, even if only faintly at first, in the Royal Society after it was officially chartered in 1662. The advantages of an empirical method and an experimental society were even more deeply appreciated in Paris after the creation of an academy of science in 1666. The French academy undertook systematic astronomical observations based in the Observatoire de Paris, which was completed in 1669; it took on the responsibility of certifying the merit of new inventions and technical processes; and it verified the publications of its members. "In some such ways," A. Rupert Hall has suggested, "perhaps most of all in its mounting of scientific expeditions and astronomical team-work, the Academy was actually closer to the Baconian ideal than was the Royal Society."[36] As for this ideal:

They were just as conscious as he had been of the importance of cooperative effort and ample means of investigation, and preferred anonymous publication of their official enterprises . . . They were just as certain as Bacon that fact-collection must precede theory. . . . The academicians found that they could agree on the 'undigested observation of some phenomenon' when agreement on cause and theory was unattainable.[37]

97

Lurking behind the promotion of this ideal in Paris, it would seem, was the same powerful presence as in the academies of art and architecture: Colbert. Those who first conceived of an academy of science pursued the initiative with Colbert, who already had patronized distinguished foreign men of science. Having agreed in principle to the plan, he came up with his own scheme, which included salaries for two classes of academicians: mathematicians, including astronomers and physicists; and natural philosophers, chemists, physicians, and anatomists; and the Royal Library as a meeting place.[38]

Colbert's patronage of this academy has not been understood, however, in such lofty terms. It has been viewed, rather, as motivated by similar concerns as his support for the academies of art and architecture – namely, as driven by an authoritarian mentality and mercantilist ideology aiming to place all the arts and sciences in the service of the state. It is even possible to focalize this aim, for it was in 1666 that Colbert both intervened in the Academy of Painting and Sculpture and presided over the birth of the Academy of Science. But even if it is agreed that his idea was to buttress orthodoxy, these interventions ultimately had the opposite effect, that of encouraging the dismantling of traditional theories; in the Academy of Science, in the name of the "new philosophy," and in the Academy of Painting and Sculpture, in the name of the "new art."

In question, then, is a form of discourse rejecting the teaching of the schools and textbooks and regarding theory as in need of rearticulation in light of systematic observations – the discourse of modern science. The doctrine of the Academy of Painting and Sculpture similarly aimed to force theory into a new discursive relation to the realities of practice. Is this to say that academic doctrine is "scientific"? It has been the other kind of discourse – in fact, that of traditional art theory – which until now has been associated with the methodology of modern science.

"Is it not possible," Panofsky asked in the classic discussion of this topic, "that the whole idea of a clean-cut separation between artistic and scientific activities must be re-examined when we deal with the Renaissance? Is it not possible that at this stage of European history a science whose speculative efforts had thus far, by and large, not sought support in empirical research and which was just beginning to turn 'experimental,' and an art whose practical procedures had thus far, by and large, not sought support in a systematic theory and which was just beginning to claim a position among the 'Artes Liberales' by doing precisely this – that such a science and such an art advanced, as it were, on a united front?"[39] This theory, Panofsky goes on to explain, was, above all, the theory of geometrical perspective, and also the theory of human proportions; closely allied to these mathematical disciplines in his discussion is the study of anatomy by "painter-anatomists," especially Leonardo.

One problem with Panofsky's point was brought out in the seventeenth-century disputes over perspective reviewed earlier – namely, that although perspective played an important role in Renaissance theory it was largely ignored in practice, and this was true of the other theoretical precepts as well; they were either ignored or pursued apart from practice – for example, Leonardo's anatomical investigations, which did not affect the manner of figural representation that he inherited from the early Renaissance and refined on the basis of his understanding of the superficial anatomy of the figure.[40] It is an exaggeration, therefore, to claim that Renaissance art represents a synthesis of theory and practice, bridging the gap between thinker and practitioner. If, as Panofsky claims, that gap was not as wide as in the Middle Ages, it was still, at the very least, considerable; the opposition of practice to theory was still unresolved.

This was the opposition perceived by and confronted in the Academy of Painting and Sculpture after 1666, following upon a review of theory in relation to the empirical evidence of practice. In observing that the Academy of Painting and Sculpture, by foregrounding the empirical phenomena, was embarked on a venture similar to one in the Academy of Science, I did not mean to suggest that its method was "scientific," or more so than that of Renaissance theory. Scientific investigation in the seventeenth century was itself a highly complex and often conflicted enterprise, characterized by particular tensions between theory and practice; the "new science" was not as strictly empirical as is often thought, having depended on many assumptions that could not be verified by means of observation.[41] The question of the relation of visual art to science is complicated, too, by the identification of the one with the other from the Renaissance through the seventeenth century; a recurrent theme in the literature of art in the Renaissance tradition and in academic discourse, that is to say, is the "science" of art. But a discussion of this question must wait until Chapter 9. It can be said here, at the very least, that the new regard for the evidence of practice in the Academy of Painting and Sculpture ran parallel to, and was no doubt encouraged by, the stress on observation in seventeenth-century empiricist philosophy. The more important point still, to which it is time to return, is that, doubts having been expressed in the *Conférences* of the Academy of Painting and Sculpture about practice having been synchronous with theory, practice was given precedence in academic doctrine.

THE ASCENDENCY OF PRACTICE

When Félibien, in the preface to his publication of the *Conférences* of 1667, attempted to articulate the rules implicit in the observations of the academicians, he found that simply putting them into words was not enough; he

thought it necessary to refer to the specific works in which they were exemplified. After summarizing compositional methods, for example, he refers the reader to Poussin's *The Israelites Gathering the Manna* (Fig. 34), which was also to be consulted for correct drawing and proportions.[42] And in another of his publications, Félibien, after analyzing Poussin's *Eliezer and Rebecca*, (Fig. 35) has one of his characters say: "You have just shown how a great painting can be made, for it is only necessary to imitate this work to produce a second masterpiece."[43] It was the consensus of the academicians from the inception of the *Conférences* that the works most deserving of imitation were those by Raphael and his school and by Poussin; as the doctrine evolved, works by Le Brun, especially his *Alexander at the Tent of Darius* (Fig. 36), were enshrined alongside those of Raphael and Poussin. These models leave no doubt that, in terms of the traditional opposition of drawing (*disegno*) and color (*colore*), drawing had scored a triumphant victory.

Imitating or copying existing works of art must be as old as art itself. The practice was certainly an accepted one during the Renaissance. As Thomas Hess noted in the remarks cited in the Introduction, artists have always looked to the works of their predecessors – Michelangelo to the Master of the Belvedere Torso, Rubens to Michelangelo, and so on. And, as was mentioned in Chapter 1, drawing instruction in workshops and schools began with copying, which was stressed at every stage of the course. As academies began to displace workshops, they too, it was explained in Chapter 2, emphasized copying. Because this activity was so central to teaching both in the Renaissance tradition and in academies, it will be examined in detail in the next chapter.

Furthermore, a "doctrine" of imitation as opposed to copying as part of an instructional strategy is closely associated, as has been noted, with an early stage of the academic tradition, namely, with the influential Carracci academy.[44] The greatness of the Carracci, the seventeenth-century writers typically claim, resulted from their imitation of the methods of the great artists of the High Renaissance.[45] And the same critical trope, a recurrent one in the literature of art from Vasari on, was reiterated by Le Brun, who in his *Conférence* on Poussin's *Manna* (Fig. 34) claimed that the painting united the drawing of Raphael, the color of Titian, and the facility and composition of Veronese.[46] Although seemingly advocated as part of its doctrine, the theory of eclecticism was in fact dismantled in the French academy along with all other previous theories of imitation.

It must be said, to begin with, that there was a fundamental contradiction inherent in these theories. That of eclecticism was sustained by the tantalizing possibility of achieving the greatness of particular artists of the past and, at the same time, proposed violating the unity of the works in which the greatness was agreed to reside; a figure whose beauty derives from the perfec-

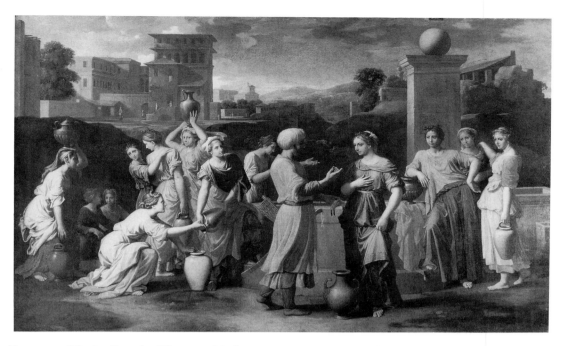

Figure 35. Nicolas Poussin, *Eliezer and Rebecca.* 1648. Paris, Musée du Louvre. (Photo: © Réunion des Musées Nationaux)

Figure 36. Charles Le Brun, *Alexander at the Tent of Darius.* 1660–1. Versailles, Château. (Photo: © Réunion des Musées Nationaux)

tion of Raphael's drawing is now to be cloaked in Titian's color, somehow uniting drawing and color without compromising the integrity of either, even though the perfection of each was, very nearly by definition, attainable only at the expense of the other. To such contradictions was added the evidence of the problematics of theory mentioned earlier: the oppressiveness of strict geometrical perspective or the tyranny of the text if required to be translated to the letter. In recognition of these difficulties, and no doubt, too, of the lofty remoteness of idealist theories, the utterances of the French academicians were always accompanied by actual examples that showed how, for example, drawing and color could be united or the spirit of the text respected. The doctrine of the French academy gave prominence to these examples of the masters on whose practice it insisted that the works of its students be based; the study of art in the academy was completely bound up with practice itself, and it remained so throughout the academic tradition.

Le Brun's *Alexander at the Tent of Darius* (Fig. 36) was one such model work at the disposal of the students, scrutinized and "imitated" for more than two centuries. That is to say, engravings of it were scrutinized, for this work, like others in the academy's repertory of models, was principally known through reproductions in black and white. Consider the following samples of its yield: Louis Licherie's diploma work of 1679, *Abigail Bringing Gifts to David* (Fig. 37); François Lemoine's *Continence of Scipio* (Fig. 38), made for a royal competition in the academy in 1727; Noël Hallé's *The Emperor Trajan, Pressed to Depart for a Military Expedition, Dismounts to Hear the Complaints of a Poor Woman*, shown in the Salon of 1765, and Anne-Louis Girodet-Trioson's, *Joseph Making Himself Known to His Brothers* (Fig. 39), his first prize work in the Prix de Rome competition of 1789.[47]

In all of these paintings, as in the *Alexander* (Fig. 36), stress is laid on drawing, the localized color merely serving to bring out the solidity of the forms. The figures are arranged in friezelike planes – all, or at least the most important of them (in the case of the Girodet-Trioson) – in a first, shallow zone; in all, the action of the principal figure is echoed in the expressions and gestures of the others. There are specific connections, too, in some of the poses and expressions: for example, the Alexander and the David and Trajan; or the wife of Darius, shown with her child, and Abigail. But there is more still that would be difficult to put into words when trying to describe this specific constellation of forms and arrangement of figures – a certain poise or balance of the figures, a similar compactness to the group of respondents in contrast to the expansiveness of the "hero," and so on. It was in recognition of the limitations of language in this area, after all, that the academy supplemented its verbal instruction with images.

For all these connections, however, none of these works is a replica of the *Alexander* (Fig. 36). "Imitation" evidently involved far more than Félibien's

words about Poussin's *Eliezer and Rebecca* (Fig. 35) generating a second masterpiece would lead one to believe; the impression that what was required was a kind of cloning is obviously false. What was it, then, that the artists of the academy were expected to derive from their study of the practice of the masters? On what terms were their works judged, both in their own right and in relation to Le Brun's "masterpiece"? Diderot, for one, thought that Hallé's "imitation" of Le Brun left something to be desired, advising him to look again at the *Alexander at the Tent of Darius* to learn how properly to relate the secondary figures to the hero.[48] What, in sum, did the academicians – and their critics – understand by "imitation?"

This is the subject, as it were, of Reynolds's *Discourses*. In the inaugural lecture he states: "I would chiefly recommend, that an implicit obedience to the *Rules of Art,* as established by the practice of the great MASTERS, should be exacted from the *young* Students. That those models, which have passed through the approbation of ages, should be considered by them as perfect and infallible guides; as subjects for their imitation, not their criticism."[49] The *Second Discourse* treats the various stages of study and the role of the great works of the past. "There is no danger of studying too much the works of those great men," Reynolds declares, "but how they may be studied to advantage is an enquiry of great importance."[50] Rather than copying the works of the masters, copy their conceptions, he advises. "Labour to invent on their general principles and way of thinking."[51] The artist whose principles and thinking (painting) he recommends above all others is Ludovico Carracci, Reynolds then promising to return to the question of the "excellences of imitation" at a future date.

He did so return in the *Sixth Discourse,* the stated subject of which is "imitation." Inveighing against the notion of inspiration, Reynolds proposes imitation as an alternative:

To derive all from native power, to owe nothing to another, is the praise which men, who do not think on what they are saying, bestow sometimes upon others, and sometimes on themselves; and their imaginary dignity is naturally heightened by a supercilious censure of the low, the barren, the groveling, the servile imitator. It would be no wonder if a student, frightened by these terrifick and disgraceful epithets, with which the poor imitators are so often loaded, should let fall his pencil in mere despair; (conscious as he must be, how much he has been indebted to the labours of others, how little, how very little of his art was born with him;) and, consider it as hopeless, to set about acquiring by the imitation of any human master, what he is taught to suppose is matter of inspiration from heaven.[52]

The point is brought home through metaphor: great works are not only the food of our infancy but the substance of our maturity; we expect to receive some radiation of the fire of greatness; the mind is but a barren soil, soon exhausted if not fertilized and enriched with foreign matter.[53]

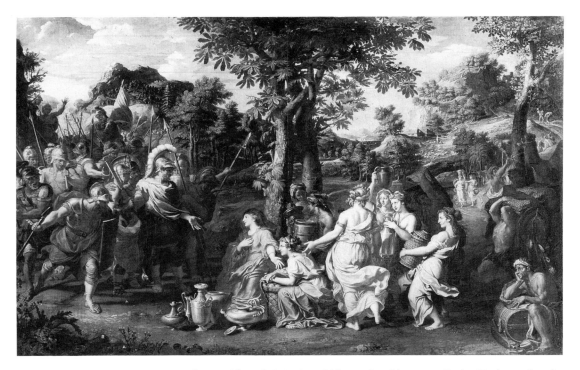

Figure 37. Louis Licherie, *Abigail Bringing Gifts to David.* 1679. Paris, Ecole nationale supérieure des Beaux-Arts. (Photo: Giraudon)

The examples of practice hold the key, next to which theory is, at best, of secondary importance: "There can be no doubt, but the art is better learnt from the works themselves than from precepts which are formed upon those works." But, he adds, "if it is difficult to choose proper models for imitation, it requires no less circumspection to separate and distinguish what in those models we ought to imitate."[54] Much of the remainder of this *Discourse* is an art history review, with remarks about what should and should not be imitated in the works of individual masters. But let us agree with Reynolds that words are not enough, that if we are to understand "imitation" we must see how it worked in practice. And what better practice to examine than that of Reynolds himself.

The works do not disappoint the reader of the *Discourses.* Reynolds's recourse to works by the masters was indeed extreme. While in Italy he filled his sketchbook with copies from works by a variety of artists and, back in England, channeled these sketches, as Gombrich, Mitchell, and Wind have shown, into his own paintings.[55] These copies were of single figures and also entire compositions; Reynolds in his recycling engaged in a practice of "borrowing" common in the Renaissance tradition.[56] If the practice itself was not

Figure 38. François Lemoine, *The Continence of Scipio.* 1727. Nancy, Musée des Beaux-Arts. (Photo: Bulloz)

Figure 39. Anne-Louis Girodet-Trioson, *Joseph Making Himself Known to His Brothers.* 1789. Paris, Ecole nationale supérieure des Beaux-Arts. (Photo: Giraudon)

Figure 40. Sir Joshua Reynolds, *Lady Cockburn and Her Children.* 1773. London, National Gallery of Art. Reproduced by Courtesy of the Trustees, The National Gallery, London. (Photo: The National Gallery, London)

unusual, however, his version of it was. For he used the grand inventions of the masters as motifs for portraits in which their appropriateness appears, at the very least, questionable. His *Lady Cockburn and her Children* (Fig. 40), for example, is a variation on an invention originating with Michelangelo and used repeatedly as an allegory of Charity;[57] his *Mrs. Siddons as the Tragic Muse* (Fig. 41), depicting a contemporary woman portrayed more directly by Gainsborough (Fig. 42), makes use of a format derived from the Isaiah or Jeremiah of Michelangelo's Sistine Ceiling (Fig. 48), and so on.[58]

Just what Reynolds had in mind is made plain in two of his drawings. On one of a satyr that he dubbed "white whiskers" (Fig. 43), he wrote, "this would serve for a fountain," a simple association of a mythical creature and its imagined habitat. On the other, which copies a subject such as Psyche and Cupid or Diana and Endymion, is inscribed: "Serve for Time Discovering

Figure 41. Sir Joshua
Reynolds, *Mrs. Siddons as the
Tragic Muse.* 1784. Pasadena,
California, The Henry E.
Huntington Library and Art
Gallery. (Photo: The Henry E.
Huntington Library and Art
Gallery)

Truth" (Fig. 44), a far more complex match, about which more will presently
be said.[59]

Precisely this practice, it should first be noted, was described by Reyn-
olds, advising students to employ the inventions of the masters "in a situa-
tion totally different from that in which they were originally employed." He
elaborated:

There is a figure of a Bacchante leaning backward, her head thrown quite behind her,
which seems to be a favourite invention, as it is so frequently repeated in bas-
relievos, camaeos [*sic*] and intaglios; it is intended to express an enthusiastick kind of
joy. This figure Baccio Bandinelli, in a drawing that I have of that Master, of the
Descent from the Cross, has adopted, (and he knew very well what was worth
borrowing), for one of the Marys, to express frantick agony of grief. It is curious to
observe, and it is certainly true, that the extremes of contrary passions are with very
little variation expressed by the same action.[60]

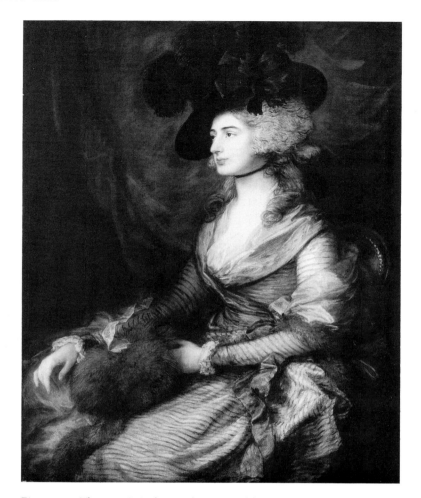

Figure 42. Thomas Gainsborough, *Mrs. Siddons.* 1783–5. London, National Gallery of Art. Reproduced by Courtesy of the Trustees, The National Gallery, London. (Photo: The National Gallery, London)

Among Reynolds's "inventions" there are indeed arrangements similar to that of Fig. 44, employed not for a "Time Discovering Truth," however, but a *Death of Dido* and the *Duchess of Manchester and Her Son as Diana Disarming Cupid.*[61]

It is to be stressed that while this enactment of the doctrine of imitation seems extreme, it is compatible with practice in the French academy. Ingres's portrait of *Madame Moitessier* (Fig. 45) was based, as were Reynolds's portraits, on an earlier work of art that was not a portrait, in this case a wall painting from Herculaneum (Fig. 46). And what did it mean to hold up Le Brun's *Alexander at the Tent of Darius* (Fig. 36) as a model if not that this

Figure 43 (left). Sir Joshua Reynolds, *"White Whiskers,"* 1750–2. Black chalk. London, The British Museum. (Photo: The Warburg Institute)

Figure 44 (right). Sir Joshua Reynolds, *Drawing after a Psyche and Cupid or Diana and Endymion,* 1750–2. Black chalk, inscribed in brown ink. London, The British Museum. (Photo: Courtauld Institute of Art)

was a configuration that would *serve* for other compositions and other subjects? The works of Licherie, Lemoine, Hallé, and Girodet-Trioson (Figs. 37–9) show how it was made to "serve" for depictions of narratives of David, Scipio, Trajan, and Joseph.[62]

That the academic method drew on such a repertory of compositional structures, as poses, gestures, and expressions derived from the works of the great artists of the past is a commonplace in art history. To be sure, the repertory was not the same in all academies; the English was somewhat broader than the French with its strict reliance on Raphael, Poussin, Le Brun, and, later, a few other artists from its early history such as Le Sueur. But these were relatively minor differences when viewed in the context of the same basic commitment to the Great Tradition. To critics of academic art such as

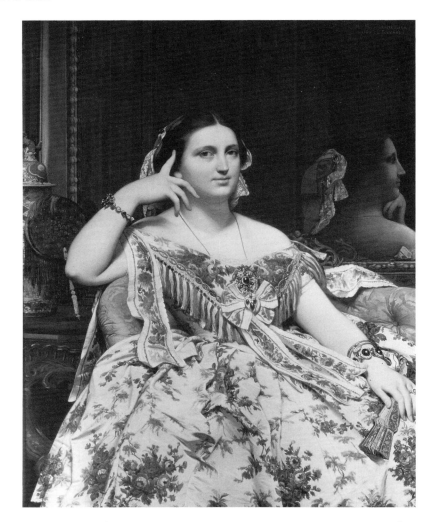

Figure 45. Jean-Auguste-Dominique Ingres, *Mme Moitessier.* 1856. London, National Gallery of Art. Reproduced by Courtesy of the Trustees, The National Gallery, London. (Photo: Bridgeman-Giraudon)

Diderot, it was to this commitment that its shortcomings could be traced, its utter conventionality and insincerity.[63] The academicians evidently felt that their method provided compensation for this loss – though it is doubtful that they perceived it as such. The gain was a new autonomy for visual art, won at the expense of history. For the time-tested images of the past were to lend to art a new and timeless authority, transcending history – and also literature. The image henceforth would be captive of neither time nor text.

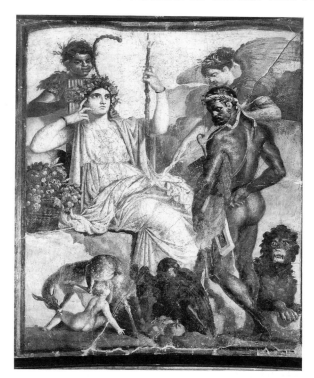

Figure 46. Herakles and the Infant Telephos. Roman copy of the fresco from Herculaneum. Naples, Museo Nazionale. (Photo: Fratelli Alinari/Giraudon)

IMAGE AND TEXT

Of all the paintings in the academy's repertoire, the one that has most seemed to indicate the contrary is Le Brun's *Alexander at the Tent of Darius* (Fig. 36), a textlike narrative accompanied by a lengthy commentary. Referred to by its alternative title, *The Queens of Persia at the Feet of Alexander,* the painting was exhaustively described and analyzed by Félibien shortly after it was completed.[64]

The subject involves a quandary. Depicted is the moment when Alexander, accompanied by his companion Ephestion, visits the tent of the family of Darius, whom he has just vanquished in battle, thereby gaining possession of all that had been his. The Persian queens, in their anxiety, first think that Ephestion is the conqueror and then, realizing their mistake, prostrate themselves before Alexander, begging for mercy. It was Le Brun's task, then, to portray two figures similar enough in appearance for one to be mistaken for the other, yet different enough for Alexander to be identifiable. The household of Darius had to be variously represented too, the queens clearly differentiated from their retainers, who also needed to be distinguished one from another. All of this Le Brun accomplished, Félibien tells us, to perfection.

His account is a meticulous inventory of the composition, identifying in turn each actor, whose pose, dress, expression, and gesture are described and commented upon in terms of the action. The description is minute. On Alexander:

The compassion he has for the princesses visibly appears, both in his looks and in his behavior; his opened hand shews his clemency, and perfectly expresses the favour he has for all that court; his other hand which he lays on Ephestion, plainly shows that he is his favourite; and his left leg which he draws backward, is a token of the civility which he pays to these princesses.[65]

This is a kind of description that had a history of its own. Originating with the *ekphrasis* of ancient literary composition mentioned earlier, it was the most common form of art criticism until well into the nineteenth century. Diderot practiced it, as noted, in the eighteenth century.[66] And not long after Félibien's description of the *Alexander,* Bellori published a collection of biographies of such artists as Annibale and Agostino Carracci and Poussin followed by *ekphrases* of their most important works.[67] The question that must be asked about Le Brun's painting and other works produced in the French academy is whether these works, more than the paintings of the Carracci and Poussin, require the same kind of "reading" as is customary in an *ekphrasis.* Assuming the effectiveness of *Alexander* as an image, does that effectiveness depend on so careful an examination of every item of clothing, every attitude, expression, and gesture? The question is the extent to which *Alexander* as a painting, apart from Félibien's literary rendition of it, is tied to a preexisting text.

If it did so completely depend upon a text, it would reflect an understanding of visual art different from that which emerged from the *Conférences.* For, as has been shown, the penchant for verbalizing in the academy notwithstanding, the focus of the *Conférences* ultimately was the image and not the word. And, too, such a focus is reflected in the academy's designation of particular images – rather than texts – as models. Those who made use of these models evidently did not view them as inextricable from particular texts, as they appropriated the form of the "original" with little regard for its content, as we saw in the examples cited earlier (Figs. 37–9); the composition invented by Le Brun for *Alexander at the Tent of Darius* (Fig. 36) could serve just as well for the stories of David, Scipio, Trajan, or Joseph.

It would seem, then, that in the academy the image was regarded as fundamentally ambiguous; and nowhere is this ambiguity more clearly brought out than in Reynolds's image and accompanying inscription, to which it is now time to return (Fig. 44).

The image is of two figures, one standing, one reclining, together with a winged cupid. The standing figure, from the notations of clothing a woman,

is the more active, its gestures indicating a response – surprise or alarm or love – to the other figure, to all appearances male, whose pose and gesture strongly suggest sleep or death. The presence of Eros precludes the latter, and so it must be sleep (unless this is a shorthand of allusion to Anteros, or Death). The text reads: "Serve for Time Discovering Truth."

Father Time, one recalls, is a bearded old man, winged, his further attributes an hourglass and scythe or sickle; Truth, an "unadorned" nude. In representations of Time and Truth these figures are sometimes accompanied by a *putto* (Eros) whose wings, in another context, Time clips. Time is related to Truth in one of two ways, as either protector or rescuer.[68]

The standing figure in Reynolds's sketch seems cloaked in an ample, billowing robe, which, if this be Father Time, would have to be read as wings. The gesture of this figure, at first taken to be surprise or love, also would have to be reread as grasping drapery in an attempt to conceal, or reveal, the nudity of the other figure (Truth), now understood as female rather than male. These last readings are determined, of course, by the inscription, which identifies the figures and action. Take away the inscription and what remains is the same image, now open to multiple readings, such as the ones mentioned earlier: Diana and Endymion, Psyche and Cupid, Echo and Narcissus, Venus and Adonis, Satyr and Nymph, Rinaldo and Armida, and, with the excision of Eros, the Lamentation of Christ and a whole range of related religious subjects. To say that this is a representation of one of these subjects, as Reynolds has done, is not in itself to cancel out any of the others. In other words, even if the figures are taken to be Time and Truth, they remain, potentially, Diana and Endymion, Psyche and Cupid, and so on.

It is worth mentioning here that when faced with the related conundrum of Magritte's *Ceci n'est pas une pipe* (Fig. 47), a work in which the text denies the "reality" of the image, Foucault drew a distinction between "resemblance" and "similitude." Resemblance, he states, has a model, an original on which all copies are dependent and to which they refer; it "presupposes a primary reference that prescribes and classes." With similitude, on the other hand, things are like one another without any of them being able to claim that it is closer to a common model. "The similar develops in series that have neither beginning nor end, that can be followed in one direction as easily as in another, that obey no hierarchy, but propagate themselves from small differences among small differences." In place of hierarchy are exclusively lateral relations: "similitude circulates the simulacrum as an indefinite and reversible relation of the similar to the similar."[69]

Reynolds's image and text are no less filled with ambiguities than Magritte's *Ceci n'est pas une pipe* (Fig. 44; cf. Fig. 47). The figures are not Time and Truth and yet evidently would serve for Time Discovering Truth. Even while so serving, they recall other subjects in a nearly endless proces-

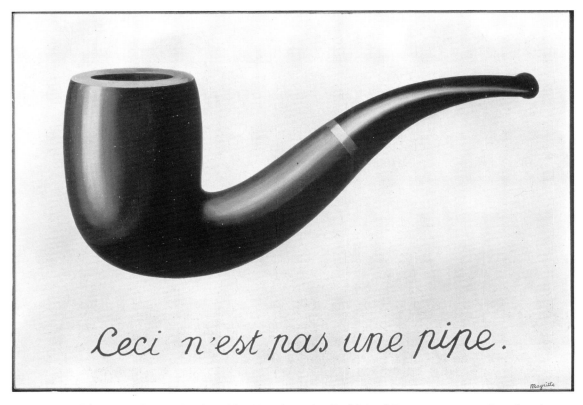

Figure 47. René Magritte, *The Treachery (or Perfidy) of Images.* 1928–9. Los Angeles, County Museum of Art. © 1996 Herscovici, Brussels/Artists Rights Society (ARS), New York. (Photothèque René Magritte–Giraudon)

sion. The intervention of language is necessary for a "correct" reading. But then, as Foucault suggests, there is no stable meaning in the pictorial arts, but only relations of the similar to the similar. Was this not Reynolds's understanding of pictorial meaning? What he was noting, after all, was not the resemblance of this image to what it represents, either in terms of observed figures or texts, but only its similarity to other representations of Time Discovering Truth. Within the broad context of the *ut pictura poesis* tradition, the primordial authority of language is radically undermined; visual art, once *mere* illustration, henceforth will be a fully autonomous activity.

THE COPY

Reynolds's discussion of imitation divides into two principal parts: one of the great works of the past, briefly examined in the preceding chapter, and the other of nature. These are the twin threads running through the academy's discourse and also that of the Renaissance tradition; they figured prominently in the modernist reaction against that tradition. To consider the role of imitation in the teaching of Western art is, therefore, to interrogate first the Renaissance tradition, then the academy as an outgrowth of that tradition, and, finally, the position of the avant-garde. And this is the purpose of this and the next two chapters, each of which treats one facet of imitation, beginning with the imitation of the masters of the Renaissance tradition by directly copying their works.

RENAISSANCE MIMESIS

No practice was more central to the Renaissance tradition than that of copying works of art. And few drawings are more often reproduced than copies of great works made by artists themselves capable of greatness: Giotto copied by Michelangelo, who in turn was copied by countless artists, none so often as Rubens, who transcribed, among other motifs, many of the figures on the Sistine Ceiling (Fig. 48).[1] Such copies corroborate the testimony of the handbooks about the key role of copying in the Renaissance studio. Cennino Cennini, as early as c. 1390, advises: "Always take pains in drawing the best subjects which you can find, done by the hand of great masters . . . and it will happen that if nature has bestowed on you any invention, you will acquire a manner of your own, which cannot be other than good."[2] Later, in the

Figure 48. Peter Paul Rubens, *Copy after Michelangelo's Isaiah.* Red chalk, Paris, Musée du Louvre, Cabinet des Dessins. (Photo: © Réunion des Musées Nationaux)

sixteenth century, when drawing books were published to facilitate the study adumbrated by Cennini, included were *exempla* by the masters. These were books, such as that of Fialetti to which I referred in Chapter 2, calling attention to the plates filled with anatomical units conceived as a kind of "alphabet" of drawing (Fig. 11). The last plates in the book are of entire compositions (Fig. 49) completing the process of copying begun with eyes, feet, and so on.[3]

Even artists who were not in the habit of making copies did so from time to time. Rembrandt seems rarely to have made direct copies of masterworks, images of this kind by him totaling, by the count of Svetlana Alpers, only fifteen or so.[4] Few in number as they are, these copies show him consulting such Renaissance masters as Mantegna and Leonardo, his "copies" typically leaving the realm of the copy proper, of reproduction, to enter that of "interpretation." For Rembrandt used such images as points of departure in creating his own, similar to his models and yet unique, original works of art. There are countless such originals by other artists, images tracing their origins to existing works of art that are nonetheless works of art in their own right, for instance, Mantegna "borrowing" from and transposing images of Donatello, Raphael those of Perugino or Leonardo, Poussin those of Ra-

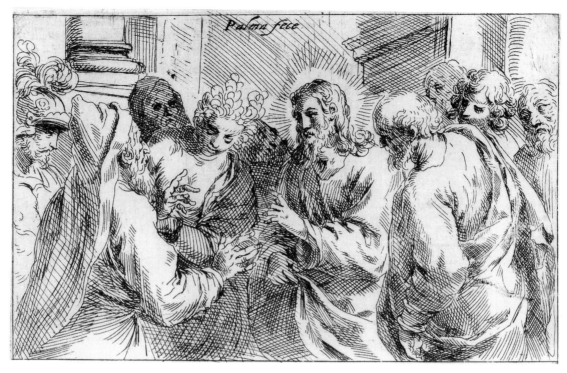

Figure 49. Odoardo Fialetti, *Il vero modo et ordine, Christ and the Woman taken in Adultery.* 1608. Etching by Palma Giovane. (Photo: The Warburg Institute)

phael. (Poussin's *Manna* [Fig. 34] is such a transposition, rephrasing Raphael's *School of Athens*.)[5]

That the practice was common makes it no less shocking to the modern sensibility. Why should highly inventive artists, obviously capable of creating extraordinary works of their own, have ransacked the works of others for serviceable motifs? Some recent literary critics would reject the question as meaningless. It is the notion of the "original" that is perverse, Barthes, for one, has argued, all the texts of literature being "copies" in an infinite regress; any single text is only a point of entry into all literary texts. Since the entire concept of literary "originality" has been replaced by one of "borrowings" or the meeting of texts, these visual images would be understood only as especially clear instances of a practice central to visual, as verbal, production.[6]

The modern painter Robert Motherwell would have agreed: "Every intelligent painter carries the whole culture of modern painting in his head. It is his real subject, of which everything he paints is both an homage and a critique."[7]

From a historical perspective, it could be argued that copying works of visual art was a matter of reflex, for artists had been copying from the time of their first lessons. But this only begs the question of why the habit of copying

was inculcated in young artists in the first place. That it was would have to seem all the more surprising in light of Renaissance theory, according to which there is only one true source of art: nature.

This is the central notion of mimesis discussed in the last chapter, in which it was explained that the term had two senses, one the exact imitation of nature and the other the selective imitation of nature.[8] Both dicta originated with Aristotle's contention that artists imitate natural things, "either as they were or are or as they are said or thought to be or to have been or as they ought to be."[9] The two approaches were recommended conjointly in early Renaissance treatises, but by the later sixteenth century stress was laid on the last clause, "as they ought to be," artists being enjoined to "correct" or perfect nature. It was proposed, moreover, that the process of selection had been accomplished by the great artists of the past – classical antiquity and the earlier Renaissance – so that by imitating them, one was imitating nature perfected. The question then became whom or what to copy; art theory, like the rhetorical theory on which it was based, divided over whether to copy one or many models.[10] It was generally agreed that the second option was the better one.

If Renaissance mimesis ultimately had the effect of encouraging copying there was still another theory that would seem to have discouraged the practice, namely the Neoplatonic theory of the Idea. This is a metaphysical concept, a completely subjective Idea existing a priori in the mind of an artist in a state of grace. This theory soon became indissolubly bound up with another, however, in which the Idea was to result from the empirical study of nature. Bellori's is the canonical statement of this theory: "The Idea, originated in nature, supersedes its origin and becomes the origin of art."[11] The means of superseding nature, it was agreed, was to study select ancient and modern works. For all their equivocation and contrariety, the theorists were in basic agreement about one thing – namely, that visual art is an imaginative enterprise based on a vision of an ideal that "corrects," perfects, and in other ways eclipses the forms of nature in which it had originated. To Plato himself, it is necessary to add, our question would have been meaningless. For we are told in the *Republic* that God created the archetype of the table, of which the table of the carpenter is a copy, that of the painter a copy of a copy, so that our whole notion of originality would have to be revised and what we have been calling original works of art renamed copies.[12]

Copying the works of the masters and antique sculptures was in any case, in Renaissance theory, a means of confronting an ideal. And practice seems to have agreed substantially with theory; beginning artists copied works by the masters as an introduction to the ideal, and older artists continued making copies as a way of refreshing their vision of the ideal by returning to its source in the masterworks of the past. In theory, these works were not to

replace nature, art oscillating between the real and the ideal. But, as the works themselves show, artists did not always follow the letter of theory. Poussin the idealist, for example, did not consult live models in his reworking of Raphael's *School of Athens* (Fig. 34). If in this regard theory and practice in the Renaissance tradition were at times at odds, in all important respects, insofar as copying was concerned, they seem to have been in accord, artists making copies for the reasons set out by the theorists.

FROM RULE TO REPETITION

This rationale was accepted by academies, whose theory of the copy was a recapitulation of the Renaissance theory of imitation. Art is an imitation of nature, it affirmed, but also and inevitably of the works of select artists that embody the ideal to which artists must aspire. This is the crux not only of Bellori's theory of the Idea but also of the *beau idéal* of the French academy, which, as was noted in the previous two chapters, highlighted the works of Raphael and his school, Poussin, and Le Brun; it was the theory of the Royal Academy as well.[13]

In keeping with theory, copying was a regular part of the routine of the academy. Approached more systematically than in the Renaissance work-shop, the first works copied were drawings or engravings, by the masters of the tradition and the academy, either of parts of the figure or the figure in its entirety. Students were forced to repeat these exercises endlessly. When Philip Otto Runge asked permission to enter the life class of the Copenhagen academy, he was told by his teacher, Abildgaard: "It was a bit too early yet; you should just go on copying my drawings." And so Runge did, in drawings some of which survive (Figs. 50, 51).[14]

From copying such figure studies, students went on to draw from casts of parts of the body to casts of complete ancient sculptures, to compositions by the masters – again from drawings and engravings – and some eventually were able to work from the original paintings. The allure of Rome was, more than anything else, its artistic treasures, which the French students were put to work copying after the academy in Rome was founded. As Colbert wrote to the director in 1672, "Make the painters copy everything beautiful in Rome; and when they have finished, if possible, make them do it again."[15] Among the first works copied were Raphael's tapestries in the Vatican, them-selves a "school" for painters.[16] However, these painted copies most often were used not for further schooling in the sense of depositing them with the academy for the instruction of students, but rather to decorate the royal residences. With the opening of the Louvre as the national museum of France in 1793, followed by the creation of public museums in other capitals, copy-ing was not only facilitated but broadened as access to original works was

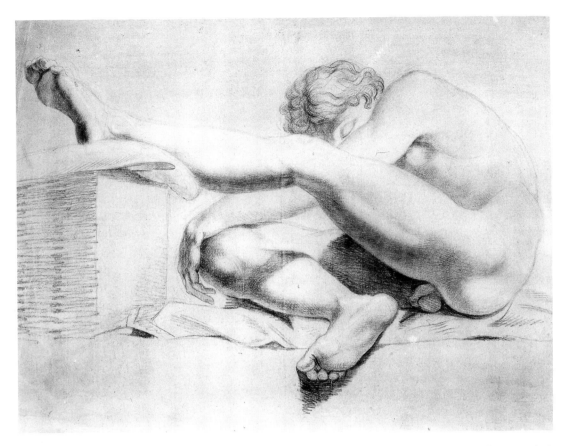

Figure 50. P. O. Runge, *Figure Study after Abildgaard.* 1799. Drawing. Berlin, Staatliche Museen zu Berlin, Preussischer Kulturbesitz, Kupferstichkabinett. (Photo: Jörg P. Anders)

provided. "Keep good company," Couture is supposed to have told Cézanne, "go to the Louvre."[17]

It must be stressed, however, as noted in Chapter 4, that copying from the masters in academies, until the opening of the Louvre and other public museums, most often was done from reproductive engravings of their works. And, in fact, the originals in museums were regarded in academies as a mixed blessing, in the sense that they presented the added complication of color and texture not found in engravings. For this reason, only advanced students of the nineteenth-century French academy were allowed to make painted copies in the Louvre; beginning students were sent to make quick sketches of the compositions in pencil. These were the two types of studies from the masters that were part of the academy's curriculum and that academically trained artists, which is to say the majority of nineteenth-century artists, typically

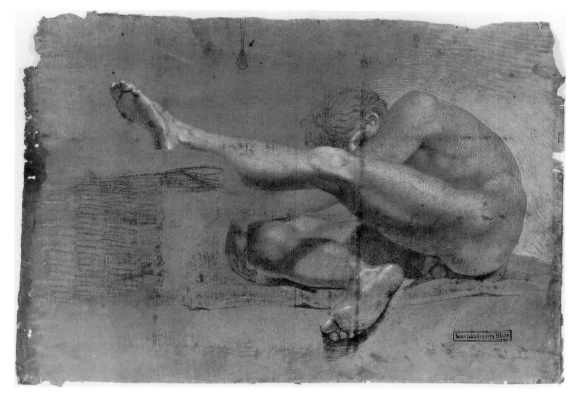

Figure 51. N. A. Abildgaard, *Figure Study.* 1780s or 1790s. Drawing. Copenhagen, Royal Academy, Library. (Photo: Jorgen Warz, Copenhagen)

continued to make throughout their careers. Delacroix is one example, having made both quick pencil sketches and painted copies during his student years and copies of both types from the masters as a seasoned artist.[18]

What must also be stressed about these copies is that they were intended to be accurate reproductions of the originals. This is something upon which the academy insisted. Rejecting the idea of the interpretive copy, the academy enforced its view of copying not as a process conducive to the emergence of an individual personality but rather as providing the foundation essential to an artist in the classical tradition. (The nineteenth-century academy nevertheless did recognize the impossibility of making a perfect copy of another's work of art because of differences in the "état psychologique particulier.")[19] The ideological premise was the one mentioned in Chapter 4 — namely, the continued life of that which was most central to the tradition, the masterpiece and all it represented.

Whether in the rooms of the academy or the Louvre, in Paris or Rome — or Bologna or Florence — copying was, then, a regular part of study.[20] Indeed, so

Figure 52. Jean-Honoré Fragonard, after Rubens, *The Virgin and S. Anne.* C. 1780–90. Black chalk over brown ink. Paris, Musée du Louvre, Cabinet des Dessins. (Photo: © Réunion des Musées Nationaux)

Figure 53. Jean-Auguste-Dominique Ingres, after Poussin, *Eliezer and Rebecca.* C. 1805. Marseilles, Musée des Beaux-Arts. (Photo: Giraudon)

important a role did it play that a museum of copies was opened in nineteenth-century Paris.[21] And many copies survive, especially from the eighteenth and nineteenth centuries – copies by Watteau and Fragonard, Géricault and Delacroix, among others.[22] There are copies after Michelangelo, Titian, and Rubens, of the last-named, for example, a copy by Fragonard of his *Virgin and Saint Anne* (Fig. 52), a work obviously related to his own.[23] But the artists whose works were considered of indispensable reference were, of course, Raphael and Poussin. As especially striking instances consider the following: Ingres's extraordinary rendition of Poussin's *Eliezer and Rebecca* (Fig. 53; cf. Fig. 35), as perfect a copy as it is pure Ingres;[24] Degas's copies of figures in Marcantonio's engraving after Raphael's *Massacre of the Innocents* (Fig. 54; cf. Fig. 30); and Redon's copy of a figure study by Raphael in the Louvre (Fig. 55).[25]

The copies made by Reynolds during his trip to Italy mentioned earlier and illustrated in Figures 43 and 44 are altogether consistent with the habit of

Figure 54. Hilaire-Germain-Edgar Degas, *Figure Study, after Marcantonio Raimondi's engraving after Raphael's Massacre of the Innocents.* C. 1854–6. Black chalk and stump. Paris, Musée du Louvre, Cabinet des Dessins. (Photo: © Réunion des Musées Nationaux)

Figure 55. Odilon Redon, after Raphael, *Figure Study.* Paris, Musée du Louvre, Cabinet des Dessins. (Photo: © Réunion des Musées Nationaux)

Figure 56. Benjamin West, after Domenichino, *St. Nilus Curing the Son of Polieuto.* 1760–3. Black chalk. London, The Royal Academy of Arts. (Photo: Courtauld Institute of Art)

copying in the Renaissance tradition, a practice later adopted by academies such as the Royal Academy, over which he presided. And Reynolds's successor as president of the Royal Academy, Benjamin West, also made such copies on a trip through Italy in the early 1760s, filling notebooks with notations from Renaissance and Baroque masterpieces (Fig. 56).[26] The copies that Reynolds filed away for future use nevertheless seemed unusual, and indeed are, for reasons that can be further illuminated by returning to the *Discourses*.

Early in his discussion of imitation, Reynolds voiced his approval of copying in words that were familiar enough by this time. "But to bring us entirely to reason and sobriety, let it be observed," he noted, "that a painter must not only be of necessity an imitator of the works of nature, which alone is sufficient to dispel this phantom of inspiration, but he must be as necessarily an imitator of the works of other painters."[27] There are those who believe, he continued, that imitating the masters is useful only to beginners and should be avoided by advanced students as potentially harmful. He was not of such a mind. He was persuaded, to the contrary, that by imitation alone, "variety, and even originality of invention is produced." "I will go further," he stated, "even genius, at least what generally is so called, is the child of imitation."[28]

In principle, it is by means of imitation that the "rules" of art are discovered, among them the rules of invention, which are learned by coming to understand the inventions of the great artists of the past. "When we have had continually before us the great works of Art to impregnate our minds with kindred ideas, we are then, and not till then," he averred, "fit to produce something of the same species." Far from being plagiarism, as the ignorant would claim, such "borrowing or stealing" is a "perpetual exercise of the mind, a continual invention."[29] Interestingly, recent discussions of copies, stressing their inventiveness and "creativity," have substantially agreed with Reynolds's assertion.[30]

Reynolds returned to this notion repeatedly during the course of his lectures. In one of the last of them, the Twelfth Discourse of 1784, he cited the practice of Raphael as proof of the efficacy of judicious imitation. His subject: a method of study. His exemplar, the first of painters, who, everyone would have to agree, had no need of "foreign assistance." Yet when Raphael was designing his tapestry cartoons, Reynolds observed, he incorporated in them figures copied from Masaccio's Brancacci Chapel, only adding a left hand not found in the original; and for the composition of the *Sacrifice at Lystra* he appropriated that of an ancient bas-relief. Masaccio's was a public work, Reynolds noted, proving that Raphael did not regard his practice as plagiarism. Rather, he was "well satisfied that his character for Invention would be little affected by such a discovery; nor is it, except in the opinion of those who are ignorant of the manner in which great works are built."[31]

There were, evidently, many such "ignorant" critics of Reynolds's own practice. For no less a public figure than Horace Walpole felt it necessary to rise to his defense:

Sir Joshua has been accused of plagiarism for having borrowed attitudes from ancient masters. Not only candour but criticism must deny the *force* of that charge. When a single posture is imitated from a historic picture and applied to a portrait in a different dress and with new attributes, this is not plagiarism, but quotation: and a quotation from a great author, with a novel application of the sense, has always been allowed to be an instance of parts and taste; and may have more merit than the original. When the sons of Jacob imposed on their father with a false coat of Joseph, saying: "Know now whether this be thy son's coat or not?" they only asked a deceitful question – but that interrogation became wit, when Richard I on the pope reclaiming a bishop whom the king had taken prisoner in battle, sent him the prelate's coat of mail, and in the words of Scripture asked his holiness whether THAT was the coat of his son, or not.[32]

Here are the origins, so to speak, of Barthes's labyrinth of texts, turned by analogy into a maze of images. One question that we would ask, however, concerns the relation of the new work to the old, to use Walpole's word, of the "merit" of the new or, really, whether or in what sense this is a new work. Consider the diploma work submitted to the Royal Academy in 1782 by John Singleton Copley, evidently heeding the advice of Reynolds's *Discourses* and the examples of his practice (Fig. 57).[33] This is just the kind of invention promoted by Reynolds's theory and practice. But is it, any more than Reynolds's "inventions," other than a ritual repetition of Rubens's original composition (Fig. 58)?[34] In the academic theory of the copy, the line separating invention from replication is easily crossed.

It did not seem so, of course, to the academicians. The members of the French academy, like their British counterparts, believed that by means of copying they were wresting secrets from the masters. The nineteenth-century painter Baudry said with respect to his copies of Raphael: "In the silent conversations we have held together he has taught me the secret of his grace and of his admirable style." And Regnault, about to copy paintings by the masters in Madrid, wrote, "I should like to devour Velasquez whole."[35]

THE PERSISTENCE OF THE COPY

The practice of copying was, then, a quintessentially traditional and academic activity. Yet there was no greater believer in it than the artist widely regarded as the first modern painter: Manet. That Manet made copies during his student years was of course to be expected, as he was trained in the academic tradition in the studio of Couture.[36] But the habit of returning to the old masters that he thus acquired remained with him throughout his

Figure 57. John Singleton Copley, *Tribute Money.* 1779. London, The Royal Academy of Arts. (Photo: The Royal Academy of Arts, London)

career. His "copies" or appropriations of the inventions of his predecessors, indeed, have presented a major stumbling block in the critical assessment of his achievement.

The paintings of the 1860s, among them landmark works in the early history of modern art, are the ones most derivative from works by the masters, based wholly or in part on Raphael, Giorgione, Titian, and Velasquez. The last-named artist's *Drinkers* was the model for the *Old Musician.*[37] *The Luncheon on the Grass* (Fig. 59), as all beginning art history students know, is a virtual copy of a figure group in Marcantonio's engraving of Raphael's *Judgment of Paris*, inspired by a conceit of "Giorgione" – the *Fête champêtre* that is now generally considered to be a work of Titian.[38] The *Olympia* is a version of Titian's *Venus of Urbino*, and so on. To the minds

Figure 58. Peter Paul Rubens, *Tribute Money,* c. 1612. San Francisco, M. H. De Young Memorial Museum. (Photo: M. H. De Young Memorial Museum, San Francisco)

even of Manet's admirers, this dependence on the works of others was excessive and seemed to point to a defect in his personality; Oswald Spengler viewed it as evidence of the final decay of painting in the West.[39]

Spengler obviously had concluded that Manet lacked the ability to compose on his own, and other, in principle more visually aware historians have reached the same conclusion.[40] Some historians alternatively have argued that Manet simply had no interest in subject matter, the subject being nothing more than a pretext for addressing issues of form and color.[41] And still others have interpreted these borrowings as being part of a strategy devised by Manet to enter into a competition with the great painters of the past.[42]

If "competition" is understood in the sense of the theory and practice of the copy taught by the academy, this interpretation would have to be the correct one. For it was the academy's teaching, as we have seen, that the path of "originality" lies through the time-tested works of the past. Manet's com-

Figure 59. Edouard Manet, *Luncheon on the Grass.* 1863. Paris, Musée d'Orsay. (Photo: ©
Réunion des Musées Nationaux)

positions would be such "originals," sharing in the greatness of the masters.
His practice resembles no other more closely, in fact, than that of the artists
of the Royal Academy most deeply implicated in the strategy of "borrow-
ing": Reynolds and, in the example cited above, Copley (Figs. 57, 58). Are
Manet's appropriations not to be understood, as theirs, as the expectation of
present and future dividends paid on investments in the past?[43] This is not to
suggest that the reservations some have had about Manet are well founded,
that he was an "academic" rather than modernist artist. For one, the possibil-
ity of a parodic transposition of works by the masters would have to be
entertained, suggesting a subversion of the doctrine of the academy. But this
is not the place for a discussion of this quintessentially modernist strategy.[44]
The important point here is that Manet's habit of referring to the old masters
was acquired during his training in the academic tradition and it remained
with him in the period of his most intense creativity.[45]

Manet's training was received, as noted, in the studio of Thomas Couture. Albert Boime has suggested that Couture similarly influenced modernist artists of the next generation – namely, the Impressionists and Post-Impressionists Monet, Pissarro, and Cézanne, among others – either directly or through artists trained in his studio.[46] Monet, for example, is said to have been indebted to Couture both for his technique and subject matter, the first involving "sharply contrasted highlight and shadow values" and the second a specific subject, the train station; "ten years earlier," he notes, "Couture had suggested the locomotive as a noble theme for easel painting."[47] The suggestion, then, is of a fundamental continuity between the academic tradition and modernism that Boime has attempted to establish on other occasions as well.[48]

Boime was not the first to link the avant-garde to an earlier tradition. It is in fact a familiar critical trope that, in this context, goes back to the period of Impressionism when, in 1878, Théodore Duret wrote: "The Impressionists did not come of nothing, they are the products of a steady evolution of the modern French school."[49] The "tradition" usually cited is that of such painters as Valenciennes and Michallon or of the Barbizon School – that is, of a tradition of landscape painting. It is something else entirely to link artists such as the Impressionists to the academic tradition. To do so is indeed to blur the distinction between traditional and modern art to the point of rendering the modernist enterprise unrecognizable. And nowhere is this brought out more clearly than in attitudes toward the copy: to the academy, eloquent testimony to the continued vitality of the Great Tradition; to much of the avant-garde, a mute reminder of the impossibility of reliving the past. If the old language of art was dead, on what was the new to be based? The consensus of the avant-garde, virtually unprecedented in Western art history, was that nature – or as Zola said, "nature seen through a temperament"[50] – was enough.

The Louvre as the principal site for copying was to be removed. "I have just come from the Louvre," Duranty has one of the characters in his review, *Réalisme*, say in what was only the first of such modernist outbursts, "had I matches, I would have set that catacomb on fire without remorse and in the conviction of having served the art of the future."[51] Monet was one of those who is supposed to have had no interest in the Louvre's collections and later to have claimed that he "didn't have the time to go to the Louvre."[52] Sisley seems to have been equally indifferent to the pictures of the Louvre.

Other artists of the avant-garde, though ambivalent about the art of the past, were proponents of copying, particularly those concerned with the human figure – Renoir, Morisot, Redon, Cézanne, and Van Gogh. They used the copy as before, that is, for study purposes early in their careers, as aids in learning how to draw the figure, and so on, and also, later, for lessons in

composition and, more generally, in the quality and lastingness of great art. The second is the link between avant-gardism and academicism. To say it in other words, copying was accepted by a substantial portion of the avant-garde, as it had been by artists in the academic tradition, as channeling the power of the great works of the tradition; the copy and lessons derived from it would transmit the potency of the past to the present. One example is Redon's copy after Raphael in Fig. 55. Still more striking examples are by Van Gogh and Cézanne.

Van Gogh understood his practice of copying as being close to contemporary academicism. "I can assure you that making copies interests me enormously," he wrote to Theo from the asylum in St. Rémy; "although copying may be the *old* system, that makes absolutely no difference to me."[53] Indeed, he had made copies from the works of other artists from childhood on, hundreds of such works that he mentions in his letters. Sixty-four copies survive, thirty-two of these produced during the year in St. Rémy.[54]

To be sure, copying at this time was, for Van Gogh, in part therapy. While working on a copy of Delacroix's *Pietà*, for example, he wrote about a conversation he had with the attendant's wife, who had told him she did not believe he was ill. "You would say the same thing yourself," he added, "if you could see me working, my brain clear and my fingers so sure that I have drawn the *Pietà* by Delacroix without taking a single measurement, and yet there are those four hands and arms in the foreground in it, gestures and twisted postures not exactly easy or simple."[55]

The works copied earlier can have had no such purpose, but were done, rather, for the same reason as in academies – namely, so that the power of the original, once tapped in the copy, would be magically transmitted to the copyist's own works. Or, to put it more simply, in order to enter into the thinking behind masterpieces.

Among the best-known examples by Van Gogh are copies he made in Paris, not after works by the masters of the Renaissance tradition, but rather of the Japanese tradition of woodblock printing, prints by Hiroshige and Yeisen. In studying both, Van Gogh took the unusual step of tracing the originals rather than making freehand copies, so that these have something of the character of facsimiles. To both, however, he added decorative borders which, though using Japanese motifs, were not parts of the original prints. That he did so enlarge upon the originals shows him attempting to enter into the thinking of this alien tradition. And he did so further in his portraits of Père Tanguy, which not only are filled with Japanese images such as the one in the Yeisen but have been recognized as being equally "Japanese" in spirit.

The Japanese prints copied by Van Gogh are exceptions in his oeuvre in the sense that he worked from the originals. More usually, as the reversed composition of Delacroix's *Pietà* shows, he worked from reproductions in

Figure 60. Vincent Van Gogh, *The Sower.* 1888. Vincent Van Gogh Stichting/Foundation, Van Gogh Museum, Amsterdam. (Photo: Van Gogh Museum, Amsterdam)

black and white.[56] Of the copies made in St. Rémy no fewer than twenty-eight were done after reproductions of figures by Millet, his copies taking the form of paintings in which, for one, the reproduced figures were transformed by color. "Painting from these drawings by Millet is much more translating them into another language," he wrote, "than copying them."[57]

This translation is more obvious still in the use to which he had earlier put another work by Millet, *The Sower* (Fig. 60).[58] Apparently working from memory, Van Gogh completely transformed Millet's figure, making it as disquieting as Millet's is heroic. The more important point is that this was a reinvention in recognition of the power of the original image. The handling may be avant-garde, but the method is that of nineteenth-century academicism.

Or nearly so. The works to which Van Gogh was drawn became part of a personal drama such as was unknown or unacknowledged in the academy. Excited by a reproduction of Rembrandt's *Raising of Lazarus,* he wrote

Figure 61. Vincent Van Gogh, after Rembrandt, *The Raising of Lazarus.* 1890. Collection Vincent Van Gogh Foundation, Van Gogh Museum, Amsterdam. (Photo: Van Gogh Museum, Amsterdam)

Theo: "The personalities are the characters of my dreams." He planned on making a copy of the work, he continued, giving Rembrandt's Mary and Martha the features of the two women in his life, Madame Rolin and Madame Ginoux (Fig. 61).[59]

Cézanne, too, felt an inner bond with works he copied. He made such copies throughout his career.[60] Two of the earliest, originally adjacent to one another on the same canvas but later separated, are *Christ in Limbo* and *The Repentent Magdalen* (Fig. 62), the first copied more or less exactly after the Renaissance painter Sebastiano del Piombo and the second a copy of the conception of a work by the Baroque artist Domenico Fetti. The painting in its entirety, it has been shown, was a perfectly orthodox Easter subject, while the Magdalen's particular attraction for Cézanne can be traced to the history and culture of Provence, of which she was protectress. Earlier he had copied still another Magdalen, this one after a painting at the time attributed to

Figure 62. Paul Cézanne, after Domenico Fetti, *The Repentent Magdalen*, c. 1867. Paris, Musée d'Orsay. (Photo: © Réunion des Musées Nationaux)

Correggio.[61] The painting joining Christ and the Magdalen – part copy, part interpretation – was made for a decorative ensemble and so must have been understood by Cézanne not as an exercise in copying but as what we would call an original work. The question therefore arises as to his understanding of originality. And an answer is provided by the academy's doctrine of the copy – namely, that copying, both in the literal sense and in the sense of the conception of a masterpiece, must precede the creation of a new work of art if that work is to be significant.

Cézanne's early copies were of subjects related to his own paintings at that

time, but the subjects of his mature works were very untraditional bathers, landscapes, and still lifes of apples, oranges, and other such objects. Works by the masters, now more usually studied in drawings, occasionally found their way even into these works.[62] One example is a plaster cast of a putto attributed to Pierre Puget, used as part of a studio still life (Fig. 63). (Another cast, shown as though part of a painting within the painting at the upper right, is of an *écorché* such as was likely to be found in every artist's studio from the sixteenth century on.) To be sure, in the academy's doctrine, the masterpiece is more than a studio prop. But it seems to have been more to Cézanne as well. His continuing regard for works of the past seems to have had much in common with the academy's doctrine, of the copy as a means of appropriating greatness.

From Van Gogh and Cézanne the trail leads inevitably to the greatest practitioner of the art of copying of all times: Picasso. Surely, no other artist, traditional or modern, has copied so intensely: twelve painted "copies" of Delacroix's *Women of Algiers* (Fig. 64), fifty-eight of Velasquez's *Las Meninas,* not to mention the hundreds of drawings made concurrently with the paintings.[63] Other copies were of Courbet, Cranach, and El Greco. Picasso seems to have been determined singlehandedly to revive the practice of the Renaissance tradition and academy that had fallen into disrepute. What was his fascination with the masters of the past? Did he copy for the reason that copies had always been made, to learn the secrets of the masters? Or was it, as some critics at the time volunteered, because he had nothing of his own left to say? How could it have been the first, when he himself often dismissed the Renaissance masters? "People are always talking about the Renaissance," he remarked, "but it's really pathetic. . . . It's nothing but cinema, cheap cinema."[64] We are left, then, with the second answer: Picasso, like Manet before him, confessing his lack of inventiveness by relying on the inventions of others.

The "copies" themselves tell a different story, however, their endless inventiveness presenting clear evidence of Picasso's vital creativity. His turning to the masters obviously was motivated by something other than a loss of confidence in his capacity for invention. His own remarks hold the key. Speaking of his copies of Delacroix's *Women of Algiers* (Fig. 64), he said, musing about a conversation with the earlier artist: "I'll tell him: You, you thought of Rubens and you made Delacroix. And I, thinking of you, I'm making something else." And again: "a master should be free by instinct and be able to break the chain of rules even at the peril of his life."[65]

Picasso's copies certainly do break with the paintings of the Renaissance tradition that he used as models. And his very conception of the copy would seem to fly in the face of the academy's theory of the copy. For the whole point of copying, whether as conceived in the Renaissance tradition or in the

Figure 63. Paul Cézanne, *Still-Life with Plaster Cast.* C. 1895. London, The Courtauld Institute Galleries, London, Courtauld Bequest, 1948. (Photo: Courtauld Institute of Art)

Figure 64. Pablo Picasso, *Women of Algiers.* 1955. New York, Private Collection. (Photo: Giraudon)

academy, was to discover the rules on which it was assumed the masters had relied, rules that were then to be applied to create new masterpieces. To Picasso, this was folly. The rules, once discovered, were not to be applied but broken. If this was dismissive of the academy's theory of the copy at its most literal, it will be shown in Chapter 11 that this theory was seen, at least by some academicians, as comprising a mesh of possibilities with which Picasso's would not be altogether incompatible; Picasso's view was not necessarily the complete rejection of the academy's theory as would at first appear.

THE ANTIQUE

Imitation of the works of classical antiquity is even more closely associated with academies than copying the works of the Renaissance masters. Indeed, it is probably the one activity, more than any other, that seems to recapitulate its ideology. An academy apart from the antique is unthinkable. But the history of Western art itself is unimaginable without the antique. And much of modern art history is the story of the survival and "reinvention" of antique concepts and forms, from early Christian and medieval times to the Carolingian renascence (*renovatio*) and the Italian Renaissance of which the academic tradition was a part.[1] The question, then, is of what distinguishes the vision of the antique in academies.

REBIRTH AND IMITATION

The writer who first christened the Renaissance with the name by which it henceforth came to be known, Vasari, saw this "rebirth of art" (*la rinascita*) as indissolubly bound up with the rediscovery of the antique. "The geniuses who came afterward [i.e., after Cimabue]," he states in the general preface of his *Lives,* "were able to distinguish the good from the bad and, abandoning the old style, reverted to the imitation of classical art with all their skill and wit."[2] The cultivation of the antique, he explains, was progressive, Brunelleschi rediscovering classical architecture, Donatello reviving ancient sculpture, with a full appreciation and restoration of the antique awaiting the great artists of the High Renaissance, "after they had seen some of the finest works of art mentioned by Pliny dug out of the earth: namely the Laocoön, the Hercules, the great torso of Belvedere, as well as the Venus, the Cleopa-

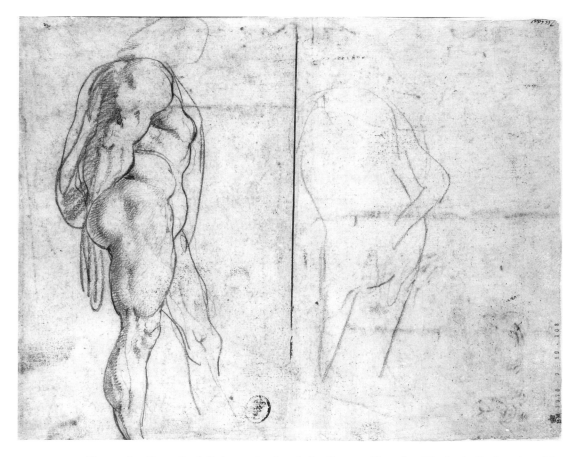

Figure 65. Peter Paul Rubens, *Study of the Farnese Hercules*. Black chalk. London, The British Museum. (Photo: Courtesy Trustees of the British Museum)

tra, the Apollo and countless others." These statues, he says, possess the appeal and vigor of living flesh, but derived from the finest features of living models; their attitudes are natural and free, exquisitely graceful and full of movement. It was they which caused the demise of a style that had become hard and dry. They made the decisive contribution, in other words, to the highest achievement of Renaissance art, High Renaissance style.[3]

Vasari's remarks focus on the appeal of the antique to the Renaissance, namely, that of the exquisitely beautiful. From early in the Renaissance it was agreed that the goal of art was the creation of the beautiful. In the words of Alberti, a painter should be attentive "not only to the likeness of things but also and especially to beauty."[4] As beauty is not to be found in one place, he states, it is necessary to seek it "here and there," to investigate it thoroughly. The process of selection that he recommends, as noted above, is of the kind

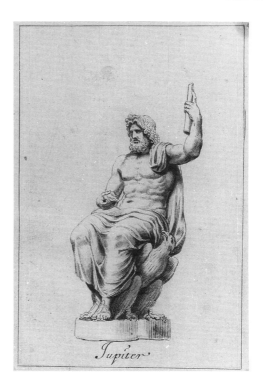

Figure 66. Charles Le Brun, *Jupiter.*
1640s. Paris, Bibliothèque Nationale
(Photo: © cliché Bibliothèque Nationale de
France, Paris)

associated with Zeuxis, who selected the best features from each of five
beautiful women.[5] By the later sixteenth century, this same investigation was
explicitly connected with study of the antique. Armenini, in 1586, for exam-
ple, sent students directly to ancient sculptures, advising them to draw from
the finest statues in Rome, the same mentioned by Vasari, the *Laocoön,*
Hercules, Apollo, the *Torso,* and so on.[6]

The style *all'antica* characteristic of the art of the Early Renaissance is
testimony to an investigation of the antique even greater than the scenario of
an Alberti would lead one to expect. And much of the modern literature of
Renaissance art history consists of attempts to identify the specific antique
models of the style.[7] There are enough works, too, about which speculation
is unnecessary, works that are direct copies of the antique.[8] And copying the
antique only intensified from the sixteenth century on.

Artists from all parts of Europe traveled to Rome to study ancient sculp-
tures. Rubens, for one, did so during a trip in the early 1600s, studying
sculptures such as the *Farnese Hercules,* to which he referred in his own
paintings from this time on (Fig. 65).[9] Poussin went in the early 1620s and
remained to draw nourishment from the antique throughout his life. And
that devotee of Poussin, Le Brun, who later helped disseminate the academy's
doctrine of the antique, while in Rome in the 1640s as a student, copied

ancient sculptures with sufficient diligence to have assembled a large collection of drawings that he later presented to his protector, Chancellor Séguier (Fig. 66).[10] West was still another who, during his study trip to Italy in the 1760s, filled his notebooks with studies of the famous examples of antique sculpture.[11]

The purpose of this study quite clearly was not simply to acquire a taste for the antique, though it was agreed that there was much to relish, but rather to learn a "language" of form. And Le Brun's works from the 1650s on show him dispensing such a repertory of forms. Here is a head, for example, that may very well have been studied from a cast of a figure of the type of the *Venus de' Medici*, which it closely resembles (Fig. 67);[12] it may, alternatively, have been drawn from memory, as figures of this kind were part of Le Brun's language at this time, shown in a variety of poses, seen from different points of view. Also from the 1650s is a sheet of studies by Carlo Maratta, who later was to play a leading role in the Accademia di San Luca, another exercise in assimilation, adjusting the musculature of a figure to the anatomical conformation of the *Torso Belvedere* (Fig. 68).[13] Originating with artists whose names came to be linked to academies, these investigations are testimony to the smooth transition of the study of the antique from the Renaissance tradition to the academy.

THE "GREAT STYLE"

The most famous statement of the theory of perfect imitation is that of the *Idea discorso* read before the Roman Accademia di San Luca in 1664 by Maratta's friend, Bellori. Art should aspire to perfect natural beauty, he states; and goes on to explain: "it is necessary to study the most perfect of the antique sculptures, since the antique sculptors . . . used the wonderful *Idea* and therefore can guide us to the improved beauties of nature."[14] Speakers in the *Conférences* of the French academy, from 1667 on, predictably reiterated this belief. And the same is true of the utterances of the eighteenth- and nineteenth-century academies. Warning of the deficiencies and deformities of nature, Reynolds counseled a quest for forms, "more perfect than any one original." The ancients are to be our instructors, he stated, both through specific examples, such as the *Hercules, Gladiator,* or *Apollo,* and in "that form which is taken from them all. . . . For perfect beauty in any species must combine all the characters which are beautiful in that species."[15]

The image of an academy by Maratta discussed in Chapter 2 (Fig. 14) includes the famous sculptures mentioned by all the writers – the *Farnese Hercules, Venus de' Medici,* and an *Apollo* – next to which is the motto NON MAI ABBASTANZA (Never Enough), for there is no such thing as too much

Figure 67. Charles Le Brun, *Study Sheet with Head of the Type of the Venus de' Medici,* Red chalk on gray-brown paper. Paris, Musée du Louvre, Cabinet des Dessins. (Photo: © Réunion des Musées Nationaux)

Figure 68. Carlo Maratta, *Figure Studies with Torso Belvedere.* Red chalk with white heightening, on light-brown paper. Düsseldorf, Kuntsmuseum. (Photo: Landesbildstelle Rheinland)

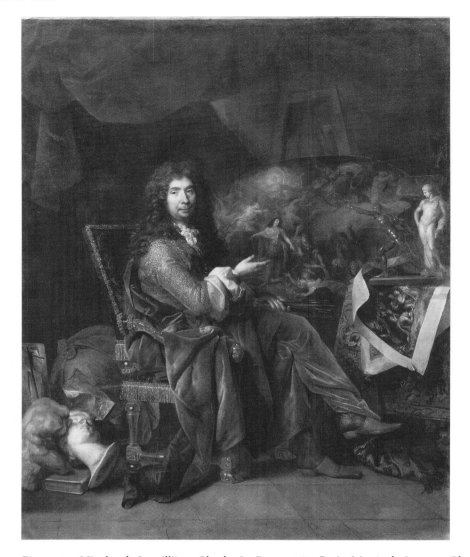

Figure 69. Nicolas de Largillière, *Charles Le Brun.* 1686. Paris, Musée du Louvre. (Photo: © Réunion des Musées Nationaux)

study of perfection.[16] And the same statues appear in other images of academies and academicians as well, documenting their use as models of the perfection that to the academy was the goal of art.

The *Farnese Hercules* figures prominently in a watercolor representing the French academy in the eighteenth century by Charles-Joseph Natoire.[17] Included, together with the *Hercules,* are the *Laocoön, Venus de' Medici,* and *Borghese Warrior* (or *Gladiator*). A cast of the *Farnese Hercules* was ordered turned over to the academy in 1665 by Colbert and was regularly consulted by the members and pupils.[18] And the other statues may be several of the

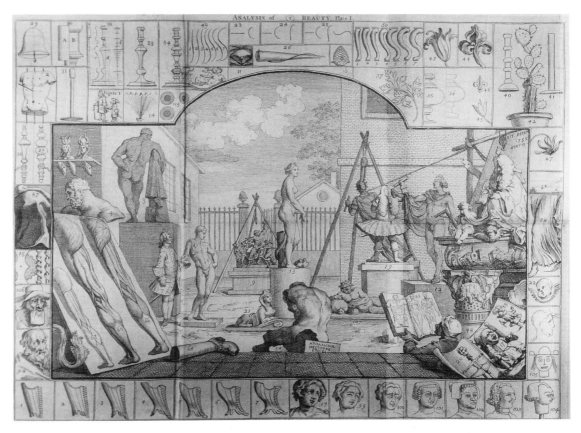

Figure 70. William Hogarth, *Analysis of Beauty.* 1753. Engraving. Walter Clinton Jackson Library, The University of North Carolina at Greensboro. (Photo: Jackson Library, University of North Carolina, Greensboro)

many casts made by pensioners at the French Academy in Rome during the 1670s and 1680s and shipped to Paris.[19]

The *Borghese Warrior* appears again, in the form of a bronze reduction, together with a plaster reduction of the *Hermes Farnese* and the *Torso Belvedere,* in Largillière's portrait of Le Brun (Fig. 69); the ancient sculptures are indispensable accessories, as though attributes, of the artist of the academy. Concerned with articulating a universal standard of beauty, Hogarth referred to these same sculptures, the *Farnese Hercules* and *Hermes,* as well as the *Venus de' Medici* and *Apollo* (Fig. 70). Posing the question as to why the great masters had not left more of a verbal record of their conception, he answers: "it is probable, they arrived at that excellence in their works, by the mere dint of imitating with great exactness the beauties of nature, and by often copying and retaining strong ideas of graceful antique statues."[20]

The commitment of the academy to the antique was stated in its regula-

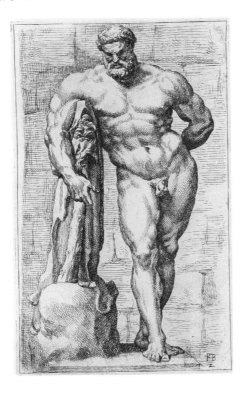

Figure 71. François Perrier, *Farnese Hercules*. Etching. From *Segmenta nobilium*, Rome and Paris, 1638. Paris, Bibliothèque Nationale. (Photo: © cliché Bibliothèque Nationale de France, Paris)

tions and the key works kept before the eyes of the students during every stage of their training. Thus the 1596 regulations of the Roman Accademia di San Luca specify supervision of students drawing from the antique.[21] And the presiding academicians in the French academy, during its earliest period, from 1648, invoked the antique in criticizing student drawings.[22]

The first public utterance of the French academy was a small book by the perspective teacher, Abraham Bosse, outlining a teaching program.[23] The student should begin by copying prints after ancient sculptures, Bosse asserts, such as those published by François Perrier that were consulted, we know, in other academies as well (Fig. 71).[24] In his own book Bosse published an engraving of the head of the *Apollo Belvedere* (Fig. 72), to be copied by students as a beginning exercise.[25]

On the next level of Bosse's drawing course, students were to work directly from ancient reliefs and then go on to draw from sculptures in the round. After this constant and assiduous study of ancient works they would be in a position to correct the imperfections of the figure in nature.

The Accademia di San Luca was given one set of casts of ancient sculptures in 1598 and another in 1663, though there was, of course, no shortage of antique originals in Rome to which students could turn.[26] Artists in Paris were not so fortunate, however, on either count. For some time, they had

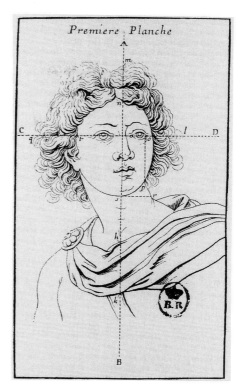

Premiere Planche

Figure 72. Abraham Bosse, *Head of the Apollo Belvedere*. Engraving. From *Sentimens*. 1649. (Photo: Author)

only engravings and a few casts from which to learn. Thus, for his *Conférence* on the *Laocoön* in 1667, Gerard van Opstal was able to display only an eighteen-inch high plaster of the father. And when, in a *Conférence* three years later, Sébastien Bourdon referred to the *Commodus as Hercules*, the *Farnese Hercules,* the *Dying Gladiator,* and one of the river gods of the Belvedere, students had only marked drawings made from the originals in Rome to examine.[27] All of this had begun to change, however, in 1666.

In that year the academy in Rome was inaugurated expressly for the purpose of facilitating the study and copying of antique works, as well as, whenever possible, arranging for their acquisition and shipment to Paris.[28] It is very clear that this was the purpose, for the French academy in Rome at first had neither teachers nor a program. The antique was to provide both for pupils who used the quarters of the academy only as a residence.

Painters made drawings after the sculptures with the aim of assimilating antique form. Sculptors were expected to submit themselves entirely to the antique, which they copied in two different ways. There were times when they would be given the job of making a marble replica of an ancient work, the task assigned, for example, to Nicolas Coustou, who copied the *Commodus as Hercules* between 1683 and 1686 from the original in the Vati-

145

can.[29] At other times, a plaster cast would be made in Rome and sent to Paris, where it would be copied in marble. A cast of the same Hercules copied by Coustou was one such plaster sent to Paris, where it was copied in marble by Noël Jouvenet between 1684 and 1687.[30]

All marbles, those copied in Rome and Paris as well as originals, were earmarked for the apartments and grounds of the palace at Versailles. But plaster casts accumulated in Rome and those which reached Paris were likely to find their way to the academy.[31] Casts of the same sculptures eventually found their way to the academy in London and to schools and academies in all parts of the world.[32]

If it is clear from all of this that study of the antique took place firmly within an academic context, it is equally apparent that this study did not originate with academies. Studying and copying the antique was, as has been shown, as ancient as Western art itself and as modern as the Renaissance tradition. To state the obvious, academies had no monopoly on the antique. From the evidence of the works produced in them it seems equally obvious that they handled the antique differently from the way in which this had been done previously, and these differences have been hard to pin down.

A NEW ROLE FOR THE ANTIQUE

One difference that I have touched upon was the academy's making the study of ancient sculptures both easier and more engaging by providing more and better casts than had hitherto been available. The academy in Paris again took the lead, other academies such as the one in London becoming, too, repositories of large collections of casts. Another difference, in part the outcome of this in-gathering of casts, was the formation of a definite canon by validating the recommendations of the Renaissance writers; in other words, the antique examples to which the Renaissance writers habitually referred became, in the academy, an official and more or less exclusive repertory. However, other initiatives by academies affected the study of the antique still more profoundly.

These initiatives were taken as part of the evolutionary process that resulted in the modern academy, as described in Chapters 1–3. It was a process whereby one academy, as an idea and institution with a program, engendered another, until, by the late seventeenth century, the academy as we have come to know it had been created. Thus, study of the antique played an important role in the Carracci Accademia degli Incamminati, whose program was influenced by that of the Florentine Accademia del Disegno and the Roman Accademia di San Luca, which it, in turn, influenced.[33] The Roman Accademia di San Luca was the model for the academy in Paris and its sister academy in Rome, which was created as a base for studying the antique.

Pupils sent from Paris worked in the Accademia di San Luca as well, and then, in 1676, the French and Roman academies merged, with such Romans as Bellori eventually becoming members of the academy in Paris.[34] As the French took the lead, the academy's approach to the antique changed. This altered approach was initially a difference between the teaching of the Italian academies on the one hand and the French academy on the other, the French becoming the dominant one. It is a difference of the kind brought out by Rudolf Wittkower in a seminal article contrasting the uses of the antique by Bernini and Poussin.[35]

Wittkower shows that Bernini, who was, incidentally, a one-time *principe* and lifelong member of the Accademia di San Luca, was no less immersed in the antique than Poussin. And he cites, among the antique prototypes of Bernini's sculptures, the *Borghese Gladiator,* which we saw earlier in images of the French academy and which he adapted for his *David.* He also notes that when Bernini addressed the students of the academy in Paris in 1665, he confessed his indebtedness to ancient statues, particularly the *Antinoüs,* which was no less admired by Poussin. Bernini and Poussin were both involved with the antique, Wittkower concludes, but in different ways. I am going to suggest that there was such a difference between the Italian and French academies as well; and it is clearly indicated in a comparison of the Accademia di San Luca with the Académie Royale. Involved in particular is an important difference that emerges when one contrasts the theory of Bellori with the *beau idéal* of the French academy, two systems altogether compatible in theory, as has repeatedly been noted in the earlier chapters, and yet, in this important respect, divergent in practice. The new approach of the French marks a turning point in the academy's teaching of the antique ideal.

As I mentioned earlier, the regulations of the Accademia di San Luca speak of copying the antique as part of the drawing course. Of equal importance in this course were lectures, presided over during the early years of the Accademia by its *principe,* Federico Zuccaro. Denis Mahon has shown that Zuccaro did his best to prevent the speakers from discussing drawing in the practical sense outlined in the regulations, wanting the lectures to address, rather, questions that he understood as taking precedence over and governing drawing as such, whether from the antique or the model – questions of the nature of *disegno* and the role of the artist's intellect in the pictorial process.[36] To ask these questions was to think of visual art in the abstract terms of Neoplatonism, a philosophy to which Zuccaro did indeed fully subscribe.

That the language of Bellori's *Idea discorso* is also that of Neoplatonism has always been clear.[37] But since Panofsky's *Idea* of 1924 it has been the habit of scholars to place Bellori at the opposite pole from Zuccaro;[38] they have understood his theory as a revision of Neoplatonism stressing the impor-

tance of experience in the sensible world. Nowhere in Bellori's writings is his Neoplatonism more apparent, however, than in his discussion of the antique; Bellori's theory in this respect is more similar to than different from Zuccaro's. What I am suggesting, therefore, is that the most persuasive voices in the Accademia di San Luca were in basic agreement as to the role of the antique, so that it is possible to speak in broad terms of the approach of the Roman academy to the antique.

Bellori's *Idea discorso* is so full of references to the ancients that to remove them would be to dispose of the discourse itself. He cites authors from Aristotle and Plato to Ovid, Cicero, and Quintilian, invoking such ancient artists as Daedalus, Apelles, and Zeuxis and retelling the famous story of how the latter formed his image of Helen by combining the best features of each of five virgins. This is the kind of perfect beauty found not in life but in art, he says, in such ancient statues as the *Medici Venus*. It is not enough to study only this Venus, however, or any other ancient statue. For there is not one type of beauty but many, so that it is necessary to look to a variety of sculptures, examining the forms of each. Nor is the artist to stop at these forms; he must also, because he is concerned with human actions, be a careful observer of nature, in its particular as well as general aspects. But also in these observations the artist is to apply what he has learned from ancient sculptures, which are to be his constant guides to perfect beauty.[39]

Ancient sculptures are such guides, Bellori says, because the sculptors of antiquity "used the marvelous Idea."[40] And the Idea is that superior beauty which artists must strive to achieve. From the remarks that I have summarized, it may seem that Bellori is making of the antique the ultimate source and measure of the Idea, suggesting that artists need only study ancient sculptures, and apply the lessons learned from them in their study of nature to achieve perfection. He makes it clear enough, however, that the Idea involves far more than this.

At the outset, Bellori tells us that the Idea originated in the mind of God and that when painters and sculptors form in their minds an example of superior beauty they are imitating their Maker.[41] He cites the case of Raphael, who used, in the artist's words, "a certain Idea that comes to my mind."[42] And he quotes from a letter by Reni about a Saint Michael: "I would have liked to have the brush of an angel, or forms from paradise, to fashion the Archangel and to see him in heaven, but I could not ascend that high, and I searched for him in vain on earth. So I looked at the form whose Idea I myself established."[43] Raphael and Reni are saying that they looked, not to the antique or to nature, neither to a sculptural nor a corporeal ideal, but rather to an intellectual ideal formed in their minds. Both the antique and nature, it is clear enough, are incorporated in this ideal, which goes beyond them, however, as it returns to its source in the mind of God. In a later

passage, Bellori makes this clearer still, as he speaks of Annibale's striving for perfection. Annibale made repeated studies and variations on ancient statues, he says, converging on an idea of perfection that he had in his mind.[44] Study of the antique is, then, a necessary but not sufficient cause of this convergence. Evidently, the Idea exists prior to and independent of works of ancient sculpture.

A similar point is made in the image of an academy by Maratta discussed earlier (Fig. 14). About those ancient statues at the upper left Maratta says that there is no such thing as too much study of perfection. But there are other figures, at the upper right, of the Three Graces, and next to them is an inscription stating that without them all is in vain (SENZA DI NOI OGNI FATICA E VANA), meaning that study of all kinds can go only so far. And a similar sentiment was expressed in the Roman academy a few years later when one of its members criticized their counterparts in Paris for leaving out of their discussions, in which the antique was constantly invoked, the most essential quality of all ("una parte dell'arte, ch'è forse la più bella") that *non so che* of grace.[45]

Bernini's thinking seems to have been of precisely this kind. In Wittkower's words: "he firmly believed that his inspiration came to him through the grace of God and that in developing a felicitous idea he was only God's tool."[46] This is the Neoplatonic thread weaving through teaching in the Roman academy from the time of Zuccaro to that of Bellori.

To sum up, members of the Accademia di San Luca, even while stressing the importance of studying the antique, made it clear that such study did not by itself insure the results they were after; it was their understanding that art at its highest is imbued with such qualities as beauty and grace, which are undefinable and ultimately traceable back not to any sensible model but to the mind of God. This, then, is the view that was revised in the French academy and its satellite, the French academy in Rome. The French began by adopting Italian ideas, as they had Italian art. And they no doubt understood their enterprise as compatible with the Italian academies such as the Accademia di San Luca. Differences between the approaches of these academies may be put in quantitive as well as qualitative terms.

Whereas study of the antique seems to have been discussed in the Accademia di San Luca infrequently, and then only in the general terms of a guiding principle, with few indications as to how it should be undertaken, in the Académie Royale this question was discussed regularly and as a definite method to be analyzed and elucidated. This was the purpose of the *Conférences*, which repeatedly focused attention on works of ancient sculpture.

One of the first such meetings was devoted to the *Laocoön:* there was one analyzing the ancient bas-relief; another outlined a course of study of the antique; and another described the different proportions of ancient sculptures. Ancient works were also conjured up in meetings discussing modern

works. The most well known of such examples was Le Brun's tracing of the ancient prototypes of figures in Poussin's *Israelites Gathering Manna* (Fig. 34).[47] The same methodical approach was taken in all lectures and it involved the most careful examination of the ancient work, in its parts and as a whole. This is the way the *Laocoön* was discussed. And in subsequent lectures this approach was developed further and explicitly recommended to students as a method of study.

In his lecture on the study of the antique, the painter Sébastian Bourdon remarks that one cannot begin this study too early. Young artists should familiarize themselves with ancient sculptures, which they should draw part by part, in their entirety, and from memory. This much had been said, of course, by Italian theorists.[48] But Bourdon departs from the Italian tradition by requiring an unprecedented exactitude: this study is to follow from the most careful measurements, which will be different for each ancient statue.[49] Drawings from the live model are also to be redone with the antique in view, which, in a general way, also had been proposed by Italian writers.[50] But what Bourdon recommends is that after such a drawing has been made, a second be done, giving the figure the character of a particular ancient statue. And here, too, the emphasis is on exactitude: the artist is to verify the accuracy of his depiction, "compass in hand," checking the measurements of his figure against those of the original. Any deviations should be corrected, for the antique is never arbitrary.[51] Figural representation will be controlled, in other words, not by any theory of classical beauty, but by the actual practice of the ancient sculptors.

Bourdon states that this method was approved by Poussin. And he says, further, that to check his information, he had his pupil Mosnier measure the statues of Rome once more, and that this was done to the satisfaction of Poussin. Indeed, Poussin's own investigations of the antique were known to have been unusually careful and to have included making measurements. Two of his measured drawings of the *Antinoüs*, which, as has been noted, Bernini also studied, were appended by Bellori to his Life of Poussin, in a section publishing some of the artist's research. Thus, there was reason to believe that the academy's method was compatible with Poussin's understanding of the antique, which, everyone agreed, had been of the most profound kind.

Not all the members of the academy were prepared to go so far as Bourdon. In one subsequent discussion, Henri Testelin cautioned against getting carried away with measurements; at the same time, he insisted on the infallibility of measurements when properly taken.[52] And this notion received definitive form in the 1683 publication of Gérard Audran's *Les Proportions du corps humain mesurées sur les plus belles figures de l'antiquité.* The title is literal. The measurements given are not those of proportional

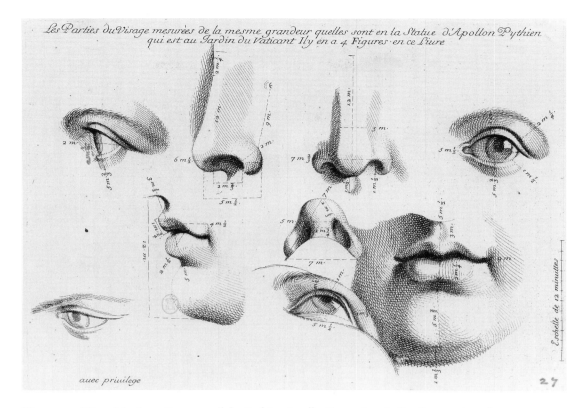

Figure 73. Gérard Audran, *Features of the Pythian Apollo*. Engraving. In *Les Proportions des corps humain*, 1683. Paris, Bibliothèque Nationale. (Photo: © cliché Bibliothèque Nationale de France, Paris)

ratios, as had been the practice in the Renaissance tradition, but actual measurements, the precise distances between chin and nose, nose and forehead, and so on (Fig. 73).[53] Armed with these numbers, students in the French academy at last were fully prepared, it was thought, to create figures of a beauty or perfection comparable to that of ancient statues.[54]

The fundamental difference between this French method and that of the Italian tradition is brought home by recalling, while keeping in mind the French insistence on measuring "compass in hand," the words of Michelangelo's often quoted aphorism, "A good judgement and an exact eye are better than compasses."[55] In deciding that the beauty of the figure is something material, the French academy distanced itself from the Italian academies, which had looked to the antique not for specific models but for a bridge to a perfection that it understood as more than the sum of discrete entities. With the ascendency of the French academy, the antique came to be regarded as the definitive measure, in the literal sense of the word, of beauty and perfection.

THE SPIRIT RESTORED

It was so regarded in the next century by the artists of the Royal Academy, particularly Benjamin Robert Haydon and Joseph Nollekens, one group of whose drawings after the antique survive. Here are the *Venus de' Medici, Farnese Hercules,* and *Laocoön,* exactly measured from head to toe: the *Venus* with more than fifty measurements, including the length and width of her fingers, the exact height of her heel, and the precise measurements of her kneecaps, the toes of *Hercules,* all precisely measured, and so on.[56] So, too, as the measure of perfection did Winckelmann regard the antique, but with a difference.

Winckelmann has seemed to incarnate the love of the antique associated with academies, and his career illuminates the relation between that love and academic institutions. "The only way for us to become great or, if this be possible, inimitable, is to imitate the Ancients," he wrote in words echoing the academy's doctrine.[57] And these words in turn, like the man who had uttered them, found their way back into the academy. His most important publications were reissued and translated by academies, which welcomed him as an honorary member, the Accademia di San Luca in 1760 and the academy in Dresden five years later. He was elected a member of the Academy of Inscriptions in Rome and of the Society of Antiquaries of London. His idol and friend, Anton Raphael Mengs, was *principe* of the Roman Accademia di San Luca from 1771 to 1773, before being called to direct the Academia de San Fernando in Madrid.

Winckelmann's view of the antique was conditioned, to begin with, by the Renaissance and academic theory of imitation, according to which nature is untrustworthy, beauty contingent upon selective imitation; the antique is an indispensable part of this process of selection, showing the "essence of what is otherwise dispersed through all of nature."[58] A few pages later in the same essay is found one of his most famous and often quoted passages: "The general and most distinctive characteristics of the Greek masterpieces are, finally, a noble simplicity and quiet grandeur, both in posture and expression. Just as the depths of the sea always remain calm however much the surface may rage, so does the expression of the figures of the Greeks reveal a great and composed soul even in the midst of passion."[59] So influential was this essay that Reynolds found it necessary to respond to these words in his eighth and tenth *Discourses,* declaring that Greek sculptures have "something besides mere simplicity to recommend them."[60]

To Winckelmann, however, simplicity was more than an aesthetic quality; it was spiritual as well. Antique statues were understood by him as models not only of physical beauty but also of spiritual perfection, a perfection that was the very essence of the Greek nation. A return to the antique was,

therefore, a restoration of the spiritual ideal embodied in antique statues. This is an ideal reflected, for example, in the *Laocoön*, whose "nobility of soul" holds his physical suffering in check; "his pain touches our very souls, but we wish that we could bear misery like this great man." "The expression of such nobility of soul," he continues, "goes far beyond the depiction of beautiful nature. The artist had to feel the strength of this spirit in himself and then impart it to his marble."[61]

Feeling the strength of the spirit clearly entails far more than imitating the outward matter of the statue. Required is a form of mystical communion on the order, indeed, of the Idea of the Platonic tradition to which Winckelmann repeatedly refers.[62] It was this spiritual dimension of the theory of perfect imitation that was excised by the theorists of the French academy. In Winckelmann's restoration, however, the theory has undergone a profound modification: beauty, having been characterized in relation to the indescribable mind of God, is now represented by the palpable marmoreality of ancient sculptures. In reviving the spirituality of the Italian tradition, Winckelmann replaced its religion with the revelation of the antique.

It must be stressed that Winckelmann was inspired by the same sculptures as the Renaissance and academic theorists – in particular, in addition to the *Laocoön*, the *Torso Belvedere, Farnese Hercules,* and *Apollo Belvedere.* That is to say, his vision was not affected by the broadened view of antiquity that resulted from the recent excavations of Pompei and Herculaneum, which he himself described. Nor was the academy's vision of the antique ideal substantially altered by the discoveries of archaeology, at this time or later. It continued, rather, to teach the antique principally by means of the key examples that had always been cited and that were recommended by Winckelmann, the teaching being justified by the academy's theory of imitation bolstered by Winckelmann's mystical evocation of the spiritual perfection of the Greeks. It is not surprising, therefore, to discover students in academies in all parts of the world, old and new, through the nineteenth century and beyond, copying the same statues – from casts – as had been copied in academies from the sixteenth to the eighteenth centuries (Figs. 74, 75).[63]

THE NEW CLASSICISM

Although Winckelmann's influence remained great, there were times when the evidence of a hitherto unknown Greek ideal caused the antique sculptures he most admired to recede into relative insignificance. In England, the revelation of the Elgin Marbles occasioned such a displacement of the repertory within the Royal Academy itself. Fuseli reportedly ran through the streets, cursing, to reach them and, after having seen them, muttered in his Swiss-German accent, "De Greeks were godes! De Greeks were godes."

Figure 74. Edme Bouchardon, *Apollo Belvedere.* Red chalk. Paris, Musée du Louvre, Cabinet des Dessins. (Photo: © Réunion des Musée Nationaux)

Compared to the *Theseus,* Flaxman is supposed to have said, the *Apollo Belvedere* is a mere dancing master.[64] West agreed, and so did William Hazlitt, who contrasted the softness and texture of flesh of the Marbles with the smoothness of the *Apollo,* whose limbs have the appearance of "being encased in marble."[65] Haydon expected the study of these works to usher in a whole new era for the academy and for British art.[66] And such an era was, indeed, inaugurated, a Greek revival; but it did not entirely dispense with the older models. It was only in a later time that a return to classical models also signaled the death of the academy's antique ideal.

Figure 75. Mosely Isaac Danforth, *Drawing of Cast of the Apollo Belvedere*. Charcoal and white chalk. New York, National Academy of Design. (Photo: National Academy of Design, New York)

As recent research has shown, the early twentieth century witnessed a broad and unexpected revival of interest in classical art — unexpected in involving artists who had been among the most radical and seemingly anticlassical members of the avant-garde: Picasso, Léger, Severini, and others.[67] Apparently sparked by the disruption of avant-garde culture of the First World War, this new classicism differed from the old in its predilection for Greek art of the fifth century B.C. Rejecting the antique models of the acad-

Figure 76. Aristide Maillol, *Standing Woman.* 1907. Alger, Musée des Beaux-Arts. © 1995 Artists Rights Society (ARS), New York/SPADEM, Paris. (Photo: Giraudon)

emy, it also rejected that apostle of academic classicism, Winckelmann. In the words of Guillaume Apollinaire:

It was the German aestheticians and painters who invented academicism, that fake classicism which true art has been struggling against ever since Winckelmann, whose pernicious influence can never be exaggerated. It is to the credit of the French school that it has always reacted against his influence; the daring innovations of French painters throughout the nineteenth century were above all efforts to rediscover the authentic tradition of art.[68]

The first signs of this new classicism appeared in France, as Apollinaire says, in the late nineteenth century, and in such early-twentieth-century works as Maillol's *Standing Woman* of 1907 (Fig. 76), which is as much a

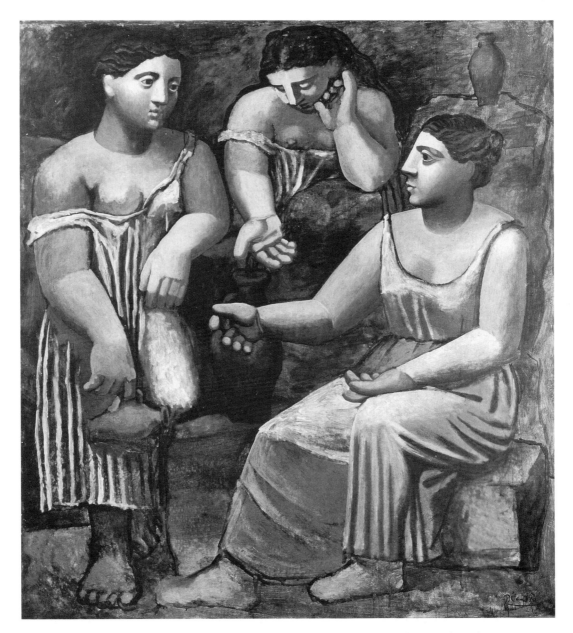

Figure 77. Pablo Picasso, *Three Women at the Spring.* 1921. New York, Museum of Modern Art. Gift of Mr. and Mrs. Allan D. Emil. © 1995 Artists Rights Society (ARS), New York/ SPADEM, Paris. (Photo: © The Museum of Modern Art, New York)

Compare to Poussin, fig. 35 p. 101

rejection of the classicism of the academy as it is of the only convincing alternative to that classicism, the sculpture of Rodin.[69] We see evidence of it in Matisse's regard for antique sculpture. Matisse, it is to be recalled, in 1908–9, unexpectedly set his students to work drawing from a cast after the antique.[70] That cast was not of one of the icons of the academy such as the *Apollo Belvedere,* however, but the fifth-century B.C. *Apollo Piombino,* which is behind Matisse in the photo of his class (Fig. 28).

Picasso's works from 1914 through the early 1920s are clearly rooted in this early classical style. Distantly related to the *Apollo Piombino,* the women of Fig. 77 suggest even more severe sculptures of the fifth century B.C., such as those from the Temple of Zeus at Olympia or Pompeian fresco painting. They are at the same time, however, related to figures that he made earlier, in 1906–7, in connection with the *Demoiselles d'Avignon,* and that were inspired not by Greek models but rather by Iberian sculptures.[71] This relationship is a key to Picasso's classicism, and perhaps to early-twentieth-century classicism as an avant-garde phenomenon. (It is certainly true of Matisse's classicism.) For archaic and classical art appealed to the avant-garde in the same ways as the "primitive" sculptures of Europe and Africa; all contributed toward a "primitive classicism,"[72] about which Roger Fry wrote the following:

A . . . curious phenomenon in the battle over Greek art is the publication of a book called *l'Art Grec* by a number of French critics of the *avant-garde.* It is illustrated with a most remarkable series of photographs. These people profess to have discovered the real Greek art at last, i.e., they propose a new series of canonical works. Their selection includes all those completely primitive and rudimentary figures which are known as Cycladic; it takes in the earliest and most primitive pottery . . . , then the seventh- and sixth-century sculpture . . . and then the grotesque masks from Sparta. The Hekatompedon figures are also insisted on, even Olympia gets in, but after that all is more or less decadent. . . . This new canon then goes from prehistoric times down to the early archaic. The authors are thus able to prove to their own satisfaction that Greek art should be reinstated in its glorious position because if you look at it at the right angle it is so much like Negro or Polynesian art.[73]

Fry goes on to observe that, in terms of the formal criteria derived from genuinely "primitive" works, early Greek art is "feeble" – once again establishing the elusiveness of the Greeks.[74]

For those who subscribed to the new "canon" there obviously was no question of a single system of measurement, neither by compass nor the eye. Proportions changed from study to finished work and from one work to another, as antique forms were manipulated and intermingled with others, from disparate artistic sources or from the live model. A different antique legacy from that of the academy was evoked, one not to be imitated but rather creatively interpreted.

LIFE DRAWING

Drawing from the live model was the culmination of the academy's program, for which the beginner prepared first by copying drawings and engravings and then by drawing after the antique. This preparation was dictated by the theory behind the program, the principal tenet of which, as should by now be clear, called for the imitation of natural things not as they are but "as they ought to be," the artist being expected to "correct" or perfect nature.[1] To confront the live model meant, therefore, recalling the lessons learned from art about the unreliability of nature. It also meant remembering stories such as the one about Zeuxis's assembling a figure out of the best features of five live models. Is this how the artists of the academy drew the figure, literally taking a thigh here, a breast there, an ankle, and so on? How does one draw "selectively" or find forms, in Reynolds's words, "more perfect than any one original" even while having before one's eyes only the insolent imperfection of that original?

How, in sum, did the artists of the academy put its theory of the ideal imitation of nature into practice? To ask this question is to touch on a greater mystery, namely, of figure drawing among the great masters of the Renaissance. For this is the transcendently beautiful figure – of Raphael, for example – that the academy had in view. Renaissance artists, too, we are to understand, worked from the live model, but selectively, perfecting the figure according to a vision or Idea experienced in advance of confronting the live model. In question here is nothing less than the practical resolution of the theoretical coupling of the real and ideal, nature and art, in the Renaissance and academic traditions and, by extension, the modernist reappraisal of both that theory and practice.

The materials I shall examine are all studies of the figure. What is here to be determined are the kinds of studies these are, how they relate to the live model. Among the possibilities are: the figure drawn (1) from observation, described as observed; (2) described with modifications (corrections); (3) completely transformed (perfected). That these all are possibilities we know from the theory. What the theory does not tell us, however, is which of these procedures – or entirely different ones – was followed in any particular study. To decide which, it is necessary to rely on the evidence of the drawings themselves, which is to say, on strictly visual recognitions or discriminations of visual "facts" such as those to which I refer in the title of my earlier book on the Carracci, *Visual Fact over Verbal Fiction*. Not having defined "fact" in that discussion, my use of the term may not have been altogether clear. To clarify my meaning on this occasion, it may be useful to begin with the definition of the term in traditional art history – namely, with the "primary level of signification" of Panofskian iconography.

To use Panofsky's own example: when a man greets me by lifting his hat, the first thing I see is a change in a formal pattern of lines, colors, and volumes. As soon as I identify the object of vision as a man and the change of detail as the lifting of a hat, I have entered a first sphere of subject matter or meaning, the "factual" meaning, "apprehended by simply identifying certain visible forms with certain objects known to me from practical experience."[2] This stage, for Panofsky, was preliminary to achieving the higher understanding of art required by the following stages and was of little importance in itself. With so little said about it, Michael Ann Holly was able to state that, to Panofsky's way of thinking, it is possible on this level only to make note of the objects involved: a gentleman and a hat. Or, in her own example, to say about Leonardo's *Last Supper* only that it is a representation of thirteen men seated around a table laden with food.[3] In the context of the present discussion, it would be possible to say about a figure study only that a figure is represented, male or female, seated or standing, and to proceed with a consideration of the significance of that figure.

If Panofsky's position was not necessarily so extreme, it nevertheless lent itself to such an interpretation, which is that of a semiotic intervention in art-historical methodology. For it is semiotics, far more than early-twentieth-century art history, that is profoundly skeptical about the meaningfulness of "factual" knowledge. Every image being a textlike collection of signs, "facts" are all semiological facts or cultural messages. Indeed, with his first mark the artist is already operating in a semiological field, for, as art scholars long ago recognized, there is no mark without style and, as semioticians tell us, style is coded culturally and historically.[4]

When Panofsky's terms are considered with regard to teaching, it becomes

clear that the level below the threshold of signification that he passed over so lightly as the thing seen in a "formal pattern of lines, colors, and volumes," is the ("pre-factual") space where instruction begins; it continues on to the next "factual" level as well. In question, indeed, are marks deployed on a surface, translating the figure plastically and spatially, lines, shapes, and colors suggesting plastic volumes. But this translation is in the form of a work of art that, while tracing its origins to "practical experience," plunges the viewer into a world of multilayered recognitions that are as much aesthetic as practical. It is here that the figure is determined to be well or badly drawn, correct or flawed; on this level mistakes are pointed out and corrections made. It is precisely here that the figure is judged in relation to nature on the one hand and to some ideal such as the antique on the other.

Within a broadened semiotic context the shift is one, in Meyer Schapiro's words, from the "picture-sign" to the "image substance." The contrast is between the image as something recognizable – the man with the hat – and the many different styles, mediums, and techniques with which that image may be represented: outlined or modeled or colored, the outline thick or thin, continuous or broken, the modeling with halftones or hatching, different colors, and so on. At the same time, "the picture-sign seems to be through and through mimetic," Schapiro notes, "and this is the source of many misreadings of old works of art."[5]

One reason for such misapprehensions is the difficulty in conveying the above judgments. How does one put into words the differences between one kind of line and another, the incorrectness or "inarticulateness" of a contour: more rounded, not full enough, (how much is enough?). Is it possible to translate into language the spatiality – or lack thereof – of configurated lines: form, volume, edges (what are the "edges" of lines?). In the studio and academy, it was agreed that such differences were better demonstrated than explained, that a pencil or crayon was more appropriate than words (Fig. 78; cf. Fig. 13).[6] The flawed work may, alternatively, have been compared with another, preferably one by a master, to make the point, as, for example, Fig. 78 with Fig. 88.[7] But consider, if you will, the nature of these "explanations." In neither case is verbal comprehension necessary; the student need only imitate the example of the teacher.

[p. 39 →]

These problems faced by the artist are compounded for the scholar desiring to differentiate among drawings basically similar in type – all "life" drawings. How is one to *prove* that a particular drawing describes the model as a whole or in certain parts, or cleaves to the antique, or doing neither, is an imaginary construct?[8] The problem is one of translating visual "facts" into spoken language. In acknowledgment of this problem, this investigation of life drawing will begin with facts of another kind, those on the other side of the equation: the model.

Figure 78. Edward V. Valentine, *Study of the Live Model with Corrections by Thomas Couture.* 1860. Charcoal. Richmond, Valentine Museum. (Photo: Valentine Museum, Richmond, Virginia)

THE QUESTION OF THE NUDE

This subheading is taken from Linda Nochlin's ground-breaking article on women artists.[9] Remarking on the centrality of life drawing in the Western tradition, Nochlin makes two observations: one, that nude female models were virtually banned from public art schools as late as 1850, and two, that aspiring women artists were not allowed to draw from any nude models, male or female, through the end of the nineteenth century. "To be deprived of this ultimate stage of training, meant, in effect," she states, "to be deprived of the possibility of creating major art works, unless one were a very ingenious lady indeed, or simply, as most of the women aspiring to be painters ultimately did, to restrict oneself to the 'minor' fields of portraiture, genre, landscape or still-life."[10]

Figure 79. Thomas Eakins, *Seated Nude Woman Wearing a Mask.* Charcoal and black crayon on pink laid paper. Philadelphia Museum of Art, Gift of Mrs. Thomas Eakins and Miss Mary Adeline Williams. (Photo: Philadelphia Museum of Art)

In support of her argument, Nochlin cites images of academies such as are reproduced in Figures 18 and 20 – all showing male students drawing from a male model. Other evidence confirms the reliability of these representations, documenting the relegation of female models to a zone of taboo and, concurrently, excluding women from life-drawing classes. A few examples: it was strictly forbidden by edict to pose a female model, even a clothed one, in the seventeenth-century Roman Accademia di San Luca and in the Florentine academy in Rome; female models were banned in the seventeenth- and eighteenth-century French academy, the sole exception arising after 1759 with the expressive head competition, obviously involving only the head of a clothed figure (Fig. 15). Studies from the model, whether resulting in male or female figures, were all done, therefore, from a male model, *M. le modèle du*

roi, as he was called. The reason was aesthetic as well as moral: the assumed superiority of the male physique.[11]

Although female models were posed in the eighteenth-century English academy, women students were not allowed to draw either from them or male models until 1893, and even then the model had to be partially draped.[12] The problem of the female model is surely summarized in Eakins's astonishing drawing of a model (Fig. 79), doubly masked, as it were, the mask not only preventing her from returning the male gaze fixed on her exposed body but also allegorizing her nakedness by associating it with personifications of ignorance and uncleanliness such as those of the Synagogue in medieval art.[13] Drawing from the female nude, then, entailed a process not only of disrobing but also of unmasking that was enabled by the transition from an imagery of ignorance to one of intelligence: the female body cleansed and ennobled by idealist theory.

Let us for the moment concentrate on the first of these questions, namely, that of the paucity of female models in the academic tradition until well into the nineteenth century.[14] As the academy was a product of the Renaissance tradition, why did it not accept the important role of female models in that tradition? To ask this question is to assume that female models had indeed played such a role, an assumption scholars have frequently made on the basis of the ubiquitousness of the female nude in Renaissance art as well as stories in biographies of artists about how they wandered the countryside in search of beautiful models. I have argued, however, that this assumption is erroneous, that female nudes in Renaissance works typically were developed from studies of male models, if from live models at all (as opposed to sculptural models or the imagination of the artist).[15] Such are the female nudes of the Carracci, not one of which, I have proposed, "can be said unequivocally to have been done from a live model."[16] Pevsner was one of those who had assumed the contrary, based on the presence of figures with breasts in Carracci works, as also on the testimony of their early biographers, who state that they posed female as well as male models in their academy.[17] To interrogate representations of the female nude is, then, to question the reliability of the biographies of artists. But most of all, it is to shift attention from the verbal to the visual, granting to the second a status at least equal to the first.

Mary Garrard has written in support of my argument, proposing that an important difference between the female nudes of Artemisia Gentileschi and those of her male counterparts has to do precisely with the question of models, the credibility of Artemisia's female nudes being attributable to her use of nude women as models, to which male artists of the time had little access.[18] This line of investigation, however, has not been pursued further by feminist scholars, who have focused attention on questions of representation in the sense of politics rather than aesthetics, rendering questions of the

model, as such, irrelevant.[19] But surely it is relevant, when representation is in question, to ask about the visual information channeled into that representation. For answers to such questions one must look to the life-drawing room in which artist and model met against a background of prejudices and preconceptions about the figure in nature and art.

THE "ACADEMY"

The outcome of this meeting in the academic tradition was an "academy," a particular type of figure drawing such as is proudly displayed by Luis Melendez in the self-portrait he painted in 1746, after one year of study in the recently established academy in Madrid (Fig. 80).[20] This was a type of drawing said already in the seventeenth century to have originated with the Carracci and most closely associated with the French academy (termed an *académie*) – the Spanish academy was one of those, as was noted above, strongly influenced by the French.[21] Such drawings from the Italian academies and the French academy of the seventeenth and eighteenth centuries show, not surprisingly, only male models, singly or, at times, in pairs; "academies" of the nineteenth century are either of male or female models (Fig. 81), though those of male models are still numerically superior. This is not to say that women artists such as Artemisia Gentileschi were the only ones to have direct access to female models until the late eighteenth or nineteenth century. There were male artists who worked regularly from the female nude, particularly Northerners, the most notable having been Rembrandt, whose school was famous for posing nude women as well as men.[22] In those schools and academies in which life drawing meant observing only the male model, however, detailed and accurate information about the figure obviously was derived largely from the male.

What do these drawings tell us about studying the nude in the academy? One thing is that there was a definite idea about the materials and techniques appropriate to such a study, though this was subject to change from one period to another. Thus, the "academy" at its inception and throughout the eighteenth century was usually a drawing in red or black chalk, with white highlights, on white or tinted paper; in describing the figure, stress was laid on the contour, the forms so articulated typically modeled with parallel strokes and cross hatchings, following the practice of such Renaissance artists as Michelangelo and also showing the effects of studying the figure first in engravings. In the nineteenth century, chalk continued to be used but was joined by pencil, charcoal, and conte crayon; the contour remained the key feature and cross-hatchings were often employed, but massed halftones were more commonly used for modeling.[23]

If the "academy" is not an entirely homogeneous category, it is neverthe-

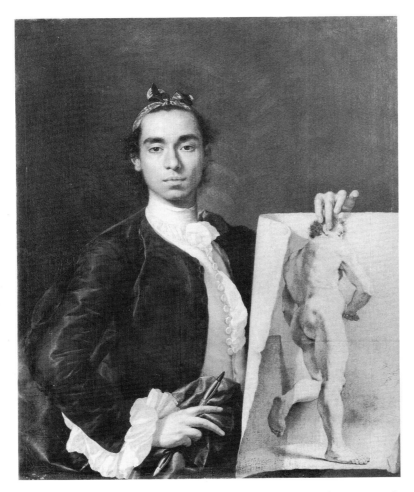

Figure 80. Luis Melendez, *Self-Portrait.* 1746. Paris, Musée du Louvre. (Photo: © Réunion de Musées Nationaux)

less a remarkably consistent one over the course of some three centuries. Consider the two drawings illustrated in Figures 82 and 83. The first (Fig. 82), a drawing in red chalk, was done by Annibale Carracci in the 1580s; the other (Fig. 83), a graphite drawing by Alphonse Legros, originated in the Slade School in London, anywhere from the late 1870s to the early 1890s.[24] Both artists clearly were confronted by an actual model, with the description of which they were preoccupied. In each, the forms were carefully rendered and firmly delineated, conveying a powerful impression of the presence of the model. What is striking, however, is the relative sameness of these descriptions. Concentrating on the contours, both artists indicated only select anatomical facts, those consistent with an articulation of the large forms, which were further amplified by the halftones in the one drawing, cross-hatchings

Figure 81. Daniel P. Huntington, *Female Nude, Seated.* 1858. Black-and-white chalk. Washington, D.C., Cooper-Hewitt Museum of Design, Smithsonian Institution. (Photo: Cooper-Hewitt Museum of Design, Smithsonian Institution)

in the other. It would be necessary only to compare these drawings to actual models to see how much has been left out.

The *académie* in Figure 84 dates from 1710, or midway between the previous two drawings. By Louis de Boullogne, it is a typical French *académie,* representing paired male models.[25] As was the usual practice, Boullogne described the figures principally by means of their contours, with highly rhythmic lines that, while suggesting anatomical activity, actually delineate few muscles; anatomical information on the whole was suppressed for the sake of a greater balance and unity, intensified by modulating the large forms with parallel strokes. If it is clear that these figures were drawn from life, it is

Figure 82 (left). Annibale Carracci, *Study of a Partially Draped Nude, Side View.* Red chalk. Paris, Musée du Louvre, Cabinet des Dessins. (Photo: © Réunion des Musées Nationaux)

Figure 83 (right). Alphonse Legros, *Figure Study.* Graphite. New York, The Metropolitan Museum of Art, Gift of the artist, 1892 (92.13.4). (Photo: The Metropolitan Museum of Art, New York)

just as evident that the information derived from the model has been selected and adjusted according to a vision formed before artist and model had met.

In the interests of this vision, then, the figure was simplified and abstracted. But if the male figure was an abstraction, how much more so was the female! Describing the female nude, the same Louis de Boullogne would appear to have gone through a process of selection far more stringent than that initiated by the male model (Fig. 85).[26] The figure consists, indeed, of only a few, undulant lines; it is virtually all contour. The female anatomy would seem not to have been closely observed or, if observed, to have undergone even more thorough editing than that of the male.

But why assume that this drawing was made from a live model, particularly since it is known that female models were banned by the academy, which, continuing a bias of the earlier Renaissance tradition, regarded only

Figure 84. Louis de Boullogne, *Study of Two Male Nudes.* 1710. Black-and-white chalk. Providence, Museum of Art, Rhode Island School of Design, Museum Works of Art Fund. (Photo: Museum of Art, Rhode Island School of Design)

Figure 85. Louis de Boullogne, *Young Girl Washing Her Feet in a Stream.* 1707. Black chalk with white heightening, on blue paper. Paris, Musée du Louvre, Cabinet des Dessins. (Photo: © Réunion des Musées Nationaux)

the male body as worthy of study? The evidence of their use would have to come from the work itself, in the form of anatomical details or partial and unusual views traceable to observation. A drawing lacking in such details, it follows, could not have been done from life. Such is the drawing in question: it is not a simplified description of a live model but a pure abstraction. This is a type of female figure ubiquitous in the Renaissance and academic tradi-

Figure 86. Rembrandt Harmensz van Rijn, *Female Nude Seated on a Stool.* C. 1654–6. Pen and brown ink, and brush and brown wash. Chicago, The Art Institute, Buckingham Rehabilitation Fund, 1953.38. (Photo: © 1994, The Art Institute of Chicago. All Rights Reserved)

tions, and there is every reason to conclude that it originated not with a live model but in the imagination of the artist.

It may be helpful in this regard to examine one of Rembrandt's drawings of the female nude, both for what the comparison may reveal about the role of the model and also about alternative methods of drawing the figure (Fig. 86).[27] This figure is, if anything, even more economically drawn than that of Boullogne, with fewer notations and less interior modeling. The notations

appear at first to be similar to those of the Boullogne, namely, delineations of the contour – but a closer inspection reveals that these discontinuous straight lines and arcs, rather than tracing the contour, describe shifting planes in space; lines indicate the directions of movement and also diagram the space inhabited by the figure, most obviously those of, and relating to, the stool. The point is not that Rembrandt's way was "better," but rather that it was different, and one reason for the difference surely was his confrontation with a live model in his space.

Rembrandt's is a "realist" figure in the literal sense of aiming to describe a live (real) model. As such, it belongs with Eakins's drawing (Fig. 79), the two being more or less equally distanced from the ideal of the academic tradition. The point here is that it was this ideal which reigned in the academy, and, insofar as the female figure was concerned, it tended to engage the imagination of the artist rather than to emerge from a discriminative study of the live model. There is every reason to believe, in other words, that the female nude of the academy, from the sixteenth to the nineteenth century, more often than not originated in something other than a live model.

At times, it is possible to determine what that something was. An example is a drawing by the nineteenth-century American artist William Page of a thoroughly idealized figure that quite clearly was derived solely from an antique torso (Fig. 87).[28] Indeed, the antique had so strong a hold on the imagination of the academic artist that even drawings from the live model made late in the nineteenth century can seem more ideal – in the sense of imaginary – than real. A case in point is a drawing by Bouguereau of a female nude that seems hardly less abstract than the Page (Fig. 88).[29] Like the latter, studied in connection with a Venus, this figure is all contour and broadly modulated form, with little anatomical content. Yet there is a ponderousness to this figure that Page's *Venus* lacks; particularly striking is the rendition of the positions and movements of the limbs as weighty forms reposing in space. On the basis of these features one would have to conclude that this figure, for all its generality, was studied from life.

Drawings of the female nude are not the only ones so general and abstract that it can be hard to say about any one whether it is a strictly imaginary construct or a figure based on study of the model. One such example, dating from early in the history of academies, is a study by Le Brun, made in connection with his *Alexander at the Tent of Darius* (Fig. 89; cf. Fig. 36).[30] A figure no less simplified than the Venuses of Page and Bouguereau, this Alexander equally embodies a vision of the antique. Because only the antique originals are so perfect, one would expect that one of them, rather than a live model, was the source of this study.

An antique model was indeed the source of a related study for the head of

Alexander: an antique medal with Alexander's name inscribed on its reverse. (It turned out that the head was in fact a representation of Minerva.)[31] Is the head of the figure study not based on this drawing after the antique? And do the other forms of that study not trace their origins equally to the balanced rhythms of antique sculptures rather than to a live model? No part of this study can be said unequivocally to be a notation of a natural form. Le Brun obviously was an artist who knew the male nude by heart as that nude had been represented by the ancients. As this was the nude embodying the synthetic form that the academy had in view, why would he have bypassed it in favor of a live model? At the same time we know that study of the live model was considered indispensable if figures were not to become static, though here, too, information from nature was to be manipulated according to a vision grounded in the antique. Is the figure study of Figure 89 the result of such a manipulation, a study of the model "perfected"? It is not possible to say that it is or is not.

More definite conclusions can be reached about the studies in Figures 82–4, namely, that they originated with live models, which, as I remarked, were adjusted and "corrected." It is necessary to look more closely at these "corrections"; for an awareness of the academy's doctrine, and our knowledge that art students were apprenticed to the antique long before being afforded a glimpse of the live model, would lead us to assume that adjustments were made in the spirit of the antique and also in direct recollection of specific prototypes. The assumption, in other words, is that research into the antique was channeled into studies of the model. Although this was true in principle, the process whereby the model was transformed was far more arbitrary than the theory would lead one to expect.

Figures 90 and 91 are typical drawings of the male nude from the nineteenth-century French academy.[32] Obviously studies from the live model, they are translations of the figure of the types of the *académies* examined earlier, though the forms are perhaps even more generalized and "sculptural"; these forms are characterized, indeed, by an exquisite smoothness suggestive of marble. Much the same could be said of another nineteenth-century "academy," this one by the American Daniel P. Huntington, which is similar in contour and form (Fig. 92).[33] The similarity would be the result, one would imagine, of consulting a like antique prototype, say, the *Apollo Belvedere* (Fig. 74). But there are notations in these studies that do not correspond to nature or the antique; especially striking are the undulant concavities and convexities of the thighs and calfs, which describe neither actual muscles nor the forms of antique sculptures. During the long course of working from the model – ordinarily one month for the same drawing – a time of constant reworking and "finishing," certain forms evidently were

Figure 87. William Page, *Study for Venus*, 1857. Pencil. Washington, D.C., National Museum of American Art, Smithsonian Institution, Gift of Pauline Page Howell. (Photo: National Museum of American Art, Smithsonian Institution)

routinely accentuated as being important in their own right, which is to say that they were dictated by a taste for the graceful and elegant. In question was not what could be observed in nature or how nature could be "improved" upon by applying lessons learned from the antique, but rather, and quite strictly, the academy's notion of the "artistic."

It should be stressed in this regard that these life drawings are not more deeply indebted to the "science" of anatomy than to the antique. This study has been mentioned repeatedly in this and preceding chapters, and it is pictured in representations of academies from Rome to Philadelphia (Fig. 9); proficiency in it was a prerequisite for admission to the nineteenth-century French academy. One point to be made is that up until that century anatomical facts in most cases were learned from books and casts, particularly the

Figure 88. William-Adolphe Bouguereau, *A Nude Study for Venus,* 1865–9. Pencil, heightened with white. Williamstown, Massachusetts. Sterling and Francine Clark Art Institute, (Photo: Sterling and Francine Clark Art Institute)

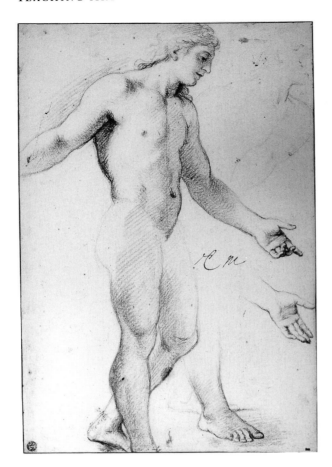

Figure 89. Charles Le Brun, *Figure Studies.* Black chalk. Paris, Musée du Louvre, Cabinet des Dessins. (Photo: © Réunion des Musées Nationaux)

flayed figures known as *écorchés,* and not from infrequent and morally problematical medical dissections.[34] (The dissection in progress in the academy of Fig. 9 pictures an ideal of the theoretical literature and is of no documentary value.) Such an *écorché,* unusual for being life-size, is shown in the corner of the life room of the Royal Academy (Fig. 18). The life studies here examined are no more transcriptions of the information in such sculptures, however, than they are direct copies of live models with "corrections" based on the antique. What all these drawings show, to put in other words the observation made above, is the academy transmitting values that fall under the heading of the "aesthetic" and not the "scientific." Indeed, much in the "science" of anatomy was aesthetically suspect. Ingres's well-known antipathy may have been extreme – he called anatomy a horrid science (*science affreuse*) – but it did not seriously conflict with the academy's aesthetic, which he wholeheartedly endorsed.[35]

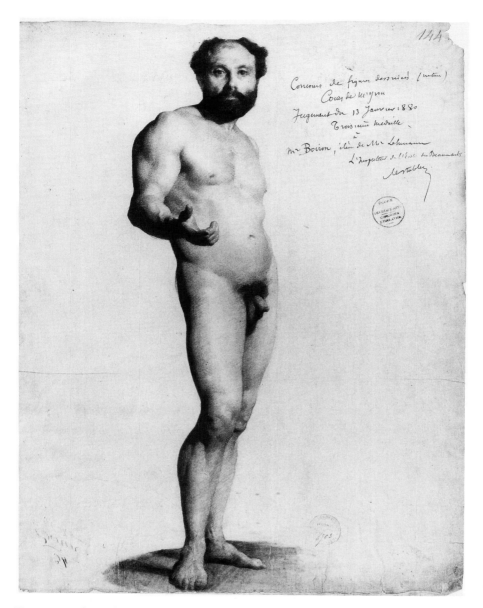

Figure 90. Alexandre Emile Boiron (pupil of Lehmann), *Académie.* 1880. Black chalk. Paris, Ecole nationale supérieure des Beaux-Arts. (Photo: Ecole des Beaux-Arts, Paris)

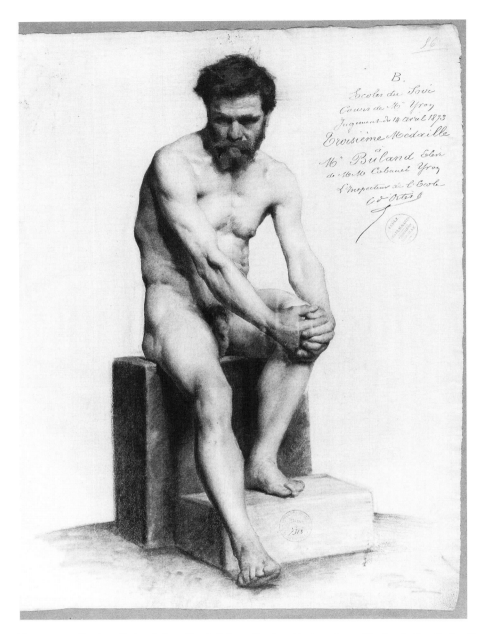

Figure 91. Eugène Buland (pupil of Cabanel), *Académie*. 1873. Black chalk. Paris, Ecole nationale supérieure des Beaux-Arts. (Photo: Ecole des Beaux-Arts, Paris)

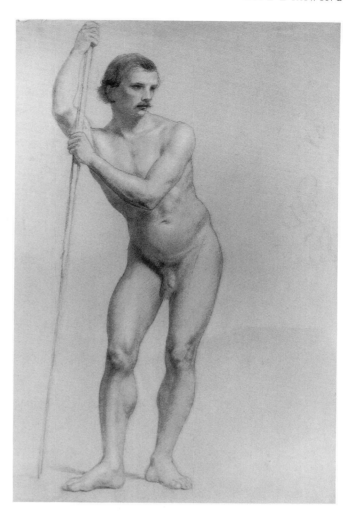

Figure 92. Daniel P. Huntington, *Male Nude.* 1866. Black-and-white chalk. Washington, D.C., Cooper-Hewitt Museum of Design, Smithsonian Institution. (Photo: Cooper-Hewitt Museum of Design, Smithsonian Institution)

THE AVANT-GARDE AND THE MODEL

It is no secret that the avant-garde rejected this aesthetic, particularly as it affected life drawing. There is no scarcity of testimony to this effect. Redon wrote of his study under Gérôme:

Whether he recognized the sincerity of my serious inclination for study, or whether he saw in me a timid person of good will, he tried visibly to inculcate in me his own manner of seeing and to make me a disciple – or make me disgusted with art itself. . . . He extolled me to confine within a contour a form which I myself saw as palpitating. Under pretext of simplification (and why?) he made me close my eyes to light and neglect the viewing of substances. . . . The teaching I was given did not suit my nature.[36]

The American sculptor Saul Baizerman, who studied in the National Academy of Design in 1910 and then in the important New York academy, the Beaux-Arts Institute of Design, until 1920, recorded a similar experience in his journal:

Recalling my school years, I remember how unhappy I was upon seeing the results of my efforts and those of my co-students. None of the pieces we produced seemed to me to possess any life-sensations. They appeared to me petrified, immobile, and artificial and commonplace. We usually had four weeks with the same model and the same pose. The first few days everybody was enthusiastic. The action of the figure was exaggerated, lively, and suggestive. But as the days went by, all the life oozed out of the work. And to see a row of similar, equally deadened figures encircling the live model was a painful sight. In the second week, they looked worse, and still more hopeless in the third. The fourth and last week saw a change. Some showed some suggestion of returning to life while others were hopelessly dead. What caused these changes that repeated themselves every four weeks, as though they followed a well-greased rail? This was the pattern: lively movement, distorted forms, disproportion. This was followed the next week by filling in the hollows, stressing equally every part, more reality in the proportions of the parts to the whole, in general a better copy of the appearance of the model. The third week was a continuation of the same equalizing of forms, evenness of tone, proportion and emphasis, a greater accumulation of subdivided forms. With the development of reality in the figure, it became more difficult to give variation to the forms. They began to repeat themselves in size, in tone, and in stress. The balance in the action of the pose and the form's proportion would tend to deaden the expression. During the fourth week, the more advanced students developed numerous details to show their craftsmanship, prove their possession of knowledge, experience, but also with an anemic academic expression.[37]

The moderns, then, repudiated the teaching of life drawing by the academy in word. That they did not do so in deed is suggested, however, by the revisionist historians who have placed their figure drawings firmly in an academic context – most notably Albert Boime, who has written, as noted in Chapter 3, of how such artists as Degas, Van Gogh, Seurat, and Matisse "extended their life drawing practice into their mature work," and of how Van Gogh was "a true heir of the academic tradition."[38] (Baizerman's statement, it should be noted, underscores a blunt separation between the method of the academy and his later life studies, such as Fig. 93.) Boime elaborates:

The 19th century academic drawings have increased sharpness and cleanliness, sustained not only by the direction of the design but by the light and shade patterns. The forms are clear, unambiguous and follow an abstract conceptualization. Often we can trace the line of action by observing the light and dark pattern . . . Degas's reclining figure – and indeed, all of his early drawings and paintings from life – attest to his total assimilation of the academic process. The line of action generates the shaded upraised arm, the left side of the torso emphasized by the background shadow, the curve of the left thigh, the shadow of the leg rest and finally the shading of the right leg . . . Seurat also shows this development from the academic to his

Figure 93 (left). Saul Baizerman, *Female Nude.* After 1931. Black chalk. Walter Clinton Jackson Library, The University of North Carolina at Greensboro. (Photo: Walter Clinton Jackson Library)

Figure 94 (right). Hilaire-Germain-Edgar Degas, *Study of a Man Standing, Seen from the Back.* 1855. Charcoal. Ottawa, The National Gallery of Canada. (Photo: National Gallery of Canada, Ottawa)

later – almost caricatural – approach. The examples illustrated demonstrate that he retained the succinct gesture and massed in his shadow to accentuate it.[39]

The Degas drawings in question are studies such as Figure 94, which does indeed reflect, in its compact form and fluent contour, the academy's teachings, to which he was exposed in the 1850s, teachings most clearly exemplified by the drawings of Ingres (Fig. 95).[40] Because the figure remained central to Degas's art, he continued to draw from the live model long after this time. But if his later approach builds on the academy's teachings in some respects,

Figure 95. Jean-Auguste-Dominique Ingres, *Study of a Seated Man.* Black chalk. New York, The Metropolitan Museum of Art, Rogers Fund, 1961 (61.128). (Photo: The Metropolitan Museum of Art, New York)

as Boime suggests, it deviates from it in others. In a typical study such as Figure 96, for example, the figure is described with broken and repeated lines, avoiding the final statement of the contour on which the academy insisted and that is so insistently articulated by Ingres (Fig. 95). If it is salutary to place Degas's early figure studies in the context of the academy's teaching, his later studies, it is as important to note, are clearly at odds with this teaching and cannot be so placed. Differences between the two periods, it is perhaps worth noting, may have resulted in part at least from his commitment to drawing from memory, a key practice within the Renaissance tradition systematically formulated at this time by Lecoq de Boisbaudran. "It is very good to copy what one sees," Degas asserted; "it is much better to draw what you can't see any more but in your memory." And he claimed that if he were to have an art school, he would put the model on one floor and have the

Figure 96. Hilaire-Germain-Edgar Degas, *Standing Female Nude.* C. 1880–3. Pastel and charcoal. Paris, Musée du Louvre, Cabinet des Dessins. (Photo: © Réunion des Musées Nationaux)

students draw on another.[41] But an even more basic objection to linking Degas's method to that of the academy, as though his later concerns were prefigured in his student works, is the fact that the conceptual focus of the one is blurred as much as that of the other.[42] And it is equally an oversimplification to speak of the sameness of Seurat's figures, some of which are strikingly "academic" – for example, those in *Les Poseuses* – while others are abstractions that the academy would have found incomprehensible.

Of the modern artists inserted in the academic tradition in Boime's argument, however, none fits so badly as Van Gogh. For though the figure and drawing itself played central roles in his art, they were approached with a passion proscribed by the academic routine, Van Gogh allowing himself neither the time nor the distance envisaged by academic theory and practice.

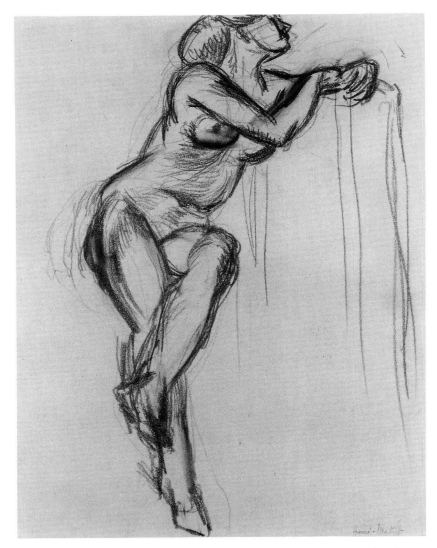

Figure 97. Henri Matisse, *Nude,* c. 1907 (?). Pencil on paper. New York, The Metropolitan Museum of Art, Alfred Stieglitz Collection, 1949 (49.70.8). © 1995 Succession H. Matisse, Paris/Artists Rights Society (ARS), New York. (Photo: The Metropolitan Museum of Art, New York)

And if his commitment to drawing as such seems to recall that of the academy, it is drawing of a very different kind: indifferent to anatomical and proportional correctness and to the descriptive – as opposed to expressive – function of the contour. For these reasons it is not at all surprising that Van Gogh's work angered, as it continues to dismay, those believing in the value of academic training and discipline.

In concluding these remarks on modern life drawing, it may be worthwhile to consider the practice of Matisse, an artist who, as mentioned in Chapter 3, not only received early training in the academy, but opened a school of his own related to it in the sense that study there consisted of copying casts and drawing and painting from the live model. Matisse's words suggest, however, as was noted above, that he understood the importance of confronting the model differently from the academy, and this difference is brought out by his own drawings.[43] Indeed, it is not possible to conceive of figure drawings more different from those of the academy than Matisse's.

Consider the drawing in Figure 97, dating from the general period of his own school ("academy"). To begin with, he has nowhere attempted to "correct" the lines translating his first response to the model, a response in which anatomy and "correct" proportion were of little – or no – concern. Thus, the lines only roughly approximate the contours of muscle groups and often, as in the legs, largely disregard them. Cézanne's words about the absence of contours in nature – "contour escapes me"[44] – might as well have been uttered by Matisse. In place of such definition is an instinctive apprehension of the movements of lines and planes in space, recorded in more or less spontaneous gestures. It was evidently to this kind of response that Matisse was referring when he spoke of an "awakened emotion" that it was the task of the artist to express.[45]

Such, then, are a few of the modern approaches to life drawing. If they are not all precisely the same – Degas's being the most conservative, Van Gogh's and Matisse's the most radical – what they nevertheless share in common is a rejection of the system imposed by the academy for some three centuries and, ultimately, of drawing in the Renaissance tradition. If this has not been altogether clear, no doubt it has been because in the history of art teaching after Matisse the question, from having been one of *how* to teach the figure, became whether the figure should be taught at all. This further transformation and ultimate displacement of the traditional figure in modern teaching will be considered in Chapter 13.

ART AND SCIENCE

One eighteenth-century treatise explained that underlying the academy's teaching of drawing in stages, from drawings to casts to the antique and the live model, is the assumption that only in this way can it be grasped as a "science."[1] This appeal to science is a constant refrain in academic discourse, that of Reynolds being no exception:

This notion, therefore, of leaving any thing to the imagination, opposes a very fixed and indispensable rule of our art – that every thing shall be carefully and distinctly expressed as if the painter knew, with correctness and precision, the exact form and character of whatever is introduced into the picture. This is what with us is called Science, and Learning.[2]

When artists in the Bauhaus spoke of the centrality of science to visual art they had in mind the exact research and objective standards to which Reynolds, in his own way, refers. The first Bauhaus manifesto outlines a program that contains a category headed "Training in Science and Theory," including the "Science of materials" and "Physical and chemical theory of color."[3] Typical Bauhaus exercises were "analytical" drawing and color "experiments." The need for such exercises was explained by Kandinsky in his Bauhaus Book of 1926:

Painting, especially, has advanced with almost fantastic strides during the last decades, and it has only recently been freed from practical meaning and liberated from the necessity of responding to the many purposes it had earlier been forced to serve. It has attained a level which imperiously demands that an exact scientific examination be made about the pictorial means and purpose of painting. Without such an investigation, further advance is impossible – either for the artist or the general public.[4]

This trust on the part of artists in the authority of science was founded on a long history, the pattern of which was already clear long before the utterances of Reynolds and Kandinsky. A famous remark by Leonardo expresses the vision and defines the means. Artistic practice is born of science, he states, without which it is like a ship lacking a compass and a rudder; the "science" of art to Leonardo's mind was geometry – that is, proportion and perspective.[5] Leonardo's remark echoes one made by Alberti, who had urged the painter to study all the liberal arts, but one of them in particular: geometry.[6] Linked to a liberal education, geometry belongs as much to theory and learning as it does to "science." And it is in this broad sense that Reynolds's remark about the importance of "Science and Learning" to the visual artist must also be understood: art as knowledge.

Science in a more restricted sense also has been associated both with Leonardo and with academies. Much has been written about Leonardo's "scientific" activities or, more accurately, whether and to what extent these activities were scientific in the modern sense of the term.[7] And academies have been widely regarded either as quasi-scientific bodies or, at the very least, centers for directing the procedures and discoveries of science into artistic channels. What may have resulted from the intersection of art and science has not been made at all clear, however. Not clear, that is to say, is the scientific status of the art of the academy or, conversely, the artistic potential of scientific methodologies. These problems are nowhere more sharply focused than in the French academy in the seventeenth century, when the new science first acquired the aura that ever since then has been attached to it. In this chapter two instances of the encounter of art and science in the seventeenth-century French academy will be examined. A discussion will follow of the relation of art to the scientific enterprise as we understand it today in a school about which little has thus far been said in this study: the Bauhaus.

MATHEMATICS, KNOWLEDGE, AND SCIENCE

In the first publication to carry the name of the newly created Royal Academy of Painting and Sculpture in Paris, Bosse's *Sentimens sur la distinction des diverses manières de peinture, dessein et graveure* (1649), is a discussion of imitation of a kind that should by now sound familiar. Art is the ideal imitation of nature based on judicious observation; imperfect nature is to be corrected according to a standard derived from ancient sculptures and the works of Raphael.[8] There is more than this, however, to Bosse's theory. As in art treatises in the Italian Renaissance tradition, Bosse discusses, in addition to imitation proper, the principles of decorum and proportion; and he discusses perspective – at great length. It is this aspect of Bosse's theory which is

most distinctive and has seemed most problematical to students of theory in the Renaissance tradition and of the French academy.[9] For whereas other members of the academy during and after Bosse's time advised artists to study geometry and perspective, as these studies had been recommended earlier by virtually every writer, Bosse identified the pictorial arts with these procedures; perspective and painting, the second, called by him "portraiture" or "representation," are synonymous. In the first pages of the *Sentimens,* he asserts: "The practice of this noble art of painting must be grounded as much as possible in a process that is orderly and exact, which is to say geometrical and, therefore, demonstrative."[10] This same injunction is repeated throughout the treatise: "All paintings not carried out according to the rules of perspective are necessarily incorrect. . . ."[11]

What Bosse finds so compelling about perspective is that it provides the means for designing pictures, the correctness of which is guaranteed and may be demonstrated mathematically, a procedure recommended by its objectivity. This dedication to perspective – we would call it an obsession – brought him into conflict with some other members of the academy, leading to his expulsion in 1661. For this reason, it must be stressed that this preoccupation was not his alone. Roland Fréart, Sieur de Chambray was another writer who agreed about the centrality of geometry and perspective to the pictorial arts.[12] And this belief was widespread in other fields, whether philosophy, science, or religion. There is indeed nothing more characteristic of learned discourse in seventeenth-century France than its appeal to the method of geometry.[13] And it was from one of the best minds engaged in such discourse that Bosse learned his method and no doubt acquired his values, the mathematician Girard Desargues. Bosse's technical publications from 1643, except for one on engraving, are applications of Desargues's work in geometry – for example, *Manière universelle de Mr Desargues pour pratiquer la perspective.*[14]

Desargues made one of the potentially most important mathematical discoveries of the seventeenth century, which was the Universal Method (*Manière universelle*) of Bosse's title. This was a method of projection defining the properties common to a figure and its section, thereby establishing the basic relationships of a projective geometry.[15] Utilitarian in outlook, Desargues wanted his discovery to be used to simplify practices based on geometry, that is perspective, and those other procedures discussed by Bosse in treatises applying the Method. Desargues exchanged views with some of the most important thinkers of the time, among them Pierre Gassendi, Etienne Pascal, Marin Mersenne, and René Descartes. These were men who shared his conception of knowledge, focusing, as he and Bosse did, on the certainty of mathematics: nothing that is known is necessarily true except for mathematical knowledge, which is demonstrable and, therefore, paradigmatic.

One especially telling example is a book published by Mersenne in 1625, *La Vérité des sciences*.[16] This is a work of more than a thousand pages, summarizing the arguments of skeptics and *libertins* who would undermine religion, science, and morality by claiming that nothing may be known with certainty. In the first book, Mersenne attempts to answer, without notable success, the arguments of the skeptics. Books 2, 3, and 4 deal strictly with mathematics, and at the outset of book 2 Mersenne remarks: "After having discoursed on science in general and after having shown that it is not always necessary to suspend our judgement, nor about all things, I wish now to show that mathematics is a certain and true science, in which the suspension of belief has no place."[17]

The certainty of mathematics derives from its abstraction. The number 4 applies to any four entities; in Euclidean geometry, the angles formed by the intersection of two straight lines always will be right angles or angles equal to right angles, and so on. Mersenne does not attempt to show how such abstractions are known in the real world. Another of the contemporaries of Desargues and Bosse did: Descartes.

Like Mersenne, Descartes viewed mathematics as the model for the other sciences because of its certainty. Up until now, he remarks, "only mathematicians have been able to discover demonstrations, that is to say certain and evident explanations."[18] As a mathematician, Descartes made a discovery that opened up the possibility of translating mathematical certainty to other fields. This was a new mathematical system establishing an exact correspondence between numbers and space, a symbolic algebra or analytical geometry joining algebra to geometry.[19] Understanding that the essence of matter is that it is extended in length, breadth, and depth, Descartes conceived the possibility of describing the material universe in terms of mathematical relations, with demonstrations thereby woven into explanations of physical phenomena. One such demonstration is part of *La Dioptrique,* a work appended to the *Discours de la méthode,* of 1637.[20]

Concerned with establishing the exact law of the refraction of light, Descartes focuses attention on its activity, leaving aside questions usually raised in treatises of this kind, of the nature of light and light rays, and so on. He begins with analogies, the way a blind man, or a man in the dark, feels his way around with a stick. And he then proposes that light rays may usefully be compared with tennis balls striking or penetrating surfaces (Fig. 98). From tennis balls, he passes to light itself (Fig. 99), the one, as the other, used in the development of a mathematical explanation. Despite the encomium to vision in *La Dioptrique,* in other words, Descartes no more observed the activity of light than he gauged the trajectory of actual tennis balls. What Martin Jay recently has called "Cartesian perspectivalism" and

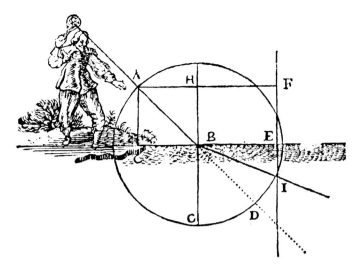

Figure 98. Light Rays as Tennis Balls. From Descartes, *La Dioptrique,* 1637. (Photo: Author)

Figure 99. Light Rays Striking a Crystal Ball. From *La Dioptrique,* 1637. (Photo: Author)

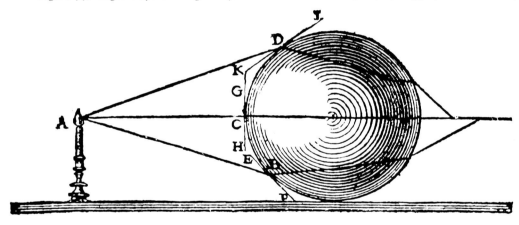

mistakenly characterized as a "quintessentially visual" practice was, in fact, the opposite, a deductive method founded before anything else on the certainty of mathematical demonstrations.[21]

Bosse does not ask questions of the mysteries of art any more than Descartes does of nature. He asserts, as we have seen, that the pictorial arts must be grounded in the geometry of perspective, for artistic practice then becomes mathematics, with knowledge of correctness or achievement sure and demonstrable. Bosse's program was based, too, as was Descartes's, on a methodological breakthrough, Desargues's Universal Method, which made more exact, as well as simple, all practices based on geometry.

There appears to be one difference between the two systems, and it is in

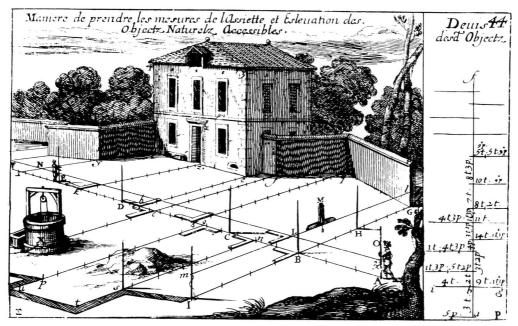

Figure 100. Abraham Bosse, *Measuring Plan and Elevation.* Engraving from *Traité.* 1665. (Photo: Author)

the seeming empiricism of that of Desargues—Bosse, based as it is on actual measurements; Figure 100, for example, shows men measuring a space in the manner of surveyors.[22] And this perspective practice always begins with such measurements, with a determination of plan, profile, and elevation in a given space. Bosse's Method departs from and rationalizes the world, however, as much as Descartes's. For it is the object that is seen from a given position and distance; the section of the object is arrived at with perspective scales, and these scales are ruled not by numbers derived from the world but rather by mathematical relations. The result: visual art becomes the ideal of a mathematical science in the sense of Mersenne and Descartes.

Here, two observations need to be made. The first concerns the stress on, and even obsession with, mathematical demonstration in seventeenth-century France. It is by now clear that this extraordinary regard for mathematics was a consequence of the Reformation.[23] During the course of the conflict between reformers and the Catholic church, the one thing that each side seemed to have shown was that the other side had no way of proving the correctness of its assertions. What was required was a new and infallible criterion of knowledge and truth. It was assumed that this same criterion would serve as a foundation for all areas of human knowledge. Mathematics provided the model for such a criterion, as mathematical propositions are infallibly and demonstrably certain.

The second observation has to do with the relation of deductive to induc-

tive reasoning at the time. For while the abstractness of mathematics furnished the model of a certain science, it also provided a means of investigation central to the scientific revolution of the seventeenth century.[24] Although we tend to think of modern science as quintessentially empirical, mathematical formulation and deduction were essential to the enterprise, for purposes both of description and explanation, the latter to be verified by observation and experimentation. It was on the basis of mathematical calculations, particularly in physics, astronomy, and mechanics, that old theories were rejected and new ones formulated that helped to shape the modern view of the world. The assumption, summed up in Descartes's phrase "as if by a natural geometry," was of a fundamental correspondence between mind and matter going deeper than appearances.[25]

But what does all of this have to do with the academy, whose universe was that only of the pictorial and plastic arts? Several artists of the academy are known to have supported the position of Bosse, among them La Hyre and Le Sueur.[26] But another academician was not of their opinion about the importance of this rigorous perspective method. He was also an artist of increasing influence during the 1650s: Le Brun. Le Brun was Bosse's principal antagonist in the academy, for reasons not difficult to understand, for during that decade Bosse frequently criticized Le Brun's works, using his method to demonstrate Le Brun's "mistakes." The most well documented of these criticisms is one dating from after Bosse's expulsion from the academy.

This was in 1668, when Charles Perrault published a poem filled with praise of Louis XIV and his artists, especially Le Brun.[27] On two folios of the publication are engravings after designs by Le Brun, whose low opinion of perspective Perrault shared. Bosse responded to this publication, therefore, with one of his own, commenting on the contents of the poem and singling out one of Le Brun's designs for – as he no doubt would have put it – constructive criticism. It is an illustration of a passage in the poem that retells one of the myths about how painting originated when a shepherdess traced the profile of her lover (Fig. 101). Bosse remarks:

I was curious enough to make a drawing such as it should have been, because the arm of the shepherdess would have to be five or six feet long to reach that wall from her position, and the shadow cast by the table on the floor, besides being half the size it should be, doesn't extend to the wall that it touches, nor is there a shadow of the lamp, which, in any case, is too small. The profile of the shepherd on the wall is wrong, because it is not larger than in life, which would be correct by daylight, but thrown by the light of the lamp it should be infinitely larger. There are other mistakes, too many to mention.[28]

If this test by means of mathematical analysis was failed by Le Brun, it also presented difficulties for the idol of Bosse, as of Le Brun: Raphael. In the

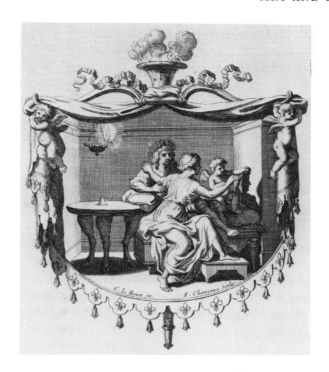

Figure 101. F. Chauveau, after Charles Le Brun, *The Origin of Painting.* Engraving from Charles Perrault, *La Peinture, poëme,* 1668. Paris, Bibliothèque Nationale. (Photo: © cliché Bilbiothèque Nationale de France, Paris)

Sentimens, Bosse notes that few old paintings will pass the test of a rigorous mathematical analysis. As he sees it, this in no way calls his criterion into question: "it seems to me that it is not a question of what has not been done or is not being done but only what it is reasonable to do."[29] This was the principle with which Le Brun and his party in the academy could not agree. As the doctrine articulated in the academy makes clear, their yardstick was the practice of the masters, not theory, no matter how ancient its lineage or noble its purpose.[30] If the masters had not applied the precepts of "scientific" perspective, it would be folly for the artists of the academy to do so. And, indeed, Le Brun proposed a perspective system as an alternative to Bosse's that is not at all systematic: the "unscientific" perspective of Le Bicheur, in which the positions of objects are approximated – what artists today would call "eyeballed" – with regard to an arbitrarily divided plan.[31]

In the dialectics of the seventeenth-century French academy, then, scientific perspective was rejected out of a respect for practice, Le Brun opting for the "unscientific" procedures on which the works of the most esteemed of the Renaissance masters typically were based.[32] Are these works, or his, any the worse for shunning scientific rigor? Would the drawing in Figure 101 be "better" if the walls of the chamber were moved or the shadows enlarged or lengthened? What role, in sum, do the numbers and figures of mathematics have to play in the figurative arts? A very small one, it evidently was con-

cluded during the larger part of the academic tradition. For though virtually all academies were obliged by statute to teach perspective, as urged by the theorists of the Renaissance tradition, from the sixteenth to the eighteenth centuries typical reports are of how the course is being neglected. Nor is there evidence in the works produced in academies during these centuries of a significant interest in geometrical perspective. The association of perspective and academies is due principally to the stress placed on the subject, as evidenced by both courses and competitions, in the French academy during the years after the reform of 1863. It was only from this time on that perspective became a regular part of the academic routine in academies around the world, particularly those influenced by the French.[33]

THE SCIENCE OF EXPRESSION

Le Brun's behavior may seem to confirm an old suspicion about the academy being intrinsically reactionary, as to reject the perspective of Desargues-Bosse was to take a stand, it would seem, against the progress represented by modern science. Is this heavy-handed refusal to accept the new, whether in art or science, not typical of the academician? In the case of Le Brun's attitude toward science, the answer is that it was not. For even as he opposed one attempt to lift art into the realm of science, he supported another. This was his investigation of expression, or the "passions of the soul," referred to earlier.[34] It was in three parts: expression in painting in general, the passions of the soul, and physiognomic expression.[35] A treatise on expression was published posthumously, in 1698, with a summary of the physiognomic research; but this and subsequent publications recuperate only a small part of the corpus of drawings made by Le Brun in connection with this project.[36]

Le Brun was not the first artist, of course, to focus attention on expression. A major preoccupation within the Renaissance tradition, expression was discussed by the principal theorists from Alberti on, as it was explored by artists from Giotto on.[37] Leonardo is especially closely associated with this study as, in Le Brun's time, were Poussin and Rembrandt, whose self-portraits frequently served this purpose. In one early etching, for example, Rembrandt scrutinizes his own features in a mirror to translate the look of fear (Fig. 102).[38] And the study of expression, frequently in front of a mirror, was common in the subsequent centuries as well. A self-portrait drawing made by Reynolds conveys an emotion related to that of the Rembrandt (Fig. 103).

Le Brun's drawings, while similar in intent, shift the terms of the investigation from nature to art; rather than contemplating his own features in the mirror, he conducts a review of the history of art – his own and also that of the classical tradition – mining images he had created earlier, particularly for his Alexander series (Fig. 104; cf. Fig. 36), as well as ancient representations

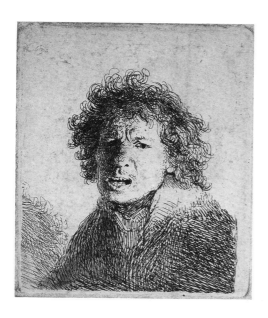

Figure 102. Rembrandt Harmensz van Rijn, *Self-Portrait Open-Mouthed, as if Shouting.* 1630. Etching. London, The British Museum. (Photo: Courtesy Trustees of the British Museum)

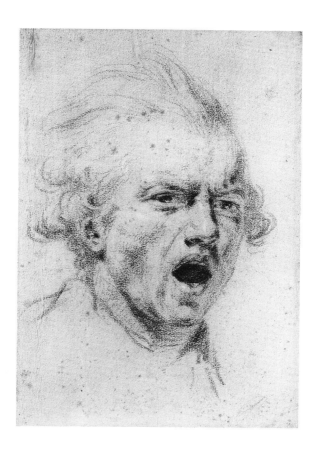

Figure 103. Sir Joshua Reynolds, *Self-Portrait as a Figure of Horror.* Black chalk. London, The Tate Gallery. (Photo: The Tate Gallery, London)

Figure 104. Charles Le Brun, *Admiration with Astonishment. Egyptian Slave,* from his *Alexander at the Tent of Darius.* Black chalk. Paris, Musée du Louvre, Cabinet des Dessins. (Photo: © Réunion des Musées Nationaux)

of such figures as Hercules, Nero, and Jupiter (Fig. 105; cf. Fig. 66).[39] He then proceeds to analyze these existing images, to put into words what it is that makes them expressive. He explains how changes of emotion are accompanied by movements of the pupil, eyebrow, nose, and mouth. The neutral and basic state of the soul is one of wonderment, he claims, which gives way in a positive state to esteem: the mouth begins to open, the nostrils to descend toward the mouth, the eye to turn upward. In a further intensification of this state, esteem turns to love; the brow smoothes and the mouth begins to rise,

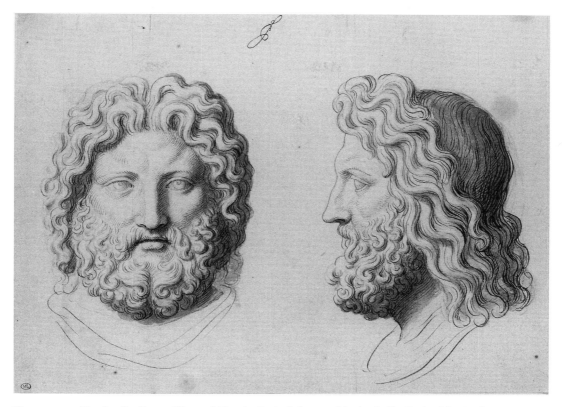

Figure 105. Charles Le Brun, *King of Greek Gods.* Ink over black chalk. Paris, Musée du Louvre, Cabinet des Dessins. (Photo: © Réunion des Musées Nationaux)

while the head inclines toward the object of love, and so on, to account for the expressions of other emotional states.[40]

In his physiognomic investigations, Le Brun explains that the essential instincts (*esprits animaux*) that circulate in the body are recapitulated in the animal world, in which they are easier to recognize, so that through the resemblance of people to animals basic character traits are revealed. He proposes, moreover, that these traits are measureable, the geometry of the profile of the animal being particularly transparent; straight lines drawn through the eye, nose, and forehead will show whether this is a noble or a disgraceful beast – or a human soul resembling that of the animal portrayed (Fig. 106).[41]

This appeal to the authority of geometry valorizes a procedure that, in the case of perspective, Le Brun seemed to have repudiated, and that is especially closely associated with Descartes and his method. And it was long ago realized that Le Brun's handling of expression is indeed Cartesian in the most literal sense: he transcribed whole sections of Descartes's own *Traité sur les*

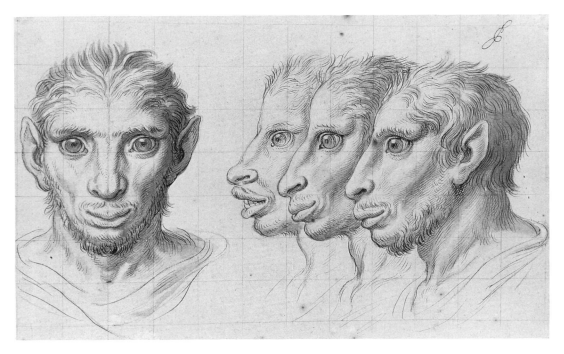

Figure 106. Charles Le Brun, *Physiognomic Sketches, Man and Donkey.* Brown ink and gray wash over black chalk. Paris, Musée du Louvre, Cabinet des Dessins. (Photo: © Réunion des Musées Nationaux)

passions de l'âme in his *Conférence.*[42] Le Brun's investigations were carried out, then, in the spirit of Descartes's "mechanical philosophy" and of the new science grounded in it. What must be stressed is that, insofar as expression was concerned, science did not contradict the practice of the masters, as Le Brun understood that practice, but was rather in harmony with it, so that the exhilaration of the new scientific enterprise could be experienced without in any way compromising the commitment of the academy to the Great Tradition.

BAUHAUS SCIENCE

Having rejected much that this tradition stood for, and aiming to abolish the old academies, the Bauhaus is perhaps the last place in which one would expect to find an echo of Le Brun's ideas.[43] Yet in the pages of its publications is an image that is Le Brun–like in the sense of tracing its origins to a common source, namely Descartes's "mechanical philosophy." The image is Oskar Schlemmer's seal (Fig. 107), the center of which is the profile of a man that is admittedly inexpressive but, even more clearly than Le Brun's expressive heads, is a human machine. After the seventeenth century, Descartes's

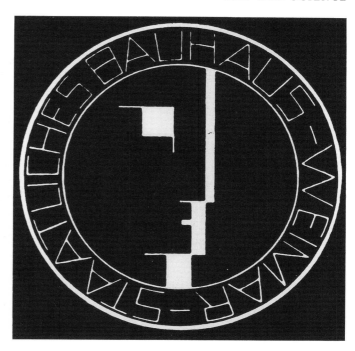

Figure 107. Oskar Schlemmer, *Bauhaus Seal.* 1921. © The Oskar Schlemmer Family Estate and Archive, Badenweiler, Germany. (Photo: Author)

contrast of men and animals – his claim that the behavior of the latter could be explained as though they were machines whereas man's capacity for speech attests to the presence of a soul – was largely ignored, and by the early twentieth century the human body was commonly regarded as yet another machine; in the social and political ideologies that addressed issues of modernization, the working body was treated as though it were a motor, the worker a laboring machine.[44]

It was in response to such issues that the Bauhaus was founded, the central one being that of the demands of mechanized production, which it addressed, increasingly after 1923, by calling for a unity of art, science, and industry.[45] Its approach to problems of production was "scientific," in the sense of stressing the importance of empirical investigation and analysis and of viewing the worker, in the then current "scientific" manner, as a measurable laboring entity or machine. But the Bauhaus was even more deeply infused with the idea of science, so that to speak of Bauhaus teaching is to evoke an image of artists conducting research into the various areas of visual activity.

In an organization as complex and conflicted as the Bauhaus, to speak of teaching quite clearly is to refer to the ideas and courses of specific teachers – for "scientific" teaching, Kandinsky most of all and also Klee. It was Kandinsky who, speaking in a tone of absolute authority, was in the habit of

referring to science and of proposing problems for scientific investigation. For the wall-painting workshop that he taught, he distinguished two such investigations, "which embrace the nature of color in the sense which is most essential for the workshop: 1. The chemical-physical characteristics of color – its material substance. 2. The psychological characteristics of color – its creative forces."[46] More well known still is the problem of the properties of color that he addressed in a questionnaire with the following instructions: "1 – Fill these three figures [square, triangle, and circle] with the colors yellow, red, and blue; 2 – If possible, provide an explanation of your choice of color."[47]

Frequently citing the discoveries of mathematics, physics, chemistry, physiology, and psychology, Kandinsky would interweave the terms of art with those of the sciences, applied metaphorically to art: sounds, growth, collision, impregnation, heat and cold, spheres of influence, dead points, living forms.[48] The model of science was indicated, ultimately, he proposed, because of similar principles at work in art as in nature; recognizing the "utilization" of line throughout nature, he conceived of the universe itself as a "self-contained cosmic composition."[49] He insisted, nevertheless, on the separateness of art and nature and warned of the dangers of confounding the two. That he and his colleagues were careful not to do so is indicated by their cold reception of Wilhelm Ostwald, an authority on the science of color, when he was invited by Gropius to speak at the Bauhaus in 1927; everyone had difficulty understanding the ideas, we are told, when explained in the language of science. Kandinsky, like many of the faculty, in fact subscribed to the alternative ideas about color of Adolf Hoelzel, who argued in favor of the eye and against the equal partnership of art and science in the study of color.[50] "Science" as evoked by Kandinsky and others in the Bauhaus provided a metaphor, it would seem, rather than an actual model of studio practice.

Klee's lectures, too, have been likened to scientific demonstrations. And his Bauhaus book, *The Pedagogical Sketchbook* (1925), has been placed in a tradition of "scientific" art treatises; his introductory formula, Marcel Franciscono has noted, the point and its extension into lines and planes, already had been used in emulation of Euclid by Alberti and Leonardo.[51] (Kandinsky's treatment of the elements in his Bauhaus book, *From Point and Line to Plane* [1926], has been judged equally systematic, and therefore as scientific as Klee's.)[52] Like Kandinsky, Klee filled his lectures with descriptions of the regularities of nature and examples drawn from the psychology of perception.[53] In one lecture series of 1924 that he called "Pictorial Mechanics of a Theory of Style," he approached the question of pictorial form by way of Newtonian physics, and in particular of changing theories of the concept of energy.[54]

Klee scholars have been quick to draw a distinction, nevertheless, between

his view of science and that of Kandinsky, as also between his scientific discourse and his own art. While belonging to the tradition of Alberti and Leonardo, Klee emphatically rejected the notion that the rules of perspective could be applied scientifically.[55] "The air of science is stronger in Kandinsky's didactic writings than it is in Klee's," Franciscono states, with the aside, "though no one would claim for this reason that they are any more objective." And there is a fundamental ambiguity in Klee's utterances, he notes, as to the possibility of the laws of nature becoming the rules of art.[56] This ambiguity was directly expressed by Klee: "Does then the artist concern himself with microscopy? History? Paleontology? Only for purposes of comparison, only in the exercise of his mobility of mind. And not to provide a scientific check on the truth of nature."[57]

The crux of this ambiguity can be found in the key tenet of Bauhaus teaching, with which Klee and the other members of the staff agreed, namely, that art cannot be taught. This proposition, intrinsic to the philosophy of the school from its founding in 1919, will be examined in Chapter 13. The point to be made here is that it was a view of art as being fundamentally autonomous, relying neither on theory nor science; the only theory it fully endorsed was one, in the words of Marcelin Pleynet, that "affirms art in its transcendental truth."[58] As stated most plainly by Albers at the beginning of his *Interaction of Color:* "This book . . . does not follow an academic conception of 'theory and practice.' It reverses this order and places practice before theory, which, after all, is the conclusion of practice."[59] As theory served to guarantee an afterlife to the masterpieces of the past in the positivistic approach of the academic tradition, Albers is not in fact reversing this order by placing practice first. In his and the Bauhaus conception, as in that of the older academies, "science" could play a role only if, and insofar as, it did not deny the privileged status of art itself.

CHAPTER

IO

 STYLE

Nowhere is the difference between the academy's conception of the history of art as reviewed in Chapter 4 and that of modern and contemporary art historians more dramatically exemplified than in the notion of the master-piece, that object of aesthetic consciousness compromised by Malraux's "mu-seum without walls" and which Walter Benjamin imagined as withering away in the "age of mechanical reproduction."[1] This is the traditionalist paradigm of art history as the story of timelessly beautiful works of art created by a few "immortals" whose achievement defies historical explana-tion. Existing apart from history, such greatness can only be acknowledged or, in the academy, imitated by returning to the past of the ancients and such modern greats as Raphael, Poussin, and Le Brun.

So conceived, art transcends not only history but culture; it is a matter of beauty and not of function or meaning. Questions of its role in society, of who or what purpose it served, are therefore redundant. What is important is safeguarding a legacy that is more spiritual than material and, as such, is the guarantor rather than the product of culture.

Early-twentieth-century art historians were determined to read history back into this model. Wölfflin in particular, though accepting the notion of the history of art as a succession of masterpieces, conceded an important role to the historical process. Art history or stylistic history is concerned primarily with expression, he states, "expression of the temper of an age and a nation as well as expression of the individual temperament"; and, a third factor, the mode of representation, which is the crux of the problem. "Every artist finds certain visual possibilities before him, to which he is bound. Not everything is possible at all times."[2]

The history in question is, specifically, the history of vision, which Wölfflin adumbrates in the form of polar contrasts: from the linear to the painterly, planarity to recession, closed to open, unity to multiplicity, and clear to indistinct. His principal focus was the classic Renaissance, severed, as it were, from the classical tradition and in contrast with the Baroque, as he also contrasted the art of Italy with that of northern Europe. He believed, however, that the development from Renaissance to Baroque was not restricted to the art of the sixteenth and seventeenth centuries but was, rather, a process occurring in most historical epoch.[3]

Although he appreciated the importance of history and changing forms of perception, Wölfflin was too much in awe of the masterpiece to track great works of art more closely through their own epochs. This was left to his contemporary Aby Warburg and, for a more systematic approach, to Erwin Panofsky who, more than any other early-twentieth-century art historian, is associated with art history as a synchronic project addressing the structures of the society in which particular works of art were produced. In recent times, the call for such synchrony has become still more insistent. Art historiography following from this principle rejects the whole notion of the masterpiece; refusing to discriminate among disparate cultural artifacts – low or high, applied or "fine" – its aim is to focalize the ideals and values embodied in all cultural utterances.[4]

The art of the academy is resistent to such a narrative. Disregarding the historicity of style and committed to the authority of the immortals, the academy places its trust in a past whose continuing life makes everything "possible at all times." In its view, art is not an experience of the present but a recapitulation of the past from which the *merely* temporal and social have been excluded. The "past" here is not the same as the "tradition," it must be stressed. It is not the "historical sense" of T. S. Eliot in his famous essay "Tradition and the Individual Talent." Consider his definition: "This historical sense, which is a sense of the timeless as well as of the temporal and of the timeless and the temporal together, is what makes a writer traditional. And it is at the same time what makes a writer most acutely conscious of his place in time, of his own contemporaneity."[5] Without a sense of the temporal, of one's own contemporaneity, that same writer to Eliot's mind would be not "traditional" but "academic." And this, indeed, was the rigorous division between past and present, and the substantial exclusion of the second, in academies.

As conceived by the academy, then, visual art has nothing, or nothing of importance, to tell us about the historical period or society in which it originated – beyond the fact that it was one subscribing to the academic ideology. If this rejection of social determinism seems just what one might expect of institutions as reactionary as academies are popularly thought to

have been, one should note that no less a social determinist than Karl Marx was unable to dismiss the academy's point of view: "The difficulty, however, does not lie in understanding that Greek art and the Epic are associated with certain social developments. The difficulty is that they still give us pleasure and are in a certain respect regarded as unattainable models."[6]

The story of the academy's view of the history of art may also be a cautionary tale. For if the academy's beliefs were shared by the majority of artists in the Renaissance tradition, as seems to have been the case, the evidentiary potential of the art of this entire tradition up to about 1850 may have been vastly overestimated. Much of this art – or more than has been thought – like that of the academy, may be principally about art with less reason to search for the social and political factors underlying it than has been imagined.

Such are the themes of this chapter. First the academy's teaching will be examined specifically with regard to what we today would call style – style in the academy in relation to modern stylistic terms and categories. In question in the academy's notion of the timelessly beautiful, however, was a kind of "stylelessness," and just what form this took will be shown by following the application of the same models in academies over the course of time.

STYLE PRIZED

The academy's students were introduced to the concept of style through the ancient sculptures and works by the modern masters they were set to work copying. It was only at a later stage of the program, however, when, graduating from the copy and the live model, they created original compositions, that they became stylists in their own right. This was during the annual competitions organized around an assigned subject that the students were to interpret, usually in the form of drawings. Such drawings will serve for the present consideration of the teaching of style.

The first examples chosen originated in the Roman Accademia di San Luca at a critical juncture in its history; they were made at a time, first, of cooperation between this academy and the French Academy in Rome and, then, of the amalgamation of the academies of Paris and Rome, creating one supranational and all-powerful institution.[7] The artists, both French and Italian, initially were trained in two different academies but in one and the same tradition, during a key stage in the development of that tradition.[8]

The French artists were in Rome, to begin with, as a result of having been awarded prizes in the competitions of the academy in Paris. They were provided with a place of residence and were expected to spend their time studying the great ancient and modern works that, until then, they had known only in casts and reproductions. This had been the purpose of estab-

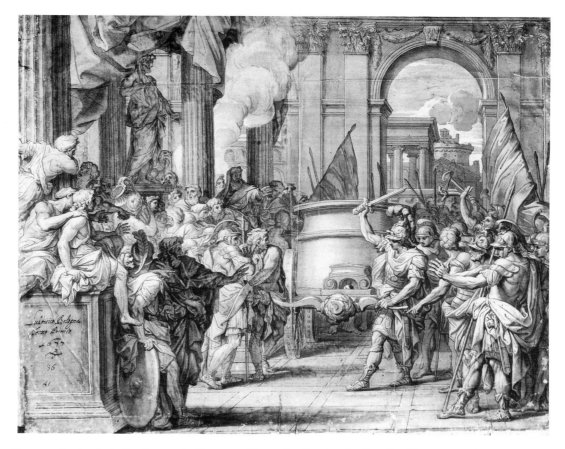

Figure 108. Louis de Boullogne the Younger, *Alexander Cutting the Gordian Knot.* 1677. Pen and brown ink, brown wash, with white heightening on gray paper. Rome, Accademia Nazionale di San Luca. (Photo: Gaggiotti)

Figure 109. Charles Le Brun, *Entry of Alexander into Babylon.* 1661–5. Paris, Musée du Louvre. (Photo: Bulloz)

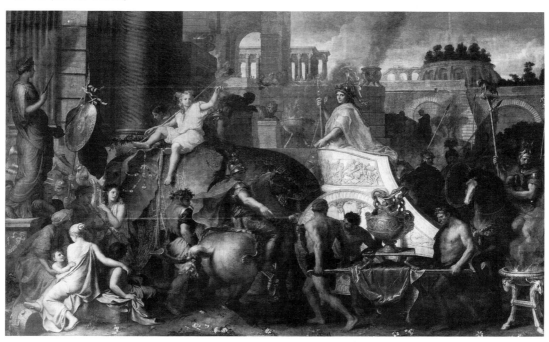

lishing a Roman branch, which, in the midst of such treasures, had no need, it was thought, of a program of instruction. The young artists obviously did not agree. Accustomed to the routine of an academy, they gravitated toward the Accademia di San Luca, whose program was organized similarly to the one in Paris, stressing life drawing and contests.

These contests were controlled with the kind of rigor associated with the nineteenth-century French academy.[9] To qualify as a contestant, the student had to undergo various tests, such as demonstrating his competence as a copyist of a masterwork. Those who passed this test were allowed to submit a drawing of the assigned subject, a *prova* then following in the form of a drawing of another subject, executed in the academy in two hours.[10] The obvious reason for these checks was to assure the authorship and originality of the submissions, a point of some importance for the following argument.

One drawing of considerable interest for the history of academies is the sole surviving prizewinner from the contest that marked the amalgamation of the academies of Paris and Rome. Bearing the inscription "Ludovico Bologna/Terzo premio/1677," it is a representation of *Alexander Cutting the Gordian Knot* (Fig. 108).[11] The subject seems to have been selected by Bellori, and it was approved by Colbert, who sent prizes that were distributed in a meeting in the Accademia in November 1677.[12] Le Brun had the title of *principe;* Bellori gave the address. His argument, as the title suggests ("Gli onori della pittura, e scoltura"), was that the arts flourish when artists are held in esteem. His examples ranged from antiquity to his own day: Alexander and Apelles, Charles V and Titian, Louis XIV and Le Brun. Louis received special praise for his support of the academy, and as an example of the benefits accruing to him for this support, mention was made of Le Brun's *Alexander* series, immortalizing the "French Alexander."[13]

No more fitting image could have been conjured up in a ceremony rewarding Louis de Boullogne for his Alexander (Fig. 108); for he not only had depicted the French Alexander of Le Brun's series but had conceived of the subject in a similar way. An "academic machine" filled with incident and yet sharply focused on its hero, it recalls in particular the *Entry of Alexander into Babylon* (Fig. 109).

Other of the drawings for which French artists received prizes are equally dependent on Le Brun's compositions. Two of these, from a contest held in 1673, have as their subject *Alexander Presenting Campaspe to Apelles* (Figs. 110, 111),[14] another favorite within a tradition tainted by misogyny: Apelles falls in love with Alexander's mistress, Campaspe, while painting her portrait; whereupon Alexander, as a sign of the esteem in which he holds the painter — and indifferent to the feelings of his mistress — gives the woman to him.[15] As in the composition by Louis de Boullogne, a variety of figures and objects articulate a space in which the action of the centrally located hero

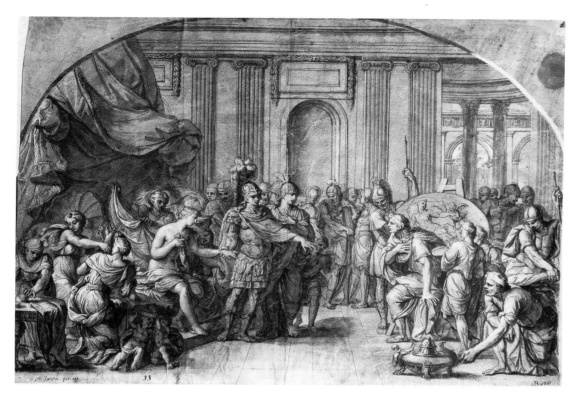

Figure 110. Charles-François Poerson, *Alexander Presenting Campaspe to Apelles.* 1673. Pen and brown ink, brown wash, with white heightening, on gray paper. Rome, Accademia Nazionale di San Luca. (Photo: Gaggiotti)

Figure 111. Louis Dorigny, *Alexander Presenting Campaspe to Apelles.* 1673. Pen and brown ink, brown wash, with white heightening, on gray paper. Rome, Accademia Nazionale di San Luca (Photo: Gaggiotti)

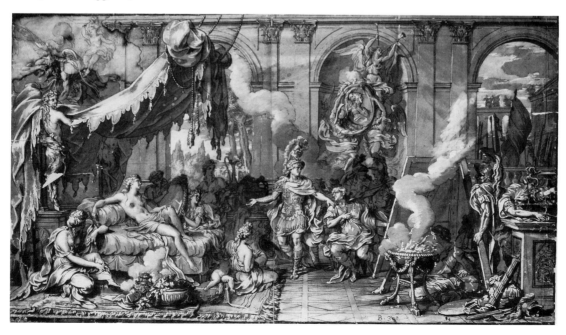

resonates. And, like the Boullogne, these works relate to Le Brun's Alexander series, most directly to his seminal *Alexander at the Tent of Darius* (Fig. 36), but also to his *Entry of Alexander into Babylon* (Fig. 109).

Two points need to be made about these drawings. The first is that they are all evidently "original" works, as originality was defined by the academy. In other words, their dependence on Le Brun's compositions would not have gone unnoticed but was, rather, rewarded. And, second, they, like Le Brun's works, are classic compositions. They conform to classic principles as these principles were adumbrated by Wölfflin: they are emphatically linear, they accept the limits of the frame, each composition unfolds in a sequence of planes parallel to the picture plane, and so on. So pronounced a form of classicism has been especially closely associated with the French academy and has come to be called academic classicism.

The French, however, were not the only ones in the Accademia's contests to produce such designs. There is no scarcity of drawings by Italian contestants, made from the last quarter of the seventeenth century and well into the eighteenth, that apply the same principles. Those done for a contest of 1702, the first Concorso Clementino, provide especially clear evidence both of the teaching of such principles and of the role of models by Le Brun in this process of indoctrination.[16]

The subject for the First Class was the "Massacre of the Innocents"; the interpretation awarded first prize, that of Giulio Solimeni or Solimena (Fig. 112). Four second prizes were awarded, to Antonio Caldana, Antonio Creccolini (Fig. 113), Giovanni Brughi (Fig. 114), and Giacomo Triga; third prize was won by Francesco Lorini.[17]

These artists are all difficult to trace, and when they are mentioned, as in Thieme-Becker, it is on the basis of indications such as the inscriptions on these drawings.[18] They had neither the superior talent nor, one imagines, the ambition that were the prerequisites of success in the art world of the eighteenth century, but rather proved themselves to be average artists for their time. That they had been more than that in school only shows that such early success did not guarantee success in the art world, and also indicates how much more than the skills the academy was able to impart was necessary. What all these drawings show, in sum, is the skillfulness of typical artists in the Renaissance tradition, the relative ease with which they were able to master the basics of figuration and composition, and how much more was expected of them if they were to be allowed access to the higher reaches of the art world.

The requirements of the Roman academy obviously differed from those of the French in one respect, namely technique: incisive pen lines in the French drawings versus blunted chalk lines in the Italian. This difference, however, is superficial, the Italian drawings being no less linear than the French for

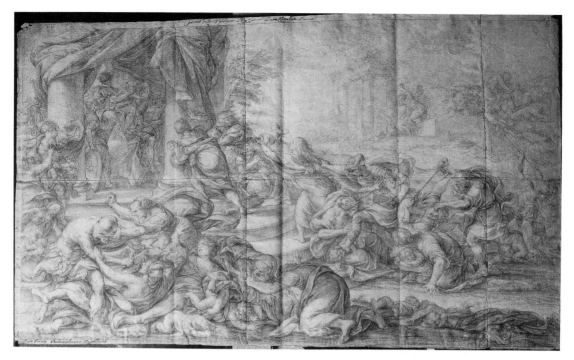

Figure 112. Giulio Solimena, *Massacre of the Innocents.* 1702. Pencil, red chalk, white chalk. Rome, Accademia Nazionale di San Luca. (Photo: Accademia Nazionale di San Luca, Rome)

Figure 113. Antonio Creccolini, *Massacre of the Innocents.* 1702. Red chalk. Rome, Accademia Nazionale di San Luca. (Photo: Accademia Nazionale di San Luca, Rome)

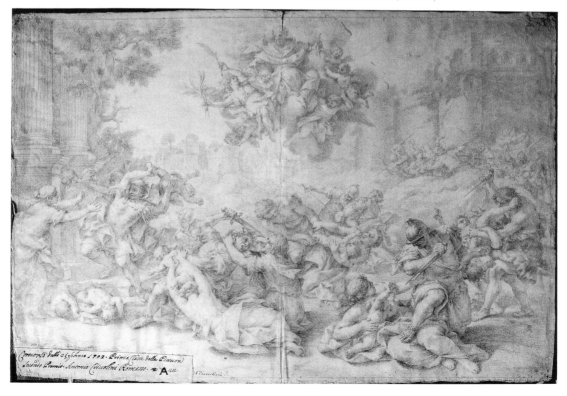

Figure 114. Giovanni Battista Brughi, *Massacre of the Innocents.* 1702. Red chalk. Rome, Accademia Nazionale di San Luca. (Photo: Accademia Nazionale di San Luca, Rome)

having been executed in a more "painterly" medium. Another difference is that the Italian drawings in this group are not as similar to one another as are the French examples. Indeed, one cannot help noticing differences in the poses and relations of the many figures, and of the figures to their setting, from one of these compositions to another. But it is precisely this multiplication of figures and abundance of incident which these drawings have in common, and these features are unusual within the Italian tradition, all the more so for treatments of this subject.

From the High Renaissance on, Italian painters tended to prefer economical compositions, to concentrate on few figures and minimal objects.[19] In the case of a "Massacre of the Innocents," a composition with few figures would

have been all the more indicated, as though mandated, by the masterpieces so representing the subject: first Raphael, in the engraving of Marcantonio and in the formerly much admired tapestry design bearing his name;[20] second, Reni, in his famous painting in Bologna;[21] and third, Pietro da Cortona, in his Massacre-like *Age of Iron* in the Palazzo Pitti.[22] (Poussin's *Massacre of the Innocents* in Chantilly also belongs in this company.)[23] That these exemplars were consulted is evidenced, moreover, in the drawing by Brughi (Fig. 114), who made use of the Raphael tapestry design, but in reverse. Yet even here figures were added, and the other drawings are, even more dramatically, multifigured compositions in which the individual figures are woven into larger groups with which they are at least partially merged.

If these are unexpected inventions for Roman artists, there are compositions that soon enough come to mind in relation to them. Rubens's *Massacre* is one; Le Brun's *Massacre* another.[24] And it is the principle of Le Brun's work, with its less turbulent composition and more descriptive and larger number of figures, that was most directly applied by the Roman artists. (Rubens's composition seems to have been consulted for the idea of developing the action on the steps of a temple.) This was a formula for embellishing and elaborating upon the inventions of the Renaissance masters demonstrated in Le Brun's early *Massacre,* as noted, as also in his Alexander series, engravings of which were to be found in the study room of the Roman academy.[25] And this is the key point: Le Brun's method is based on the classic principles of the High Renaissance, so interpreted and amplified as to have inaugurated the stylistic subspecies of academic classicism. All of the drawings thus far discussed in this chapter, those by French and Italian artists alike, fall into this stylistic category.

IN STYLE

Giacomo Triga, who won one of the second prizes for his *Massacre of the Innocents,* was awarded second prize in yet another of the academy's contests, this one requiring a representation of "Philemon and Baucis" (Fig. 115).[26] Two other drawings from the same contest have survived, the first-prize entry of Domenico Brugieri (Fig. 116), and the third-prize work of Carlo Patacchia (Fig. 117).[27]

The story of Philemon and Baucis tells of how Jupiter and Mercury, in disguise, were refused hospitality at one home after another until they arrived at the humble cottage of this old couple; at the dinner table, the vessels containing food and drink, no matter how many times they passed from host to guest, were miraculously replenished, thus making known the identities of the gods, who then declared their intention to flood the entire countryside

Figure 115. Giacomo
Triga, *Philemon and
Baucis*. Pen and brown ink,
brown wash, with white
heightening. Rome,
Accademia Nazionale di
San Luca. (Photo:
Gaggiotti)

Figure 116. Domenico
Brugieri, *Philemon and
Baucis*. Black chalk with
white heightening. Rome,
Accademia Nazionale di
San Luca. (Photo:
Gaggiotti)

Figure 117. Carlo Patacchia, *Philemon and Baucis.* Pen and brown ink, brown wash, with white heightening. Rome, Accademia Nazionale di San Luca. (Photo: Gaggiotti)

and destroy its population, sparing only this good couple. Granted one wish, Philemon and Baucis asked to be allowed to remain as guardians of the temple that was their cottage transformed.[28]

It is this last part of the story that is portrayed in all three drawings, the academy obviously having settled on it for the contest. And it is an unusual choice for this story. More usual in representations of Philemon and Baucis is the moment of greatest tension and drama, when the miracle of the food was performed and the identities of the guests revealed. A painting by Rembrandt in the National Gallery of Art, Washington, D.C., is an example of such a focus, representing the scene in a way similar to stories of Christian miracles paralleling Philemon and Baucis, particularly Christ at Emmaus. The acad-

emy must have had a reason for choosing the later moment in the story, perhaps simply because, representations of it being less usual, it would present more of a challenge. But having been given a particular event in the story to depict, the contestants would have had to decide how to do so in order to arrive at "original" interpretations of it. And what is again noteworthy about these competition drawings is their basic uniformity; all were organized according to basically the same narrative and compositional principles.

Philemon and Baucis are to one side in the foreground or in a first shallow zone, with Jupiter and Mercury seated on clouds above them on, or inclining toward, the other side of the composition, with a view of the flooded countryside below and behind them; a diagonal rhythm that begins with the couple draws us up and into the pictorial space. We are drawn into the space, in other words, by the kind of diagonal movement that Wölfflin identified as a hallmark of baroque composition. (Rembrandt's treatment of the story in this instance shows the "classic" alternative.)

It must be said that not all these arrangements are equally baroque. Just as the drawings display certain differences in touch, so they exhibit noticeable structural differences. Triga's drawing style (Fig. 115) is based on that of Carlo Maratta, and his composition, too, counterbalancing a baroque diagonal with a classic sequence of planes – from the old couple to Jupiter to Mercury – is indebted to the baroque classicism of that artist. Brugieri's handling (Fig. 116) also owes something to Maratta, and his composition, like Triga's, is an example of baroque classicism. Patacchia's figure style (Fig. 117), by contrast, belongs within the orbit of the most baroque of Roman artists, Baciccio and the Cortoneschi, and his composition, of the three, is the most emphatically baroque.

It would be reasonable to suppose that the students arrived at their compositions by consulting specific examples done by their teachers or other artists in the academy. And there are, indeed, models by Cortona and his followers of precisely such baroque compositions, as there are related examples of baroque classicism by Maratta and his disciples.[29] Nor is there anything particularly unusual about the presence of these stylistic alternatives in the academy, for, as Wölfflin had noted in stressing the descriptive, as opposed to evaluative, character of his criteria: "baroque has its classicism, too."[30] Whether classic or baroque, to his way of thinking the style of a work is determined by the period in which it is made, which, with regard to the present argument, would limit the scope of the investigation to works produced in or around the academy in the late seventeenth century.

There is another possibility, however, raised by the fundamental sameness of conception of the three competition drawings – as of those from the contests discussed earlier – and it is of the existence of a single model, interpreted by each artist according to his previous training. Such a model would

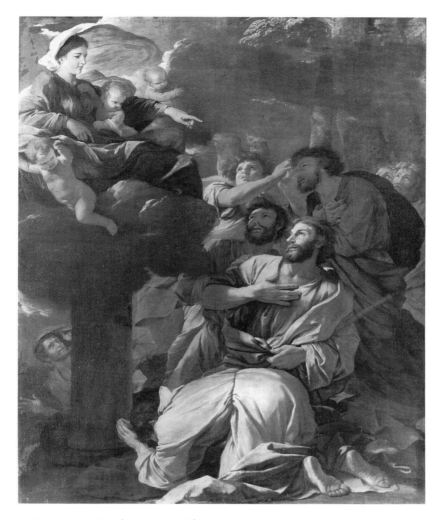

Figure 118. Nicolas Poussin, *The Virgin Appearing to Saint James the Great.* 1629–30. Paris, Musée du Louvre. (Photo: © Réunion des Musées Nationaux)

have been used specifically for subjects of divine intervention – as Le Brun's compositions served as models of imperial intercession. It need not have originated in the period in which these works were made, but may have been passed down from an earlier time, and could have provided a model for works produced all through the seventeenth century. For a model of this kind one would look not to the academy's teachers but rather to its exemplars, for the kind of composition in question, perhaps Poussin (Fig. 118).

The artist reinterpreting such a model would be expressing himself in the one visual language that had passed the test of time, expecting that his work would no more be supplanted than the model on which it was based. And,

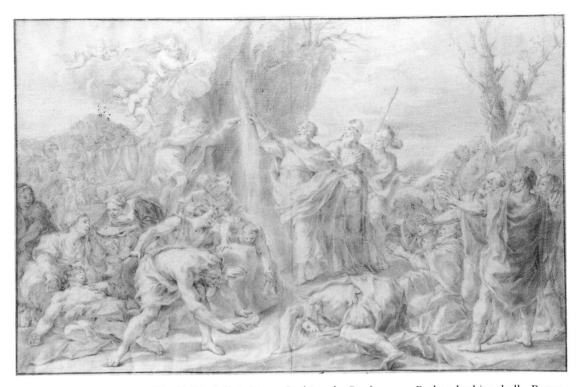

Figure 119. Nicolò Ricciolini, *Moses Striking the Rock.* 1703. Red and white chalk. Rome, Accademia Nazionale di San Luca. (Photo: Accademia Nazionale di San Luca, Rome)

indeed, if the models are the same, the style of the new should be fundamentally similar to that of the old, style itself remaining relatively constant. If the artists of the academy based their works on the same masterpieces from one period to another, in other words – and we know that they did just that – their art would neither "express their epoch" in the Wölfflinian sense nor be analyzable in terms of the historicity of vision.[31] We should find the Baroque as recurrent as the classic simply because models exemplifying each continued to be used. And this is precisely what we do find.

A MASTER STYLE

Let us return to the Roman academy on the occasion of the competition of 1703. The subject of the First Class was "Moses Striking the Rock." Two first prizes were awarded, to Nicolò Ricciolini (Fig. 119) and Giovanni Battista Armilli (Fig. 120).[32] The two compositions are strikingly classic: the figures are arranged to achieve a basic equilibrium and are placed in planes parallel to the picture plane. Certainly there is nothing surprising about this. It is what one would have expected of young artists in an academy domi-

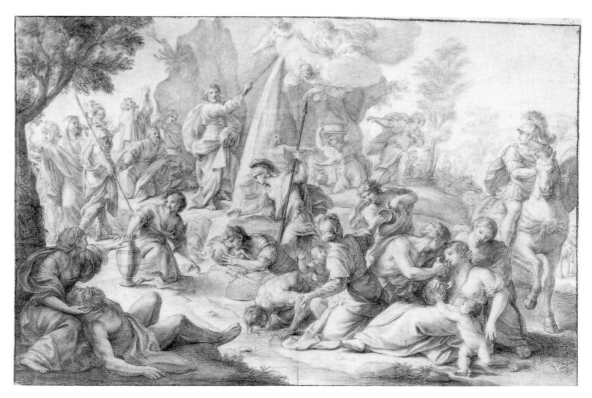

Figure 120. Giovanni Battista Armilli, *Moses Striking the Rock.* 1703. Red chalk. Rome, Accademia Nazionale di San Luca. (Photo: Accademia Nazionale di San Luca, Rome)

Figure 121. Benjamin West, *Moses and the Waters in the Wilderness.* 1788–1803. Pen and brown ink and wash, with white heightening, on brown paper. London, The Royal Academy of Arts. (Photo: The Royal Academy of Arts, London)

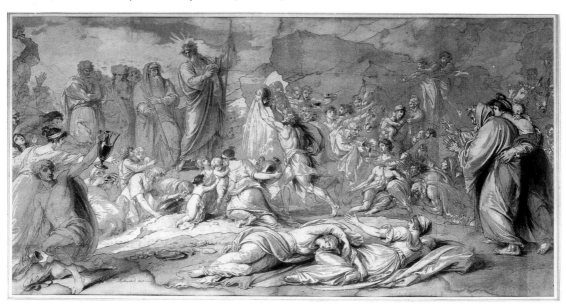

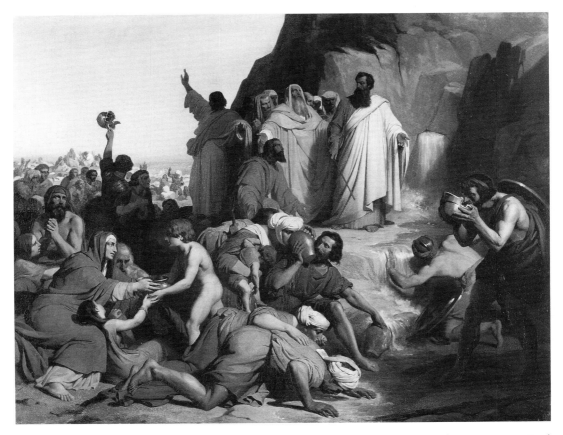

Figure 122. Dominique-Louis-Ferréal Papety, *Moses Striking the Rock.* 1836. Paris, Ecole nationale supérieure des Beaux-Arts. (Photo: Ecole des Beaux-Arts, Paris)

nated by the classical Carlo Maratta. (The baroque compositions of Figures 115–17 are the ones one might not have expected.)

To account for the classicism of these works it is necessary to invoke neither the teaching of Maratta nor the theory of the academy. They are classic because of, and in the same sense as, the model(s) on which they were based, models that are among the most classic of the Renaissance tradition: Poussin's two versions of this subject. The Ricciolini (Fig. 119) varies the arrangement of the first version, in Edinburgh, whereas the Armilli (Fig. 120) subtly reconfigures the elements of the later painting, in St. Petersburg.[33]

Clearly these drawings owe little to the time or even the place in which they were made. Other artists, working in different academies, in other times, but using Poussin's works as their models, predictably arrived at the same or similar results. Consider, as an example, Benjamin West's manipulation of elements from the same two compositions by Poussin about a century after the Roman competition drawings, arriving at his own "original" inter-

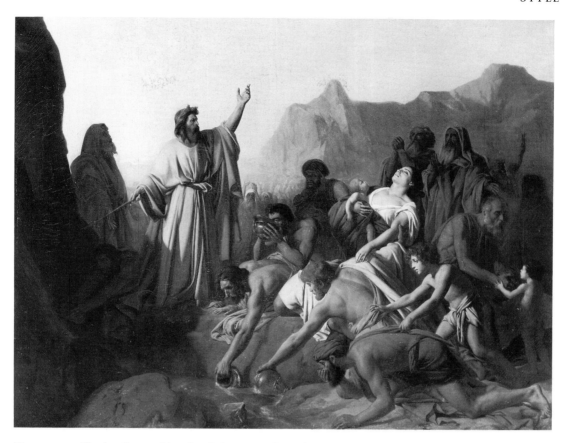

Figure 123. Charles-Octave Blanchard, *Moses Striking the Rock*. 1836. Paris, Ecole nationale supérieure des Beaux-Arts. (Photo: Ecole des Beaux-Arts, Paris)

pretation and quintessentially classic statement (1788, reworked 1803; see Fig. 121).[34] And the same is true of other versions of this subject, made during other periods in the history of academies, such as the prizewinning paintings from the Prix de Rome competition in the French academy in 1836. One first-prize work, by Papety (Fig. 122) was inspired, like the Ricciolini (Fig. 119) by Poussin's treatment of the subject in Edinburgh, while a second-grand-prize work, by Blanchard (Fig. 123), is similarly indebted, like the Armilli (Fig. 120), to Poussin's later painting in St. Petersburg.[35] Did these artists, West or Papety and Blanchard, arrive at such compositions through a process of "seeing" peculiar to their own epochs? Obviously not, or not primarily. Their works are all classic because they consciously used classic compositions as their models.

It is worth pausing over another drawing by West, related to Figure 121 in handling and with a similar history, *Death on a Pale Horse* (Fig. 124).[36] This is a visionary and "sublime" conception, the type imagined as antithetical to

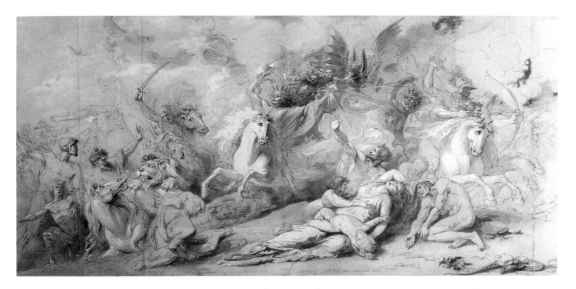

Figure 124. Benjamin West, *Death on a Pale Horse.* 1783–1803. Pen and brown ink and wash, with white heightening, on brown paper. London, The Royal Academy of Arts. (Photo: The Royal Academy of Arts, London)

the classic – a "romantic" work. Yet, what is most strange about it is explained by the text that West set out to depict, namely, Revelations 6:8: "And behold, a pale horse: and he that sat upon him, his name was Death; and Hades followed with him. And there was given unto them authority over the fourth part of the earth, to kill with sword, and with famine, and with death, and by the wild beasts of the earth." The "style," as opposed to the content, has much in common with West's own *Moses and the Waters in the Wilderness* (Fig. 121), the similarity being that of a common source – namely, Poussin. In this case, West combined elements originating with such paintings as the *Moses Striking the Rock* or *The Israelites Gathering the Manna* (Fig. 34) with others from a baroque rather than classic source: Rubens's hunting scenes. Is the alchemy of style such that the romantic is nothing more than a distillation of the classic and the baroque?

Roughly contemporary with West's drawings is a painted sketch of the *Funeral of Patroclus* (Fig. 125) made by David in 1778, while a laureate at the French Academy in Rome. Although much has been made in the David literature of the agitation of this multifigured composition, the "swarm of figures" and "wildly baroque character of the plumed helmets," in the words of Anita Brookner,[37] this work is classic in its strict planarity and a striking example of academic classicism in the sense of Le Brun's Alexander paintings (Figs. 36, 109). The connection, too, is no more fortuitous than in the cases of the earlier competition drawings that show scenes from the life of Alexan-

Figure 125. Jacques-Louis David, *The Funeral of Patroclus.* 1778. Dublin, The National Gallery of Ireland. (Photo: Courtesy of the National Gallery of Ireland, Dublin)

der (Figs. 108, 110–11); David's arrangement, down to details such as the plumed helmets, no less than these, was modeled after Le Brun's.[38]

A short time later, in 1780, David produced what is perhaps his most strikingly baroque work, *St. Roch Interceding for the Plague-Stricken* (Fig. 126). This is the diagonal negation of the rectilinear frame of the Philemon and Baucis competition drawings as well (Figs. 115–17), which is to say that it was one sanctioned earlier by the Roman academy. That it would have been equally sanctioned by the French, and all other academies, at this and all times, is also clear in light of the use of this design by the "immortals"; Poussin was one (Fig. 118),[39] Le Brun another.[40] Because it was indicated particularly for subjects of divine intervention, it was natural for David to follow such a model for his representation of St. Roch.

A similar design was adapted by Ingres for a like subject, the *Vow of Louis XIII* (Fig. 127). Here, the usual stylistic expectations are confounded, however, in the convergence of classic and baroque modes: baroque for Louis XIII and classic for the Virgin, Child, and angels. Indeed, these last figures, and their symmetrical arrangement, were derived from a work by the principal exemplar of classicism: the *Sistine Madonna* of Raphael.[41] What is one to make of such an intermingling of the baroque and the classic by a Neoclassic artist? Was this a deliberate "evocation of a lost historical epoch" in style as well as content?[42] The first question may not be particularly interesting, as art historians are well aware of the inadequacy of the old stylistic categories, which they freely manipulate. The second question is important, however, for it brings us back to the whole concept of the historicity of style that the

Figure 126. Jacques-Louis David, *St. Roch Interceding for the Plague-Stricken.* 1780. Marseilles, Musée des Beaux-Arts. (Photo: Giraudon)

academy had in effect repudiated and that must therefore be discarded or, at the very least, modified for a proper understanding of its art.

If the values of art are eternal and the works of the great masters timelessly universal, as the academy believed, the old belongs as much to the present as the new; through constant renewal, the art of the future will be virtually identical with that of the past, on which it will, of course, be based – or nourished, as Ingres said ("J'ai sucé leur lait, je m'en suis nourri . . ."), vehe-

Figure 127. J.-A.-D. Ingres,
Vow of Louis XIII. 1824.
Montauban, Cathedral.
(Photo: Lauros-Giraudon)

mently denying the charge that his *Vow* was nothing but a pastiche or copy of Raphael.[43] Style so understood is and ever will be as unchanging as the masterworks from which it is borrowed.

In question is a notion of style in a non-Wölfflinian sense: style that does not change and cannot, therefore, recur. This is the history of style of the academy – a story not of the historicity of vision but of the heritage of masterpieces.[44]

ORIGINALITY

That the academy's own particular mode of creation involved the quotation or imitation of the masterpiece has been remarked upon throughout this study, but especially in Chapters 4 and 5 and the last chapter. Although it has been made abundantly clear that this involved more than cloning, the inventiveness of academic works may still come as a surprise; for it is an inventiveness indicative of a large and well-defined idiom of visual expression. These works are, indeed, the "originals" the academy considered them to be – some more obviously so than others – adjusting and altering the elements of a common language that was not restricted to what had already been said by a few artists of the past. If I am using the word "language" loosely for what more strictly should be called a "system" or "method," my use is in keeping not only with the rhetoric of comparison of academic discourse but also, more importantly with the academy's view of visual art as a means of communication analogous to language.[1] The purpose of this chapter is to examine the components of this visual language more closely, further to clarify the role of the masterpiece and the academy's notion of originality. Let us begin this review of "traditional originality" by considering the academy's language of sculpture, which has scarcely been mentioned in the previous chapters.[2]

MODERN CLASSICS

The reason for this seeming neglect is that in the academy sculpture was understood as fundamentally similar to painting or, at the very least, as similarly anchored in the classical tradition and, specifically, in the central activity of that tradition: drawing. The initial stages of the sculpture curriculum were

precisely the same as those for painting, sculpture students also being required to copy the flat and round and to draw after the antique. It was only in the relatively advanced life class that the specific demands of sculpture were recognized, sculpture students modeling in clay as well as drawing from the live model. And in the final stage of the program, there were sculpture competitions parallel to those for painting – for the three-dimensional expressive head, the composition test as a relief sculpture, and so on.[3]

The *paragone* of the Italian Renaissance, stressing differences between the arts and setting painting and sculpture against one another, had no currency, then, in the academy, which subscribed rather to a still more fundamental notion, tracing its origins to the beginning of the academic tradition, about the unity of all the arts of *disegno*.[4] This unity being conceptual rather than material, the academy downplayed the physical differences between works. Having students model in clay was, in fact, a kind of concession to sculpture not usually made to painting. Painting itself, as a technical practice, was rarely taught in academies, which were adamant in their refusal to engage the actual conditions of artistic production. (The techniques of painting were "picked up" by watching, and receiving instruction from, painters in the studios.)[5]

In keeping with this stress on conception and design, sculpture in the academy, at least from the later seventeenth century on, was created strictly on paper and in clay. Nor was sculpture design restricted to trained sculptors. Le Brun and Maratta were among the painters of the academy whose paper projects were executed by the sculptors of Paris and Rome.[6] In the execution of these and their own designs, sculptors showed little concern for the definitive material of the work; resolved conceptually, the sculpture would be equally satisfactory, it was thought, in marble or in bronze.

Marble, however, was usually the material of choice, as it had been chosen over all others, it seemed, by the ancient sculptors. For sculpture, far more than painting, entered directly into a field dominated by the ancients. The classical canon consisted almost exclusively, after all, of a corpus of marble sculptures, the incomparable *Apollo Belvedere* (Fig. 74), the *Laocoön*, and others, which, in their perfection, were agreed to have established the range and defined the means of the art of sculpture for all time. There could be no question of ignoring or displacing these works, which the sculptors of the academy in any case had learned to adore. But how were they to get beyond the copy and create something new with the authority of the old? The one possibility was to create something in the spirit of the antique that could thereby stand comparison with it. The sculptors of the academy aimed, in sum, to create what H. W. Janson has called "modern classics."[7]

One such work is Guillaume Coustou's *Hercules on the Funeral Pyre* (Fig. 128), a reception piece submitted to the French academy in 1704.[8] The

Figure 128. Guillaume Coustou, *Hercules on the Funeral Pyre.* 1704. Paris, Musée du Louvre. (Photo: © Réunion des Musées Nationaux)

subject is that personification of heroism and strength represented in one of the most illustrious works of ancient sculpture, the *Farnese Hercules* (Fig. 71). Coustou's work, like this and most sculptures of the classical tradition, is of a single figure in the round, ideal in its nudity. In this case, the specific model was revised, Coustou modifying the hypermuscularity of the *Farnese Hercules* by taking into account the anatomy of a live model. If the form of Coustou's *Hercules* is new, so is its content. For in place of the expressionless and timeless *Farnese Hercules,* is an anguished figure, acting out the moment in the Hercules' myth when, still struggling to tear off the poisoned tunic of Nessus, he prepares to die.[9]

For this depiction of Hercules, without precedent in ancient sculpture, Coustou referred to an antique work with a different subject, that great exemplar of suffering, the father in the *Laocoön* group – though this *Hercules* no more copies the *Laocoön* than it does the *Farnese Hercules.* That a subject was chosen for which there was no specific sculptural precedent brings home the importance of novelty and originality in the academy. The choice of subject also shows how little distinction was made among the various arts, for a Hercules of this kind, acting in a moment in time, though unexpected and perhaps unprecedented in sculpture, would be perfectly at home in painting.

Hercules subjects were frequently assigned for painted reception pieces

Figure 129. François Dumont, *Titan Struck Down.* 1712. Paris, Musée du Louvre. (Photo: © Réunion des Musées Nationaux)

during this period, such subjects as "Hercules and the Hydra" (1673), "Hercules and the Centaurs" (1677), and others – though not "Hercules on the Pyre."[10] Another sculpture of this period, also made as a reception piece, depicts a subject assigned to a painter as well. Like Coustou's *Hercules,* François Dumont's *Titan Struck Down* (Fig. 129) of 1712 is further evidence of the academy's taste for subjects involving extreme, Laocoön-like suffering.[11] The grotesqueness of this expression of suffering is unlike the Greek work, however; and unlike it and other ancient sculptures, too, is the sprawl of the figure over a group of rocks. Similar figures are found in a painting by

Jean Leblond, also made as a reception piece and submitted in 1681, but in the context of the larger subject of the *Fall of the Titans*. Dumont's Titan, in pose and setting, would fit right into this work. But, then, it was not made to be part of such a composition but to be, rather, an autonomous sculpture, and that seems to be just the point. For whatever we may think of the appropriateness of this "pictorial" conception for a work of sculpture, the undeniable fact is that it is one different from that which underlay the ancient sculptures it recalls: the base, which within the classical tradition, served merely as a support, here is literally the ground on which the drama unfolds. And to be like yet unlike a work in the canon was to be original, as originality was understood in the academy.[12]

A *Falling Titan* made by the English academician Thomas Banks toward the end of the century (1786) is evidence both of the academy's continued interest in such dramatic subjects and of the academician's search for sculptural conceits to enlarge upon, rather than simply rehearse, the repertory of the ancients. Banks, said at his death to deserve a place alongside the Greeks and Michelangelo, shows a figure more restrained than Dumont's, and therefore, in the eyes of some, more "Greek," but equally divergent from the classical canon in its horizontality and exploitation of the base.[13] That this was a sculptural conceit – as opposed to an unusual arrangement occasioned by this peculiar subject – is proven by its recurrence in the academy's sculpture of this period, other such subjects inhabiting the base having been assigned or chosen and treated similarly. To cite just one further example: Paul-Ambroise Slodtz's reception piece of 1743, the *Fall of Icarus* (Fig. 130).

It is worth mentioning that while it was common for the sculptors of academies to interpret subjects usually more at home in painting, the painters, in turn, often organized their compositions around the principal motif of sculpture: the single nude figure of antique sculpture. An example is the diploma work of John Francis Rigaud deposited with the Royal Academy in 1784, *Samson and Delilah* (Fig. 131), a painting more of an ideal nude than a narrative, the nude being based on the *Torso Belvedere*.[14] And an equal concentration on the nude of ancient sculpture is found in Nicolai Abildgaard's *Philoctetes* of 1775 (Fig. 132); in Rome with a stipend from the Danish academy, he decided on a content for that same heroic *Torso*, making of it the Laocoön-like warrior whose foot has just received the wound that would not heal.[15]

As for the sculptural figure, the redefinition of the base was only one tactic in the academy's ongoing interrogation of the classical tradition. Another and more central one was to accept the challenge of such works as the *Apollo Belvedere, Farnese Hercules,* and others: the standing figure.[16] One work obviously confronting the classical ideal in the cause of "modernity" is David

Figure 130 (above). P. A. Slodtz,
Fall of Icarus. 1743. Paris, Musée
du Louvre. (Photo: © Réunion
des Musées Nationaux)

Figure 131 (left). John Francis
Rigaud, *Samson and Delilah*.
1784. London, The Royal
Academy of Arts. (Photo: The
Royal Academy of Arts, London)

Figure 132. Nicolai Abildgaard, *Philoctetes.* 1775. Copenhagen, Statens Museum for Kunst. (Photo: Statens Museum for Kunst, Copenhagen)

d'Angers's *Philopoemen* of 1837 (Fig. 133).[17] Conventional enough in its classical subject, the work is markedly unconventional in form, both in relation to the subject and to the sculptural tradition: the young hero of the battle of Sellasia who yanked a javelin out of his leg before leading his troop to victory appears here in the guise of an old man. The figure is appropriately classical in its nudity, modified only by a few neoclassical accessories of which the helmet is most prominent, but modern in directing attention to time. This was done, David explained in response to criticism of the work, to allude to the "last of the Greeks," implying the twilight of Hellenic civilization.[18] Such criticism notwithstanding, the work must be understood in light of the reinterpretation of classical models within the academic tradition of more orthodox academicians such as Coustou, Dumont, and Banks.

If the modernity of David's *Philopoemen* may escape viewers, the classicism of Daniel Chester French's *Minute Man* of 1871–5 may equally be missed.[19] Here is a representation, to all appearances, of a modern man, an early American colonist as imagined by the artist and recreated by a model posing in the studio. That French aimed to create such an effect cannot be in

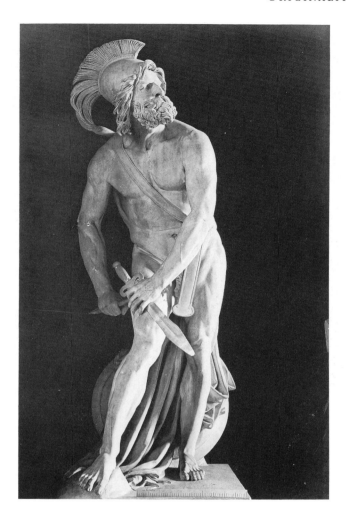

Figure 133. David d'Angers, *Philopoemen*. 1837. Paris, Musée du Louvre. (Photo: Giraudon)

doubt. But his conception was controlled by the classical and academic ideal of beauty and heroism as embodied in ancient sculptures, to one of which he turned for his model: the *Apollo Belvedere*. Indeed, the success of the work and even its "Americanness" were attributed to his artful use of this model. In the words of the sculptor-critic Lorado Taft: "It is interesting to note what the figure, so alert and so American in character, owes to its senior colleague, the 'Apollo Belvedere.' It would never be suspected, but a large cast of the 'Apollo' was Mr. French's sole model. . . ."[20]

COMPOSITION

The sculptors of the academy were accustomed to going back and forth between such figures in the round and figures in sculptural relief. The subject

of the sculpture competitions typically was to be executed as a bas-relief – though in the nineteenth century the relief alternated with the figure in the round – and the relief remained a principal mode of sculptural expression. These reliefs reflect, even more clearly than free-standing sculptures, the academy's conception of the unity of painting and sculpture, and also its promotion of a single, universal language.

David d'Angers was awarded first prize in a contest in the French academy in 1811 for such a relief, *Epaminondas after the Battle of Mantinea* (Fig. 134).[21] Arranged on the plane, with varying degrees of relief, are many figures and objects acting out the death of this Theban general, who, having been wounded while leading his troops and carried from the field, upon regaining consciousness is told of the Theban victory; knowing that the removal of the spear point lodged in his chest will cause his death, he asks if his shield has been saved and then says, "It is time to die," directing that the spear point be removed.[22]

To state that David's figures act out this story is to note a fundamental similarity between this sculptural relief and a drawing or painting in which figures interact in an illusioned space. And there is, indeed, a painting of this subject made in 1773 by Benjamin West in which the figures do so interact (Fig. 135).[23] But the similarity is greater than this. For, not only are the figures in the two works equally free to move about in an illusioned space, but they do so with similar poses, gestures, and expressions, and relate similarly to the hero of the story: in both, Epaminondas, ideally nude except for his helmet and a swathe of drapery, appears in the center of a strictly symmetrical and planar composition, surrounded, and physically supported by followers, whose gestures and expressions variously convey their distress. Even the design is similar: standing figures on the right, bending and kneeling figures on the left.[24]

Works this similar must depend, it is usually assumed, either upon one another or both upon a common model. And given the existence in the academic tradition of a repertory of models, there would be reason to assume the latter. But there was not in fact a model for these works in the usual sense of the term – say, a composition by Poussin from which both were derived. If not in a common source, where did these similar designs originate? Their similarity would be explained if the two artists had relied on a common system or language.

Evidence for the dissemination of such a language is found in representations of a subject just as popular in the academic tradition as the Death of Epaminondas but for which a model by Poussin was available, the Death of Germanicus. Among the translations of this subject are Heinrich Füger's 1789 reception piece for the Viennese academy (Fig. 136) and a relief made in 1774 by Thomas Banks (Fig. 137).[25] The Füger is obviously closer to the

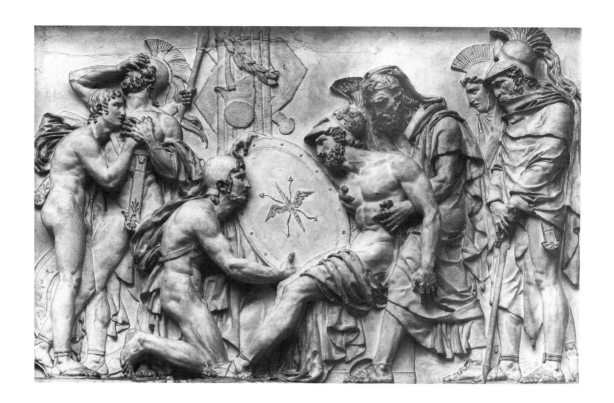

Figure 134. David d'Angers, *Epaminondas after the Battle of Mantinea.* 1811. Paris, Ecole nationale supérieure des Beaux-Arts. (Photo: Bulloz)

Figure 135. Benjamin West, *Death of Epaminondas.* 1773. London, Kensington Palace. (Photo: The Royal Collection © Her Majesty Queen Elizabeth II)

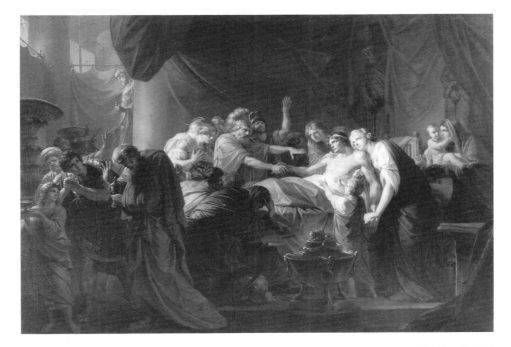

Figure 136. Heinrich Füger, *Death of Germanicus.* 1789. Vienna, Osterreichische Galerie Belvedere. (Photo: Osterreichische Galerie Belvedere, Vienna)

Poussin than is the Banks, in which, for one, the figure of Germanicus appears in the ideal nudity more typical of neoclassical sculpture. But in overall design, as well as in its poses, gestures, and expressions, Banks's relief is nevertheless, like Füger's painting, fundamentally similar to Poussin's work. And Robert Rosenblum has remarked that the same model by Poussin stands not only behind these works but countless other depictions of deathbed scenes of the late eighteenth and early nineteenth centuries as well, scenes of Hector, Variathus, Socrates, or Seneca.[26]

To suggest that these works may be traced back to Poussin is to argue for their essential dependence on one and the same model. And this was, indeed, the argument of the last chapter, in which works similarly conceived were said to have resulted from an engagement with the same model. But on closer examination, these works are seen to be more different from their putative model, as from one another, than at first appeared. The compositions, while similar, are hardly identical; rarely is one of Poussin's figures, in pose or expression, actually repeated. That these works are Poussinesque is not in doubt. But it is equally obvious that what is in question is not Poussin's imagery but his approach, which the artists of the academy knew to the point where specific models would have been redundant.

Figure 137. Thomas Banks, *Death of Germanicus.* 1774. Viscount Coke and the Trustees of the Holkham Estate. (Photo: Courtauld Institute of Art)

Although this distinction may seem overly subtle today, it was an important one in academies. It was the task of Félibien, we recall, not only to record the observations of the academicians about specific works by Raphael, Poussin, and others, but to extrapolate general rules from them that could be applied by the students, thereby rendering the models dispensable.[27] Félibien did so articulate a set of rules, and so did the academy on other occasions.[28] The more important of these rules may be summarized as follows (the order is that of the academy):

1. Composition: only one subject or event may be depicted, with nothing detracting from it; if many figures are required, they all must relate clearly to the main figure, which is to be the most prominent in the composition.
2. Expression: the faces and gestures of the figures are to display their reactions in signs that are varied but appropriate to the event.
3. Decorum: careful attention is to be paid to dress, locality, and customs, all of which must be appropriate to the time and place in which the event occurred; the principal figure must always appear heroic, even if known from literature or history not so to have looked; and the actors are to be

depicted with suitable dignity or, if required, baseness, though if the latter, avoiding all the more the unseemly.

4. Drawing: the contours of the figures are to be well defined, the figures clearly placed in space.

5. Color should be subordinate to drawing, consistent with the light source, and appropriate to the subject.[29]

All of the academy's resources were mobilized to impart these rules, in a program in which attention was focused on the means necessary for their implementation. Such was the purpose, after all, of stressing study of the figure in a variety of situations and of insisting on the mastery of a "language" of facial expressions. This knowledge would not have been necessary had the academy expected students to do nothing more than clone existing works of art. Consider as examples of the channelization of such studies Jacques-Louis David's *Andromache Mourning Hector* (Fig. 138), his diploma work of 1783, and Ingres's *The Ambassadors of Agamemnon before Achilles* (Fig. 139), his Rome prize work of 1801. The origins of the sorrowing Andromache of the first may be traced directly to David's studies of facial expressions such as Figure 16, whereas the figures of Ingres's painting are equally grounded in his academic figure studies. That the paintings were accepted, and the artists rewarded, means that these were the kinds of originals the academy had in view, and that the artists understood they must express themselves, not by quoting definitive works by the immortals, but rather by manipulating the elements of a grammar borrowed from them.

The depictions of Epaminondas and Germanicus discussed above (Figs. 134–5, 136–7) are to be understood, too, as the original works the academy had in mind, though they may at first appear less original than the Jacques-Louis David or Ingres. For David d'Anger, West, and the others applied the rules of usage more strictly as they were stated by Félibien and in academic discourse, and with predictable results: one event is shown in its most dramatic moment; the principal figure is centered and highlighted in the composition and is accompanied by a supporting cast amplifying, through their poses, gestures, and facial expressions, the drama of the moment. Differences such as those between the works by Jacques-Louis David and Ingres (Fig. 138, 139), on the one hand, and David d'Angers and West (Figs. 134, 135), on the other, suggest more than one way of applying the rules and understanding originality in the academy. But, then, the whole notion of academic originality as proposed at the outset of this chapter must have struck many readers as a flagrant contradiction. Has it not been agreed that the academy was the enemy of originality, for which reason it was attacked by the avant-garde? There are two important discussions of this question for the nineteenth-century academy.

Albert Boime has called attention to the focus on originality in the reform of the French academy in 1863.[30] Radical reformers, among them Viollet-le-

Figure 138. Jacques-Louis David, *Andromache Mourning Hector.* 1783. Paris, Ecole na-
tionale supérieure des Beaux-Arts. (Photo: Giraudon)

Figure 139. J.-A.-D. Ingres, *The Ambassadors of Agamemnon.* 1801. Paris, Ecole nationale supérieure des Beaux-Arts. (Photo: Bulloz)

Duc, advocated originality as individual self-expression, rejecting even the Prix de Rome for encouraging standardization – the winners, he said, "have lost all semblance of originality." Other members of the academy, attaching no less importance to originality, disagreed. There are two types of originality, Ludovic Vitet for one argued: true and false, the true being what traditional teaching in the academy had in view. The fact that originality was essential was not at issue; the controversy centered on the kind of teaching most likely to promote "true" originality.

Boime's larger argument was that this controversy signaled profound changes in academic doctrine, ultimately encouraging originality in the modern sense of the term and contributing toward the emergence of the avantgarde. His argument was challenged by Richard Shiff, who noted fundamental conceptual differences between academic and modern painting. With Boime's point about the importance of originality in the academy, however, Shiff agreed:

To imitate the vision of past genius was to regain originality, not to sacrifice it. Academics such as Delécluze (and perhaps Vitet) stressed the perfection of received "original" ideas through a technical mastery of representation; they discounted innovation as an indication of willful, insincere individuation. Their argument often made reference to Homer, whose "original" genius was preserved in the imitations by those modern geniuses who recognized the eternal truth of his originality; Ingres gave visual form to this theory of recycled genius in his *Apotheosis of Homer* [Fig. 29] exhibited at the Salon of 1827. For the supporter of the academic tradition, the imitation of genius by genius produced a desirable compounding of originality: Ingres wrote that "Raphael, in imitating [the ancients] endlessly, was always himself."[31]

At the same time, these loyal academicians were aware of the danger, Shiff noted, of attempting to teach what "could not be taught," namely genius itself. And academicians earlier in the century had had similar misgivings about teaching. Quatremère de Quincy, the supporter of David and Ingres, for example, championed traditional teaching but opposed measures designed to codify genius. "What the genius finds, and what we call invention, he shows us [already] fully found in his works, but he does not instruct us at all in how to discover it."[32]

Even Félibien, for all his advocacy of models and rules, warned against too complete a reliance on either:

As I worked, I realized that the execution of a painting brings up a thousand difficulties that no precepts can teach us to surmount. For we cannot say how to give figures more force, more majesty, and more grace: all this depends on the excellence of the painter's genius. . . . If there is a way to show off the various parts of a painting . . . it is a way that does not consist of rules that can be taught but rather one that can be discerned by the light of reason and that sometimes works *against* the ordinary rules of art.[33]

Kant would have agreed. The domain of the "aesthetic" is a valid and separate sphere of experience, he declared, characterized by a dimension of transcendence of which genius alone is capable; genius, as if by definition, is that which transcends rules. Nevertheless, he believed, along with the academicians, it is essential to learn the rules in order to take this liberty.[34]

The remainder of this section will examine other of the academy's works, further to elucidate the whole notion of "originality" – its own, at times ambiguous, concept and that of current thinking. Let us first examine works that firmly adhere to the rules, beginning with one produced during its early period, when these rules had only recently been articulated, Charles-Joseph Natoire's *Sacrifice of Manoah* (Fig. 140), awarded first prize in 1721.[35] The arrangement should by now seem familiar, as should the poses, gestures, and expressions (awe, reverence, and so on), which are reminiscent of those in the depictions of *Moses Striking the Rock* discussed earlier in relation to models by Poussin (Figs. 119–23). Natoire's conception is only generally similar to Poussin's, however, surely in part at least because the subject is different.

Figure 140. Charles-Joseph Natoire, *Sacrifice of Manoah.* 1721. Paris, Ecole nationale su-périeure des Beaux-Arts. (Photo: Bulloz)

There is a work of a related subject by one of the idols of the academic tradition, the *Sacrifice of Noah* conceived by Raphael for the Vatican Loggie, to which this composition is, indeed, more closely related in design and certain figure poses, particularly Manoah and the men in the left foreground. But here, too, the similarity is only of a general kind.

Another painting, apparently from the same contest, also recalls both Poussin and Raphael, whose Noah may directly have inspired this Manoah. But the work this interpretation of the story most closely resembles is that of Natoire made for the same contest. And another prize-winning translation of the related subject of the *Sacrifice of Noah* (Fig. 141), made more than a century later (1837) by Jean Murat, also only faintly echoes Poussin and Raphael while more loudly proclaiming its compliance with the same rules observed by the artists of the 1721 contest.[36] Clearly, it was a question not of plagiarizing and disguising the composition or figures of an acknowledged masterpiece but of making an original statement by using a common lan-guage taught in the academy over the centuries.

Figure 141. Jean Murat, *Sacrifice of Noah.* 1837. Paris, Ecole nationale supérieure des Beaux-Arts. (Photo: Ecole des Beaux-Arts, Paris)

To insure originality, the painters, like the sculptors expected to produce "modern classics," typically would be assigned unusual subjects – unusual in the sense of not having been treated by the masters of the past. One such subject was rendered by Louis Galloche in a first-prize work of 1695, *Joseph's Brothers Bringing His Robe to Jacob* (Fig. 142). Another episode from the same story appears in the first-prize work of 1699 by Pierre-Jacques Cazes, *Jacob's Vision on the Journey to Egypt* (Fig. 143). Both show only one highly dramatic instance of "heroic suffering," such as is treated in the sculptures from this period by Coustou and Dumont (Figs. 128, 129). As in the sculptures, the principal figure in each (the Galloche, more obviously) is based on that embodiment of suffering, the father in the *Laocoön* group. This antique exemplar was not simply copied, however, but rather recreated in the image of the father of the Old Testament. The spirit, then, is that of the antique, but it is also of Poussin, as Poussin was interpreted by Le Brun. This is clearest in the Cazes (Fig. 143), in which the figures on the right are

interrelated in a way broadly similar to those in Poussin's *Death of Sapphira*[37] and also in Le Brun's *Entry of Jesus into Jerusalem*,[38] to which it is closer in style. The style is, above all, that of the academy however, a mixture of the styles, inventions, and "spirits" of its idols, here used in the representation of a subject they had not yet depicted and that was intended to take its place alongside their works as an autonomous "classic."

Not all of the works thus far discussed in this and the preceding chapters are of rarely depicted subjects, however. Indeed, a subject already treated in a great work of art would have been the most challenging of all – too much so, perhaps, to the minds of the academicians – for relatively inexperienced artists. The young and ambitious Jacques-Louis David, in Rome with a stipend from the French academy, thought to accept this challenge, notating a design for an Alexander subject (Fig. 144) that would have demanded comparison with one of the most famous academic works of all time, Le Brun's *Alexander at the Tent of Darius* (Fig. 36).[39] Choosing a different moment in the story, which he turned into a deathbed scene, he evidently expected to receive all the more credit for creating an original work on Le Brun's most clearly stated terms. In the event, he abandoned the project.[40]

What must surely astonish modern viewers is the public's agreement with the academy about the originality of such creations. For agree the public did. The prize paintings and reception pieces, exhibited publicly, were admired and even cheered. Such was the welcome accorded Fragonard's 1765 reception piece, *The High Priest Coresus Sacrificing Himself to Save Callirhoë* (Fig. 145).[41] When the picture was exhibited in the Salon, we are told, the audience stood transfixed in front of it, deeply moved by the act of the high priest who, rather than sacrifice the intended victim, Callirhoë lying at his feet, plunges the dagger into his own heart. Diderot was only one of those who thought the painting absolutely sublime.[42] And sublime the sentiment may indeed be. But even if Fragonard was the first to translate this unusual subject into paint, the image is one that by now should appear rather mundane. Here is that single moment of resonating drama that we have seen in one work after another, produced in academies from at least the end of the seventeenth century on. It is a drama not unlike that in the paintings by Galloche and Cazes (Figs. 142–3), to whose Jacob Fragonard's high priest bears more than a passing resemblance, having originated similarly in the father or priest of the *Laocoön* group.

The work was found so impressive, it has been suggested, because it was seen in relation to the frivolous mythologies of Boucher and Lagrenée.[43] And

Figure 142 *(opposite, top).* Louis Galloche, *Joseph's Brothers Bringing His Robe to Jacob.* 1695. Paris, Ecole nationale supérieure des Beaux-Arts. (Photo: Giraudon)

Figure 143 *(opposite, below).* Pierre-Jacques Cazes, *Joseph's Vision on the Journey to Egypt.* 1699. Paris, Ecole nationale supérieure des Beaux-Arts. (Photo: Giraudon)

Figure 144. Jacques-Louis David, *Alexander at the Death-bed of Darius' Wife.* 1779. Paris, Ecole nationale supérieure des Beaux-Arts. (Photo: Bulloz)

such comparisons certainly would have worked to its advantage in the minds of those applying academic criteria. For art was constantly changing or, from the point of view of the academy, regressing. To those who accepted this point of view, works conforming to the standards of the academy could not be praised too often or too highly if the art of the tradition was to survive.

A final word must be said about the role of the masterpiece in what I have been calling the language of the academy. That it was a central one has been made clear throughout this study, but especially in discussions of the utterances, both verbal and visual, of Sir Joshua Reynolds, who seemed to encourage reusing the imagery of the masters in a way suggesting little more than plagiarism.[44] It has been shown, too, that an equal stress was laid on imitating the masters in other academies, particularly the French. That such imitation was common in practice was evidenced by academic works freely quoting from the masters, both in details such as poses and in entire compositions. Where did imitation end and invention begin? What was the relationship between a language borrowed from the masters and the works from which it was borrowed? Obviously, the relationship was subject to alteration, and even crisis. When Félibien speaks of creating a second masterpiece by "imitating"

Figure 145. Jean-Honoré Fragonard, *The High Priest Coresus Sacrificing Himself to Save Callirhoë.* 1765. Paris, Ecole nationale supérieure des Beaux-Arts. (Photo: Giraudon)

Poussin's *Eliezer and Rebecca,* for example, the real question, as we know he does not have cloning in mind, is that of his understanding of "imitation."[45] For if the source of art is not life but art itself, and indeed a limited repertory of works of art, then the distance between an "original" work and a paraphrase (copy) will be diminished to the point where it may appear to shrink into insignificance. In the final analysis, however, recognition of the hermeticism of the academy's system renders simple binary models of opposition inadequate.

TAKING LIBERTIES

If the boundaries of this system were well defined, they could also be transgressed without changing its conceptual focus. Minor transgressions were sanctioned as a matter of course in the cause of "originality," it was noted,

Figure 146. Jacques-Louis David, *Leonidas at Thermopylae.* 1814. Paris, Musée du Louvre. (Photo: Bulloz)

artists being allowed a certain license in their interpretations of the classics. This was the license, to cite one further example, of Jacques-Louis David, who, in his *Leonidas at Thermopylae* (Fig. 146), spurned one of the academy's key precepts.[46] The subject is Leonidas, King of Sparta who, with an army consisting of forces from all the Greek states, was charged with holding the key pass of Thermopylae against the invading Persian army. A surprise move by the Persians caused all but the Spartans to flee, Leonidas and his men remaining to confront the enemy though realizing it meant their own deaths.[47]

Here are the figures of the classical tradition, ideal in their nudity, but in a surprising range of apparently unclassical proportions. Leonidas is in the center where, in the language of the academy, the hero belongs; but from the attitudes of the other figures it is not clear either how they relate to one another or to the hero, who, contrary to standard academic practice, is absolutely impassive. What is unclear, in other words, is the action and in what sense it is "heroic."

While working on the painting, David had his pupils represent the same subject in order to encourage and instruct them. Upon being presented with one such composition, he spoke the following words: "This is very good . . . it is a most difficult subject, as you now understand. Here are several groups, well thought out and invented and in the character of the subject." The figures and groups in the character of the subject consisted of Leonidas giving the signal to take up arms and march into combat and the Spartans responding to the call.[48] This interpretation applies the academic formula, and it is one that David in fact essayed during an early stage of the planning of his own composition.[49] He found it wanting, however, and decided to aim at something more thoughtful and serious: "I want to paint a general and his soldiers preparing for combat as true Spartans, knowing that they will not survive it; some completely calm, others plaiting wreathes for a banquet in the underworld. I want neither movement nor extreme expression, except on the figures that inscribe on the rock: 'Passer-by, go tell Sparta that her children have died for her.' "[50]

This is the deviation from the classical norm of David d'Anger's later *Philopoemen* (Fig. 133), which, like Jacques-Louis David's work, refocused the academy's image of the classical past to render it more moving and meaningful to his contemporaries. Nevertheless, both artists shared the academy's veneration of the antique, accepting its assumption about the form and content of art being necessarily classical. To challenge this assumption would have been to compromise the academy's essential ideology. Even here, however, not every liberty taken was an assault on this ideology.

Flagrantly unclassical in subject are such genre paintings by Jean-Baptiste Greuze as his *Le Fils puni* (Fig. 147), which displaces the subjects of ancient history with a scene of everyday family life: the punishment of a modern-day Prodigal Son. The setting is that of a bourgeois interior; the actors, inhabitants of modern France. Or so they apparently appeared to eighteenth-century viewers. In fact, the figures conform to the canonical types of the classical tradition, which is also recalled by the draperylike dresses of the women.[51] And the subject is no less moralizing than those of the classics. A deathbed scene, it is altogether comparable to the representations of Germanicus discussed above and, like them, ultimately traces its origins back to Poussin's treatment of that subject. To say that the conception originated with Poussin, is to suggest an affiliation with his great systematizer, Le Brun, with whom Greuze was in fact compared in his time.[52] Thus evoking memories of both Poussin and Le Brun, it is hardly surprising that he was the idol of Diderot.[53] In sum, what is inescapable about Greuze, despite his genre subjects, is that, as Anita Brookner has observed, "He is in fact painting classical pictures."[54]

More usual within the academic tradition were strategies of renewal or renovation, at times more drastic than that of a Jacques-Louis David but still

respecting the academy's credo. A work that was perhaps the most famous in mid-nineteenth-century France was conceived in such a spirit of liberal reform: Thomas Couture's *Romans of the Decadence* (Fig. 148). Admired for reconciling classicism with romanticism, the Italian with the northern tradition, the painting was equally praised for unmasking immorality. That this was done by means of a seeming inversion of the academy's rules – focusing as it does on stasis rather than action, debauchery as opposed to heroism – was viewed, on balance, as contributing to its effectiveness.[55] Such revisions would, it was hoped, resolve the dilemma of the academy's commitment to the past in a world increasingly preoccupied with the exigencies of the present.

A commitment to this past seemed not incompatible with a recognition of differences in the present to the late-nineteenth-century artist best known for attempting to reinvigorate the classical tradition by overhauling the academy's ideal, Couture's pupil Puvis de Chavannes.[56] A highly eclectic painter, Puvis was motivated by a desire to restore the austerity of an authentically classical art, which he thought the academy had first debased and then fetishized. The goal of paintings such as *Young Girls at the Seashore* (Fig. 149) was to open up a more timeless and universal experience by returning to the "true" spirit of classical art. Engaging, then, the classical tradition, his vision was different from that of the academy in degree rather than kind.

If the academy was able to countenance the modifications to its system made by Couture and Puvis, it could not acquiesce to those of Courbet, who in fact aimed not at the renovation but the destruction of academicism; of all the artists associated with the antiacademicism unleashed by the early modernist dynamic, none was so irredeemably opposed to the academy as Courbet. Conceiving of art as a matter of personal experience and choice, he was the antithesis of the artist dreaming of ancient Greece and Rome. And nowhere is the difference more clearly seen than in his *The Painter's Studio* (Fig. 150). Here is a work, at first glance an academic machine, with its centrally located hero and cast of supporting characters ranged symmetrically on either side to intensify the drama. This is the academy's design for a representation of an Epaminondas surrounded by his soldiers, Moses and the Israelites, and so on. This "hero," however, is none other than the artist himself; the action, nothing more dramatic than his habitual activity of painting. As if this activity were not prosaic enough, the secondary figures, like Courbet in modern dress, are completely indifferent to it. They are also indifferent to one another – passive, expressionless, as emotionally distant from each other as they are from the artist in the center.

Figure 147 (opposite, top). Jean-Baptiste Greuze, *Le Fils puni*. Paris, Musée du Louvre. (Photo: © Réunion des Musées Nationaux)

Figure 148 (opposite, below). Thomas Couture, *Romans of the Decadence*. 1847. Paris, Musée du Louvre. (Photo: © Réunion des Musées Nationaux)

Figure 149. Puvis de Chavannes, *Young Girls at the Seashore.* 1879. Paris, Musée du Louvre. (Photo: © Réunion des Musées Nationaux)

What does the act of the artist signify? Why are the other figures present and what do they represent? What, in sum, does the painting mean? Such questions rarely have to be asked of academic works, and, in fact, despite the existence of letters in which Courbet refers to parts of the painting, we still do not know what it means.[57] The public rhetoric of the academy has given way to an art as personal and esoteric as the obscure feelings from which it springs.

Figure 150. Gustave Courbet, *The Painter's Studio.* 1855. Paris, Musée d'Orsay. (Photo: © Réunion des Musées Nationaux)

THE CLASSICAL REVIVAL

These various revisions of, or challenges to, the academy's language were responses to a tradition as pervasive as it was monolithic; it could be embraced or renewed, but not ignored. And renewal was in fact part of a strategy as old as the academy itself. The goal of the early-twentieth-century classical revival discussed in Chapter 7 was one not of renewal, however, but transformation on the part of avant-garde artists who earlier had rejected the academy and now entered directly into a dialogue with it, the more completely to undermine its authority.

The academy's faith was placed, to say it once again, in select antique sculptures and in subjects culled principally from the Bible and the classics, on the assumption that this ideal, like these subjects, constituted the excellence and preeminence of Western civilization. The artists of the avant-garde questioned this notion of superiority, proposing that non-Western art is no less accomplished than Western. And once having embraced a classical model, a different one from that of the academy, it disengaged that model from the classical tradition, first by joining it to nonclassical forms, and then by altering these forms further to undermine, if not ridicule, their claim to timeless authority.

In a painting such as Picasso's *Two Women Running on the Beach* (Musée Picasso), the figures clearly reflect a fascination with fifth-century B.C. Greek sculpture, but they have been manipulated in utter disregard of the character of that sculpture. The proportions of a Greek original are gone, as is any trace of a canon; proportions vary from figure to figure, as from part to whole, some parts, such as the legs, being arbitrarily elongated and exaggerated. Far from constituting a new ideal, these deformed figures literally explode the whole notion of ideal form. Classical content emerges no less subverted. The figures originated, as has often been noted, from bacchantes on Greek vases or Roman sarcophagi or from Poussin's bacchanals incorporating such figures.[58] But the "subject" of Picasso's painting is neither a bacchanal nor a subject in the traditional sense. Lacking the attributes of figures in classical narratives and a context as well, these figures are just that: two figures disporting themselves on a beach.

This is perhaps, on balance, the most radical manifestation of anti-academicism of early-twentieth-century classicism. For the subject-centered art of the academy has been overthrown. The answer to the question what is the painting about? is, therefore: it is about itself. To cite just one further example, Picasso's *Three Women at the Spring* (Fig. 77) shows figures traceable to various prototypes in ancient frescoes, whereas the grouping itself has been compared to a metope from the Parthenon; sources within the French and academic traditions have also been identified in Poussin's *Eliezer and Rebecca* (Fig. 35) and, even more, in works by Puvis, who painted a strikingly similar subject of women at a well.[59] That Picasso's improbable "women" have not come to draw water is made clear, however, by their diminutive vases. They have congregated for no other purpose than to take their places in a shallow, modernist space behind the picture plane. That the work makes an original statement within the broad framework of the classical tradition is clear. It is equally clear that next to such a work the uses to which the academy put the term "original" must seem blatantly contradictory.

THE REVOLT OF
THE CRAFTS

It is time to resume the historical narrative suspended at the end of Chapter 3, to take into account changes in teaching in the nineteenth century that were more basic than any discussed in the preceding chapters. One point must immediately be clarified. The proliferation of academies in the eighteenth century was the result not only of the fame of the specific academies of Rome and Paris noted in Chapter 3 but also of their complicity with commerce. This was the justification for the reorganization of the Vienna academy in 1725, for example, and for the Dresden academy in 1763. "Art," it was declared in the latter, "can be looked at from a commercial point of view"; and "while it redounds to the honour of a country to produce excellent artists, it is no less useful to raise the demand abroad for one's industrial products."[1] The success of French products being ascribed to a nexus between the French academy and manufacture, a like outcome was anticipated from the intervention of an academy in the Meissen porcelain manufacture, the Leipzig printing trades, and so on.

The French academy was not in fact involved with manufacture but was rather exclusively dedicated, as its name proclaims – Académie Royale de Peinture et de Sculpture – to painting and sculpture, to the "fine" as opposed to the applied arts;[2] it neither admitted nor trained those destined to work in manufacture. The Manufacture des Gobelins, created in 1663, was the facility conceived specifically for such purposes, and its only formal connection with the academy was a course in drawing instruction supervised by one of the academicians and consisting principally of copying engravings.[3] The academy nevertheless did deserve much of the credit for the success of the Gobelins, in which manufacture meant the execution in different materials

and a variety of techniques of the designs of the academicians; Figure 151 is one such tapestry woven from a cartoon after a design by Le Brun, appropriately representing Louis XIV visiting the Gobelins to inspect its wares, furniture, silver plate, and tapestries, an example of the last, hanging on the rear wall, being after still another design by LeBrun. Le Brun, it should be mentioned, as head of the Académie Royale, was also director of the Gobelins.[4] The best-known designers of Sèvres porcelains were the most talented sculptors of the eighteenth-century academy, such as Clodion and Falconet.

Many of the newer academies outside France, unlike the French, directly addressed such commercial needs. They did this principally by enlarging upon the drawing course to include drawing for "art industry," elementary instruction in ornament, including flower and at times animal drawing; the remainder of the course was taught as in the older academies, however, drawing the figure from engravings, part by part and as a whole, drawing from plaster casts and from the live model. The course was strictly of drawing, to emphasize the point, whether taught to artists or artisans, with all questions of materials and working procedures being marginalized.[5] This was the type of program, too, that was formulated in the French school eventually conceived to address the needs of industry, the Ecole Royale Gratuite de Dessin, which opened in 1767 and later became the better-known Ecole Nationale des Arts Décoratifs. The bias was that of all the academies in the Renaissance tradition beginning with Vasari's – namely, against the technical and manual components of the activity; the same bias was behind the trivialization of the material differences between painting and sculpture, painters in academies designing sculpture and sculptors composing reliefs as though they were painters. As conceived in academies and schools, the intellectual potency of drawing alone was capable of rescuing art from the lower occupations and could even elevate the status of the products of commerce.

THE MACHINE

If the division of responsibility between designer and artisan within manufacture was consistent with the academy's expressed contempt of materiality, it was animated at the same time by an unspoken appreciation of the beauty of fine handiwork and a respect for skilled workers. For who was to be entrusted with the execution of a complex tapestry design or the fashioning of an intricate composition using exotic woods or silver if not a technician schooled in the demanding skills of that particular craft and committed to the highest standards of workmanship? As any visitor to the château at Versailles knows, the delight in finely crafted objects of all kinds was not restricted to those in which, by means of "drawing," matter had been subdued by spirit.

Figure 151. Charles Le Brun, *Visit of Louis XIV to the Gobelins.* 1673–9. Tapestry. Paris, Musée des Gobelins. (Photo: Giraudon)

This indulgence in beautifully crafted objects was thwarted, however, when handiwork was displaced, not by a further denigration of matter in academies, but by the single most decisive intervention of the modern world: the machine.

To be sure, workers had always used mechanical aids such as stencils and molds. And mass-produced, stamped metalwork and ornamental silverplate were being produced already in the eighteenth century. But mechanized modes of production, made possible by the introduction of new materials and technologies, by the 1840s brought about a nearly total transformation of manufacture. Objects once produced singly and by hand now were mass-produced by machine, die-stamped, punched, embossed, plated, and cast; these were decorative objects, based on or simulating traditional designs, marketed not only as equal to the older handmade objects but even as superior to them. And actual works of art, until then existing as unique works in museums or known through the exact reproductions of casts, also were mass-reproduced through new techniques of electroplating.[6] (Photo-

graphic reproduction emerged at this time, too, with the consequences for the history of art discussed in Chapter 4.) The whole enabling structure of traditional manufacture was much eroded. And with this erosion came the first real appreciation of something taken for granted, when not despised, in the Renaissance and academic traditions: the human hand.

Honest workmanship and respect for materials were now the contrary ideals advanced, demystifying and displacing the academy's notion of "drawing"; in an inversion of traditional categories, the hand now was viewed as the predominantly spiritual instrument. As for the contest between hand and machine, the first was the undisputed winner: machine-made replicas were declared not only aesthetically but also morally inferior to handmade originals. In the words of John Ruskin:

at all events one thing we have in our power – the doing without machine ornament and cast-iron work. All the stamped metals, and artificial stones, and imitation woods and bronzes, over the invention of which we hear daily exultation – all the short, and cheap, and easy ways of doing that whose difficulty is its honour – are just so many new obstacles in our already encumbered road. They will not make us happier or wiser – they will extend neither the pride of judgment nor the privilege of enjoyment. They will only make us shallower in our understanding, colder in our hearts, and feebler in our wits.[7]

Ruskin's early rejection of mechanized production is indeed the most well known of all such responses, and both the man and his writings have been studied in detail. His arguments need to be reviewed here, nevertheless, for they are expressive not only of a rift between handcrafting and machine production but also between the new work ethic and the doctrine of the academy that has been a principal theme of this book. Ruskin's position was the same, that is to say, with regard both to the fine and the decorative arts – to all of the arts of manufacture, painting, sculpture, and architecture, whether made by those we would call artists or artisans – all to his mind carrying traces of the hearts and hands of the workers who made them.

A MORAL IMPERATIVE

When Ruskin thought of academic doctrine he recalled Reynolds's utterances, which are examined in the second volume of *Modern Painters* (1847). He begins with Reynolds's doctrine of imitation, which, as was noted in Chapter 5, is a restatement of the idealist theories of the Italian Renaissance tradition as interpreted by the French academy. Repudiating this ideology, Ruskin transgresses the traditional boundaries of art criticism by focusing attention not on its concepts but rather its language, which he declares vague and contradictory.

Reynolds contrasts two schools of painting, Ruskin notes, the Dutch and

the Italian, representing, respectively, low and high forms of art, the first involving literal imitation ("petty peculiarities"), the second generalization ("beauty of a superior kind"). After reviewing the arguments made in justification of this distinction, he states: "There is an instinctive consciousness in his own mind of the difference between high and low art; but he is utterly incapable of explaining it, and every effort which he makes to do so involves him in unexpected fallacy and absurdity."[8] And he continues: "the plain truth, a truth lying at the very door, has all the while escaped him . . . namely, that the difference between great and mean art lies, not in definable methods of handling, or styles of representation, or choices of subjects, but wholly in the nobleness of the end to which the effort of the painter is addressed. . . . He is great if . . . he has laid open noble truths, or aroused noble emotions."[9]

Viewed in the light of these "truths" and "emotions," the history of art needs to be rewritten, which Ruskin proceeds to do, revising the arguments that academies since the time of Vasari had made for the superiority of High Renaissance art. Artists from Cimabue and Giotto and including those of the Quattrocento, especially Fra Angelico, hitherto viewed as childish or inadequate, now were preferred to Raphael and Michelangelo. And if Michelangelo had redeeming qualities, Raphael, the head of the academy's pantheon, had none.[10] His works are examples of "monstrosity" and "hypocrisy," Ruskin avers; after Raphael, "Christianity and 'high' art took separate roads."[11] What is so false about Raphael's art, Ruskin makes clear, is precisely the dispassionate perfection that had recommended it to academies. Art is moral and spiritual striving or it is nothing. There was no way to reconcile this schema with that of the academy.

About Ruskin's polemic with academic doctrine, Quentin Bell has written the following:

It is not easy for us to accept Ruskin's moral terminology. But this is an important truth and one that justifies us in seeing in Ruskin the grand executioner of academic theory. It was a point worth making that the difference between great and mean art is certainly to be found nowhere but in the sentiment of the artist. It is not a matter of canonical rules or approved manner, but of a species of innocence or integrity which is indeed moral.[12]

Bell's recommendation of the Ruskinian model is hardly surprising, as this model, stripped of its urgent imperative, has become indissociable from modernism. Before it could so become, however, the unity that for Ruskin was only theoretical had to be made a reality. This was the contribution of William Morris.

In the firm Morris founded in 1861 and eventually called Morris & Co., design and craft harmonized in the production of everything from furniture and stained glass to textiles, tapestries, and wallpaper, all viewed as the

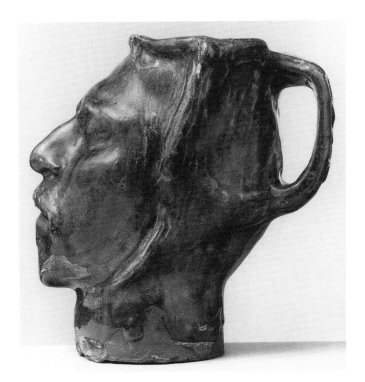

Figure 152. Paul Gauguin, *Jug in the Form of a Head, Self-Portrait.* 1889. Copenhagen, Museum of Decorative Art. (Photo: Ole Woldbye, Museum of Decorative Art, Copenhagen)

"expression by man of the pleasure of his labor."[13] As a practitioner, Morris was able to moderate the more apocalyptic aspects of Ruskin's theory and did so in essays and lectures that nevertheless, in their eloquence, rival Ruskin's own. Reiterating Ruskin's faith in work, he also stressed the importance of a sensitivity to the properties of materials: "Never forget the material you are working with and try always to use it for doing what it can do best: if you feel yourself hampered by the material in which you are working, instead of being helped by it, you have so far not learned your business. . . . The special limitations of the material should be a pleasure to you, not a hindrance . . . it is the pleasure of understanding the capabilities of the special material, and using them for suggesting (not imitating) natural beauty and incident, that gives the *raison d'être* for decorative art."[14]

On this question of materials, as on that of work itself, the Ruskin–Morris perspective eventually won the day. This is not to say that it did not meet with resistance from industry and the academy, the first refusing to concede the aesthetic inferiority of factory-made wares, the second committed as always to "drawing" as an essentially intellectual activity that it would not allow to be contaminated by traces of the hand. But this continuing duality of the academy's doctrine came increasingly to be viewed as a major liability and thus a valid reason for repudiating it. Gauguin was only one of the

enemies of the academy who rejected the distinction it drew between the fine and decorative arts, carrying out his ideas in home furnishings and ceramic wares that he produced alongside his paintings and sculptures (Fig. 152). A belief in the higher consciousness of artists continued to be held, nevertheless, by many members of the avant-garde.

In founding the Omega Workshops in 1913, for example, Roger Fry's aim was to encourage the interaction of the arts and crafts. But he did not believe in the equality of the two; he neither advised artists and craftsmen to work together nor attempted to blur the distinction between the fine and applied arts. The artists who designed fabrics in the workshops did not weave or print on them; they designed but did not make furniture. "In many branches of design," he stated, "it would be wasteful to employ the designer in the actual execution."[15] And in her book on the workshops, Judith Collins remarks on the poor workmanship of many Omega products.[16] What Fry did believe in was the importance of *the hand of the artist,* art as a physical as well as an intellectual activity. And if he did not go as far as Morris, his workshop, certainly in the eyes of the academy, was still part of the Morrisian assault on its doctrine, in this case launched on two fronts: handicraft and the revolutionary new French ideas – namely, those of the Post-Impressionists – that the workshop was conceived to disseminate.

NEW PHILOSOPHIES, NEW SCHOOLS

As early as 1854, Ruskin, an accomplished draughtsman, agreed to teach at the Working Men's College, founded that year for the purpose, we are told, of "giving to the manual workers some opportunity of satisfying the human instinct for knowledge and beauty."[17] He published two books in connection with his teaching, *The Elements of Drawing* (1857) and *The Elements of Perspective* (1859). He later established and endowed a drawing school at Oxford, which still exists. Ruskin's conception of drawing was surprisingly traditional, and he urged that life drawing serve as the basis for the education of designers. "The fact is," he stated, "that all good subordinate forms of ornamentation ever yet existent in the world have been invented, and others as beautiful *can* only be invented, by men primarily exercised in drawing or carving the human figure."[18] To his mind, this was, indeed, all that one could hope to teach designers. "Drawing may be taught by tutors," he stated, "design only by heaven."[19] Having played a major role in formulating an antiacademic ideology, Ruskin here shows a side of his thought that is allied to the doctrine of the academy, an alliance formed, paradoxically, in opposition to those who, like him, questioned the wisdom of regarding the machine as nothing more than a mechanized hand and began to conceive of the possibility of new forms of education for industrial designers.

The first steps in this direction were taken in England in 1835, when a Select Committee was established by Parliament "to enquire into the means of extending a knowledge of the arts and principles of design among the people (especially the manufacturing population) of the country, and also to enquire into the constitution of the Royal Academy and the effects produced by it."[20] Although superior in production, the committee's report stated, England was inferior in the art of design, for the simple reason that design is not taught in schools, "though there are persons that are called designers, yet they have not been educated as such, and in point of fact they know little of the principles of design."[21] Citing the existence of eighty drawing schools in France and thirty-three in so small a country as Bavaria, it recommended the introduction of a similar system in England. The Royal Academy, the principal site of "design" education, saw to it, however, that any new schools would be restricted to the teaching of ornament, the responsibility for a more comprehensive course remaining with it.

As a result of the report, a national School of Design was created in 1837 and monies were appropriated for regional schools – all, as had been ensured, teaching only ornament. As Quentin Bell has observed: "The study of the human figure, . . . was of central importance in the whole scheme of academic teaching; it had assumed an almost mystical value and it was through this study and, one may almost say, through this study alone, that the historical painter was formed. It was for this very reason that it was to be forbidden; the purpose of the schools was emphatically not to produce artists but rather to form the taste of artisans."[22] The course, then, was only of elementary drawing, principally through copying; nor was there any instruction in production techniques. No significant change in English design resulted, and the schools were declared a "complete failure."[23]

The first major changes in design education seem to be traceable to Morris's influence. Pevsner has remarked: "Not one of the founders and principals of the schools of decorative or industrial art down to almost the end of the century had an idea of the organic inter-relation between material, working process, purpose and aesthetic form which William Morris rediscovered. It is therefore due to him and his indefatigable creative energy alone that a revival of handicraft and then industrial art took place in Europe. The Modern Movement in design owes more to him than to any other artist of the Nineteenth-Century."[24] Pevsner cites as the first school to incorporate some of Morris's ideas the Municipal School of Art of Birmingham, which was founded in 1881 and enlarged in 1890 by a special training school for jewellers and silversmiths that was recognized as revolutionary. This school was followed in 1896 by the London Central School of Design, with W. R. Lethaby as coprincipal, also aiming to put Morris's ideas into practice by providing craft training for artisans. With teaching workshops for the crafts,

the Central School of Design directly anticipated the Bauhaus, which may in some sense have been modeled after it; for Hermann Muthesius, while cultural attaché at the German embassy in London from 1896 to 1903, was charged with surveying developments in English architecture and design. Muthesius became one of the founders of the Werkbund, from which the Bauhaus evolved.[25] There can be no question, in any case, but that Morris's ideas played a major role in the Bauhaus's bringing together of artists and artisans.

THE BAUHAUS

The Bauhaus came into existence in 1919, when Walter Gropius reorganized and fused two Weimar institutions, one an academy of fine arts and the other a school of applied arts (*Kunstgewerbeschule*). The name itself was significant. For the German noun *Bau,* though literally meaning "building," echoed the term for the medieval guilds of masons, builders, and decorators, the *Bauhütten,* which the Bauhaus evidently was meant to recall.[26] Both senses of the term entered into the manifesto with which Gropius defined the ideology of the new school:

The ultimate aim of all visual arts is the complete building! To embellish buildings was once the noblest function of the fine arts; they were the indispensable components of great architecture. Today the arts exist in isolation, from which they can be rescued only through the conscious, cooperative effort of all craftsmen. Architects, painters, and sculptors must recognize anew and learn to grasp the composite character of a building both as an entity and in its separate parts. Only then will their work be imbued with the architectonic spirit which it has lost as "salon art."

The old schools of art were unable to produce this unity; how could they, since art cannot be taught. They must be merged once more with the workshop. The mere drawing and painting world of the pattern designer and the applied artist must become a world that builds again.[27]

There is a dual emphasis here: on the creation of a federation of the visual arts under the aegis of architecture and on the merger of art and craft. Gropius enlarges upon the second union in the next paragraph:

Architects, sculptors, painters, we must all return to the crafts! For art is not a "profession." There is no essential difference between the artist and the craftsman. The artist is an exalted craftsman. In rare moments of inspiration, transcending the consciousness of his will, the grace of heaven may cause his work to blossom into art. But proficiency in a craft is essential to every artist. Therein lies the prime source of creative imagination.[28]

This position, deriving, in the words of Reyner Banham, from the "Morrisian standpoint of inspired craftsmanship,"[29] leaves one question in suspension, namely, that of when the techniques of craft were to be put aside to pursue

those "rare moments of inspiration in art." This was a question raised in the mind, for example, of Joseph Albers, an early Bauhaus student who later became a member of its teaching staff. It was begged by the very presentation of the manifesto, for the text was introduced by a woodcut made by Lionel Feininger, a work not of craft but of art, and art of a Cubist-Expressionist tendency. "All I knew of the Bauhaus," Albers later wrote, "was derived from a single sheet, the first manifesto, with one side giving Gropius's new program for reuniting art and the crafts and the other side showing Feininger's woodcut, *The Cathedral of Socialism*."[30] From regarding the two, he had "no idea of how study would be conducted there."[31]

The juxtaposition of image and text in the manifesto, intended to evoke an ideal society of artists and craftsmen on a medieval model, was in fact an outward sign of conflict and tension within the school. It had inherited four professors from the old academy of art and also its students. And Gropius's first appointments were of still more fine artists – two painters, Feininger and Joannes Itten, and the sculptor Gerhard Marcks – all "Expressionists" connected with the Berlin gallery Der Sturm and the periodical of the same name. The reaction of these artists to Gropius's ideology is perhaps summed up in a letter written by Feininger. After referring to the force of Gropius's personality, he wrote: "I am also a fanatic. Gropius sees in art the craft – I the spirit." And he adds, in words that are important for an understanding of relationships in the early Bauhaus: "But he will never demand that I change my art."[32]

The appointments of other artists followed – Muche, Schlemmer, Klee, Schreyer, Kandinsky, and Moholy-Nagy – all on the staff as form masters by 1924. Artisans were appointed as well, the crafts masters being experienced in the various crafts that were to be joined to art as part of Gropius's aim of creating a community of artists-craftsmen, based on master–journeyman–apprentice relations. The crafts were not in fact accorded equal status with the fine arts, however, the crafts masters not even included in the Master's Council. The artists were the ones who took it upon themselves to interpret and refine the curriculum. Itten the fine artist was principally responsible, for example, for the famed Preliminary Course that was supposed to remove the barrier separating art from craft and that is nowhere mentioned in the elaborate tripartite program outlined in the manifesto – craft, drawing and painting, science and theory (the last including, it may be worth mentioning, art history, "not presented in the sense of a history of styles, but rather to further active understanding of historical working methods and techniques.")[33] About the goals of the Preliminary Course Itten wrote the following:

This course is intended to liberate the student's creative power, to give him an understanding of nature's materials, and to acquaint him with the basic principles

which underlie all creative activity in the visual arts. Every new student arrives encumbered with a mass of accumulated information which he must abandon before he can achieve perception and knowledge that are really his own. If he is to work in wood, for example, he must know his material *thoroughly;* he must have a "feeling" for wood. He must also understand its relation to other materials. . . . Preparatory work also involves exact depiction of actual materials. If a student draws or paints a piece of wood true to nature in every detail, it will help him to understand the material. The work of old masters, such as Bosch, Master Franke or Grünewald also offers instruction in the study of form, which is an essential part of the preliminary course. This instruction is intended to enable the student to perceive the harmonious relationships of different rhythms and to express such harmony through the use of one or several materials. The preliminary course concerns the student's whole personality, since it seeks to liberate him, to make him stand on his own feet, and makes it possible for him to gain a knowledge of both material and form through direct experience.[34]

As a first-year student, Albers enrolled in the course. "After destroying most of my academic studies," he wrote, "I began over again in Weimar, beginning with the 'Preparatory Course.' "[35] And his works from the 1920s are indeed strikingly different from those he had made before entering the Bauhaus, the earlier ones being Cubist-Expressionist in the same sense as Feininger's *Cathedral* – no doubt one reason he was drawn to the school – the Bauhaus works, abstractions organizing colors and shapes with regard to the properties of the materials used – art, it would seem, steeped in craft (Fig. 153). But is it? And is this Albers's "true" personality, the artist at last standing on his own feet?

If Albers's works of the twenties are a far cry from those he made earlier, they are strikingly similar to others made by his contemporaries in the Bauhaus at about the same time: all geometrical abstractions. It may seem that there is nothing remarkable about this, as abstraction is a modernist mode and the Bauhaus is identified with modernism. But geometrical abstraction was only one of many such modes in the early twentieth century. The kind of Expressionist style on the margins of which Albers had been working maintained its authority, nourishing a new Expressionism in Berlin in the 1920s; dada and surrealism were international styles that embraced an aleatory abstraction; and Picasso and the School of Paris continued to discover new dimensions of figurative or "representational" abstraction.[36] There are few traces of these developments in Bauhaus works. And if geometrical abstraction was a preeminently modernist mode, it was also a formalist one, tracing its origins specifically to developments in art – not the crafts. It would be hard to imagine a greater contradiction than that between a formalist aesthetic and traditional handiwork. Aware of this and other contradictions, Schlemmer wrote: "the construction and architecture class or workshop, which should be the core of the Bauhaus, does not exist officially, but only in Gropius' private office. . . . It is an architectural bureau, its aims directly

Figure 153. Joseph Albers, *Rhenish Legend.* 1921. Glass shards mounted on copper sheet. New York, The Metropolitan Museum of Art, Gift of the Artist, 1972 (1972.40.1). Courtesy the Josef and Anni Albers Foundation. (Photo: The Metropolitan Museum of Art, New York)

opposed to the schooling function of the workshops." And he added, "If only the Bauhaus would admit to being a modern art school."[37]

Whether an art or a design school, the Bauhaus's championship of the materiality that the academy had repressed made an enduring mark on the teaching of art. Bauhaus methods were adopted by art schools from London to Tokyo to New York. "New Bauhauses" created in Chicago by Moholy-Nagy in 1937 and at Black Mountain College and Yale University by Albers facilitated the dissemination of these methods in North America. What is perhaps most surprising from a postmodernist perspective is the typical denial, by all the assorted Bauhauses and new Bauhauses, of having had a method at all.

In concluding this discussion of Bauhaus philosophy, it should be noted that much importance has been attached to a statement made in 1923 calling

for adjustments of craftsmanship in recognition of the means of mechanized production, an appeal for the union of art and technology understood as having altered the direction of the institution.[38] And evidence for a change in direction has been found in Itten's departure in that year, with responsibility for the Preliminary Course passing to Moholy-Nagy and Albers. But the conflict that existed in the Bauhaus from its early years was present until its dissolution in Berlin in 1933. Itten was not the only staff member to resign: Muche followed in 1927, Moholy-Nagy and Gropius in 1928, Schlemmer in 1929, and Klee in 1930. At the end, of the original staff only Kandinsky remained. What must be stressed is that, insofar as teaching was concerned – as opposed to temperament – there was a broad consensus and a degree of unanimity indeed astonishing in view of the number and strength of the personalities involved.

A NEW VISION

One Bauhaus innovation that deserves special mention is the teaching of photography as an art – or, from the point of view of design, the combining of photography with montage and typography. At first used strictly as a means of documenting activities in the workshops, as well as to produce a "biography" of the new school, photography came to be understood as an autonomous activity deserving a place of its own in the curriculum.

As with painting and sculpture, Bauhaus photography was based not on radically new ideas but rather on those of the avant-garde, in this case particularly that of the Soviet Union as transmitted to Weimar Germany. The key figure was Moholy-Nagy, whose *Painting, Photography, Film*, published as a Bauhaus book in 1925, offered an analysis of recent photographic technology in many ways paralleling that later articulated by Walter Benjamin: photography as a uniquely modern form of "optic creation," arrogating to itself the role until then played by modern painting. (My subheading is taken from the title of Moholy's later and still more famous book, *The New Vision*, 1935.) Moholy perceived the photograph as a means for discarding inherited pictorial conventions and replacing them with objective images of a new reality, contributing to the creation of an authentically modern consciousness. Constantly experimenting, his modern vision consisted of an array of innovations: rotating images, diagonal compositions, tipped perspectives, bird's-eye and worm's-eye views, and extreme close-ups, and using such techniques as the photogram, montage, and multiple exposure.[39]

Although Moholy had introduced many of these ideas and techniques into the Bauhaus, he did not actually teach the course, which was offered regularly only from 1929 on and was entrusted to Walter Peterhans. There was, indeed, considerable opposition to photography by members of the staff,

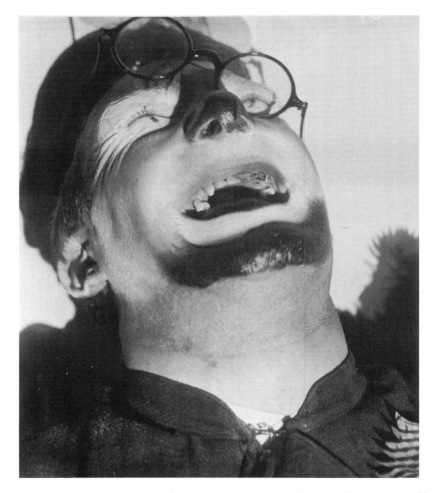

Figure 154. Irene Bayer, *Andor Weininger.* C. 1925. Gelatin silver print. Ackland Art Museum, The University of North Carolina at Chapel Hill, Gift of Dorothy and Eugene Prakapas, 89.111. (Photo: Ackland Art Museum)

particularly to Moholy's extreme view that photography had rendered "static" painting obsolete. Photographic exercises and experiments in the Bauhaus typically were continuous, nevertheless, with Moholy's own (Fig. 154), and these were the models that were placed before the students in the New Bauhaus in Chicago, above all by György Kepes, brought from Berlin to direct the light and color workshop, which included photography. An outgrowth of Moholy's preliminary course, this workshop introduced students to the study of materials and processes such as the photogram (Fig. 155) and explored such techniques as multiple exposure, superimposition of negatives, and solarization, all conceived as the action of light on a light-sensitive emulsion. This legacy of experimentation with a broad range of photo tech-

Figure 155. Arthur Siegel, *Untitled.* Photogram. 1949. Ackland Art Museum, The University of North Carolina at Chapel Hill, Ackland Fund (81.47.1). © Lowinsky Gallery, New York. (Photo: Ackland Art Museum)

nologies set New Bauhaus – and Institute of Design – photography apart from other modernist forms of photography and photographic teaching in North America.[40]

WOMEN AND THE CRAFTS

Up to this point women have been conspicuously absent from my list of Bauhaus staff, among whom, as is well known, there were women. (Here, I refer to staff, other women having played important unofficial and largely unacknowledged roles – in photography, for example, Lucia Moholy and Irene Bayer [Fig. 154], both of whom contributed to their husbands' photographic innovations.) The best known of the women on the staff was Gunta Stölzl, Bauhaus trained and later director of the weaving workshop. When she left in 1931, direction of the workshop was entrusted to another woman, Lilly Reich. The most outstanding graduates of this workshop were all women: Otti Berger, Lis Beyer, Helene Nonné-Schmidt, and, of course, Anni Albers, who had begun her studies in a school of applied art making flowered wallpaper designs and, after her Bauhaus training, went on to teach weaving at one of the new Bauhauses, Black Mountain College. Indeed, from the time

of its inception, this workshop seems to have been conceived as the preserve of women, initially having included in its syllabus crocheting, knitting, and sewing, other work for the "beautiful" as opposed to the "strong" sex, as Gropius himself put it, calling for a "tough separation . . . [of] the female sex."[41]

That weaving was included in the curriculum was hardly surprising as this was an important handicraft; that is was commended to women was no more unexpected, because weaving and such related skills as knitting and sewing had always been considered "women's" work, pursuits consistent with the place of women in the world – namely, the home. In this sphere images of security and virtue traditionally have been dominant. Consider such an image: in the guarded privacy of the home, a faithful wife or virgin whiles away the time weaving or knitting. The image is of truly ancient lineage, ranging from Homer's Penelope to Goethe's Gretchen and beyond. But reflect upon two assumptions that lie behind it. One is that there are activities that are naturally and appropriately feminine; and the second, that these activities, being dominantly manual, are inferior. The second is the one to be stressed here. For "women's" work, falling within that zone of taboo to which the Renaissance and academic traditions had relegated all things associated with the hand rather than the mind, was greeted with contempt, even when ostensibly applauded for signifying virtue.

To eliminate the hand–mind dichotomy, the Bauhaus placed its workshops under the joint direction of artists and artisans, as was noted above, and the weaving workshop was no exception. However, revealingly, the artistic director of this workshop was Georg Muche, neither a woman nor a weaver but a painter. (The craft master was a woman, Helene Börner.) Stölzl returned to the Bauhaus to assist Muche as technical director and was given full charge of the workshop as "junior master" when he left in 1927. In this capacity, she turned it into one of the most innovative and successful in the Bauhaus, experimenting with materials never before used by weavers (cellophane, for example) and also designing for machine production (Fig. 156). Nor did design or form lag behind materials and techniques, the wall hangings, carpets, and other fiber products of the workshop reflecting Bauhaus ideology no less than, say, its pottery or furniture. There is an important difference between weaving and these other activities, however, and it is its labor-intensiveness; no matter how innovative or simple the design, there is no substitute for patient and skilled execution. This was stressed by Stölzl: "Weaving is an old craft, which developed its own principles upon which present-day mechanical principles must still build. Manual skills, ability, and knowledge must be thoroughly mastered and are not – as is the case with a tapestry – to be nourished on imagination and artistic perception."[42] Mastering such skills, like executing their designs, would have kept the women of the workshop at their looms for long periods of

Figure 156. Gunta Stözl, *Runner.* 1923. Wool. Berlin, Bauhaus-Archiv. © 1994 Gunta Stözl/ VAGA, New York. (Photo: Hans-Joachim Bartsch)

time, far longer for this executive phase than in the other workshops, endlessly repeating the same maneuvers. And the sight of such work evidently called to mind images of women at home, patiently sewing and knitting, signs of virtue but, in the traditional hierarchy, also of weakness, with the result that the Bauhaus masters, for all their commitment to handicraft, talked disparagingly of weaving.[43]

And not only the male masters. Having been more or less segregated in the weaving workshop, the women were made complicitous in their manual enslavement. Writing in 1926 about the workshop, both Stölzl and Nonné-Schmidt rehearsed the major themes of masculine prejudice and superiority. "Weaving is primarily a woman's field of work," Stölzl stated. Nonné-Schmidt went further. The artistic woman works two-dimensionally, she suggested, because she lacks "the spatial imagination characteristic of men"; in addition: "the way the woman sees is, so to speak, childlike, because like a child she sees the details, instead of the over-all picture." This is not a handicap, she assures the reader, for "the woman's way of seeing things is not to be taken as a deficiency, rather it is simply the way she is constituted, and it enables her to pick up the richness of nuances which are lost to the more comprehensive view." But this was, of course, taken precisely as a deficiency and as justification for barring or, at the very least, discouraging women from entering the other workshops.[44]

At Black Mountain, Anni Albers continued the work of Stölzl, teaching weaving and textile design as a response to both materials and weaves; her teaching, with its focus on the thread and structure of the weave, came, indeed more than that of anyone else, to be so identified (Fig. 157)[45] – the title of this book alludes to *both* Albers. Anni Albers also continued the Bauhaus tradition of designing for industry, while stressing at the same time, as Stölzl had, the continuity of principles between traditional methods and mechanized weaving; she had her students learn to weave on the backstrap loom, pointing out the beauty and complexity of traditional textiles produced on such looms in Peru.[46] What she was noting, too, was a lineage that has recommended tradi-

Figure 157. Anni Albers, *Study for "Six Prayers" II.* 1965–6. Mixed fibers, metallic thread, cotton thread. Weatherspoon Art Gallery, The University of North Carolina at Greensboro, Gift of Burlington Industries, 1978 (78.2516). Courtesy the Josef and Anni Albers Foundation. (Photo: Weatherspoon Art Gallery)

tional weaving and related crafts to feminist historians – namely, that of occupations invariably associated with women.

Having at first set themselves the task of identifying women artists and inserting them into art history ("old art history with women added"), feminists went on to conduct a radical critique of both art history and the hierarchi-

cal relations on which it has been based.[47] A part of this critique has been of activities traditionally classified as crafts. Consider the following argument:

Women have always made art. But for women the arts most highly valued by male society have been closed to them for just that reason. They have put their creativity instead into needlework arts which exist in a fantastic variety wherever there are women, and which in fact are a universal female art form transcending race, class and national borders. Needlework is the one art in which women controlled the education of their daughters and the production of art, and were also critics and audience . . . it is our cultural heritage.[48]

One problem with this approach, it has been argued by other feminists, is that a defense of women's work that refuses to accept the old distinction between art and craft will not thereby displace the ideology in terms of which such work has been demeaned.[49] The question of "women's" art, like that of "women's" work, cannot be separated, in other words, from that of the evolving role of women in society or, the larger issue, of art in society. In question is not only gender but class, not only creation but consumption.

This objection is supported by the evidence reviewed in this chapter. For, as has been shown, the ideal of Morris and the Bauhaus of reviving the practices of the old guilds, and thereby restoring the dignity of work and the equality of workers, was itself a fantasy. From the treatment of the women weavers in the Bauhaus it is clear that this project was compromised from the start by prejudices of which its members were hardly aware and evidently would have seen no reason to put aside. As Marcelin Pleynet has noted with regard to Kandinsky's anti-Semitism, "what strikes me most in the rereading of the Bauhaus adventure . . . is the fact that in 1919, as in the years following, the ideology informing all the conceptual references of the *masters* of the Bauhaus was the dominant ideology of the time in the Germany of the Weimar Republic."[50] In the end, the revolt of the crafts only reaffirmed old relations that went deeper than those between art and craft – relations based on class, gender, and culture. This is a warning, surely, to be heeded by the next reformers of art teaching.

TEACHING MODERNISM

That there was a broad consensus about teaching among the Bauhaus staff, as I claimed in the previous chapter, is not self-evident. The names of Klee and Kandinsky evoke different images, both of studio practice and classroom performance. And the Bauhaus curriculum invariably has been reconstructed in terms of the contributions of remarkable individuals. Such have been the arrangements of important Bauhaus exhibitions, with sections devoted to Klee's course, Kandinsky's course, Albers's course, and so on.[1] Because of the stature of these figures within the history of modern art it has seemed vital, too, to grasp their individual ideas about teaching in order better to understand their own art. And these ideas, in the form of lecture notes and classroom assignments, have been published in great detail. There is a separate monograph, for example, on Kandinsky's teaching; Klee's lecture notes have been published in two volumes running to more than one thousand pages.[2] The lessons of these artists are, in sum, more fully documented than those of any of the other artist-teachers whose names appear in this book, but in such a way as to reinforce the notion that the Bauhaus was an institution based on an uneasy alliance of fiercely independent personalities.

There is no scarcity of testimony seeming to support such a view. Consider the following report by Klee who, to acquaint himself with the institution in 1921, dropped in on Itten's class:

After a few turns around the room, the master went over to an easel holding a drawing board and scrap paper. He seized a piece of charcoal, his body contracted as though charging itself with energy, and then suddenly he made two strokes in swift succession. Two strong lines, vertical and parallel, appeared on the scrap paper. The students were asked to imitate them. The master looked over their work, had a few

students do it over again, checked their posture. Then he ordered them to do it in rhythm and then he had them all practice the same exercise standing. The idea seems to be a kind of body massage to train the machine to function with feeling. In very much the same way he drew new elementary forms (triangles, circles, spirals) and the students imitated them, with considerable discussion of the why of it and the modes of expression.[3]

Itten's method, then, was highly physical and struck Klee as ridiculously theatrical. And Itten was one of the original members of the staff who resigned, as was noted, after Gropius expressed a distaste for his conduct. Yet the exercises described by Klee were conceived as the means of achieving one of the goals set forth in the description of the Preliminary Course cited earlier, namely, to acquaint students with the "basic principles which underlie all creative activity in the visual arts." About the exercises assigned for this purpose and witnessed by Klee, Itten wrote:

The three basic forms, the square, the triangle, and the circle, are characterized by the four different spatial directions. The character of the square is horizontal and vertical; the character of the triangle is diagonal; the character of the circle is circular. I first tried to convey these three forms as an experience. I made the students stand and trace a circle with the arm until the whole body was in a relaxed, swinging motion. . . . Thus the circle was experienced as an evenly curved line in continuous motion. Then followed concentration on the circle as form; it had to be felt without moving the body. Only then followed drawing the circle on paper.[4]

If Itten's classroom antics repelled Klee, his stress on underlying principles clearly would not have done so. For Klee, in his own more systematic way, taught the same principles, beginning with points and lines, activated to form the square, the triangle, and the circle.[5] And Kandinsky did the same, adding color. Here is a passage in which he discusses the chromatic properties of the three forms:

The cold-and-warmth of the square and its clearly plane nature immediately point to red, which represents a middle stage between yellow and blue and carries these cold-warm qualities with it . . . among the angular (diagonal) a certain angle must be emphasized which lies between the right and the acute angle – an angle of 60 (right−30 and acute+15). When two such angles are brought together with their openings, they produce an equilateral triangle – three acute, active angles – and point to yellow. Thus the acute angle is yellow inside. The obtuse angle loses more and more of the aggressive, the piercing, the warmth and is thus distinctly related to a non-angular line, which provides the third primary schematic plane shape – the circle.[6]

The other chief goal of the Preliminary Course as defined by Itten was the development of an understanding of and "feeling" for materials; he used a variety of them – wood, glass, feathers, metal, stones, and so on – which he had the students touch and experience for their different textures before

drawing them or using them in collages. In all this, his investigations were carried out in an expressive mode, his method intuitive and "wild." But in taking over the course after Itten's departure, Moholy-Nagy and Albers placed no less emphasis on the handling of materials, even though they insisted on a more or less "objective" assessment of their properties and worked with a more limited repertory, Moholy-Nagy concentrating on sheet metal, wire, wood, and synthetic materials, and Albers on paper. Each of these artist-teachers carried out his investigations in his own way, in classroom and studio, but all were versions of an interrogation of the agreed-to universal or "pure" means of creativity.

That this was a definitive program and not simply the channeling of a variety of modernist strategies is shown, too, by what happened to artists during their years at the Bauhaus. Klee, for example, having found it necessary in his role as teacher to articulate the principles underlying his work up until this time, in the process developed a "theory of form" that he then applied more self-consciously: his line became more diagrammatic; his color relationships were prompted by a heightened awareness of mass, weight, and rhythm.[7] Kandinsky, too, having embarked on a new period of reflection and experimentation, formed a style based on "objective" laws governing line, plane, and color that he himself characterized as "restrained."[8]

If all this is not evidence enough of a common cause in the Bauhaus, there is still more, perhaps the most compelling of all, and it comes from the school's approach to that central focus of traditional teaching: the live model. For life drawing was taught in the Bauhaus from its earliest years, both by Itten, as part of the Preliminary Course, and also, from 1921 until 1929, by Schlemmer. Here was that exercise in description, involving endless adjustments and "corrections," by means of which the old academy had instilled its vision of perfect beauty; subserving morality, the vision had been of a godlike entity as the supreme and only justifiable end of art.

To Itten, by contrast, life drawing was no more than capturing the rhythmic movement of a pose, an exercise in gestural drawing carried out to the accompaniment of music (Fig. 158).[9] Schlemmer's was a more prolonged confrontation with the figure. Beginning with a straightforward life-drawing class, he went on to develop a synthetic course "On Man," conceived as a decidedly utopian investigation of the figure throughout history, and specifically with regard to the machine age (Fig. 159; cf. Fig. 107). The point here is that, for all its ambitiousness, this investigation was based on an approach to the figure utterly different from that of the tradition. One entry in Schlemmer's journal reads: "the square of the chest, the circle of the stomach, cylinders of the arms and lower part of the legs, spheres of the joints at elbow, knee. . . ."[10] His interest, evidently, was in the geometrical means required to represent the new man-machine, the same means upon which the other Bauhaus teachers relied.

Figure 158. M. Jahn, *Figure Study.*
1921. Charcoal and pencil. Bauhaus-
Archiv, Berlin. (Photo: Bauhaus-
Archiv, Berlin)

EXERCISES

Despite this ample documentation of teaching, coupled with evidence of a
consensus, the Bauhaus method has remained elusive; it has not been clear in
what sense or to what degree this teaching was distinctive or effective. Ques-
tions have remained about the existence of a Bauhaus system, whether it is
possible to speak of Bauhaus teaching except in the context of modernist
practices as they evolved in the early twentieth century. And because the
Bauhaus itself regularly published statements about the impossibility of teach-
ing art, many scholars have concluded that there is not even an issue that
needs confronting.

That Bauhaus teaching cannot be considered apart from the history of
modernism is not in dispute. The style it favored – geometrical abstraction –
itself belonged to this history, tracing its origins to cubism and constructivism,
as "deconstructed," too, by Mondrian and Van Doesburg, whose ideas it
helped disseminate. Without this history Bauhaus teaching could not have

Figure 159. Oskar Schlemmer, *Man in the Sphere of Ideas.* 1928. © 1994 The Oskar Schlemmer Family Estate and Archive, Badenweiler, Germany. (Photo: Archive C. Raman Schlemmer, Oggebbio, Italy)

existed. But this is not the same as saying that the Bauhaus did nothing more than endorse various modernist practices. That its teaching involved the crystallization of specific and exclusive modernist concepts is proven by the works produced in it by faculty and students. In this section one such group of works will be examined in an attempt to clarify the distinctiveness of Bauhaus teaching: works based on the grid or checkerboard.

The basic grid structure, like so much else in Bauhaus teaching, originated with cubism, after which it was explored by Malevich and Mondrian, among others; the modular grid, still more radically nonfigurative, was rarer and associated principally with a series of "checkerboard" paintings made in 1918–19 by Mondrian. From that time on, and especially since the 1960s, the grid and related checkerboard have featured prominently in modern painting.[11] The point here is that within this history the Bauhaus played an especially important role, that it was not just another place in which grid and checkerboard were mobilized, but one in which, from its early days, they were given particular prominence in its struggle against the tradition; fundamentally antinaturalistic, antimimetic, they were among the devices deployed to effect that rupture with the old methods of figuration that was so central to the Bauhaus project.

In the Preliminary Course, samples of various materials would be arranged on grids and checkerboards in order to observe similarities and contrasts, to study materials and textures completely divorced both from nature and from their uses in the real world. In working with paper in a checkerboard format, for example, "pure" relationships would be created by means of such operations as punching, pricking, and scratching. Diverse materials also would be formatted so as to enlarge the possibilities of strictly visual and tactile relationships. And color was studied in this way, too, in terms of contrast and with regard to value, weight, and rhythm.

For confirmation of the centrality of grid and checkerboard in Bauhaus teaching one need look no further than Albers's student works. Here is a complete about-face, Albers having "begun over again" by abandoning the Expressionist mode he had brought with him and displacing trees and cathedrals with grids and checkerboards (Fig. 153). It was a displacement, however, of a kind familiar from the exercises of other Bauhaus students: an arrangement of shards of colored and textured glass with regard to their optical and tactile properties.[12] (Albers's works from the later twenties, it should be noted, negotiate the grid even more rigorously than these first Bauhaus exercises.)

Itten deserves the credit for introducing the grid into the Bauhaus, and his teaching has been characterized as "loose" compared with the more systematic approaches of Klee and Kandinsky.[13] ("Systematic" in the context of this discussion means only a still more careful analysis of form and color, for an

Figure 160. Paul Klee, *New Harmony.* 1936. Collection of The Solomon R. Guggenheim Museum, New York. © 1995 Artists Rights Society (ARS), New York/VG Bild-Kunst, Bonn. (Photo: The Solomon R. Guggenheim Museum, New York)

understanding of which they, no less than he, found the grid indispensable.) A grid often underlies Klee's explications of pictorial space and movement; he would chart the weight and rhythm of colors on checkerboards.[14] Having used grids in his own works before joining the Bauhaus staff, Klee resorted to them still more from this time on and, indeed, for the remainder of his career (Fig. 160).[15] Kandinsky, though not relying on grids and checkerboards to the same degree, nevertheless used them in his teaching and his own works — in the first similarly to Itten and Klee, to study the interrelationships of colors, and in the second, making the checkerboard part of his repertory of abstract shapes.[16]

Of all the members of the Bauhaus staff the one most committed to grid and checkerboard, however, as should by now have been evident, was Albers. Having taken over the Preliminary Course from Itten, he continued the practice of using such schemata for research into the properties of materials and colors. And he did the same after moving to Black Mountain College and later to Yale University.[17] As an artist, he submitted inexorably to these

Figure 161. Joseph Albers, *Color Sketch.* 1969. Weatherspoon Art Gallery, The University of North Carolina at Greensboro, Dillard Collection, 1969 (69.1655). Courtesy the Josef and Anni Albers Foundation. (Photo: Weatherspoon Art Gallery)

structures, first applying them in glass constructions and later in serialized paintings. The "Homage to the Square" series on which he labored for nearly thirty years and for which he is best known (Fig. 161) is, in its elegant simplicity, only the final consummation of his lifelong affair with the grid system.

These serialized grids of Albers, it has been noted, encouraged the spread of such imagery in American art from the later 1950s on.[18] The question of how direct a role his own teaching played in this process has been harder to answer, however, and will be examined in the following section. At this time two things should be kept in mind: one, that grids and checkerboards were ubiquitous in the Bauhaus and equally pervasive in the programs established by Albers in the United States and, two, that they then became increasingly important to a generation of North American artists, many of whom, it turns out, had received Bauhaus training in these programs (Figs. 162–3, 167).

THE UNIVERSITY ART DEPARTMENT: THE NEW ACADEMY?

To suggest that prominent artists may have been formed in the classroom is to provoke the kind of response described some years ago by Harold Rosenberg. In a lecture calling attention to a shift in art training from art schools and artists' studios to university art departments, he noted that of ten leading artists of the generation of Pollock and De Kooning, only one had a degree, whereas the majority of artists prominent in the mid-1960s had B.A.s and B.F.A.s. The mere mention of this difference led one younger painter in the audience, Rosenberg reported, to protest that he and his peers were being labeled "academic." Promising not to use this term, Rosenberg proceeded nevertheless to characterize the work of university-trained artists in precisely the terms commonly reserved for types of "academic" art:

Can there be any doubt that training in the university has contributed to the cool, impersonal wave in the art of the sixties? In the classroom – in contrast to the studio, which has tended to be dominated by metaphor – it is normal to formulate consciously what one is doing and to be able to explain it to others. Creation is taken to be synonymous with productive processes, and is broken down into sets of problems and solutions. . . . New painting and sculpture typical of the past decade make the spectator aware of the presence of model works that have not been so much imitated or drawn upon for imaginative hints as systematically analyzed and extended by rational inference. For instance, Josef Albers' impacted color squares have become the basis of impacted-color rectangles, chevrons, circles, stripes – works bred out of works, often without the intervention of a new vision.[19]

To Rosenberg, then, the proliferation of grids and checkerboards in North American art from the later 1950s is no mystery; resulting neither from the conjuncture of individual visions nor from some general modernist impulse, it can be traced, quite simply, to university training – training in the method of Albers or, in fact, by Albers. For who were the artists using Albers's color squares as the basis for color rectangles, chevrons, stripes, and so on, if not his own former pupils, Kenneth Noland (Fig. 162), Richard Anuskiewicz (Fig. 163), and others?

Rosenberg's reservations were not about teaching modern art as such, it must be made clear, but only about the way this was being done in universities. For he was a great believer in the teaching of Hans Hofmann, who, from the early 1930s on, presided over a "studio" school famous for rejecting the traditional hierarchies. That this school taught a definite method has always been obvious; but even at its most complete it has seemed no method at all, not in the sense of Albers's in any case. For it was a method conceived to teach art – which Albers claimed could not be taught – and accepted what Albers would not: the individual gesture, the accident, and mystery of creativity.[20] The Hofmann "look." Expressionist in essence, regularly was derided by Albers – as Hofmann, in turn, denigrated Bauhaus teaching.[21] And there

Figure 162. Kenneth Noland, *Study in Color Relationships No. 2.* Early 1950s. Courtesy Arts and Science Museum, Statesville, North Carolina. (Photo: Arts and Science Museum, Statesville)

Figure 163. Richard Anuszkiewicz, *Untitled.* 1971. Silkscreen. Weatherspoon Art Gallery, The University of North Carolina at Greensboro, Weatherspoon Benefactor's Gift, 1973 (73.1908). © 1994 Richard Anuszkiewicz/VAGA, New York. (Photo: Weatherspoon Art Gallery)

could be no greater contrast than that between works by their respective students. In this contest, Rosenberg's preference is clear. But what is really behind it is not some definitive measure of artistic performance but only the conviction that he shared with Hofmann as to how works reflecting systematic teaching such as that of Albers are the suicide of art.

Oddly enough, many of Albers's former pupils, among them those most committed to his approach, seem to have agreed with this view. Ilya Bolotowsky was his more important teacher at Black Mountain, Noland for one has said, because Bolotowsky, "took us back to Impressionism when we were all beginners and through Cubism into neo-plastic art and Surrealism."²² What Noland is claiming here is that Bolotowsky's teaching, by rehearsing the history of modern art, prepared him to take his place as heir to a whole tradition, of which Albers's teaching encompassed only one part — teaching that, by implication, posed the threat of academicism inherent in any too definite model. (The question of Albers's effectiveness as a teacher has been turned, too, into a beauty contest, with students grading him according to whether he was "tense and rigid" or "wonderfully sweet.")²³ Clearly, as Rosenberg remarks at the opening of his essay, the training of students in universities to be painters and sculptors is an extremely touchy subject among artists.

One objection to Rosenberg's indictment of university teaching must immediately be entered, and it is that although the programs of Black Mountain College and Yale University produced an unusually large number of successful artists, few of them fit his stereotype: among the Yale students, in addition to those already mentioned, William Bailey, Jennifer Bartlett, Rackstraw Downes, Nancy Graves, Robert Mangold, Brice Marden, and Richard Serra; at Black Mountain, together with Noland, Robert Rauschenberg, Dorothea Rockburne, and Cy Twombly.²⁴ Few of these artists can be said to echo Albers's aesthetic, whereas some seem clearly at odds with it, figurative artists and Pop and Minimal artists — and not only painters of chevrons, circles, and stripes. And whereas some of these artists have stated their differences with Albers, others have described his teaching in such ways as to suggest that there was nothing with which to take issue. "To follow me, follow yourself," he is reported by one former pupil to have advised; reaffirming the Bauhaus belief in the unteachability of art, he urged students, we are told, to venture beyond problem solving into individual poetry and personal vision.²⁵

That Albers did not provide his pupils with recipes — any more than Hofmann — is not, then, in dispute. His teaching was unquestionably conceived, as he often said, "to open eyes"; it ran counter to the whole philosophy and weight of the monolithic academic system. Yet there was a definite content to it, one tracing its origins to Bauhaus teaching with its stress on

"pure" means and the handling of materials. And that is the key point here. In question is not whether or to what extent Albers's pupils mimicked him and whether such mimicry is indicative of "academicism," but rather and simply whether modernist methods can and have been taught. And the answer to both questions is yes, often with results that one would never have expected.

FROM THE UNIVERSITY TO THE ART WORLD

Of Albers's former pupils none would seem to have been more indifferent to his teaching than Robert Rauschenberg. Compare a typical Rauschenberg such as *Canyon*, 1950 (Fig. 164) with one of Albers's Hommages (Fig. 161). The first, a seemingly random arrangement of papers, cardboard, wood, a stuffed eagle, and a tied pillow, with unevenly applied and dripped paint, would seem a total repudiation of the second – which is to say, a complete rejection of everything Albers stood for. And Rauschenberg's later works are equally distant from those of Albers, as informal as his are formal, the "Jammer" series of 1975–6, for example, casually combining poles and cloth. Yet Rauschenberg repeatedly has stated his indebtedness to his teacher. "Albers was a beautiful teacher and an impossible person," he has said. "He wasn't easy to talk to, and I found his criticism so devastating that I never asked for it. Years later, though, I'm still learning what he taught me, because what he taught had to do with the entire visual world. . . ."[26]

Confronting the visual world was, in fact, what Albers always said his teaching was about. His courses were conceived to sensitize students to visual phenomena, to form and color, and to the properties of materials, which were constantly to be altered and transformed in the creation of new structures and relationships. His preferred material, we recall, was paper, but he had students use objects made of other materials as well – razor blades, burlap, matchsticks, and so on. If such things as poles, cloth, stuffed birds, and pillows would not be out of place on such a list, would not the gap between Albers and Rauschenberg be bridged? It would have to be shown, of course, that Rauschenberg's handling of these materials in some sense applied Albers's lessons.

Few writers have thought to track Rauschenberg's use of materials to its source.[27] Max Kozloff, for example, in the early 1960s, identified Rauschenberg's work as "the most significant art now being produced in the United States by anyone of the younger generation" and proceeded to discuss it principally in terms of its imagery.[28] And Leo Steinberg, some ten years later, substantially agreed, crediting Rauschenberg with the invention of the "flatbed or work surface picture plane," capable of carrying more messages from a world that it "let in."[29]

The paintings in question are the key "combines" of the 1950s and 1960s, works striking in their use of imagery, particularly so at the time for seeming to contradict a basic tenet of abstract expressionism. But these images are in fact stripped of their assigned meanings and are barely legible; photographic reproductions, comic strips, and other images are literally embedded in the paint surface, layered and stacked, partially covered or spattered with paint and other materials.

In *Canyon* (Fig. 164), for example, the paint was applied in varying densities from tarry and opaque to semitransparent, mostly semitransparent coats being layered over photographic reproductions that are themselves layered with words, word fragments, and isolated letters; these last also vary in size and real or apparent texture, as do the fabrics, wood, cardboard, and so on. The paint application itself is unusually varied, suggesting a kind of inventory: stroke, smear, drip, splatter. The images, materials, and paint are not merely on the surface; each is in a particular stratum, positioned in relation to others of like or different color and texture, each having a specific visual weight and density. So artificial is this montage that it seems as though, in Leo Steinberg's words, "the Abstract Expressionists were still nature painters."[30]

These painters, that is to say, for all their hierarchical ranking of the means of painting, nevertheless were too committed to the traditional definition of a painting as a window on the world to undertake the exploration of the actual properties of these means. Rauschenberg took what must have seemed to him the next logical step, subjecting the means themselves to an investigation as things, an investigation conducted with the kind of thoroughness that Albers expected of his pupils. There is the difference, of course, that whereas Albers required that materials and objects be emptied of their associative content, Rauschenberg accepted and exploited such associations, exploring not only the visual properties of materials but also their potential *meanings*.

Rauschenberg's work from the early seventies is even more obviously indebted to Albers's teaching. Inventing structures of new and improbable kinds by exploiting the properties of soft and light materials, he remarked, "Materials have a reserve of possibilities built into them."[31] These words could just as well have been uttered by Albers.

If Rauschenberg's statements encourage an examination of his art in relation to Albers's teaching, those of Noland, such as the one quoted above, do the opposite. When confronted by the work itself, however, regular and geometrical, using motifs such as the chevron, circle, and stripe, it is difficult to suppress thoughts of Albers. Diane Waldman, writing about Noland's development on the occasion of a retrospective in 1977, for example, was unable to do so. After reporting Noland's remark that Bolotowsky was his most important teacher, she states, "it is undeniable that Albers' influence was all pervasive at the school and surely left its mark on Noland."[32]

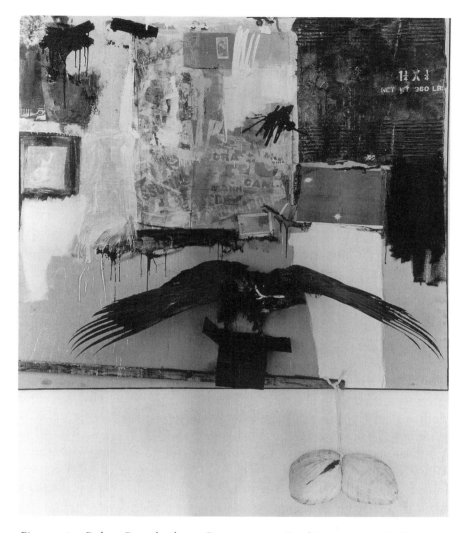

Figure 164. Robert Rauschenberg, *Canyon.* 1959. Combine painting. Collection of Ileana Sonnabend, New York, on indefinite loan to the Baltimore Museum of Art. © 1994 Robert Rauschenberg/VAGA, New York. (Photo: Leo Castelli Gallery, New York)

However, the modern artist is, as always, allowed the last word. Because Noland had stated his indebtedness to Bolotowsky, whom he described as "coming out of Mondrian," Waldman proceeds to examine Noland's work for evidence of concerns similar to these two artists. "Noland's mature works owe much to Mondrian in their classic purity," she observes, with the following qualification: "although Noland is by no means the purist that Mondrian was, the essential grid structure of Mondrian's art – the demarcation of the canvas with black bands which often stop short of the edge and create a

sensation of movement in flat space – and the way color works within that structure became basic components in Noland's own work."[33] This statement, though accurate enough in characterizing the works of these two artists, in fact points away from Mondrian and toward Albers, whose grids Noland's more directly recall, especially those of paintings of the early 1950s that are by now familiar Bauhaus-type color exercises (Fig. 162). And equally close to Albers are paintings that are far more pivotal in Noland's career: his "Targets."

Here it seemed to Waldman that Albers's influence could not be denied. "Noland's concentric circles more closely resemble Albers's concentric [*sic*] squares than they do Mondrian's paintings," she states.[34] The differences are greater than the similarities, however, she cannot help but argue: "[Noland's] concern is unique and is opposite in intent to Albers, who used the square to maintain a static balance and interacting color to create illusory motion. Noland appears in this connection to have been impressed by Kandinsky's color theories as expressed in *Concerning the Spiritual in Art*."[35] Differences between Noland's and Albers's color notwithstanding, the basic format of the Targets, it turns out, was anticipated by Albers in a design that was ubiquitous at Black Mountain.

The design was for a seal and library bookplate that Albers published in 1935 with an explanation that restates the positivist approach of the Bauhaus after Itten (Fig. 165); it is perhaps worth quoting in its entirety:

On the front of this leaflet we present our new seal and on the back our library bookplate.

Since we are now in the middle of our second year, it is clear that we have not designed them in a hurry. Meanwhile we have tried to clarify differing opinions concerning this matter of a college emblem.

As will be at once obvious, we have no inclination to play at being Greeks, Troubadours, or Victorians; for we consciously belong to the second third of the Twentieth century. We are not enamoured of astrological, zoological, heraldic or cabalistic fashions. We have hunted neither the phoenix nor the unicorn, nor have we tacked on learned mottoes. And for "Sapientia" or "Virtus" we are still too young.

Instead, as a symbol of union, we have chosen simply a simple ring. It is an emphasized ring to emphasize coming together, standing together, working together. Or, it is one circle within another: color and white, light and shadow, in balance. And that no one may puzzle over cryptic monograms, we give our full address. Judgment of the esthetic qualities we leave to the competent; for unsure critics we cite a rather distinguished authority:

"By beauty of shape I do not mean, as most people would suppose, the beauty of living figures or of pictures, but, to make my point clear, I mean straight lines and circles, and shapes, plane or solid, made from them by lathe, ruler, and square. These are not, like other things, beautiful relatively, but always, and absolutely." (Plato *Philebus* 51c)[36]

Do Noland's Targets not equally reflect this dismissal of the circles and

Figure 165. Joseph Albers, *Black Mountain College Seal.* 1935. Raleigh, North Carolina, Department of Archives and History, Courtesy the Josef and Anni Albers Foundation. (Photo: North Carolina State Archives)

targets of artists with more spiritualist aesthetics – in his time, say, of Gott-lieb and Newman – and concentration on these means as such, as the elements of a "language" of art? And is it not likely that this approach, like the target itself, was suggested to him by Albers, his teacher at Black Mountain College?

Here it must be said that, for an understanding of the role of teaching modern art in schools and universities, it would make little difference if Albers had not been the inventor of so specific a motif as the target later disseminated by Noland or, for that matter, if other members of the faculty had made more of an impression on students. Consider, for example, what Noland would have learned from Bolotowsky. A geometrical abstractionist allied to the European constructivists and neoplasticists, his understanding of the nature and function of art was similar to that of the Bauhaus artists (Fig. 166); his lessons about the plane and about shape and color would not have differed significantly from Albers'. And if the Yale faculty consisted of a more diverse group of artists, including Stuart Davis, James Brooks, and Esteban Vicente, most of these artists, too, were in agreement about basic questions. What the abstract painter Brice Marden would have learned about making marks on the plane from Vicente, for example, would have been fundamentally similar to Albers' own lessons of this kind. The point is simply that modern art can be, and has been, taught no less than the art of the tradition.

Figure 166. Ilya Bolotowsky, *Small Diamond.* 1940s. Weatherspoon Art Gallery, The University of North Carolina at Greensboro, Weatherspoon Gallery Association Purchase, 1990 (1990.4270). © 1994 Estate of Ilya Bolotowsky/ VAGA, New York. (Photo: Weatherspoon Art Gallery)

And though the point seems simple enough, it has rarely been conceded, for in the region of modernist ideology eminence is inseparable from originality, and originality understood as such is unteachable.[37]

Certainly there can be no question about the originality of Eva Hesse, one final Albers pupil to be discussed in this section. Nor can it be denied that she was engaged with Albers's theory and practice during the formative period of her development. A photograph taken at Yale in the late 1950s shows her with Albers, as his star pupil; and her color studies were included in his *Interaction of Color.*[38] Her "serious" paintings at this time were not related to these studies, however, but were rather in the abstract expressionist mode that Albers denigrated.

It was in the mid-1960s that Hesse's work took the turn on which her reputation is based. One thing that has been found striking about this work is its blurring of the line separating art from craft through the use of such non-art materials as cord, rubber, and plastics. These materials typically are deployed, at the same time, within structures traceable to the modernist repertory, chief among them the grid (Fig. 167). The elements are repeatable units, the most recurrent ones being the circle and the line: the circles typically concentric, at times target circles; the lines "drawn" with threads, strings, or wires.

The names of a host of art-world figures have been mentioned in connection with this work, Ad Reinhardt and Jasper Johns among them, principally

Figure 167. Eva Hesse, *Untitled No. 1. 1967.* String and wash. Weatherspoon Art Gallery, The University of North Carolina at Greensboro, Dillard Collection, 1967 (67.1508). (Photo: Weatherspoon Art Gallery)

in support of the claim that, though Hesse shared interests with many of them, she did not "get anything" from anyone. That she may have "gotten something" from her teacher seemed inconceivable. Yet circles, lines, and grids, as has been shown, were among the elements and structures preferred by Albers, who stressed the investigation of the properties of ordinary materials; in one such "rearrangement" exercise involving the grid, he had students

shift elements, including the wire of window screening and the thread of onion sacks, to create spatial effects without compromising the flatness of the plane.[39]

This is the type of shift on which such works as Hesse's *Metronomic Irregularity, 1* of 1966 is based (Wiesbaden Museum, Germany): two wood panels covered by modular grids are connected by cotton-covered wire that runs from holes in the corners of one grid to those of the other, accentuating the horizontal within the horizontal/vertical order of the grid and also giving it a dramatic spatial action. The oddities and idiosyncracies of this action are peculiar to Hesse and surely would have been criticized by Albers; nonetheless, it was his teaching that, in a fundamental sense, was behind it. If this seems far-fetched, consider Hesse's own words. "There isn't a rule . . . I don't want to keep any rules. I want to sometimes change the rules," she has said, wondering, "How much more can be done with this notion."[40] Is this not the desire to transcend the rules that was noted among the nineteenth-century "originals"?[41] For Hesse as for them, it was essential, however, that the rules first be learned. In other words, this would be one of those acts of rebellion for which avant-garde artists are known, and that frequently can be observed among university-trained artists who go on to produce works contrasting in spirit with what they were taught was "serious"; here, as in other cases, the rules needed regularly to be repeated even as they were broken.

One is left pondering the connection between works such as this one and related Minimal objects produced in New York during these years by such artists as Sol LeWitt, whose name is frequently coupled with Hesse's – as Johns's and Stella's are with Noland's. For it is incontestable that what these artists did "fit in" with works produced in New York from the late 1950s on. And there is the question, too, of the time lag, in both cases perhaps five years before the artists consistently put Albers's ideas into their own practice. What is the relation between Noland and Hesse and the New York art world, as opposed to the university, and why did several years after their experience of Albers's teaching have to elapse before they were drawn into its grasp? The likely answer is that the moment was propitious, a convergence of factors in the art world having revived memories of Albers's teaching in the minds of his former pupils; it was as though, in recapitulating the history of modernist art, he had anticipated its latest episode – or, in the case of Hesse, redirection. As a prophecy, however, it was self-fulfilling, the pupils he had turned into believers guaranteeing that it would come true.

PRESENT AND FUTURE ACADEMIES

One question hanging over this discussion has been left suspended: is this art of the university "academic" art? It is, after all, as Rosenberg has said, self-

conscious and cool, and are these not the attributes of an academic art? Clement Greenberg, who has worried about academicism in modern art more than most critics, would probably answer in the affirmative, but only in part; the hallmark of academic art to his mind is indeed a self-consciousness, but, more importantly, one in the service of a "false" originality. (Greenberg taught at Black Mountain, incidentally, during the summer of 1950.) He has drawn a contrast between authentically avant-garde art and art that is merely "avant-gardist," the latter subverting the originality of the former by making it an end in itself.[42] "Academic qualms are omnipresent," he states, "like mold spores in the air. They arise from the need for security, which artists feel as much as other human beings do. Until recently any kind of art in which this need predominated declared itself more or less openly as academic. There were, of course, degrees and degrees; and it never was, and never will be, easy to distinguish among them. Yet when we look back it seems that it used to be easier to do so than it is now, when so many sheep have taken to wearing wolf's clothing." What separates these disguised sheep from real wolves, he goes on to say, are the historical conditions under which the latter produced their work. "Superior art comes, almost always, out of a tradition," he affirms along with T. S. Eliot; it is the quest for novelty as important in its own right that leads to academicism in avant-gardist disguise.[43]

The painters of chevrons, circles, and stripes of Rosenberg's argument would not, or certainly not all, impress Greenberg as avant-gardist – or academic. Noland, for one, is an artist he admires, precisely for creating an art of "superior" quality by working through the modernist tradition.[44] That he was introduced to this tradition in school would make, it seems, no difference to Greenberg, which is to say that, for the sake of his argument, the origins of such an art, whether in a studio or a university art department, matter little. It would have to be the tradition as he understood it, of course, and the teaching of it not too "fixed."

If, under certain conditions, Greenberg would accept the art of the university, it would follow that, to his mind, that art is not "academic," a term that in his writings is strictly pejorative; and so it clearly has been for the majority of artists who identify with the avant-garde yet teach in universities. There has been one notable exception, an artist obsessed with the academy, which he seems to have wanted to revive: Ad Reinhardt.

Reinhardt was an abstract painter broadly committed to the neoplastic tradition strongly represented in the American Abstract Artists, of which he, like Bolotowsky, was a member. A teacher throughout most of his life, he was a member of the regular faculty of Brooklyn College in New York City, taught from time to time at Yale and other universities, and also instructed in his own way by means of cartoons and essays published in newspapers and art magazines. Musings about the academy appear in many of the latter, the

most famous being his "Twelve Rules for a New Academy" or, as he explains in the essay, "The Twelve Technical Rules (or How to Achieve the Twelve Things to Avoid)." His list:

1. No texture. Texture is naturalistic or mechanical and is a vulgar quality, especially pigment texture or impasto. Palette knifing, canvasstabbing, paint scumbling and other action techniques are unintelligent and to be avoided. No accidents or automatism.

2. No brushwork or calligraphy. Handwriting, hand-working and hand-jerking are personal and in poor taste. No signature or trademarking. "Brushwork should be invisible." "One should never let the influence of evil demons gain control of the brush."

3. No sketching or drawing. Everything, where to begin and where to end, should be worked out in the mind beforehand. "In painting the idea should exist in the mind before the brush is taken up." No line or outline. "Madmen see outlines and therefore they draw them." A line is a figure, a "square is a face." No shading or streaking.

4. No forms. "The finest has no shape." No figure or fore- or background. No volume or mass, no cylinder, sphere or cone, or cube or boogie-woogie. No push or pull. "No shape or substance."

5. No design. "Design is everywhere."

6. No colors. "Color blinds." "Colors are an aspect of appearance and so only of the surface." Colors are barbaric, unstable, suggest life, "cannot be completely controlled," and "should be concealed." Colors are a "distracting embellishment." No white. "White is a color and all colors." White is "antiseptic and not artistic, appropriate and pleasing for kitchen fixtures, and hardly the medium for expressing truth and beauty." White on white is "a transition from pigment to light" and a "screen for the projection of light" and "moving" pictures.

7. No light. No bright or direct light in or over the painting. Dim, late afternoon absorbent twilight is best outside. No chiaroscuro, "the malodorant reality of craftsmen, beggars, topers with rags and wrinkles."

8. No space. Space should be empty, should not project, and should not be flat. "The painting should be behind the picture frame." The frame should isolate and protect the painting from its surroundings. Space divisions within the painting should not be seen.

9. No time. "Clock-time or man's time is inconsequential." There is no ancient or modern, no past or future in art. "A work of art is always present." The present is the future of the past, not the past of the future. "Now and long ago are one."

10. No size or scale. Breadth and depth of thought and feeling in art have no relation to physical size. Large sizes are aggressive, positivist, intemperate, venal, and graceless.

11. No movement. "Everything else is on the move. Art should be still."
12. No object, no subject, no matter. No symbols, images, or signs. Neither pleasure nor pain. No mindless working or mindless non-working. No chess-playing.[45]

What is left for painting? Surely, Reinhardt was writing with his tongue in his cheek, as has usually been supposed. Yet there is something deadly earnest about these tragicomic negations, many of which are rejections of rules in particular systems – those of Mondrian, Hans Hofmann, Greenberg, Albers, and so on. (Albers, for his part, in a 1950 interview, had compiled a list of his negations: "No smock, no skylight, no studio, no palette, no easel, no brushes, no medium, no canvas, no variation in texture or *matière*, no personal handwriting, no stylization, no tricks, no twinkling of the eyes. I want to make my work as neutral as possible.")[46] Why should one person's rules be any better than another's, or why should modernist dicta have any more validity than those of traditional orthodoxy, namely, the ones associated with the old academies? In his own teaching, Reinhardt rejected both. (His answer to the question about a new academy: yes. "A new world-wide pseudo-academy of semi-abstract art is with us and is having a heyday.")[47] Having been assigned a life-drawing class, he had his students, I am told, draw on one and the same sheet of paper all semester long; they had to erase the image at the end of each class and start over again on the same sheet in the next, before long having only a torn and tattered surface left. The lesson was his Rule No. 3: "No drawing." And when I was in his painting class in the late 1950s, he would advise students who showed real talent for painting to leave school, rent a space among artists – and paint.

Reinhardt would have agreed with the Bauhaus and Albers about one thing – namely, that art cannot be taught – but he also had no interest in design (No. 5:"No design") or in anything that was not art, namely craft. Most of all, he was objecting to the how-to mentality of art teaching. He wrote: "The one purpose of the art academy university is the education and 'correction of the artist'-as-artist, not the 'enlightenment of the public' or the popularization of art. The art college should be a cloister–ivyhall–ivory-tower–community of artists, an artists' union and congress and club, not a success school or service station or rest home or house of artists' ill-fame."[48] Art devalued by the new "academy university" is to be elevated, in this plan, by the next academy, an academy returning, interestingly, to the original ideal of the Renaissance tradition. For an academy such as Reinhardt envisaged would be like those first created in Florence on the model of Plato's, an academy that would not lurch in the currents of the art world but be a center of pure research and discourse.

EPILOGUE: POSTMODERNIST CONTINGENCIES

The importance of the term "tradition" to Clement Greenberg in the remark cited in the previous chapter is twofold: one, modern artists must be aware of the tradition, in the sense of the Renaissance and the academy, in order to go beyond it; and, two, new art of value – or "quality" – inevitably will take its place as the latest episode of an alternative, modernist tradition that he traced through abstract expressionism into postpainterly abstraction, from Jackson Pollock to Kenneth Noland and Jules Olitski. With the last, he thought, modernism had achieved its ultimate triumph – and untimely end, untimely because the art world had allowed itself to be deflected from its modernist course into Pop, Minimalism, Conceptualism, and so on; it had turned its back on the tradition that had nurtured it, succumbing to "avant-gardism," a seeking after the new for its own sake. Deploring this traditionless art, Greenberg stopped writing criticism.[1]

What Greenberg called "avant-gardism" has since been placed under the umbrella of postmodernism, a revaluation of modernism now generally agreed to have been set into motion with the Pop of such artists as Rauschenberg. (Albers's teaching as placed in relation to the work of his one-time pupil, Rauschenberg, in the preceding chapter would seem, paradoxically, to have contributed to the crisis of the modern tradition to which he was so firmly committed.) Accepting the random and the ordinary, these artists narrowed the gap, in Rauschenberg's phrase, between art and life, rejecting the notion of a high art with a life and tradition of its own; whole areas of social and psychological expression that had been relegated to a zone of taboo were elevated to the status of art. From having been identified with the historical process itself, art henceforth could be, it seemed, anything at

all. And so it has been: art during the last thirty or so years, as compared with modern art before that, has been conspicuously lacking in coherence and continuty – in sum, in a definite tradition, modern or other.

This has been especially true of architecture, the one of the visual arts most publicly disruptive to modernism, in this case, the Bauhaus tradition of functionalist architecture. Rejecting functionalism for its own sake, architects "rediscovered" the language of architecture, which is to say that of the classicist tradition, an idiom that they found to be of a forgotten complexity and richness; "relearning" this language, they have created an architecture of a new eclecticism and historicism, rewriting modernist architectural theory – and the history of modern architecture.[2]

With the decline of the prestige of modernism, the premodern tradition regained some of its former appeal for painting and sculpture as well. Modern art having been shown to be neither monolithic nor inevitable, the classical art of the Renaissance and academic traditions showed signs of making a comeback. Indeed, to some what seemed proven was that modern art had been doomed from the start for denying the importance of the traditional disciplines and skills central to both the making and judging of premodern art – skills such as figure drawing, as indispensable, they argued, as ever.[3]

Against this advocacy of traditionalism, however, there were those who thought that reports of the death of modernism had been greatly exaggerated. The modern tradition itself, they suggested, was much older, and of a different kind, from the one described by Greenberg. Whether traced to the beginning of the "modern age" in late-fifteenth-century Europe or to the Enlightenment, the modern tradition in this view was only the latest episode in the "Great Tradition" of the Renaissance that, having been safeguarded in academies, has been the principal focus of this book. Modernism thus understood is inseparable from the culture and institutions central to European civilization from early in modern history until well into the twentieth century. Postmodernism is understood, in turn, either as a crisis in the authority of this culture and civilization or as a redirection of its energies, as modernism in a new socioeconomic context; indeed, it increasingly has been understood in this second sense, as part of an ongoing and self-conscious critique from within modernism itself, occasioned by changes in late-twentieth-century capitalism.[4] However varied or conflicting, these analyses, by more sharply focusing attention on tradition(s), have taught one lesson above all others: that the Western tradition, modern as well as Renaissance, has been ethnocentric and antifeminist, marginalizing the cultures of non-Western peoples and women.[5] Much of society – or the population of the world – from the Renaissance into modern times, in other words, has been ridiculed by and excluded from the cultural mechanisms by means of which Western culture represented and therefore viewed itself.

In no institutions are these failings and biases more clearly evident than in the academies and schools studied in this book. The Renaissance tradition of teaching, as has been shown, was based on a vision, embodied in a set of cultural landmarks, justifying a belief in the preeminent singularity of Western man – "man" meant literally. The central image, and self-image, of this tradition is of a male figure such as was first created by the ancients, "perfect" in its features, proportions, and bearing; repressed are those awkward elements found in less-than-perfect male figures, namely non-Westerners and women, the latter "improved" through masculinization. The works in which this image appeared were of subjects familiar to a lettered public, which is to say that this art was meaningful only to an educated elite, those living in and through a group of canonized texts. The majority of the population, not or poorly educated, lived a reality for which there was no acceptable means of representation and which, for this reason, could not be, and was not, expressed.[6] The literature, of course, was that of the Christian West, an expression of the only system of belief deserving to be called "civilized." As for the more strictly modernist phase of the tradition, it was no less ethnocentric – its interest in non-Western ("primitive") art notwithstanding – no less masculine in its imperatives, and no less strongly committed to the notion of "high" art, as was proven by the fate of weaving and other crafts in the Bauhaus. The modernist rejection of classical norms therefore was not a repudiation of the cultural apparatus in which these norms were embedded but rather an attempt to gain control of this apparatus in order to assume the authority hitherto reserved for the tradition alone, an authority that, once usurped, it exercised with no fewer prohibitions. One could go on.

As badly as this model matched the societies of the past, from the Renaissance into the mid-twentieth century, it has even less to recommend it in today's "global village." Postmodernists, having learned this lesson from the Renaissance and modern traditions, have been reluctant to propose an alternative to them; they have deliberately refused to speak with an authoritative voice or to take a clear position vis-à-vis the past. And they have not been alone in refusing to do so. As a result of the postmodernist project, the visual arts find themselves in precisely the same position as other humanist subjects such as literature, philosophy, and history. They find themselves, in sum, in the midst of a raging "culture war."[7]

Typically represented in the press as consisting of women and minorities, on the one side, and "dead white males," on the other, this conflict has focused attention on the whole question of the canon, its audience and continued validity. If it is agreed that the world we live in is fundamentally different from that of the ancients or of the Renaissance, how meaningful can we expect works made in those times to be to the public of today? This question, in itself as old as the Quarrel of the Ancients and Moderns men-

tioned earlier in this book, is asked with a new urgency. For the recognized public is constituted differently from that of the past, comprising populations marginalized, when not denigrated, in earlier times: women and multiple ethnic groups. No longer blind to the biases of works in the canon, to what is repressed and omitted, to its underlying ideological assumptions and the fact that they were those of a male elite, many critics have been denying the possibility of applying or defending an objective and universal cultural standard. What may have been valid – if not particularly laudable – in other times, when societies could act as though they were homogeneous, is no longer defensible, they have maintained, given the greater ethnic and racial consciousness of the present environment. Just what this means for the teaching of canonical works, whether by Aristotle, Shakespeare, or Goethe, is the subject of the present controversy in literary and philosophical studies. What is important for the arguments of this book, however, is that the debate is ongoing and is about teaching itself, what to teach, how to teach it, and for whom this teaching is intended.

To be sure, this is not the first time in recent memory that such questions have been asked about the teaching of art. During the heady years following the triumph of modernism, it was widely believed that the tradition, having been dismantled, had nothing to offer modern artists or, at best, was to be consulted only insofar as it could be accommodated within a modernist program. The Old Masters were taught in the Bauhaus, for example, in such a way as to conceal the devices and conventions that had made their works ideologically effective in their own times: a vision of the figure and a set of aesthetic and moral "truths"; these works henceforth were to be consulted simply and exclusively for what could be learned from them about form, color, and composition. And many modernist artists were convinced that the masters did not have even that much to offer, or that such lessons were to be learned at the peril of falling into the grasp of an art agreed to be moribund.

Some of today's postmodernists would reject the notion that the works of the masters are of value in the formalist sense of the Bauhaus, that is, of greater value than – say – billboard advertisements, newspaper photographs, or magazine illustrations. They reject the requirement, in other words, that art be "high," like that of the masters. And if others have decided that recent history has overturned the modernist verdict, proving that the masters still have much to offer, what precisely does that consist of? Does admiring, or teaching by means of, the masterpieces of the tradition mean accepting the ideology bodied forth by them? If not, how is that "content" to be separated out while preserving their form? Given the uncertainty in the world about the definition and direction of the visual arts, if teaching is not to be an altogether fruitless activity, on what may it reasonably and justifiably be based?

A view apparently widespread among those teaching art is that these

questions do not pertain to their activity. Many teachers continue to think in terms of the old opposition between the tradition and modernism and opt for the first, which they interpret, paradoxically, according to the second, in a fashion similar to that, say, of the Bauhaus: in other words, the traditional figure and works composed with it are emptied of content and treated as, or as consisting of, so many formal elements and devices, both, of course, respecting the appearance of actual figures in space. A recent article on the "crisis" in English art schools, for example, laments the displacement of the old disciplines by photography and video, and the stress placed on success in commercial terms rather than "by ascertainable formal criteria." Cited with approval is a proposal to establish a traditionalist academy, "with a syllabus comparable to pre-war [i.e., World War II] art schools."[8]

An academy of this type had indeed been created in New York City ten years earlier; teaching with a traditional syllabus organized around drawing from casts after the ancients and such moderns as Michelangelo, and drawing from live models, it has grown into one of the largest graduate art schools in the United States, its program being the envy, it would seem, of many teachers in university art departments.[9] Asked in 1982 how their teaching had changed in recent years, teachers typically responded: not appreciably, describing a type of teaching easily meshed with that of an academy of the tradition. "What I am teaching today is no different from what I taught ten years ago and what I plan to teach in the future. . . . If my teaching has changed at all, it is that the unpreparedness of incoming students on a graduate level, owing to the teaching of trends instead of techniques, has created a need for basic remedial instruction at a level where more independent work would have been appropriate." Another remarked: "Since I teach painting from the nude model, I have always been concerned with perception, anatomy, perspective, tone, and color. I feel that whatever the student's future style will be, she cannot know too much."

The response of the teacher committed to modernism laid no less stress on knowledge, nor was he less dismissive of postmodernist initiatives. "Since political opinions in the art world are but varying dilutions of the same old leftism (I include myself in this) and since stridency and not thoughtfulness is the common carrier, I am really wary of the whole business . . . I favor painting. I favor abstract painting, and I favor abstract painting that tries to make its case without coyly fooling around with bad taste or being *outré*. Although my own ideas of what might work inside a painting and what might not have changed, and are changing slowly, I still give thumbs up, thumbs down, and a few lateral positions in between; it's what I teach best, and those who desire something else are free to go to somebody else."[10]

The "trends" taught in place of techniques would have to be those of the "low" practices, learned at the expense of such "high" techniques as drawing

and painting, which need to be reinstated through "remedial instruction." These are the skills that cannot be too highly developed, about which the student cannot "know too much." Nor can students of modernist painting know too much about formal invention, about what "works," what is "good" or in good taste. In teaching, whether it is of abstraction or figuration, the lineage from the Renaissance to the present day would seem to be unbroken; art is, and forever will be, what it has been up until now. The assumption, in other words, is the central one of the Renaissance and academic traditions: the continuing validity of universal values and of the judgments based on them. Postmodernism, in this view, is just one more political trend that, once having lost its novelty, will find itself in the dustbin of history.

This is the place for me to remind the reader that the eternal verities of the tradition(s) ended up being regarded as neither timeless nor universally true; the entire modernist episode from 1850 on was only one of the "trends" that did not pass, but rather left the tradition radically altered. I could argue, citing the analyses of social and political theorists, that this is true of postmodernism as well; taking its side, I would then urge an enlargement of the syllabus to include the various "low" forms of art such as video, advertising, and magazine and comic book illustration, an expansion of the field of teaching that has been advocated as both historically inevitable and culturally desirable. I would have to conclude by noting that because art teaching today most often takes place – in North America, at least – in a university as part of a general education, it is proper and fitting that it take into account the configurations and problems of the societies in which students later will produce art.

Instead, I will end simply by asking two questions. About to enter not only a new century but a new millennium, can we say that we are clear about what art is and what role we expect it to play in our lives and in society? Are we clear enough about these crucial issues to say that art should be taught in one way and in that way only?

NOTES

INTRODUCTION

1. Pevsner (1940).
2. Ibid., pp. viii–ix: "the historian of art must for a while give up looking at the development of aesthetic phenomena exclusively, and give up summarizing aesthetic realizations into groups to form the phases and epochs of a style, or the regional and national characteristics of a people. It is only a social history of art that can help here." As for his historicism: "Only by throwing into relief the individual oneness of any given period or style or nation, and the logical coherence of all its utterances in the most varied fields of human activity, will the historiographer in the end be able to make his reader discover what form a certain problem must take at the present moment."
3. Boschloo et al., eds. (1989).
4. Two exhibitions could be visited at this writing: *Bauhaus-Künstler: Malerei und Grafik aus den Beständen der Kunstsammlungen zu Weimar und der Deutschen Bank* and *Bauhaus Dessau Dimensionen, 1925–1932*.
5. Hess (1967), pp. 8–10.
6. The preceding paragraph is much indebted to Paz (1988), p. 471.
7. See the suggestive remarks of Pleynet (1977), pp. 111–28.

1: THE PROBLEM OF THE FIRST ACADEMY

1. Pevsner (1940), pp. 25–30; Goldstein (1988), p. 79.
2. Cellini (n.d.), p. 58; cf. Jack (1976), pp. 3–20.
3. Vasari (1568), 5:350, 6:609–10.
4. See Cole (1983), pp. 30–35; Frinta (1993), pp. 19–34; Ames-Lewis and Wright (1983).
5. Ibid., nos. 29, 30; Ames-Lewis (1981), pp. 49–61.
6. Waźbiński (1987), pp. 89–95.
7. Vasari (1568), 4:256, 7:142, where this "school" is called an "academy." Cf. Wittkower and Wittkower (1964), p. 45; Waźbiński (1987), pp. 205–6. The artists of Vasari's *Lives* are organized into "schools"; see Goldstein (1991), p. 645.
8. See Weil-Garris (1981), pp. 223–51. In the 1531 engraving of Bandinelli's academy, however, copying is shown. See Roman (1984), pp. 81–95.
9. Waźbiński (1987), p. 66.
10. Vasari (1568), 1:168. Cf. Summers (1981), pp. 229, 519n49.
11. Waźbiński (1987), pp. 57–9.
12. See esp. Field (1988).
13. Hankins (1991), pp. 429–75. Hankins (1990) argues for the last of these possibilities. p. 7.
14. See Panofsky (1962a), pp. 129–69.
15. See esp. Waźbiński (1987), passim; Gold-

stein (1988), pp. 78–88. Also see Cavallucci (1973); Frey (1923); Pevsner (1940), pp. 42–58; Jack (1976); Ward (1972); Reynolds (1974).

16. Pevsner (1940), p. 55; Borea (1963), p. 88; Waźbiński (1987), pp. 208–11.
17. Wittkower and Wittkower (1964).
18. Ibid., pp. 43–4.
19. Summers (1969), pp. 67–90; Waźbiński (1987), pp. 111–54.
20. Waźbiński (1987), vol. 2, figs. 35–41.
21. See Calamandrei (1956), pp. 1345–61; Winner (1968), pp. 293–304; Pope-Hennessy (1985), pp. 278–9; Goldstein (1988), pp. 83–4. For the Socratic theory, see esp. Gombrich (1981).
22. Pevsner (1940), pp. 296–304; Waźbiński (1987), pp. 423–36.
23. See esp. Prinz (1966), pp. 5–158.
24. Waźbiński (1987), p. 493. See below, Chap. 8.
25. Barzman (1985), pp. 354–99.
26. Dempsey (1977), p. 69; idem (1980), pp. 552–689.
27. Barzman (1985), esp. pp. 354–99; idem (1989a), pp. 4–32; also, idem (1989b), pp. 459–63; idem (1991), pp. 37–48.
28. Waźbiński (1987), p. 493.
29. Ibid., pp. 489–93. For differences between Zuccaro's ideas about study and those of the academy, see Waźbiński (1985), pp. 275–341.
30. Bottari-Ticozzi (1922–5), 3:529.
31. Goldstein (1991).
32. Panofsky (1960a), chap. 1; Gombrich (1966); Baxandall (1971); Summers (1981).
33. A key text is White (1973); also Bann (1984).
34. See Eagleton (1983).
35. Vasari (1568), 4:9–11.
36. Goldstein (1988), p. 87.
37. Vasari (1568), 4:373–4.
38. Ibid., p. 445; Vasari (1960), p. 146.
39. Lorenzoni (1912), pp. 12–13; Barocchi (1960), 1:82; cf. Goldstein (1988), pp. 87–8.
40. Goldstein (1988), pp. 85–8; Waźbiński (1987), pp. 401–2.
41. Waźbiński (1987), 2:432.
42. Waźbiński (1978), pp. 47–57.
43. *Dessins baroques florentins du musée du Louvre* (1981), nos. 8, 34.
44. *Mostra di disegni dei fondatori dell'Accademia delle Arti del Disegno nel IV centenario della fondazione* (1963), no. 64.
45. Pevsner (1940, p. 55; Ward (1972), p. 296.
46. Waźbiński (1987), 2:401. The Medici, later in the seventeenth century, in turn emulated the French; see Goldberg (1983), 135.

2: A TRADITION IN THE MAKING

1. Missirini (1823).
2. Pevsner (1940), p. 61; Rossi (1984); Goldstein (1978), p. 4. For the academic system at the beginning of which the Roman course stands, see van Peteghem (1868).
3. See especially, Mahon (1947), pp. 166–76.
4. Alberti and Zuccaro (1604), pp. 115–25.
5. On Zuccaro's theory, see Panofsky (1960b), pp. 85–95.
6. Alberti and Zuccaro (1604), p. 38.
7. Ibid., pp. 67–70.
8. Mahon (1947), p. 176.
9. Pevsner (1940), p. 62.
10. Ibid., p. 62.
11. Missirini (1823), p. 80; Goldstein (1978), pp. 4–5.
12. Noehles (1969), p. 362; de la Blanchardière (1973), p. 79; Thuillier (1990), pp. 100–5.
13. Passeri (1934), p. 81; see also Goldstein (1978), p. 5; Harris (1977), pp. 33–7; Turner (1973), pp. 231–48.
14. Goldstein (1988), p. 81.
15. Ibid.
16. For this and the whole tradition of drawing books, see Gombrich (1960), pp. 156–72; Rosand (1970), pp. 5–53; Amornpichetkul (1984), pp. 108–18; and Goldstein (1988), pp. 47–8.
17. Goldstein (1988), pp. 49–50, 89.
18. For the first, see Dempsey (1977); idem (1980), pp. 552–69; idem (1989), pp. 33–43. An example of the second view is Posner (1971), p. ix.
19. Goldstein (1988), pp. 89–155.
20. Ibid. The most recent discussions again make a muddle of the figure drawings by treating them all as illustrations of the theoretical and biographical texts, without considering the visual evidence, and arguments based on it in my Carracci book of 1988, for differences between these texts and the practices of the Carracci, whose figure drawings were at times based on live models and at times, other types of models; see Feigenbaum (1990), pp. 145–65; idem (1993), pp. 59–76. For the whole

question of types of figure drawing, see Chapter 8 below.

21. Pevsner (1940, p. 72; Malvasia (1678), 2:258–60; Stone (1991), esp. pp. 146–51. For the lasting influence of the Carracci within the academic tradition, see Boschloo (1989), pp. 105–17.

22. Baldinucci (1728), 4:511; cf. Six (1925–6), pp. 229–41.

23. See Hofrichter (1983), pp. 36–49; Reznicek (1963), pp. 247–53.

24. Bok (1990), pp. 58–68.

25. Bruyn (1992), p. 80, noted that drawings of the nude in Rembrandt's studio "may be called 'academies' (in the informal sense of the word)." Later writers such as Sandrart criticized Rembrandt's operation precisely for its incompatibility with "academic" doctrine, which by the later seventeenth century had been well formulated; see Slive (1953). Such distinctions notwithstanding, in the most recent discussion, Rembrandt is made to preside over an "academy"; Janssen and Sumowski (1992).

26. For Rembrandt as a teacher, see Janssen and Sumowski (1992), and Haverkamp-Begemann (1969), pp. 21–30; Alpers (1985), pp. 58–87; Bruyn (1992), pp. 68–89.

27. Bruyn (1992), no. 21.

28. See Bolten (1985).

29. Alpers (1985), pp. 69–70.

30. Ibid., p. 72.

31. Pevsner (1940), p. 72.

32. See Wittkower (1958), pp. 171–80; Mahon (1960), pp. 237–63; idem (1962), p. 96; Goldstein (1978), pp. 4–5.

33. Goldstein (1971), pp. 345–55; Thuillier (1960), pp. 49–238, 84–5; Barocchi (1964), pp. 125–47; Haskell (1963), pp. 17–19.

34. Rosenberg and Thuillier (1988); *Charles Le Brun, 1619–1690, peintre et dessinateur* (1963). More generally, Thuillier and Châtelet (1964), pp. 61–125; Wright (1985), pp. 93–126.

35. See Thuillier (1964), pp. 181–209; Schnapper (1990), pp. 27–36. See also Sterling (1956), pp. 42–51.

36. Yates (1947), pp. 290–1.

37. For the early history of the academy, see Vitet (1861); Teyssèdre (1965), pp. 15–26; Goldstein (1966).

38. *Procès-verbaux de l'Académie Royale de Peinture et de Sculpture* (1875), 1:9.

39. Guiffrey (1910).

40. *Procès-verbaux de l'Académie Royale de Peinture et de Sculpture* (1875), 1:76; amplified in Bosse (1665), p. 13.

41. *Procès-verbaux de l'Académie Royale de Peinture et de Sculpture* (1875), 1:76.

42. Vitet (1861), p. 236.

43. *Procès-verbaux de l'Académie Royale de Peinture et de Sculpture* (1875), 1:255–64.

44. Ibid., p. 315; Fontaine (1909); Teyssèdre (1965), pp. 70–92; cf. the review of Goldstein (1967), pp. 264–8.

45. Félibien (1668); Jouin (1883).

46. Montagu (1994); Wilson (1981); Kirchner (1991).

47. See also, Cropper (1974), pp. 376–85. For Gericault's paintings of severed heads and limbs as an ironic commentary on this academic practice, see Athanassoglou-Kallmyer (1992), esp. pp. 616–17. For Barthes's interest in such alphabets, see Barthes (1985a). On the most recent attempts to outline such an "alphabet" and "language," see Saint-Martin (1990) and Sönesson (1989); cf. the review of both books by Manovich (1991), pp. 500–2.

48. Bryson (1981), p. 32. For the broader issues, see esp. Dufrenne (1966), pp. 1–43; Zemsz (1967), pp. 40–73; Barthes (1985b), pp. 149–52.

49. Lapauze (1924).

50. See Goldstein (1978), pp. 3–5; Cipriani and Valeriani (1988), 1:17.

51. In a letter of 1669, Colbert asks for a list, "en marquant en marge ce que vous avez déjà fait copier et ceux qui restent encore à faire copier, ou en peinture ou en sculpture"; see Pevsner (1940), p. 99. For these artists, see Goldstein (1970), pp. 227–41; Boyer (1950), p. 117; Pirotta (1964), pp. 5–9; Bousquet (1980).

52. Bousquet (1980), pp. 110–1.

53. Mahon (1947), p. 188.

54. Ibid., p. 189.

55. Goldstein (1978), pp. 3–4.

56. For Bellori's theory, see Panofsky (1960b), pp. 105–11.

57. See Goldstein (1978), p. 1. For the tradition of such representations, see Winner (1962), pp. 168–70.

58. See Mahon (1947), p. 189.

59. Ibid., pp. 189–90.

60. This "doctrine," it should be made clear, will be tracked to its source in teaching. There

was in Rome all during the seventeenth century a heavy traffic in art theory by such members of the Accademia di San Luca as Pietro Testa and Poussin, which, however, so far as can be determined, did not directly affect its teaching. For this theoretical tradition, see Cropper (1984); Bell (1993), pp. 91−112; Goldstein (1994).

61. Pevsner (1940), p. 110. Goldberg (1983), pp. 134−72.

3: THE TRIUMPH OF THE ACADEMY, LEADING TO THE REACTION OF THE AVANT-GARDE

1. See, e.g., Oursel (1989), pp. 244−53.
2. Pevsner (1940), p. 119; Mai (1989), pp. 320−9.
3. Saabye (1989), pp. 520−32; see also Monrad (1989), pp. 549−59.
4. Pevsner (1940), pp. 119−22; Sarabianov (1990).
5. On the academy in Madrid, see Bédat (1974); for earlier attempts to win support for an academy, see Volk (1977); J. Brown (1989), pp. 177−85. In Mexico City, the Academia and Museo de San Carlos dates from 1783−7; the Escuela Nacional de Bellas Artes in Buenos Aires opened in 1878. To mention only two others, Havana's Academia de San Alejandro was established in 1818, and the Escuela de Bellas Artes of Santiago in 1849.
6. Howitt (1886), 1:44−5, translation from Andrews (1964), pp. 5−6.
7. Schnapper (1990), pp. 34−5; Teyssèdre (1965); cf. Puttfarken (1985).
8. E.g., Janson (1986), p. 556.
9. See, e.g., Loquin (1912), pp. 258−64; Thuillier and Châtelet (1964), pp. 141−9; Levey (1993), pp. 1−18, 173−86; Conisbee (1981), esp. pp. 73−110.
10. See, e.g., Rosenblum (1967), passim; Honour (1968), pp. 17−32.
11. For the reform, see Wilson (1981), pp. 6−11; Fried (1980), pp. 35−55.
12. See below, Chap. 8. For other drawings from the competitions, see Kirchner (1991), pp. 210−13. For drawing in the eighteenth-century academy, see Rubin (1977), pp. 16−37.
13. On the eighteenth-century Salons, see Crow (1985), pp. 1−22; Wrigley (1993), passim; the nineteenth-century, Mainardi (1993). For Salon criticism, see *Collection des livrets des anciennes expositions depuis 1673−1800* (1867−71).
14. Levey (1993), p. 2.
15. Ibid.; Diderot (1957−67); Bukdahl (1980−2).
16. See Monty (1961), pp. 26−31. As a result, these Salons remained virtually unknown in France until their publication, beginning in 1795, after Diderot's death.
17. On *ekphrasis*, see O'Malley (1979), pp. 63−7; Fumaroli (1980), pp. 258−61; Marek (1985).
18. See esp. Van Tieghem (1955), pp. 255−63; Fried (1980), pp. 76−82.
19. Fried (1980), p. 79.
20. Whitley (1928), 1:157−8; Paulson (1971), 1:244−51; Kitson (1968), pp. 46−111.
21. Bignamini (1989), pp. 434−50; Hutchison (1968), p. 43; idem (1989), pp. 451−63.
22. Kitson (1968), pp. 56−7.
23. Nochlin (1971), pp. 22−39, 67−71.
24. "A List of the students of the Royal Academy who have obtained Premiums . . . ," uncatalogued ms, Royal Academy, London.
25. Ibid.
26. For Diderot, see Desne (1967), p. 565.
27. Quoted in Ireland (1798), 3:76. For this "aesthetic of iconoclasm," see Paulson (1989).
28. J. Reynolds (1975), p. 13.
29. *Minutes of the General Assemblys of the Academicians of the Royal Academy*, vol. 1, fol. 30.
30. Cf. Hilles (1936).
31. Wornum (1848); Galt (1820).
32. A contrary view − namely, that David emphatically rejected the aesthetic of the academy − frequently has been put forward, most recently by D. Johnson (1993). What her evidence shows is not a rejection, however, but another of those periodic adjustments referred to above, as, for example David's role in reforming − not abolishing − teaching of the "expressive head" and of the figure (pp. 147−73). For David as a student in the academy, see also *David e Roma* (1981).
33. Pevsner (1940), pp. 199−201; Boime (1971), pp. 5−8; idem (1982), pp. 95−101.
34. See esp. Grunchec (1986); also Boime (1971), pp. 133−48. The Düsseldorf academy was especially well known for its attention to

landscape, but in the northern and romantic traditions; see Hutt (1964). The Weimar academy, which eventually was absorbed by the Bauhaus, also was so known; see Chap. 12.

35. Mouilleseaux (1990), pp. 131–9.
36. Boime (1971), pp. 48–78.
37. See esp. Boime (1977), pp. 1–39; Grunchec (1990), pp. 33–46.
38. Ibid., p. 35.
39. Sauer (1990); see also Boime (1982), pp. 98–101; Weinberg (1991), pp. 13–23; Radycki (1982), pp. 9–13; Garb (1993), pp. 33–42; idem (1994), esp. pp. 70–104.
40. The principal surveys are: Nochlin and Harris (1976); Greer (1979); Parker and Pollock (1981). The important monographs on individual artists are: Garrard (1989); Hofrichter (1989); Perlingieri (1992). For further bibliography, see the excellent survey by Gouma-Peterson and Mathews (1987), pp. 326–57.
41. On the question of male and female models, see below, Chap. 8.
42. See above, Chaps. 1 and 2.
43. Garrard (1989), p. 34; Roworth (1992); Parker and Pollock (1981), pp. 28, 97–8; Nochlin and Harris (1976), pp. 161, 174, 190–1.
44. For some differences between still lifes as painted by men and women, see Bryson (1990), pp. 136–78.
45. Parker and Pollock (1981), p. 49.
46. Ibid.
47. See Higonnet (1990); also idem (1992). More dramatic still would be the emphatic nonconformity of the animal painter Rosa Bonheur; see Boime (1981), pp. 384–409.
48. See Gouma-Petersen and Mathews (1987), pp. 350–7. For the crafts, see below, Chap. 12.
49. See, e.g., Charlot (1962); Ades (1989), pp. 27–39.
50. Ades (1989), pp. 27–39; Fernandez (1952), pp. 83–95.
51. Borges (1930); cited in Ades (1989), p. 3.
52. Brughetti (1987–8), pp. 3–7; "Transcripciones, Las escuelas de dibujo del Consulado de Buenos Aires," pp. 41–9.
53. Calderón de la Barca (1954; first published 1843), pp. 127–8; cited in Ades (1989), p. 27. The basic discussion of such cultural imperialism is Said (1978).
54. Cf. Iturburu (1958), p. 7. Contrasting Argentina with its neighbors: "Qué ocurre entretanto, por ese entonces, en lo que hoy es nuestro país? Nuestros indígenas son nómades, cazadores, guerreros. No fueron más allá, en suma, de los inferiores de la barbarie."
55. Paz (1959), p. 24; idem (1961); and idem (1993), pp. 113–68.
56. Paz (1959), p. 24.
57. See Goodyear (1976), pp. 12–48; for more on the Americans and Paris, see Fink (1990).
58. Goodrich (1982), pp. 8–14; Homer (1992); Johns (1983), pp. 11–18.
59. Homer (1992), pp. 8–49; Lippincott (1976), pp. 162–87. See also G. M. Ackerman (1969), pp. 235–56.
60. See Mosby (1991); Boime (1993), pp. 415–42.
61. Goodrich (1982), pp. 167–89.
62. Blake (1966), p. 58.
63. Held (1966), p. 214.
64. Boime (1971), passim; idem (1980), passim; Pool (1963), p. 254.
65. Boime (1971), esp. pp. 79–115.
66. *Strictly Academic: Life Drawing in the Nineteenth Century* (1974), p. 5.
67. Escholier (1960), p. 172.
68. For a direct account, see Flam (1978), pp. 2–6; see also Elsen (1972), p. 15; Lyman (1968), pp. 2–5.
69. Radio interview, 1942, in Barr (1951), p. 563.
70. Letter to Henry Clifford, 1948, in Chipp (1968), p. 140.
71. Barr (1951), p. 550.

4: DOCTRINE 1: ART HISTORY

1. For the academy's exhibitions, see above, Chaps. 1–3.
2. See Rouchette (1959); Gombrich (1966), pp. 1–10; Goldstein (1991), pp. 644–7.
3. Vasari (1965), p. 354.
4. Ibid., p. 380.
5. Ibid., p. 317.
6. Ibid., p. 318.
7. See Goldstein (1991), passim; Vasari (1987), p. 254.
8. The canon has received far more attention in literary studies than in the history of art; see, e.g., Fiedler and Baker (1981); Altieri (1990); Lauter (1991); Gates (1992).

9. See above, Chap. 1.

10. Goldberg (1988), pp. 8–14.

11. Ibid.; Goldstein (1991), pp. 647–9.

12. Goldstein (1991), pp. 647–9.

13. For the positions of Michelangelo and Raphael in the literature of art after Vasari, see Soussloff (1989), pp. 581–602; Thuillier (1957), pp. 352–91; idem (1983), pp. 11–36.

14. Goldberg (1988), p. 10.

15. Bosse (1649), passim; Félibien, 6th *Entretien* (1725), 3:146: cf. Goldstein (1966), pp. 6–10. For the *Conférences*, see above, Chap. 2, and below, Chap. 5.

16. "It is to Michael Angelo, that we owe even the existence of Raffaelle: it is to him Raffaelle owes the grandeur of his style. . . . Though our judgement must upon the whole decide in favour of Raffaelle, yet he never takes such a firm hold and entire possession of the mind as to make us desire nothing else, and to feel nothing wanting." Sir Joshua Reynolds (1975), p. 83.

17. Quatremère de Quincy (1823).

18. J. Reynolds (1975), pp. 32–3, 86, 147.

19. See Teyssèdre (1965), passim; Thuillier (1983), pp. 21–2.

20. For a review of the history of this concept, see Mahon (1947), pp. 195–229.

21. See Goldstein (1988), pp. 18–28, 172–91.

22. J. Reynolds (1975), p. 32.

23. See below, Chap. 5.

24. See Alpers (1960), pp. 190–212; and the recent discussion, with further bibliography, Carrier (1991), pp. 101–19.

25. Prinz (1966). For a proposal to supplement the *Lives* with a corpus of engravings, see Melion (1990), esp. pp. 467–74.

26. See above, Chap. 1.

27. For such collections, see Fontaine (1910), along with Klingsohr (1986), pp. 556–78. For other collections, see Savage (1988), pp. 258–63; Salling (1989), pp. 533–46.

28. An example is a watercolor of 1746 of the French academy by Charles-Joseph Natoire in the Courtauld Institute, London. This apparently was Natoire's image of an ideal collection, for these paintings were not in fact all owned by the academy. See *Charles-Joseph Natoire* (1977), no. 42, the related drawing in Montpellier. For the disposition of the collection, see Klingsohr (1986).

29. J. Reynolds (1975), p. 15.

30. See Alsop (1982), pp. 163–7; McClellan (1994), esp. pp. 13–48. A museum was opened in the Luxembourg in 1750 in response to complaints about the royal collection being inaccessible. An exception was the Ambrosian Museum, an integral part of the Accademia del Disegno of Milan, founded in the early seventeenth century expressly for the benefit of art students and housing masterworks as well as painted copies of such; see Jones (1993), esp. pp. 145–6.

31. Malraux (1947).

32. References to Malraux (1953), pp. 22, 82.

33. Ibid., pp. 21–2.

34. Ibid., p. 30.

35. Ibid., p. 47.

36. Ibid., p. 21.

37. Benjamin (1969), pp. 217–51.

38. Ibid., p. 221. For a historical critique, see Baas (1987), pp. 337–47; also Snyder (1989), pp. 158–74.

39. It was the point of departure for an exhibition of printed reproductions, Lambert (1987); see also Preziosi (1989); Miller (1992), pp. 19–31, 61–79; and Crimp (1993).

40. "Photography, which started in a humble way as a means of making known acknowledged masterpieces to those who could not buy engravings, seemed destined merely to perpetuate established values." Malraux (1953), p. 17.

41. Benjamin (1969), p. 220.

42. Ivins (1953); see also idem (1930).

43. Ivins (1953), p. 94: "A faith was put in the photograph that had never been and could not be put in the older hand-made pictures."

44. Ibid., p. 60.

45. Ibid., p. 61.

46. Ibid., p. 66. For more on these translations, see Eaves (1992), esp. pp. 153–272.

47. Ivins (1953), p. 167.

48. For a convenient compilation, see *Raphaël et l'art français* (1983), pp. 37–45, 411–28.

49. See Shoemaker and Broun (1981); also Lambert (1987), pp. 62–6. For the reverberations of *The Judgment of Paris* throughout art history, see Damisch (1992).

50. See above in this chapter.

51. The only suggestion is: "Process reproduction is more independent of the original than manual reproduction." Benjamin (1969), p. 220.

52. Compare the useful remarks by Lambert

(1987), p. 16; for the origins of color reproduction, see ibid., pp. 87–106. Malraux's complaint about the falsifications of color reproductions was also that of Albert Barnes who, for this reason, would not allow any of the paintings in his collection to be reproduced in color.

53. Raphael's more consistent use of antique models would nevertheless have been appreciated; see Shoemaker and Broun (1981), pp. 146–7.

54. Boime (1971), p. 25.

55. Clark (1966), p. 52; Broun (1981), p. 30.

56. Reproduced in English translation in Clark (1966), pp. 193–209.

57. See Broun (1981).

58. De Piles (1699); Du Camp (1866), cited in Thomson (1992), p. 19.

59. See Freund (1992), pp. 96–100.

60. See *Copier Créer, de Turner à Picasso* (1993), no. 158.

5: DOCTRINE 2: THEORY AND PRACTICE

1. Lee (1967), p. vii.

2. Ibid.

3. See Greene (1982).

4. Pliny the Elder, *Nat. Hist.* 35.65, 35.95. See also Kris and Kurz (1979); Goldstein (1993), pp. 9–18.

5. L. B. Alberti (1972), p. 67.

6. Leonardo (1882), no. 411, cited in Panofsky (1960b), pp. 47–8. For the different senses of Leonardo's use of the term, see Bialostocki (1963), pp. 19–30.

7. Pliny the Elder, *Nat. Hist.* 35.61.

8. L. B. Alberti (1972), p. 99.

9. Clark (1956), p. 4.

10. L. B. Alberti (1972), p. 99; cf. Panofsky (1960b), p. 498.

11. See Félibien (1668); Jouin (1883); Fontaine (n.d.); Coypel (1721); cf. Goldstein (1975a), esp. p. 103.

12. Penny (1986), no. 112.

13. Lee (1967), passim.

14. See above, Chap. 2.

15. Leonardo (1651), p. 5.

16. Goldstein (1965), p. 233; Kauffmann (1960), pp. 16–25; Bialostocki (1960), pp. 133–9; Kemp (1987); Goldstein (1994), pp. 76–7.

17. L. B. Alberti (1972), passim.

18. Goldstein (1965), p. 236.

19. "S'il y a quelque ouvrage où Raphael ait manqué dans la Perspective perdra-t-il pour cela sa réputation?" Félibien (1668–88; 2d ed., 1684), 1:507.

20. See above, Chap. 2.

21. Félibien (1668).

22. Ibid., pp. 76–101. For more on the perspective dispute, see below, Chap. 9.

23. Félibien (1668), pp. 101–2.

24. Ibid., p. 103; cf. Schweizer (1972).

25. Félibien (1668), pp. 208–23; Montagu (1992), pp. 236–7. In their own works, the academicians tended to observe the unity of action for the transgression of which they defended Poussin; see Thuillier (1967).

26. *Procès-verbaux de l'Académie Royale de Architecture* (1911–29), 1:3. The discussion of theory by Egbert (1980) is an unintentional parody. As with painting and sculpture, the architecture of the nineteenth-century academy has received the most attention in recent times; see esp. Drexler (1975); Middleton (1982).

27. Chambray (1650).

28. *Procès-verbaux de l'Académie Royale de Architecture* (1911–29), 1:5.

29. Blondel (1675–83).

30. Perrault (1673), fol. 2v.

31. Ibid., p. 114.

32. See Hermann (1958), pp. 23–53.

33. See Mead (1991), pp. 199–203.

34. Bacon (1857–64), 4:13.

35. *Novum Organum*, bk. 1, p. xix.

36. Hall (1983), p. 225.

37. Ibid.

38. Ibid., p. 220; see also Brown (1934), pp. 148–51.

39. Panofsky (1953), pp. 123–82; see also Di Santillana (1959), pp. 33–66; Ackerman (1985), pp. 94–129.

40. See Goldstein (1988), pp. 61–6.

41. See Ackerman (1961), pp. 63–90.

42. Félibien (1668), preface, fol. 9 v. Almost a century later, Charles Coypel similarly conceived of a discussion of the rules, citing works by the masters that could be seen in Paris exemplifying each rule: *Jugemens sur les principaux ouvrages exposés au Louvre le 27 août 1751* (Amsterdam, 1751), p. 9; cited by Wrigley (1993), p. 259.

43. Félibien (1666–88; ed. Trevoux, 1725), 4:115. Nineteenth-century artists from Turner to Géricault and Ingres seem to have

taken Félibien at his word, copying the *Eliezer and Rebecca;* see *Copier créer, de Turner à Picasso,* pp. 171–2.

44. See above, Chap. 2.

45. Bellori (1976), pp. 89–90; cf. Goldstein (1988), pp. 22–8.

46. See above in this chapter.

47. See Goldstein (1969), pp. 346–51; idem, (1975a), pp. 104–5; Bordeaux (1985), p. 68. The Girodet is based equally on a *Solomon and the Queen of Sheba* in Raphael's Loggie; see *Raphaël et l'art français* (1983), no. 110.

48. Diderot (1957–67), 2:84: "comment on fait concourir les subalternes à l'interet des principaux personnages."

49. J. Reynolds (1975), p. 17.

50. Ibid., p. 28.

51. Ibid., p. 30.

52. Ibid., p. 95.

53. Ibid., pp. 98–9.

54. Ibid., p. 102.

55. Wind (1930–1), pp. 1–52; idem (1938–9), pp. 69–73; Gombrich (1942), pp. 40–5; C. Mitchell (1942), pp. 5–40; L. Hermann (1968), pp. 650–8; Perini (1988), pp. 141–68. See also Paulson (1975), pp. 80–94.

56. See Steinberg (1978), pp. 8–28.

57. Wind (1937–8b), pp. 322–30.

58. In the catalogue published on the occasion of the monumental Reynolds exhibition, Robert Rosenblum (1986; p. 51) proposes a portrait by Drouais as mediating between Michelangelo's figures and Reynolds's *Mrs. Siddons,* but the portrait in question strikes me as too different from the one as the other. (For Reynolds and Gainsborough, see Paulson [1975], pp. 80, 209–10.) Another portrait of Mrs. Siddons, this one based on a Hellenistic muse, has recently been reidentified: Watson (1992), pp. 147–51.

59. Binyon (1902), 3:207. The drawing seems to be a free translation of *Psyche Asleep in Cupid's Garden* in the Palazzo del Tè, Mantua.

60. J. Reynolds (1975), pp. 221–2; cf. Wind (1937–8a), pp. 74–6.

61. Illus., Penny (1986), pp. 294, 239. The actual source for the *Duchess of Manchester* was a composition by Albani; see Newman (1986), pp. 344–54.

62. It could as easily serve for other subjects as well. Consider Michael Levey's observation about Jean Jouvenet's *The Raising of Lazarus*

of 1706: ". . . Mary, the sister of Lazarus, takes on the role of heroine, distressed yet decorous, and very consciously posed, in garments of gleaming white, gold, and green, to hold the centre of the stage. She is the embodiment of French academic classicism and could serve equally as Esther before Ahasuerus or as the wife of Darius at the feet of Alexander – would, effectively, serve in comparable guise in many other pictures of the period" (1993; p. 14).

63. E.g., Fried (1980), pp. 71–105.

64. Félibien (1663); see Bryson (1981), pp. 52–6.

65. Félibien, *Les Reines de perse aux pieds d'Alexandre,* trans. Colonel Parsons (London, 1703), as *The Tent of Darius Explained,* 11; cited in Bryson (1981), p. 53.

66. See above, Chap. 3.

67. See Borea, in Bellori (1976), pp. 50–60.

68. See Panofsky (1962b), pp. 69–93.

69. Foucault (1982), p. 44; idem (1970), passim. For a helpful discussion, see Almansi (1982), pp. 305–9. Barthes (1974), p. 12, argues similarly: "the one text is not an (inductive) access to a Model, but entrance into a network with a thousand entrances." For these arguments in art history, see Bryson (1983), passim.

6: THE COPY

1. See Glück and Haberditzl (1928), nos. 14–21; Lugt (1949), nos. 1040–7.

2. Cennini (1932–3), chap. 27.

3. See Rosand (1970), pp. 5–53; see above, Chap. 2.

4. Alpers (1985), p. 72; see also Clark (1966), esp. pp. 41–84.

5. See, e.g., Haverkamp-Begemann (1988), nos. 1–3, 28.

6. Barthes (1974), p. 12; see also Payant (1979), pp. 5–8; idem (1980), pp. 25–32.

7. *New York Times,* June 19, 1977, quoted in the preface to Lipman and Marshall (1978), p. 7.

8. See above, Chap. 5.

9. *Poetics* 1460b; cf. Wittkower (1965), p. 147.

10. See Goldstein (1991), p. 645.

11. See Lee (1967), pp. 9–16; Wittkower (1965).

12. Plato, *Republic* 10.

13. See above, Chaps. 4 and 5.

14. Monrad (1989), p. 553.

15. *Correspondance des directeurs de l'Académie de France à Rome avec les surintendants des bâtiments* (1887–1908), 1:226.

16. Ibid., p. 25; cited in Thuillier (1983), pp. 18–19.

17. Rewald (1946), p. 230; cited in Boime (1971), p. 124.

18. See *Copier Créer, de Turner à Picasso* (1993), pp. 234–48; cf. the excellent review, going far beyond the scope of the exhibition, Andersen (1994), pp. 97–106.

19. *Dictionnaire de l'Académie des Beaux-Arts*, pp. 43–44, 138; cited in Shiff (1984), p. 74.

20. *Copier Créer, de Turner à Picasso* (1993), pp. 42–7, 122–7.

21. Boime (1964), pp. 237–47; see also Duro (1989), pp. 44–58; idem (1988), pp. 249–54.

22. See Maison (1960); Haverkamp-Begemann (1988); Steinberg (1978), pp. 8–31; Thompson (1992), pp. 19–37; *Copier Créer, de Turner à Picasso* (1993). Copies from the sixteenth and seventeenth centuries are less often discussed than those of later centuries because of the formidable problems of attribution they present. See Costamagna (1991), pp. 51–9.

23. For this and other Fragonard copies after Rubens, see Maison (1960), pp. 115–19.

24. See *Copier Créer, de Turner à Picasso* (1993), no. 106.

25. See Thomson (1988), pp. 16–18; idem (1992), pp. 23–4.

26. For one of his studies after Raphael, see Haverkamp-Begemann (1988), no. 47.

27. J. Reynolds (1975), p. 95.

28. Ibid., p. 96; cf. H. D. Goldstein (1967), pp. 213–35.

29. J. Reynolds (1975), pp. 99, 107.

30. Haverkamp-Begemann (1988), passim; Thomson (1992), passim.

31. J. Reynolds (1975), p. 217; cf. Wittkower (1965), pp. 153–4. Reynolds is referring to the fresco of *St. Paul Visiting St. Peter in Prison,* in fact not by Masaccio but Filippino Lippi, compared with Raphael's *St. Paul Preaching at Athens.*

32. Walpole (1876), 1:xvii; cited in Wind (1930–1), pp. 19–20.

33. Prown (1966), 2:294.

34. Copley surely worked from an engraving, but one closer to the painting than that reproduced in ibid., fig. 421. Noting the derivation,

Prown proposes, in the spirit of Reynolds, that the work is nevertheless "pure Copley" (ibid., p. 294).

35. See Cox (1905), p. 200; Regnault (1873), p. 186; both cited in Boime (1971), p. 124.

36. For copies after Raphael, see De Leiris (1969), nos. 23, 24. For Manet and Couture, see Boime (1980), esp. pp. 457–72.

37. See DeLeiris (1964), pp. 401–4; Fried (1969), pp. 30–1, 46; Reff (1969), pp. 40–8.

38. See Reff, (1969) pp. 40–8; Damisch (1992), esp. pp. 53–64.

39. E.g., Bazin (1932), pp. 152–63; Huyghe (1932), pp. 165–84; Spengler (1926), p. 293.

40. E.g., Richardson (1967); Bowness takes issue with Richardson (1961), pp. 276–7.

41. E.g., Colin (1937).

42. See Sandblad (1954), pp. 37–9, 42–5; Reff (1975). For a discussion of these and still other interpretations, see Carrier (1991), p. 206.

43. This was noted by Reff (1964), p. 553. Contemporary critics might reasonably be expected to have gotten this point, which most, however, did not, concluding that Manet's aim was simply to shock. And when the borrowings were detected, Manet was criticized for them. This may be indicative of nothing more than an even greater gap than in earlier times that had opened up between artists and critics. For criticism of Manet, see Hamilton (1954), pp. 165–89. Hanson (1977), p. 45, has also noted that critics were equally hostile to other, more conventional artists, observing that "part of the pose of the intellectual elite was to make light of serious issues."

44. E.g., Pointon (1990), p. 116: "By deploying the mechanism of History painting, the genre and the practice which a modernist historiographic trajectory tends to define as oppressive, Manet's image ruptures the polemics of the avant-garde. But since history in the sense of *istoria*, the grandest and most venerated of genres, has to coexist with such signs of modernism as contemporary dress and freely-handled paint in *Le Déjeuner sur l'herbe*, the idea of History is deployed also to critique the very traditions upon which History painting depends." For the more general issues, see esp. Foucault (1982); Rose (1979).

45. For other possible debts to Couture, see Boime (1980), pp. 457–71.

46. Ibid., pp. 473–80.
47. Ibid., pp. 474–5.
48. E.g., Boime (1974), pp. 5–15.
49. Duret (1878), p. 12; quoted in Broude (1991), p. 17.
50. Letter to Valabrègue of 1864, reprinted in Zola (1927), p. 248; cited in Shiff (1984), p. 88.
51. "Je viens du Louvre. Si j'avais eu des allumettes, je mettais le feu sans remords à cette catacombe, avec l'intime conviction que je servais le cause de l'art à venir." (Duranty [1856], pp. 1–2; cited in Reff [1964], p. 553.) Duranty expressed a decidedly different point of view in his short story "Le Peintre Louis Martin," in which his fictional hero, described as a painter of modern life, accepts a commission to copy a painting by Poussin in the Louvre, where he encounters Degas and Fantin-Latour engaged in similar projects; Duranty (1881), p. 321; cf. Aichele (1989), pp. 385–96. On the antimuseum stance of the avant-garde, see further Groys (1994), pp. 144–61.
52. Reff (1964), p. 553.
53. Van Gogh (1978), 3:215.
54. Chetham (1976), p. 8.
55. Van Gogh (1978), 3:207.
56. Chetham (1976), p. 182.
57. Ibid., pp. 181–205.
58. Ibid., p. 175. For more on his empathetic response to this work, see Graetz (1963), p. 165.
59. Van Gogh (1978), 3:269.
60. Bertold (1958); Chappuis (1973).
61. Lewis (1989), pp. 47–62.
62. Chappuis (1973), passim; *Copier Créer, de Turner à Picasso* (1993), pp. 107–34.
63. See esp. Steinberg (1972a), pp. 125–234; *Copier Créer, de Turner à Picasso* (1993), pp. 359–73; Lavin (1993), pp. 203–60. For a work that inspired Picasso and others, see Hayum (1989), pp. 118–50. More generally on copying in the twentieth century, see *Nachbilder. Vom Nutzen und Nachteil des Zitierens für die Kunst* (1979).
64. Ashton (1977), p. 167.
65. Ibid., p. 168.

7: THE ANTIQUE

1. For a useful overview, see Greenhalgh (1978); also Panofsky (1960a).
2. Vasari (1965), p. 47; cf. Panofsky (1960a), p. 31. See above, Chap. 4.
3. Vasari (1965), p. 251.
4. L. B. Alberti (1972), p. 90.
5. Ibid., p. 91; see above Chap. 5.
6. Armenini (1587), pp. 61–2.
7. See, e.g., Gombrich (1963), pp. 31–41.
8. E.g., *Natur und Antike in der Renaissance* (1986).
9. See White (1987), p. 36; Muller (1982).
10. Jouin (1889), p. 400. The album is in the Bibliothèque Nationale: *Livre d'antiques tirées d'après celles qui sont à Rome*. The drawings are highly finished and in the same format, so they must have been copied over from the originals. It should be noted that Le Brun later put his study of ancient sculptures to direct use as a designer of sculptures; see Montagu (1976), pp. 88–94.
11. Von Erffa and Staley (1986), pp. 14–22.
12. The head may have been used for the Hebe on the ceiling of the Hôtel de la Rivière, though the painting is too worn for the identification to be certain. For the ceiling, see Montagu (1963), p. 407.
13. See Harris and Schaar (1967), p. 97, no. 213.
14. Bellori (1976), p. 23.
15. J. Reynolds (1975), pp. 44, 47. So did Reynolds transfer the characters of his sitters to ancient sculptures, for example, Commodore Keppel to the Apollo; see Penny (1986), no. 19; cf. Paulson (1989), pp. 278–9.
16. The drawings for the engraving, one of which was described by Bellori (1976), pp. 629–30, show the Belvedere *Antinoüs* next to the Hercules and Venus, as Bellori says. See Vitzthum (1971), p. 72, fig. 21; *Major Themes in Roman Baroque Art from Regional Collections* (1974), no. 78. In the engraving, the Apollo of Raphael's *School of Athens* has been substituted for the *Antinoüs*. This is only one of the references to Raphael; the figures in the foreground recall those in the Stanza della Segnatura, the Graces, figures in the Loggia di Psiche.
17. See *France in the Eighteenth Century* (1968), no. 490. A nearly identical drawing in the Musée Atger, Montpellier, is also inscribed with Natoire's name and the date 1745. It also carries the inscription: "l'académie de peinture à rome"; see *Charles-Joseph Natoire* (1977), no. 42. Natoire was a professor in the academy in Paris, and in 1751 was appointed

director of the academy in Rome. But both drawings, it is agreed, show the academy in Paris.

18. Chantelou (1885), pp. 138, 147; cited in Haskell and Penny (1981), p. 37.

19. *Correspondance des directeurs de l'Académie de France à Rome avec les surintendants des bâtiments*, 1:129–41; cited in Haskell and Penny (1981), p. 38. It is to be noted that Natoire's watercolor has been recognized as an invention, gathering together works that had been displayed separately; see *Charles-Joseph Natoire* (1977), no. 42.

20. Hogarth (1955); for the irony of this image, see Paulson (1989), pp. 156–68.

21. Pevsner (1940), p. 61. See above, Chap. 2.

22. *Memoires pour servir à l'histoire de l'Académie Royale de Peinture et de Sculpture depuis 1648 jusqu'en 1664* (1853), pp. 48–9.

23. Bosse (1649).

24. Perrier (1638); cf. Haskell and Penny (1981), p. 21.

25. Bosse (1649), p. 98.

26. Pevsner (1940), p. 62.

27. Jouin (1883), pp. 19, 140.

28. See above, Chap. 5.

29. Illus. Souchal (1977), vol. 1, A–F, p. 153. Coustou replaced the child Hylas, however, with the golden apples of the Hesperides.

30. Illus. ibid., vol 2, G–L, p. 183.

31. See Haskell and Penny (1981), pp. 37–42.

32. For more on the antique room of the Royal Academy, see Hope (1988), p. 55 and plates 3a, 3b. For one such American collection, in the nineteenth-century Yale School of Fine Arts, see Fahlman (1991), pp. 1–9.

33. See above, Chap. 2; and Goldstein (1988), pp. 126–36.

34. Goldstein (1970), p. 227.

35. Wittkower (1963), pp. 41–50.

36. Mahon (1947), pp. 157–82; see above, Chap. 2.

37. E.g., Panofsky (1960b), p. 59.

38. Ibid., pp. 60–1.

39. Bellori (1976), pp. 32–3; cf. Goldstein (1988), pp. 29–33.

40. Bellori (1976), p. 24.

41. Ibid., pp. 13–14.

42. Ibid., p. 17.

43. Ibid.

44. Ibid., pp. 91–2.

45. Missirini (1823), p. 145; cf. Mahon (1947), p. 189.

46. Wittkower (1963), p. 49.

47. Jouin (1883), pp. 19–27, 108–14, 137–40, 168–79. See above, Chap. 3.

48. See above, Chap. 2.

49. Jouin (1883), p. 138.

50. See above, Chap. 5.

51. Jouin (1883), p. 139.

52. Ibid., pp. 168–9.

53. Audran (1683), fol. 5. The initial divisions of the figure are based, as was usual, on those of the head. But the parts are then broken down into smaller and smaller units, which carry the numbers of actual distances.

54. Audran (1683; fol. 4) states, it should be made clear, that it is a question of a particular mentality and of developing proper working habits: "Quand je donne de si grands éloges au Peintres dont on peut mesurer les Ouvrages, mon intention n'est pas néanmoins de vous faire employer un temps trop considerable à mesurer vos Figures avec le compas, ce qui retarderoit assurément vostre progrès dans le dessein; mais vous pouvez vous servir du compas & de mes mesures pour resoudre les difficultés que vous naistront sur les proportions: alors vous en estant plusieurs fois eclaircis, la chose vous deviendra naturelle, & vous formerez l'habitude de les observer regulièrement sans compas."

55. Vasari (1568), 4:445). For a substitution in the early nineteenth century of the academy's "beau idéal" by a "beau visible," the notion that proportion should be discovered in the manner of Zeuxis, by consulting a variety of live rather than sculptural models, see D. Johnson (1993), esp. p. 161.

56. Hope (1988), pp. 94–5. These were artists in a tradition recharged by French ideas and indifferent to the homegrown wisdom of a Hogarth, who had explained that the beauty of ancient sculptures such as the *Apollo Belvedere* resulted from their disproportion, an element of "surprise" in their measurements: "if we examine the beauties of this figure thoroughly, we may reasonably conclude, that what hath been hitherto thought so unaccountably *excellent* in its general appearance, hath been owing to what hath seem'd a *blemish* in a part of it." Hogarth (1955), p. 101; cited in Paulson (1989), p. 198.

57. Winckelmann (1987), p. 5. For an account of Winckelmann's career, see Irwin (1972), pp. 3–57; Potts (1978).

58. Winckelmann (1987), p. 21.

59. Ibid., p. 33.

60. J. Reynolds (1975), p. 151.

61. Winckelmann (1987), p. 35; cf. Bieber (1942).

62. See Justi (1943), 1:595; also Stafford (1980), pp. 65–78; Fried (1986), pp. 87–97.

63. Fink and Taylor (1975), p. 139. For similar drawings after the *Apollo* made in the eighteenth-century Accademia di San Luca, see Cipriani and Valeriani (1988), 3:99, 112–14.

64. Crook (1972), p. 39; cited in Jenkyns (1992), p. 89. Flaxman later repented, however, placing the *Apollo* above the *Theseus*.

65. William Hazlitt, "A Journey through France and Italy"; cited in Jenkyns (1992), pp. 89–90.

66. Ibid.

67. Green (1987); Silver (1989); Cowling and Mundy (1990).

68. *Apollinaire on Art*, p. 444; cited in Cowling and Mundy (1990), p. 20.

69. For nineteenth-century French classicism, see below, Chap. 11. For Maillol, ibid., pp. 148–57; George (1965), pp. 39–42.

70. See above, Chap. 3.

71. See W. Rubin (1988), pp. 367–487.

72. The phrase was coined by Maurice Denis; see Cowling and Mundy (1990), p. 26 and n. 46.

73. Fry (1939), p. 173.

74. Ibid.

8: LIFE-DRAWING

1. On the academic system of drawing, see esp., Peteghem (1868); for the theory, see above, Chap. 5.

2. Panofsky (1955), pp. 26–54.

3. Holly (1984), p. 178; for a critique of Holly's reading, see Preziosi (1989), pp. 111–14.

4. E.g., Barthes (1977), pp. 42–3. For Panofskian iconology and semiological research, see Hasenmueller (1978), pp. 289–301; and Damisch (1975), pp. 27–36.

5. M. Schapiro (1969), pp. 26–32.

6. About Couture's criticism of this drawing, Valentine wrote: "His criticism was chiefly on the simplicity and balancing of the lines – he said the arms of my figure looked like sticks of wood. He took the crayon and showed me how to make the lines." Valentine, *My Recollections*, cited in *Strictly Academic: Life Drawing in the Nineteenth Century* (1974), no. 47.

7. For masters correcting pupils, see Boime (1971), pp. 24–36.

8. For a recent attempt to sort through Renaissance figure drawings, see Ames-Lewis (1992), pp. 1–6.

9. Nochlin (1971), pp. 32–6.

10. Ibid., pp. 32–3.

11. *Ordini dell'Accademia de' pittori et scultori di Roma* (1609), p. 6; Langheit (1962), p. 32, and docs. 114–15, 254; J. H. Rubin (1977), p. 22, n. 41. On attitudes toward the female body, see Goldstein (1988), pp. 66–8.

12. Pevsner (1940), p. 231. For the Ecole des Beaux-Arts, see Garb (1994), esp. pp. 70–104.

13. Goodrich (1982), p. 11; *Strictly Academic* (1974), no. 48. For the allegory, see Panofsky (1962c), esp. pp. 110–11. For anecdotes about nineteenth- and twentieth-century artists and their models, see Borel (1990), passim; on the model's perspective, see Garb (1993), pp. 33–42; Hollander (1971), pp. 152–4; Kluver and Martin (1971), pp. 156–63, 183.

14. Van Gogh wrote from Antwerp in 1885–6 that female models were not used in the academy and only with exception privately, (1978), 2:494; cited in Pevsner (1940), p. vi.

15. Goldstein (1988), pp. 58–78.

16. Ibid., p. 106.

17. Pevsner (1940), p. 231.

18. Garrard (1989), pp. 199–200. For records of Artemisia employing female models, see Nochlin and Harris (1976), pp. 118–19. For Artemisia, see above, Chap. 3.

19. E.g., Pointon (1990); Suleiman (1986). The question of the model is not raised in the otherwise valuable state of research article, Gouma-Peyterson and Mathews (1987), pp. 326–57.

20. After professional setbacks, Melendez settled into a career of still-life rather than figure painting. See Tufts (1985).

21. See above, Chap. 2. On the history of the *académie*, see Goldstein (1988), pp. 50–1, 89–106; J. H. Rubin (1977), pp. 17–37; idem (1992), pp. 7–18; Michel (1989), passim; Postle (1991), pp. 16–24; Bowron (1993), pp. 75–85; *Strictly Academic* (1974), esp. pp. 5–15; *The Academic Tradition*, passim.

22. See above, Chap. 2.
23. See J. H. Rubin (1977), pp. 26–31; Boime (1971), pp. 24–36.
24. For Annibale, see Goldstein (1988), p. 95; Legros, see *Strictly Academic* (1974), no. 13.
25. See Schnapper and Guicharnaud (n.d.), no. 41. For other *académies* by Boullogne, see J. H. Rubin (1977), pp. 56–60.
26. See Vallery-Radot (1953), p. 125; Schnapper and Guicharnaud (n.d.), no. 36.
27. See Bevers, Schatborn, and Welzel (1991), no. 38.
28. See Fink and Taylor (1975), no. 46, and the painting, no. 47.
29. See *Strictly Academic* (1974), no. 11.
30. See Goldstein (1977), pp. 42–7.
31. See Schwarzenberg (1969).
32. From the *Concours d'émulation* of 1832; see Boime (1971), p. 25.
33. See Fink and Taylor (1975), no. 22.
34. On this question, see the exhibition catalogue *L'Écorché* and Goldstein (1988), pp. 58–78, 119–26.
35. "Vous avez appris l'anatomie? – Ah! oui; – eh bien! voilà où mène cette science affreuse, cette horrible chose, à laquelle je ne peux pas penser sans dégoût. – Si j'avais du apprendre l'anatomie, moi, messieurs, je ne me serais pas fait peintre." Amaury-Duval (1993), p. 130.
36. Redon (1922), quoted in J. Rewald (1973), p. 73. See also Goldstein (1977), p. 44.
37. Baizerman (1975), p. 17; see also Goldstein (1977), p. 46.
38. See above, Chap. 3.
39. Boime (1974), pp. 12–13.
40. *The Academic Tradition*, nos. 38 and 65; Thomson (1988), pp. 30–1.
41. See Kendall (1993), pp. 210–11. As noted by Kendall, Degas's words echo advice he is said to have received from Ingres: "Never work from nature. Always from memory, or from the engravings by the masters." For Lecoq, see Boime (1971), pp. 181–2.
42. The early and late drawings of Figs. 94 and 96 are so linked by Thomson (1988), pp. 121–4.
43. See above, Chap. 3.
44. Rouault, *Souvenirs intimes,* p. 34; cited in Schneider (1984), p. 589.
45. See above, Chap. 3.

9: ART AND SCIENCE

1. Jombert (1755), p. 35; cited in J. H. Rubin (1977), p. 19.
2. J. Reynolds (1975), p. 164.
3. Wingler (1969), p. 32.
4. Kandinsky (1947), p. 18.
5. Leonardo (1939), 1:119; cf. Kandinsky (1947), pp. 31–2.
6. L. B. Alberti (1972), pp. 65, 95.
7. See esp. Panofsky (1953), passim; Di Santillana (1959), pp. 33–66; Ackerman (1985), pp. 94–129.
8. Bosse (1964), p. 138.
9. See Blum (n.d.); Fontaine (1914), pp. 67–114; Goldstein (1965), pp. 231–9.
10. Bosse (1649), fol. 4v: "La pratique de ce noble Art de Peinture, doit estre fondée en la plus part de ses parties sur un raisonnement droit et reglé, qui est à dire Geometric, & par consequent démonstratif."
11. Ibid., p. 141: "Tous les Ouvrages de portraiture et Peinture qui ne sont executez par la règle de la perspective ne peuvent estre que fautifs."
12. Chambray (1662); see Goldstein (1965), pp. 234–9.
13. See, e.g., P. Rossi (1970); Losee (1977).
14. See Bosse's own bibliography (1674).
15. See Poudra (1864); for Desargues and Bosse, see the excellent discussion in Kemp (1990), pp. 119–31.
16. Mersenne (1625).
17. Ibid., p. 225: "Apres avoir discouru des sciences en general, & apres avoir montré que nous ne devons pas suspendre notre judgement à tout propos, ni sur toutes choses, ie veus maintenat vous faire voir que les Mathematiques sont des sciences tres-certaines, & tres-veritables, esquelles la suspension ne treuve point de lieu."
18. Descartes (1897–1913), 6:19: "il n'y a eu que seuls Mathematiciens qui ont pu trouver quelques demonstrations, c'est à dire quelques raisons certaines & evidentes."
19. See Burtt (1932); Dijksterhuis (1961). For the role of experience in Descartes's system, see R. M. Blake (1960).
20. Descartes (1897–1913), 6:81.
21. Jay (1993), esp. pp. 69–82.
22. Bosse (1665), p. 94.

23. See esp. Popkin (1970); B. J. Schapiro (1983).
24. See, e.g., Hall (1983).
25. The passage is cited in translation in Jay (1993), p. 78.
26. Le Sueur's *St. Paul Preaching at Ephesus* of 1649 is one of the more obvious applications of Bosse's method; see the preparatory study in the Louvre, Cabinet des Dessins, MI 909. For a discussion of the construction, see Goldstein (1965), esp. n. 90. For other studies for the same project, see Mérot (1987), figs. 291–304. See also Kemp (1990), pp. 128–9.
27. Perrault (1668).
28. Bosse (1668, unpaginated): "J'ai eu la curiosité d'en faire un dessein tel qui faudroit qu'il fust, car le Bras de cette Bergere, doit avoir plus de cinq à six pieds de long pour atteindre à ce mur suivant la situation d'icelle, & outre que l'ombrage que fait la Table sur le plancher est du double plus petit qu'il ne faut, elle n'en fait point contre ce mur, bien qu'elle y touche, ny la lampe aussi, & toutefois il y en doit avoir une très-grande. Le profil du Berger contre l'autre mur opposé est faux, puisqu'il n'est plus grand que celuy du naturel, ce qui seroit bon à une clarté du Soleil, mais à celuy d'une lampe il doit estre extraordinairment plus grand sans comparaison; il y a encore d'autres fautes que je ne vous dis point. . . ." For the geometrical translation of shadows, see Bosse (1665).
29. Bosse (1649), p. 38: "Il me semble qu'il ne s'agit point de ce qui n'a pas esté fait, ou de ce qui ne se fait pas: mais seulement de ce qu'il est raisonnable de faire."
30. See above, Chap. 5.
31. For the differences between these two perspective systems, see Goldstein (1965), pp. 239–40*n*90.
32. There is a considerable literature of recent origin, summarized and endorsed in Martin Jay's *Downcast Eyes* (1993; e.g., pp. 69–70), identifying perspective with seeing itself as a means, pure and simple, of reproducing the observed world. As the Bosse/Le Brun polemic shows, one way of "seeing" was not the same as another, nor were perspective systems equal. What these discussions most importantly omit is the mistrust of "seeing" of the Platonic tradition, as alive at this time as in the preceding periods. On this see,

among others, Deleuze (1983), pp. 45–56; Baudrillard (1984), pp. 253–83.
33. For examples of perspective exercises from the late-nineteenth-century French academy, see Grunchec (1990), pp. 37–9. The publication of books on perspective proceeded with unabated intensity, however, from the Renaissance on, this having become a minor industry in its own right; see Kemp (1990). For remarks on perspective in the nineteenth century, ibid., pp. 231–3. For a renewed interest in perspective in the early-nineteenth-century Royal Academy, see Davies (1993), passim.
34. See above, Chap. 2.
35. Montagu (1994); Teyssèdre (1965), pp. 628–30; Kirchner (1991), pp. 29–50.
36. The treatise is reprinted in Jouin (1889), pp. 371–93; the drawings are catalogued in ibid., pp. 590–93; see also Guiffrey and Marcel (1907–21), 8:68–73, nos. 6447–509.
37. See the basic discussion of Lee (1967), pp. 23–32; Montagu (1994), pp. 58–67.
38. See Chapman (1990), pp. 10–33.
39. For a discussion of Le Brun in relation to Rembrandt, as insightful as it is pithy, see Gombrich (1960), pp. 345–9.
40. See Bryson (1981), pp. 48–9.
41. For such images as reconstructed in the publication by Morel d'Arleux (1806), see Baltrušaitis (1957), p. 23.
42. As demonstrated in Montagu (1994), pp. 17–19; cf. Bryson (1981), pp. 60–1.
43. The Bauhaus was created, in the words of its founder, Walter Gropius, to combat "stagnating academicism." See Gropius (1935), p. 92.
44. See Rabinbach (1990), pp. 1–10. For the body as machine between Descartes and the early twentieth century, though viewed negatively, see Asendorf (1993).
45. See, e.g., Wingler (1969), p. xviii.
46. Ibid., p. 80.
47. Ibid., p. 74; Poling (1986), pp. 33, 73. The majority confirmed Kandinsky's own theory, though Klee and Schlemmer disagreed about particular combinations.
48. Franciscono (1991), p. 258.
49. Kandinsky (1947); cited in Franciscono (1991), p. 259.
50. Henry (1989), pp. 147–65, n. 23; Gage (1993), pp. 259–63. Gage suggests a greater

receptiveness to Ostwald's ideas from 1930 on.

51. Ibid., p. 248.
52. Poling (1986), p. 33.
53. Franciscono (1991), p. 256.
54. Henry (1989), pp. 147–65; Aichele (1993), pp. 309–15.
55. Ibid., p. 154; and Klee (1961), pp. 133–92.
56. Franciscono (1991), p. 258.
57. From notes for a lecture delivered in 1924, published in English as Klee (1948) reprinted in Herbert (1968), p. 88.
58. Pleynet (1977), p. 125.
59. Albers (1963), p. 10.

10: STYLE

1. See above, Chap. 4, and Cahn (1979), pp. 104–30.
2. Wölfflin (n.d.), pp. 10–11.
3. For a discussion of Wölfflin's ideas in the context of art historiography, see Podro (1982), pp. 98–151; Alpers (1987), pp. 137–40; also Hart (1982), pp. 292–300; M. Brown (1982), pp. 379–404.
4. See Podro (1982), pp. 178–208; also Holly (1984). For Benjamin and this project, see Levin (1988), pp. 77–83. The argument of the philosopher Max Wartofsky (1979) for a culturalist reading is the most extreme. For a discussion of this whole issue, see Jay (1993), pp. 1–20.
5. Eliot (1932), pp. 4–5.
6. Marx (1973), pp. 110–11. For a discussion, with further bibliography, see Wolff (1993), pp. 73–4. The spectre is that, too, of the Kantian aesthetic (*Critique of Aesthetic Judgement*), according to which great works of art will be recognized as such by all peoples at all times.
7. See M. Missirini (1823), p. 137; Arnaud (1886), p. 45; *Procès-verbaux de l'Académie Royale de Peinture et de Sculpture,* (1875), 2:68, 77, 89, 95, 102; *Correspondance des directeurs de l'Académie de France à Rome avec les surintendants des bâtiments* (1887–1908), 1:59.
8. See Cipriani and Valeriani (1988); I published some of the drawings here to be discussed in two articles principally concerned with documenting stylistic exchanges between the academies of Paris and Rome: Goldstein (1970), pp. 227–41, idem (1978), pp. 1–14.
9. See above, Chap. 3.
10. The rules are outlined in detail in "Ordini e statuti dell'accademia del disegno de' pittori, scultori, e architetti di Roma . . ." (1716), p. 44.
11. No. 38. See Goldstein (1970), pp. 236–7; Cipriani and Valeriani (1988), 1:63–6.
12. Cipriani and Valeriani (1988), pp. 63–4; *Le Nouveau Mercure galant, contenant tout ce qui c'est passé de curieux au mois de avril de l'année 1678,* p. 45; cited in Mahon (1947), p. 186n74.
13. It was published at the end of Bellori (1695), p. 105; cited by Mahon (1947), p. 186n74.
14. Poerson: A. 28. Dorigny: A. 30. See Goldstein (1970), pp. 230, 235; Cipriani and Valeriani (1988), 1:49–55.
15. Pliny, *Nat. Hist.* 35.10. There are insufficient grounds for reattributing these drawings, as I formerly attempted to do in Goldstein (1970), pp. 230–5.
16. For a description of this solemn academic occasion, see Ghezzi, *Le pompe dell'accademia del disegno solennemente celebrate nel Campidoglio il di 25 febraio 1702 descritte da Giuseppe Ghezzi pittore, e segretario di essa. Dedicate dagli accademici alla santità di nostro signore Clemente undecimo pontefice ottimo massimo.*
17. Solimena: Concorso Clementino, 1702, A.123; Caldana: A.124; Creccolini, A.125; Brughi, A. 127; Triga, A. 128; Lorini, A. 129; Cipriani and Valeriani (1988), 2:9–19; see Goldstein (1978), p. 12.
18. Five of the six are listed in Thieme-Becker's *Allgemeines Künstlerlexicon,* the exception being Lorini. The three French artists whose drawings were discussed earlier are somewhat better known.
19. This was not, of course, always true, and the famous dispute in the Roman academy during the 1630s concerned precisely this question. See above, Chap. 2.
20. For the engraving, see Bartsch (1854–76), vol. 14, pl. 18; cf. Pope-Hennessy (1970), p. 156; Freedberg (1971), p. 138.
21. Illus. Gnudi and Cavalli (1955), p. 54.
22. Illus. M. Campbell (1977), p. 41, fig. 12.
23. Illus. Blunt (1966), no. 67.

24. For Rubens, see J. Held and Posner (n.d.), fig. 205; for Le Brun, see Goldstein (1978), fig. 15.
25. See Goldstein (1978), p. 12.
26. No. A.107. The drawing is inscribed: "Seconda classe della pittura. Giacomo Trighi Romano. Secondo premio. 1667," but the contest has been traced to 1694. Cipriani and Valeriani (1988), 1:135–44; cf. Goldstein (1978), p. 6 and notes 42–4.
27. Nos. A.106, A. 109. See Goldstein (1978), p. 6; Cipriani and Valeriani (1988), 1:135–44.
28. Ovid, *Metamorphoses* 8. 621–96.
29. For Cortona, see Briganti (1982), pp. 54, 192; for Maratta, see Golzio (1968), 1:684.
30. Wölfflin (n.d.), p. 14.
31. Ibid., pp. 10–11.
32. Concorso Clementino, 1703, A. 141, A. 143. See Cipriani and Valeriani (1988), 2:25–33.
33. Illus. Blunt (1966), pl. 198.
34. Royal Academy. See Goldstein (1975a), pp. 106–7; Von Erffa and Staley (1986), no. 256.
35. See Grunchec (1983), pp. 220–1.
36. Goldstein (1975a), p. 108; Von Erffa and Staley (1986), no. 402, pp. 390–1.
37. Brookner (1980), p. 56.
38. This dependence was noted by Bryson (1981), p. 220.
39. Illus. Blunt (1966), pl. 48.
40. *Charles Le Brun, 1619–1690* (1963), p. 33.
41. And also Raphael's *Madonna of Foligno.* See *Raphaël et l'art français,* cat. 126.
42. Rosenblum and Janson (1984), p. 126. For the political context, see Duncan (1993), pp. 57–78.
43. Amaury-Duval (1993), p. 74.
44. Robert Rosenblum, in an earlier discussion, noted the proliferation of styles at this time, proposing that paintings be grouped not by style but type; (1967), pp. 50–106.

11: ORIGINALITY

1. The same view was held by Walter Benjamin (1985), pp. 107–23. For differences between "languages," see Goodman (1968). The question of the possibility of an autonomous semiotics of images, independent of the model of language, is among the most hotly disputed in contemporary visual theory. To mention a few key discussions: M. Schapiro (1969), pp. 223–42; idem (1973); W. J. T. Mitchell (1986); Bryson (1991), pp. 61–73; Summers (1991), pp. 231–59.
2. The terms, though understood well enough to be transmitted, were rarely defined. A typical attempt to verbalize the means of academic sculpture is the following explanation of the reasons for an award in a competition of 1843: "because the chief figure is well rendered, because the composition is well understood, because each figure is well felt from the point of view of placement, and because there are some heads either well done or remarkable in terms of expression." Archives Nationales, Paris, AJ 52.75; cited in Wagner (1986), p. 94. There were times, however, when academies did explicitly state their criteria. See below in this chapter.
3. For nineteenth-century examples of both, see Wagner (1986), pp. 84–108; also *La Sculpture française au XIXe siècle,* pp. 42–8.
4. See above, Chap. 1. For the *paragone,* see Mendelsohn (1982).
5. The French academy, for example, by then the Ecole des Beaux-Arts, only began offering instruction in painting after the reforms of 1863. "Is it not extraordinary," the decree implementing the reform states, "that in a school in which painters are in the majority, there is no professor of painting?" See Boime (1977), p. 11.
6. See Montagu (1976), pp. 88–94; F. Den Broeder (1967), pp. 360–5.
7. Janson (1985), p. 13.
8. See Souchal (1977), pp. 130–1.
9. Ovid, *Met.,* 9. 230–9.
10. See Duvivier and De Chennevières (1852–3), pp. 353–91.
11. See Souchal (1977), p. 272. A better-known work in this tradition is Falconet's *Milo of Crotona* of 1754, for which see, e.g., Levey (1993), pp. 128–31. For the whole question of the ambiguity of the *Laocoön* within the canon, see Richter (1992).
12. On this question, cf. Wagner (1986), p. 95.
13. Illus. Irwin (1966), fig. 62. The comparison with the Greeks and Michelangelo was made by Flaxman (1838), p. 272; cited in Irwin (1966), p. 55. For more on Banks, see Whinney (1964), chap. 22.
14. See *Treasures of the Royal Academy* (1963), no. 52. As suggested in this catalogue, the figure also resembles Michelangelo's *Haman,*

only one of the Sistine figures indebted to the *Torso*.

15. See Skovgaard (1961); Rosenblum (1967), p. 13.
16. See Read (1956), pp. 25–45.
17. See De Caso (1992), p. 4; Fusco and Janson (1980), no. 101.
18. See De Caso (1992), pp. 4–6.
19. See Richman (1976), pp. 38–47.
20. Taft (1903), pp. 312–15; cited in Richman (1976), p. 43.
21. De Caso (1992), pp. 33–4.
22. Diodorus of Sicily 15.
23. Irwin (1966), p. 148; Von Erffa and Staley (1986), pp. 165–6.
24. One difference is that in West's version Epaminondas grasps the spear point himself, which David's figure does not do, though other reliefs entered in the competition along with David's include this detail. For illustrations, see Wagner (1986), pp. 102–3.
25. For Füger, see Stix (1925). A Poussinesque preparatory drawing is reproduced in pl. 58. For Banks, see Whinney (1964), p. 176. The two are discussed in relation to Poussin in Rosenblum (1967), pp. 30–1.
26. Rosenblum (1967), pp. 30–1.
27. See above, Chap. 5.
28. See Goldstein (1975a), p. 103 and n. 13.
29. Félibien (1668); idem (1663); Jouin (1883); Fontaine (n.d.); J. Reynolds (1975); Wornum (1848).
30. Boime (1971), pp. 174–84.
31. Shiff (1984), p. 72.
32. Quatremère de Quincy (1823); cited in Shiff (1984), p. 73.
33. Italics mine; Félibien (1666–88), preface, 25–26.
34. Kant (1952), pp. 196–200.
35. *Charles-Joseph Natoire* (1977), no. 1.
36. Grunchec (1983), pp. 222–5.
37. Illus. Blunt (1966), pl. 220.
38. Illus. *Charles Le Brun*, no. 48.
39. See Brookner (1980), pp. 56–7. Le Brun himself had planned a painting of this subject but never executed the final work.
40. On the question of rivaling the masters, see Sheriff (1990), p. 33n12.
41. See esp., ibid., pp. 30–57.
42. Ibid., p. 30.
43. Ibid., p. 31.
44. See above, Chap. 5.
45. Félibien (1666–88), 4:115.

46. See Kemp (1969), pp. 178–83; Goldstein (1975a), pp. 108–9; *Jacques-Louis David, 1748–1825* (1989), pp. 487–97; D. Johnson (1993), pp. 162–73.
47. Herodotus, *History* 7. 198–239.
48. Delècluze (1855), p. 224.
49. See the Montpellier drawing reproduced in Kemp (1969), fig. 3.
50. Delècluze (1855), p. 225. Cf. Bryson (1984), pp. 90–5.
51. As noted by Brookner (1972), p. 122.
52. Bryson (1981), p. 137.
53. Ibid.
54. Brookner (1972), p. 122.
55. For an exhaustive account of the genesis, iconography, and reception of the work, see Boime (1980), pp. 133–88.
56. See ibid., pp. 480–9; *Puvis de Chavannes, 1824–1898* (1976).
57. The two most recent discussions are: Fried (1990), pp. 155–64; Herding (1991), pp. 45–61; see also Fried (1981), p. 127. Fried relates the painting to the "machines" of the academy, but those – David's especially – in which the figures are "wholly absorbed" in their actions.
58. See, e.g., Cowling and Mundy (1990), p. 218.
59. Silver (1989), pp. 274–7; *Copier Créer, de Turner à Picasso* (1993), p. 454.

12: THE REVOLT OF THE CRAFTS

1. Pevsner (1940), p. 153.
2. For the origins of this distinction, see Kristeller (1962), pp. 145–206.
3. Pevsner (1940), p. 159.
4. For drawings for the tapestry, see *Charles Le Brun 1619–1690* (1963), no. 145; for other designs by Le Brun for mirrors, tables, and so on, see ibid., nos. 119–22. For designs by other artists for such objects, see Montagu (1989), pp. 99–125, 173–99.
5. Pevsner (1940), pp. 172–6.
6. See Wosk (1992), pp. 20–1, 105–7; also Gombrich (1979), p. 33.
7. Ruskin (1907), p. 219.
8. Ruskin (1987), p. 295.
9. Ibid.
10. Ruskin treats Michelangelo more harshly in his later lectures, citing bad workmanship, violence, distortion, and so on; see Q. Bell (1978), pp. 101–3.

11. Ruskin (1987), pp. 313–14.
12. Bell (1978), p. 60.
13. Morris, *Collected Works*, pp. 20, 40, and 42; cited in Pevsner (1968a), p. 20.
14. Morris (1899; rpt. 1903), p. 38; cited in Naylor (1971), p. 104.
15. "A Visit to the Omega Workshops. Mr. Roger Fry on Modern Design and Applied Art," *Drawing and Design*, August 1917, p. 76; cited in Collins (1984), p. 6.
16. Ibid.
17. The words are those of Arthur Mackmurdo, in "History of the Arts and Crafts Movement," unpublished typescript; cited in Naylor (1971), p. 29.
18. "The Two Paths," Lecture 3, no. 81; cited in Naylor (1971), pp. 30–1.
19. Ruskin, *Complete Works*, 15:344; cited in Wosk (1992), p. 121.
20. MacDonald (1970), p. 67; Q. Bell (1963), p. 52; Stansky (1985), pp. 24–5; Wosk (1992), p. 120.
21. Q. Bell (1963), p. 52.
22. Ibid., p. 67.
23. Wosk (1992), p. 120.
24. Pevsner (1940), pp. 259–60; see also idem (1968b).
25. Pevsner (1968b); also Banham (1960), pp. 68–78; Stansky (1985), pp. 9, 28; J. Campbell (1978), pp. 3–56.
26. Whitford (1986), p. 29; Franciscono (1971), pp. 13–25; Long (1986), pp. 201–17. For the final, Berlin period, see *Bauhaus Berlin, eine Dokumentation* (1985), passim.
27. Translation from Wingler (1969), p. 31.
28. Ibid.
29. Banham (1960), p. 278.
30. Quoted in Gomringer (n.d.), p. 27.
31. Ibid.
32. Quoted in Wingler (1969), p. 34. See also Forgács (1995), p. 317.
33. Wingler (1969), p. 32; see also Forgács (1995), pp. 46–62.
34. Quoted in *Bauhaus, 1919–1928* (1938), p. 36; see Franciscono (1971), pp. 173–237.
35. Gomringer (n.d.), p. 27. The academic studies in question were under Franz von Stück, who had been the teacher of Klee and Kandinsky as well; see *Franz von Stück und die Münchner Akademie von Kandinsky bis Albers* (1990).
36. See, e.g., Welsh (1970), p. 46.
37. Quoted in Whitford (1986), p. 78. Given the Bauhaus project as defined by Gropius, teaching craft was in itself problematical. Consider the following criticism from *Starba*, a leading Czechoslovakian architectural periodical: "Unfortunately, the Bauhaus is not consistent as a school for architecture as long as it is still concerned with the question of applied arts or 'art' as such. Any art school, no matter how good, can today be only an anachronism and nonsense.... If Gropius wants his school to fight against dilettantism in the arts, if he assumes the machine to be the modern means of production, if he admits the division of labor, why does he suppose a knowledge of crafts to be essential to industrial manufacture? Craftsmanship and industry have a fundamentally different approach, theoretically as well as practically. Today, the crafts are nothing but a luxury, supported by the bourgeoisie with their individualism and snobbery and their purely decorative point of view. Like any other art school, the Bauhaus is incapable of improving industrial production." Karel Teige, cited in *Bauhaus, 1919–1928* (1938), p. 91.
38. E.g., Wingler (1969), p. xviii. Also, Forgács (1995), pp. 104–17.
39. See J. Fiedler (1990), esp. pp. 127–88; Hambourg and Phillips (1989), pp. 88–91, 106–7.
40. Prokopoff (1985); Suhre (1990); Boxer (1993); Solomon-Godeau (1991), pp. 52–84.
41. See esp. Weltge (1993), esp. pp. 41–2; also Westphal (1991), pp. 130–5; Whitford (1986), pp. 175–8; Wingler (1969), pp. 461–5.
42. *Bauhaus Journal*, 1931, p. 2; quoted in Wingler (1969), p. 465.
43. Weltge (1993), pp. 41–5; Westfall (1991), p. 135.
44. Stölzl, "Weberei am Bauhaus," in *Offset, Buch und Werbekunst* 7 (1926): 405; Nonné-Schmidt, in Wingler (1969), pp. 116–17; both cited in Weltge (1993), p. 100.
45. M. E. Harris (1987), p. 86; N. F. Weber (1985), *The Woven and Graphic Art of Anni Albers*. A weaving workshop also was included in Moholy-Nagy's Chicago Institute of Design; its director was Marli Ehrmann, the only woman on that staff.
46. See Anni Albers, "Handweaving Today: Textile Work at Black Mountain College," *The Weaver* 6, 3–7; cited in M. E. Harris (1987).

47. See Gouma-Petersen and Mathews (1987), p. 351; the phrase is Carol Duncan's.
48. Mainardi (1973); cited in Parker and Pollock (1981), p. 58.
49. Ibid.
50. Pleynet (1977), p. 128 and n. 24.

13: TEACHING MODERNISM

1. E.g., *Bauhaus (50 Years)* (1969).
2. Poling (1986); Klee (1961, 1973).
3. From a letter to his wife, Lily, quoted in Klee (1961), pp. 29–30.
4. Itten (1964), p. 79.
5. Klee (1961), passim.
6. Kandinsky (1947), p. 72.
7. See Jordan (1977), pp. 152–7; Tower (1981), pp. 139–204.
8. Ibid.; and Poling (1983), pp. 36–56.
9. See Wingler (1969), pp. 280–3; Whitford (1986), pp. 58–9.
10. Kupferberg (1971), p. 80.
11. See esp. Elderfield (1972), pp. 52–9; Krauss (1979), pp. 51–64.
12. See Rowell (1972), pp. 26–37; *Josef Albers, a Retrospective* (1988).
13. Franciscono (1971), pp. 214–15.
14. Klee (1961), esp. pp. 223–35.
15. See esp. Triska (1979), pp. 43–78; also Poling (1983), pp. 47–9.
16. See ibid., pp. 49–56; idem (1986) passim.
17. See Goldstein (1979), pp. 109–11. Such research was conducted during the same period, 1953 on, in the new German Bauhaus, the Hochschule für Gestaltung in Ulm, directed by Max Bill, an alumnus of the Bauhaus – and with Albers as a guest instructor. See *Ulm Design: The Morality of Objects* (c. 1991), esp. pp. 33–68.
18. Coplans (1969), pp. 7–9.
19. H. Rosenberg (1973), pp. 92–3.
20. See esp. Hofmann (1967); H. Rosenberg (1970); Sandler (1973); C. Goodman (1979).
21. Hofmann (1967), p. 47.
22. *Kenneth Noland, a Retrospective* (1977), p. 10.
23. Duberman (1972), p. 69n52.
24. See *Twenty Artists: Yale School of Art: 1950–1970* (1981); Sandler (1982), pp. 14–21.
25. Sandler (1982), p. 16.

26. Tomkins (1968), p. 199; see also Duberman (1972), p. 429; Goldstein (1979), p. 112.
27. Duberman is one (1972), pp. 68, 71.
28. Kozloff, "Robert Rauschenberg," *The Nation*, December 7, 1963; reprinted in Kozloff (1968), p. 212.
29. First argued in *Artforum*, March 1972; reprinted in Steinberg (1972b), pp. 85–91.
30. Ibid., p. 84.
31. Quoted in Alloway (1976), p. 20.
32. *Kenneth Noland, a Retrospective* (1977), p. 10; cf. Wilkin (1990), p. 7: "[At Black Mountain] Noland studied briefly with the head of the Art Department, Josef Albers, assimilating his Bauhaus-derived color theory, and with Ilya Bolotowsky, who introduced him to modernist geometry, particularly to Mondrian."
33. *Kenneth Noland*, p. 11. John Gage recently has noted the indebtedness of Noland to Albers's color ideas; see Gage (1993), p. 266.
34. *Kenneth Noland*, p. 11.
35. Ibid.
36. "Black Mountain College Papers," North Carolina Department of Archives and History, Raleigh, N.C., 2:25.
37. For the ambiguity of the academy's concept of originality, see above, Chap. 11.
38. See Lippard (1976), p. 13; Albers (1963), pl. 35.1.
39. See Albers (1969), p. 73; Goldstein (1979), p. 111. Discussions of Hesse and Albers fix on her early abstract expressionist paintings and Albers's lack of sympathy for them; see, most recently, Norden (1992), pp. 59–61.
40. Nemser (1970); see also E. H. Johnson (1983).
41. See above, Chap. 11.
42. Greenberg (1971), pp. 16–19. Cf. his earlier handling of the question in the more famous, "Avant-Garde and Kitsch," Greenberg (1961), pp. 3–21.
43. Greenberg (1971), p. 18; see also idem (1966), p. 109: "Modernist art develops out of the past without gap or break, and wherever it ends up it will never stop being intelligible in terms of the continuity of art." For Eliot, see above, Chap. 10.
44. The theoretical justification is in Greenberg (1966).
45. Published in *Art News*, May 1957; see Reinhardt (1975), pp. 203–8. For Reinhardt and Albers, see Lippard (1981), pp. 82–3.

46. De Kooning (1950), p. 40.
47. Reinhardt (1975), pp. 207–8.
48. Ibid., pp. 53–6, 54.

EPILOGUE

1. This was in 1969, the date of the last piece in the Collected Writings, Greenberg (1993), vol. 4.
2. See Jencks (1977).
3. E.g., Hughes (1990), pp. 11–12.
4. At this writing, the most widely quoted views are: Lyotard (1984); Jameson (1984), pp. 53–92. See also Wellmer (1991).
5. See Owen (1992), pp. 166–90.
6. The exception is the alternative "carnivalesque" tradition, to which Mikhail Bakhtin has called attention (e.g., 1968).
7. See esp. Smith (1988); Graff (1992); Oakley (1992).
8. Cohen (1992), pp. 256–8.
9. For this academy, see Zorpette (1993), pp. 84–9.
10. Colker (1982), pp. 33–8; the statements are by, respectively, Vera Klement (University of Chicago), Sylvia Sleigh (New York City), and Peter Plagens (then University of North Carolina at Chapel Hill).

BIBLIOGRAPHY

ABBREVIATIONS

AB	*Art Bulletin*
AH	*Art History*
AiA	*Art in America*
AJ	*Art Journal*
AM	*Arts Magazine*
AQ	*Art Quarterly*
BM	*Burlington Magazine*
BSHAF	*Bulletin de la Société de l'Histoire de l'Art Français*
GBA	*Gazette des Beaux-Arts*
JWCI	*Journal of the Warburg and Courtauld Institutes*
ZfKg	*Zeitschrift für Kunstgeschichte*

The Academic Tradition. An Exhibition of Nineteenth-Century French Drawings. Intro. and cat. by Sarah Whitfield. Bloomington, Ind.

Ackerman, G. M. 1969. "Thomas Eakins and His Parisian Masters." *GBA* 73:235–56.

Ackerman, J. 1961. "Science and Visual Art." In *Seventeenth-Century Science and the Arts,* ed. H. H. Rhys. Princeton, pp. 63–90.

1985. "The Involvement of Artists in Renaissance Science." In *Science and the Arts in the Renaissance,* ed. J. W. Shirley and F. D. Hoeniger, Washington, London, and Toronto, pp. 94–126.

Ades, D. 1989. *Art in Latin America: The Modern Era, 1820–1980.* New Haven and London.

Aichele, K. P. 1989. "Seurat's 'Les Poseuses' in the Context of French Realist Literature." *Nineteenth-Century French Studies* 17: 385–96.

1993. "Paul Klee and the Energetics–Atomistics Controversy." *Leonardo* 26: 309–15.

Albers, J. 1963. *Interaction of Color,* New Haven. 1969. *Search Versus Re-search.* Hartford.

Alberti, L. B. 1972. *On Painting and on Sculpture.* Ed. C. Grayson. London.

Alberti, R., and F. Zuccaro. 1604. *Origine e progresso dell'accademia del disegno di Roma.* Pavia.

Alloway, L. 1976. In his *Robert Rauschenberg.* Washington, D.C., pp. 3–22.

Almansi, G. 1982. "Foucault and Magritte." *History of European Ideas* 3: 305–9.

Alpers, S. 1960. "Ekphrasis and Aesthetic Attitudes in Vasari's Lives." *JWCI* 23:190–212.

1983. *The Art of Describing: Dutch Art in the Seventeenth Century*. Chicago.

1985. *Rembrandt's Enterprise: The Studio and the Market*. Chicago.

1987. "Style is what you make it; the Visual Arts once again." In *The Concept of Style*, ed. B. Lang. Ithaca and London, pp. 137–62.

Alsop, J. 1982. *The Rare Art Traditions: The History of Art Collecting and Its Linked Phenomena Wherever These Have Appeared*. New York.

Altieri, C. 1990. *Canons and Consequences: Reflections on the Ethical Force of Imaginative Ideals*. Evanston, Ill.

Amaury-Duval. 1993. *L'Atelier d'Ingres*. Ed. D. Ternois. Paris.

Ames-Lewis, F. 1981. "Drapery 'Pattern' – Drawings in Ghirlandaio's Early Apprenticeship." *AB* 63:49–61.

1992. "The Renaissance Draughtsman and His Models." In *Drawing: Masters and Methods, Raphael to Redon*, ed. D. Dethloff. New York and London, pp. 1–6.

Ames-Lewis, F., and J. Wright. 1983. *Drawing in the Italian Renaissance Workshop*. London.

Amornpichetkul, C. 1984. "Seventeenth-Century Italian Drawing Books: Their Origin and Development." *Children of Mercury: The Education of Artists in the Sixteenth and Seventeenth Centuries*, pp. 108–18.

Andersen, W. 1994. "To Copy to Create: The Louvre's Bicentennial." *Drawing* 15:97–106.

Andrews, K. 1964. *The Nazarenes: A Brotherhood of German Painters in Rome*. Oxford.

Armenini, G. B. 1587. *De' Veri precetti della pittura*. Ravenna.

Arnaud, J. 1886. *L'Académie de Saint-Luc à Rome, considérations historiques depuis son origine jusqu'à nos jours*. Rome.

Asendorf, C. 1993. *Batteries of Life: On the History of Things and Their Perception in Modernity*. Trans. D. Reneau. Berkeley, Los Angeles, and London.

Ashton, D. 1977. *Picasso on Art: A Selection of Views*. Harmondsworth and New York.

Athanassoglou-Kallmyer, N. 1992. "Géricault's Severed Heads and Limbs: The Politics and Aesthetics of the Scaffold." *AB* 74:599–618.

Audran, G. 1683. *Les Proportions du corps humain mesurées sur les plus belles figures de l'antiquité*. Paris.

Baas, J. 1987. "Reconsidering Walter Benjamin: 'The Age of Mechanical Reproduction' in Retrospect." In *The Documented Image: Visions in Art History*, ed. G. P. Weisberg and L. S. Dixon. Syracuse, pp. 37–47.

Bacon, F. 1857–64. *The Works of Francis Bacon*. Ed. J. Spedding et al. 14 vols. London.

Baizerman, S. 1975. "The Journal, May 10, 1952," ed. C. Goldstein. *Tracks* 1, no. 2:8–23.

Bakhtin, M. 1968. *Rabelais and His World*. Trans. H. Iswolsky. Cambridge, Mass.

Baldinucci, F. 1728. *Notizie de' professori del disegno da Cimabue in qua*. Florence.

Baltrušaitis, J. 1957. *Aberrations, légendes des formes*. Paris.

Banham, R. 1960. *Theory and Design in the First Machine Age*. New York.

Bann, S. 1984. *The Clothing of Clio*. Cambridge.

Barocchi, P., ed. 1960. *Trattati d'arte del cinquecento fra manierismo e contrariforma*. 3 vols. Bari.

1964. "Ricorsi italiani nei trattatisti d'arte francesi del seicento." In *Il mito del classicismo nel seicento*, ed. S. Bottari. Messina and Florence, pp. 125–47.

Barr, A. H., Jr. 1951. *Matisse: His Art and His Public*. New York.

Barthes, R. 1974. *S/Z*. Trans. R. Miller. New York.

1977. *Image, Music, Text*. New York.

1985a. "Erté or à la lettre." In *The Responsibility of Forms: Critical Essays on Music, Art and Representation*, trans. R. Howard. New York, pp. 103–28.

1985b. "Is Painting a Language?" *The Responsibility of Forms*, pp. 149–52.

Bartsch, A. 1854–76. *Le Peintre graveur*. Leipzig.

Barzman, Karen- edis. 1985. "The Università, Compagnia, ed Accademia del Disegno." Ph. D. diss. Johns Hopkins University.

1989a. "The Florentine Accademia del Disegno: Liberal Education and the Renaissance Artist." In *Academies of Art between Renaissance and Romanticism*, ed. Boschloo et al., pp. 14–32.

1989b. "Liberal Academicians and the New Social Elite in Grand Ducal Florence." In *World Art: Themes of Unity and Diversity (Acts of the XXVIth International Congress of the History of Art)*, ed. I. Lavin. University Park, Pa., pp. 459–63.

1991. "Perception, Knowledge, and the Theory of Disegno in Sixteenth-Century Florence." In Larry J. Feinberg, *From Studio to Studiolo*,

Florentine Draftsmanship under the First Medici Grand Dukes. Oberlin, Ohio, pp. 37–44.

Baudrillard. J. 1984. "The Precession of Simulacra." In *Art after Modernism,* ed. B. Wallis and M. Tucker. New York, pp. 253–83.

Bauhaus, 1919–1928, 1938. Ed. H. Bayer, W. Gropius, and I. Gropius. New York.

Bauhaus (50 Years). 1969. Exhibition catalogue. Chicago, Toronto, Pasadena.

Bauhaus Berlin, eine Dokumentation. 1985. Ed. P. Hahn. Berlin.

Bauhaus Dessau Dimensionen, 1925–1932. 1993. Bauhaus Dessau.

Bauhaus-Künstler: Malerei und Grafik aus den Beständen der Kunstsammlungen zu Weimar und der Deutschen Bank. 1993. Weimar and Weisbaden.

Baxandall, M. 1971. *Giotto and the Orators.* Oxford.

Bazin, G. 1932. "Manet et la tradition." *L'amour de l'art* 13:152–63.

Bédat, C. 1974. *L'Académie des Beaux-Arts de Madrid, 1744–1808.* Toulouse.

Bell, J. 1993. "Zaccolini's Theory of Color Perspective." AB 75:91–112.

Bell, Q. 1963. *The Schools of Design.* London.
 1978. *Ruskin.* New York.

Bellori, G. P. 1976. *Le vite de' pittori, scultori ed architetti moderni.* Ed. E. Borea, intro. G. Previtali. Turin.

 1695. *Descrizione delle imagini dipinte da Rafaelle d'Urbino nelle camere del palazzo apostolico vaticano.* Rome.

Benjamin, W. 1969. "The Work of Art in the Age of Mechanical Reproduction." In *Illuminations,* ed. H. Arendt. New York, pp. 217–51.

 1985. "On Language As Such and on the Language of Man." In *One-Way Street and Other Writings,* trans. E. Jephcott and K. Shorter. New York and London, pp. 107–23.

Bertold, G. 1958. *Cézanne und die alten Meister.* Stuttgart.

Bevers, H., P. Schatborn, and B. Welzel. 1991. *Rembrandt: The Master and His Workshop, Drawings and Etchings.* New Haven and London.

Bialostocki, J. 1960. "Poussin et le 'Traité de la peinture' de Léonard." In *Nicolas Poussin,* ed. A. Chastel. Paris, 1:133–9.

 1963. "The Renaissance Concept of Nature and Antiquity." *The Renaissance and Man-*

nerism: *Studies in Western Art* (Acts of the Twentieth International Congress of the History of Art, 2), 2:19–30.

Bieber, M. 1942. *Laocoön: The Influence of the Group Since Its Rediscovery.* New York.

Bignamini, I. 1989. "The 'Academy of Art' in Britain before the Foundation of the Royal Academy." *Academies of Art between Renaissance and Romanticism,* pp. 434–50.

Binyon, L. 1902. *Catalogue of Drawings by British Artists . . . in the British Museum.* London.

Black Mountain College Papers. Manuscript. North Carolina Department of Archives and History, Raleigh.

Blake, R. M. et al., eds. 1960. *Theories of Scientific Method: The Renaissance through the Nineteenth Century.* Seattle.

Blake, W. 1966. *The Complete Writings of William Blake.* Ed. G. Keynes. London.

Blanchardière, N. de la. 1973. "Simon Vouet, prince de l'Académie de Saint-Luc." *BSHAF* (1972), pp. 79–94.

Blondel, F. 1675–83. *Cours d'architecture enseigné dans l'Académie Royale d'Architecture.* Paris.

Blum, A. N.d. *Abraham Bosse et la société française au dix-septième siècle.* Paris.

Blunt, A. 1966. *The Paintings of Nicolas Poussin.* London.

Boime, A. 1964. "Le Musée des copies." *GBA* 64:237–47.

 1969. "Georges Rouault and the Academic Curriculum." *AJ* 29:36–9.

 1971. *The Academy and French Painting in the Nineteenth Century.* London.

 1974. "Curriculum vitae: The Course of Life in the Nineteenth Century." *Strictly Academic: Life Drawing in the Nineteenth Century.* Binghamton, N.Y., pp. 5–15.

 1974–5. "The Instruction of Charles Gleyre and the Evolution of Painting in the Nineteenth Century." *Charles Gleyre, ou les illusions perdues.* Lausanne, pp. 102–24.

 1977. "The Teaching Reforms of 1863 and the Origins of Modernism in France." *AQ* 1:1–39.

 1980. *Thomas Couture and the Eclectic Vision.* New Haven and London.

 1981. "The Case of Rosa Bonheur: Why Should a Woman Want to be More Like a Man?" *AH* 4:384–409.

 1982. "American Culture and the Revival of

the French Academic Tradition." *AM* 56, no. 9:95–101.

——. 1993. "Henry Ossawa Tanner's Subversion of Genre." *AB* 85:415–42.

Bok, M. J. 1990. " 'Nulla dies sine linie.' De opleiding van schilders in Utrecht in de eerste helft van de zeventiende eeuw." *De zeventiende eeuw*, 6:58–68.

Bolten, F. 1985. *Method and Practice: Dutch and Flemish Drawing Books, 1600–1750*. Landau, Germany.

Bordeaux, J.-L. 1985. *François Le Moyne (1688–1737)*. Paris.

Borea, E. 1963. "Mostra di disegni dei fondatori dell'Accademia. *Arte antica e moderna.*" Exhibition review, p. 88.

Borel, F. 1990. *The Seduction of Venus: Artists and Models*. Geneva.

Borges, J. L. 1930. *Figari*. Buenos Aires.

Boschloo, A. W. A. 1989. "L'Accademia Clementina e la fama dei Carracci." *Academies of Art between Renaissance and Romanticism*, pp. 105–17.

Boschloo, A. W. A., et al., eds. 1989. *Academies of Art between Renaissance and Romanticism*, vols. 5–6 (1986–7). *Leids Kunsthistorisch Jaarboek*. The Hague.

Bosse, A. 1649. *Sentimens sur la distinction des diverses manières de peinture, dessein et graveure, et des originaux d'avec les copies*. Paris.

——. 1964 [1667]. *Le Peintre converty aux precises et universelles règles de son art. Sentimens sur la distinction. . . .* Ed. R. A. Weigert. Paris.

——. 1665. *Traité des pratiques géométrales et perspectives, enseignées dans l'Académie Royale de la Peinture et Sculpture*. Paris.

——. 1668. *Lettres écrites au Sr. Bosse . . . avec ses reponses sur quelques nouveaux traitez concernans la perspective & la peinture*. Paris.

——. 1674. *Catalogue des traittez que le Sr. A. Bosse a mis au jour avec une déduction en gros de ce qui est contenu dans chacun*. Paris.

Bottari, G. G., and S. Ticozzi. 1922–5. *Raccolta di lettere sulla pittura, scultura, ed architettura*. Milan.

Bousquet, J. 1980. *Recherches sur le séjour des artistes français à Rome au XVIIe siècle*. Montpellier.

Bowness, A. 1961. "A Note on Manet's Compositional Difficulties." *BM* 103:276–7.

Bowron, E. P. 1993. "Academic Life Drawing in Rome, 1750–1790." In *Visions of Antiquity:*

Neoclassical Figure Drawing, catalogue by R. J. Campbell, V. Carlson et al. Los Angeles and Minneapolis, pp. 75–85.

Boxer, A. J. 1993. *The New Bauhaus: School of Design in Chicago, Photographs 1937–1944*. New York.

Boyer, F. 1950. "Les Artistes français, étudiants, lauréats, ou membres de l'académie romaine de Saint-Luc, entre 1660–1700, d'après des documents inédits." *BSHAF*, pp. 117–32.

Briganti, G. 1982. *Pietro da Cortona, o della pittura barocca*. Florence.

Brookner, A. 1972. *Greuze: The Rise and Fall of an Eighteenth-Century Phenomenon*. Greenwich, Conn.

——. 1980. *Jacques-Louis David*. New York.

Broude, N. 1991. *Impressionism: A Feminist Reading, the Gendering of Art, Science, and Nature in the Nineteenth Century*. New York.

Broun, E. 1981. "The Portable Raphael." In *The Engravings of Marcantonio Raimondi*, ed. I. Shoemaker and I. Broun, pp. 20–42.

Brown, H. 1934. *Scientific Organizations in Seventeenth-Century France (1620–1680)*, New York.

Brown, J. 1989. "Academies of Painting in Seventeenth-Century Spain." In *Academies of Art between Renaissance and Romanticism*, ed. Boschloo et al., pp. 177–85.

Brown, M. 1982. "The Classic Is the Baroque: On the Principle of Wölfflin's Art History." *Critical Inquiry* 9:379–404.

Brughetti, R. 1987–8. "La ensenanza artistica en Buenos Aires." *Anuario 15, Academia Nacional de Bellas Artes*, pp. 3–7.

Bruyn, J. 1992. "Rembrandt's Workshop: Its Function and Production." In C. Brown, J. Kelch, and P. van Thiel, *Rembrandt: The Master and His Workshop*. New Haven and London, pp. 68–89.

Bryson, N. 1981. *Word and Image, French Painting of the Ancien Régime*. Cambridge, London, and New York.

——. 1983. *Vision and Painting: The Logic of the Gaze*. New Haven and London.

——. 1984. *Tradition and Desire, from David to Delacroix*. Cambridge, London, and New York.

——. 1990. *Looking at the Overlooked: Four Essays on Still-Life Painting*. Cambridge, Mass.

——. 1991. "Semiology and Visual Interpretation." In *Visual Theory, Painting and Interpreta-*

tion, ed. N. Bryson, M. A. Holly, and K. Moxey. New York, pp. 61–73.

Bukdahl, E. M. 1980–2. *Diderot critique d'art*. 2 vols. Copenhagen.

Burtt, E. A. 1932. *The Metaphysical Foundations of Modern Physical Science*. New York.

Butcher, S. H. 1923. *Aristotle's Theory of Poetry and Fine Art*. 4th ed. Critical text and translation of the *Poetics*. London.

Cahn, W. 1979. *Masterpieces: Chapters on the History of an Idea*. Princeton.

Calamandrei, S., and P. Calamandrei. 1956. "Inediti Celliniani. Il sigillo e i caratteri dell'accademia." *Il ponte* 12:1345–61.

Calderón de la Barca, F. 1954. *Life in Mexico*. London.

Campbell, J. 1978. *The German Werkbund: The Politics of Reform in the Applied Arts*. Princeton.

Campbell, M. 1977. *Pietro da Cortona at the Palazzo Pitti*. Princeton.

Carrier, D. 1991. *Principles of Art History Writing*. University Park, Pa.

Cavallucci, C. I. 1973. *Notizie storiche intorno alla R. Accademia delle Arti del Disegno in Firenze*. Florence.

Cellini, B. n.d. *The Autobiography of Benvenuto Cellini*. Trans. J. A. Symonds. New York.

Cennini, C. 1932–3. *Il libro dell'arte*. Ed. J. Thompson. 2 vols. New York.

Chambray, R. F. Sieur de. 1650. *Parallèle de l'architecture antique et de la moderne, avec un recueil des dix principaux auteurs qui ont écrit des cinq ordres*. Paris.

　　1662. *Idée de la perfection de la peinture*. Le Mans.

Chantelou, M. de. 1885. *Journal de voyage du Cavalier Bernin en France*. Ed. L. Lalanne. Paris.

Chapman, P. 1990. *Rembrandt's Self-Portraits*. Princeton.

Chappuis, A. 1973. *The Drawings of Paul Cézanne: A Catalogue Raisonné*. 2 vols. Greenwich, Conn.

Charles-Joseph Natoire. 1977. Troyes, Nîmes and Rome.

Charles Le Brun, 1619–1690, peintre et dessinateur. 1963. Versailles.

Charlot, J. 1962. *Mexican Art and the Academy of San Carlos, 1785–1915*. Austin.

Chetham, C. 1976. *The Role of Vincent Van Gogh's Copies in the Development of His Art*. New York and London.

Chipp, H. B. 1968. *Theories of Modern Art: A Source Book by Artists and Critics*. Berkeley and Los Angeles.

Cipriani, A., and E. Valeriani. 1988. *I disegni di figura nell'archivio storico dell'Accademia di San Luca*. Rome.

Clark, K. 1956. *The Nude*. London.

　　1966. *Rembrandt and the Italian Renaissance*. London.

Cohen, D. 1992. "The Art Schools in Crisis?" *Apollo*, pp. 256–8.

Cole, B. 1983. *The Renaissance Artist at Work, from Pisano to Titian*. New York.

Colin, P. 1937. *Manet*. Paris.

Colker, E. 1982. "Present Concerns in Studio Teaching: Artists' Statements." *AJ* 42: 33–8.

Collection des livrets des anciennes expositions depuis 1673–1800. 1869–71. Ed. J. J. Guiffrey. 4 vols. Paris.

Collins, J. 1984. *The Omega Workshop*. Chicago.

Conisbee, P. 1981. *Painting in Eighteenth-Century France*. Ithaca, N.Y.

Copier Créer, de Turner à Picasso: 300 oeuvres inspirées par les maîtres du Louvre. 1993. Paris.

Coplans, J. 1969. *Serial Imagery*. New York and Pasadena.

Correspondance des directeurs de l'Académie de France à Rome avec les surintendants des bâtiments. 1887–1908. Ed. A. de Montaiglon and J. Guiffrey. Paris.

Costamagna, P. 1991. "L'Etude d'après les maîtres et le rôle de la copie dans la formation des artistes à Florence au XVIe siècle." *Disegno* (Actes du colloque du Musée des Beaux-Arts de Rennes), pp. 51–9.

Cowling, E., and J. Mundy. 1990. *On Classical Ground: Picasso, Léger, de Chirico, and the New Classicism, 1919–1930*. London.

Cox, K. 1905. *Old Masters and New*. New York.

Coypel, A. 1721. *Discours prononcez dans les conférences de l'Académie Royale*. Paris.

Crimp, D., with L. Lawler. 1993. *On the Museum's Ruins*. Cambridge, Mass., and London.

Crook, J. M. 1972. *The Greek Revival*. London.

Cropper, E. 1974. "*Disegno* as the Foundation of Art: Some Drawings by Pietro Testa." *BM* 116:376–85.

　　1984. *The Ideal of Painting: Pietro Testa's Düsseldorf Notebook*. Princeton.

Crow, T. E. 1985. *Painters and Public Life in*

Eighteenth-Century Paris. New Haven and London.

Damisch, H. 1975. "Semiotics and Iconology." In *The Tell-Tale Sign*, ed. T. A. Sebeok. Kisse, Germany, pp. 27–36.

———. 1992. *Le Jugement de Paris, iconologie analytique*. Paris.

David e Roma. Rome, 1981.

Davies, M. 1993. *Turner as Professor: The Artist and Linear Perspective*. London.

De Caso, J. 1992. *David d'Angers, Sculptural Communication in the Age of Romanticism*. Trans. D. Johnson and J. de Caso. Princeton.

De Kooning, E. 1950. "Albers Paints a Picture." *Art News* 49, no. 7:40–43, 57–8.

Delécluze, E. 1855. *Louis David, son école et son temps*. Paris.

De Leiris, A. 1964. "Manet, Guéroult, and Chrysippos." *AB* 46:401–4.

———. 1969. *The Drawings of Edouard Manet*. Los Angeles and Berkeley.

Deleuze, G. 1983. "Plato and the Simulacrum." *October* 27:45–56.

Dempsey, C. 1977. *Annibale Carracci and the Beginnings of Baroque Style*. Glückstadt, Germany.

———. 1980. "Some Observations on the Education of Artists in Florence and Bologna during the Later Sixteenth Century." *AB* 62:552–689.

———. 1989. "The Carracci Academy." *Academies of Art between Renaissance and Romanticism*, ed. Boschloo et al., pp. 33–43.

Den Broeder, F. 1967. "The Lateran Apostles: The Major Sculpture Commission in Eighteenth-Century Rome." *Apollo* 85:360–5.

De Piles, R. 1699. *Abrégé de la vie des peintres, avec des reflexions sur leurs ouvrages, et un traité du peintre parfait, de la connoissance des desseins, et de l'utilité des estampes*. Paris.

Descartes, R. 1897–1913. *Oeuvres de Descartes*. Ed. C. Adam and P. Tannery. Paris.

Desne, R. 1967. "Diderot et Shakespeare." *Revue de littérature comparée* 41:532–71.

Dessins baroques florentins du Musée du Louvre. 1981. Paris.

Diderot, D. 1957–67. *Diderot: Salons*. Ed. J. Adhémar and J. Seznec. 4 vols. Oxford.

Dijksterhuis, E. J. 1961. *The Mechanization of the World Picture*. Oxford.

Di Santillana, G. 1959. "The Role of Art in the Scientific Revolution." In *Critical Problems in the History of Science*, ed. M. Clagett. Madison, Wisc. pp. 33–66.

Drexler, A., ed. 1975. *The Architecture of the Ecole des Beaux-Arts*. New York.

Duberman, M. 1972. *Black Mountain: An Exploration in Community*. New York.

Du Camp, M. 1866. "Le Salon de 1866." *Revue des deux mondes*, June 1866.

Dufrenne. M. 1966. "L'Art est-il langage?" *Revue d'esthétique* 19:1–43.

Duncan, C. 1993. "Ingres's Vow of Louis XIII and the Politics of the Restoration." In *Art and Architecture in the Service of Politics*, ed. L. Nochlin and H. Millon. 1978, Cambridge, Mass. 80–91. Reprinted in C. Duncan, *The Aesthetics of Power: Essays in Critical Art History*. Cambridge and New York, pp. 57–78.

Duranty, E. 1856. "Notes sur l'art." *Réalisme* 1 (July 10, 1856):1–2.

———. 1881. "Le Peintre Louis Martin." *Le Pays des arts*, Paris.

Duret, T. 1878. *Les Peintres impressionistes*. Paris.

Duro, P. 1988. "Copyists in the Louvre in the Middle Decades of the Nineteenth Century." *GBA* 6, no. 61:249–54.

———. 1989. "Un Livre ouvert à l'instruction': Study Museums in Paris in the Nineteenth Century." *Oxford Art Journal* 10, no. 1:44–58.

The Düsseldorf Academy and the Americans. An Exhibition of Drawings and Watercolors. 1972, Atlanta.

Duvivier, M., and P. de Chennevières. 1852–3. "Sujets des morceaux de réception des membres de l'ancienne Académie de Peinture, Sculpture et Graveure, 1648 à 1793." *Archives de l'art français, documents inédits*, 2:353–91. Paris.

Eagleton, T. 1983. *Literary Theory, an Introduction*. Minneapolis.

Eaves, M. 1992. *The Counter-Arts Conspiracy: Art and Industry in the Age of Blake*. Ithaca and London.

Edelstein, T. J., ed. 1990. *Perspectives on Morisot*. New York.

Egbert, D. D. 1980. *The Beaux-Arts Tradition in French Architecture*. Princeton.

Elderfield, J. 1972. "Grids." *Artforum* 10:52–9.

Eliot, T. S. 1932. "Tradition and the Individual Talent." *Selected Essays, 1917–1932*. New York, pp. 3–11.

Elsen, A. E. 1972. *The Sculpture of Matisse*. New York.

Escholier, R. 1960. *Matisse, a Portrait of the Man.* New York.

Fahlman, B. 1991. "A Plaster of Paris Antiquity: Nineteenth-Century Cast Collections." *Southeastern College Art Conference Review* 12:1–9.

Feigenbaum, G. 1990. "Drawing and Collaboration in the Carracci Academy." In *IL 60: Essays Honoring Irving Lavin on his Sixtieth Birthday,* ed. M. A. Lavin. New York, pp. 145–65.

——— 1993. "Practice in the Carracci Academy." *The Artist's Workshop.* Studies in the History of Art, 38. Washington, D.C., pp. 59–76.

Félibien, A. 1663. *Les Reines de Perse aux pieds d'Alexandre, peinture du cabinet du roy.* Paris. Published in English as *The Tent of Darius Explained,* trans. C. Parsons. London, 1703.

——— 1666–88. *Entretiens sur les vies et sur les ouvrages des plus excellens peintres anciens et modernes.* Paris.

——— 1668. *Conférences de l'Académie Royale de Peinture et de Sculpture, pendant l'année 1667.* Paris.

Fernandez, J. 1952. *Arte moderno y contemporaneo de México.* Mexico City.

Fiedler, J., ed. 1990. *Photography at the Bauhaus.* Cambridge, Mass.

Fiedler, L., and H. Baker, eds. 1981. *English Literature: Opening up the Canon.* Baltimore.

Field, A. 1988. *The Origins of the Platonic Academy of Florence.* Princeton.

Fink, L. M. 1990. *American Art at the Nineteenth-Century Paris Salons.* Washington and New York.

Fink, L. M., and J. Taylor. 1975. *Academy: The Academic Tradition in American Art.* Washington, D.C.

Flam, J. 1978. *Matisse on Art.* New York.

Flaxman, J. 1838. *Lectures on Sculpture.* London.

Fontaine, A. n.d. *Conférences inédites de l'Académie Royale . . . d'après les manuscrits des archives de l'Ecole des Beaux-Arts.* Paris.

——— 1909. *Les Doctrine d'art en France: Peintres, amateurs, critiques, de Poussin à Diderot.* Paris.

——— 1910. *Les Collections de l'Académie Royale de Peinture et de Sculpture.* Paris.

——— 1914. *Académiciens d'autrefois.* Paris.

Forgács, E. 1995. *The Bauhaus Idea and Bauhaus Politics,* trans. J. Bátki. Budapest, London, and New York.

Foucault, M. 1970. *The Order of Things: An Archaeology of the Human Sciences.* New York.

——— 1982. *This Is Not a Pipe.* Trans. and ed. J. Harkness. Berkeley and Los Angeles.

France in the Eighteenth Century. 1968. London, Royal Academy of Arts.

Franciscono, M. 1971. *Walter Gropius and the Creation of the Bauhaus in Weimar: The Ideals and Artistic Theories of Its Founding Years.* Urbana, Chicago, and London.

——— 1991. *Paul Klee: His Work and Thought.* Chicago and London.

Franz von Stück und die Münchner Akademie von Kandinsky bis Albers. 1990. Milan.

Freedberg, S. J. 1971. *Painting in Italy, 1500 to 1600.* Harmondsworth and Baltimore.

Freund, G. 1992. *Photography and Society.* New York and London.

Frey, K. 1923. *Der Literarische Nachlass Giorgio Vasari.* Munich.

Fried, M. 1969. "Manet's Sources: Aspects of his Art, 1859–65." *Artforum* 7:28–82.

——— 1980. *Absorption and Theatricality: Painting and Beholder in the Age of Diderot.* Berkeley, Los Angeles, and London.

——— 1981. "Representing Representation: On the Central Group in Courbet's 'Studio.' " *AiA,* pp. 127–33, 168–73.

——— 1986. "Antiquity Now: Reading Winckelmann on Imitation." *October* 37:87–97.

——— 1990. *Courbet's Realism.* Chicago and London.

Frinta, M. S. 1993. "Observations on the Trecento and Early Quattrocento Workshop." *The Artist's Workshop* (Studies in the History of Art, 38). Washington, D.C., pp. 19–34.

Fry, R. 1939. *Last Lectures.* New York and Cambridge.

Fumaroli, M. 1980. *L'Age de l'éloquence, Rhetorique et 'res literaria' de la renaissance au seuil de l'époque classique.* Paris.

Fusco, P., and H. W. Janson, eds. 1980. *The Romantics to Rodin: French Nineteenth-Century Sculpture from North American Collections.* Los Angeles and New York.

Gage, J. 1993. *Color and Culture: Practice and Meaning from Antiquity to Abstraction.* Boston, Toronto, and London.

Galt, J. 1820. *The Life, Studies, and Works of Benjamin West, Esq.* London.

Garb, T. 1993. "The Forbidden Gaze: Women Artists and the Male Nude in Late Nineteenth-Century France." In *The Body Imaged: The*

Human Form and Visual Culture since the Renaissance, ed. K. Adler and M. Pointon. Cambridge, pp. 33–42.

1994. *Sisters of the Brush*. New Haven and London.

Gareau, M. 1992. *Charles Le Brun*. New York.

Garrard. M. 1989. *Artemisia Gentileschi: The Image of the Female Hero in the Italian Baroque*. Princeton.

Gates, H. L., Jr. 1992. *Loose Canons: Notes on the Culture Wars*. New York.

George, W. 1965. *Aristide Maillol*. Greenwich, Conn.

Ghezzi, G. 1702. "Le pompe dell'accademia del disegno solennemente celebrate nel Campidoglio il di 25 febraio 1702 descritte da Giuseppe Ghezzi pittore, e segretario di essa. Dedicate dagli accademici alla santità di nostro signore Clemente undecimo pontefice ottimo massimo." Manuscript. Accademia di San Luca, Rome.

Glück, G., and F. M. Haberditzl. 1928. *Die Handzeichnungen des Peter Paul Rubens*. Berlin.

Gnudi, C., and G.-C. Cavalli. 1955. *Guido Reni*. Florence.

Goldberg, E. 1983. *Patterns in Late Medici Art Patronage*. Princeton.

1988. *After Vasari: History, Art, and Patronage in Late Medici Florence*. Princeton.

Goldstein, C. 1965. "Studies in Seventeenth-Century French Art Theory and Ceiling Painting." *AB* 47:231–56.

1966. "Abraham Bosse: Painting and Theory in the French Academy, 1648–83." Ph.D. diss., Columbia University.

1967. Review of B. Teyssèdre, *Roger de Piles et les débats sur le coloris, AB* 49:264–8.

1969. "Theory and Practice in the French Academy: Louis Licherie's 'Abigail and David.'" *BM* 111:346–51.

1970. "Observations on the Role of Rome in the Formation of the French Rococo." *AQ* 32:227–45.

1971. "Forms and Formulas: Attitudes Towards Caravaggio in Seventeenth-Century France." *AQ* 34:345–55.

1975a. "Towards a Definition of Academic Art." *AB* 62:102–9.

1975b. "Vasari and the Florentine Accademia del Disegno. *ZfKg* 38:145–52.

1977. "Drawing in the Academy." *Art International* 21, no. 3:42–7.

1978. "Art History without Names: A Case Study of the Roman Academy." *AQ* 1, no. 2:1–16.

1979. "Teaching Modernism: What Albers Learned in the Bauhaus and Taught to Rauschenberg, Noland, and Hesse." *AM* 54:108–16.

1988. *Visual Fact over Verbal Fiction: A Study of the Carracci and the Criticism, Theory, and Practice of Art in Renaissance and Baroque Italy*. Cambridge.

1991. "Rhetoric and Art History in the Italian Renaissance and Baroque." *AB* 73:641–52.

1993. "The Image of the Artist Reviewed." *Word & Image*, 9, no. 1:9–18.

1994. "L'Académie de Poussin." *Nicolas Poussin, 1594–1665*, ed. P. Rosenberg and L. A. Prat. Paris, pp. 74–8.

Goldstein, H. D. 1967. "Ut Pictura Poesis: Reynolds on Imitation and Imagination." *Eighteenth-Century Studies* 1:213–35.

Golzio, V. 1968. *Seicento e settecento*. 3d ed. Turin.

Gombrich, E. H. 1942, "Reynolds' Theory and Practice of Imitation." *BM* 80:40–5.

1960. *Art and Illusion: A Study in the Psychology of Pictorial Representation*. New York.

1963. "The Style all'Antica: Imitation and Assimilation." *The Renaissance and Mannerism: Studies in Western Art (Acts of the Twentieth International Congress of the History of Art, Vol. 2)*, Princeton, pp. 31–41.

1966. "The Renaissance Conception of Artistic Progress and Its Consequences." *Norm and Form: Studies in the Art of the Renaissance*. London, pp. 1–10.

1979. *The Sense of Order: A Study in the Psychology of Decorative Art*. Ithaca, N.Y.

1981. "Image and Code: Scope and Limits of Conventionalism in Pictorial Representation." In *Image and Code*, ed. W. Steiner. Ann Arbor, pp. 11–41.

Gomringer, E. n.d. *Josef Albers*. New York.

Goodman, C. 1979. "Hans Hofmann as a Teacher." *AM* 53:120–5.

Goodman, N. 1968. *Languages of Art: An Approach to a Theory of Symbols*. Indianapolis and New York.

Goodrich, L. 1982. *Thomas Eakins*. Cambridge, Mass.

Goodyear, F. H., Jr. 1976. "A History of the Pennsylvania Academy of the Fine Arts, 1805–1976." In *In This Academy: The*

Pennsylvania Academy of the Fine Arts, 1805–1976. Philadelphia, pp. 12–48.

Gouma-Peterson, T., and P. Mathews. 1987. "The Feminist Critique of Art History." *AB* 69:326–57.

Graetz, H. R. 1963. *The Symbolic Language of Vincent Van Gogh.* London.

Graff, G. 1992. *Beyond the Culture Wars: How Teaching the Conflicts Can Revitalize American Education.* New York.

Green, C. 1987. *Cubism and Its Enemies: Modern Movements and Reaction in French Art, 1916–1928.* New Haven and London.

Greenberg, C. 1961. "Avant-Garde and Kitsch." In his *Art and Culture.* New York, pp. 3–21.

— 1966. "Modernist Painting." In *The New Art,* ed. G. Battcock. New York. pp. 100–9.

— 1971. "Counter-Avant-Garde." *Art International* 15:16–19.

— 1993. *Clement Greenberg: The Collected Essays and Criticism.* Vol. 4, *Modernism with a Vengeance, 1959–1969,* ed. J. O'Brian. Chicago and London.

Greene, T. M. 1982. *The Light in Troy: Imitation and Discovery in Renaissance Poetry.* New Haven.

Greenhalgh, M. 1978. *The Classical Tradition in Art.* London.

Greer, G. 1979. *The Obstacle Race: The Fortunes of Women Painters and Their Work.* New York.

Gropius, W. 1935. *The New Architecture and the Bauhaus.* London.

Groys, B. 1994. "The Struggle against the Museum; or, the Display of Art in Totalitarian Space." In *Museum Culture: Histories, Discourses, Spectacles,* ed. D. J. Sherman and I. Rogoff. Minneapolis, pp. 144–61.

Grunchec, P. 1983. *Le Grand Prix de peinture. Les Concours des prix de Rome de 1979 à 1863.* Paris.

— 1986. *Les Concours d'esquisses peintes 1816–1863.* Paris.

— 1990. "Les Élèves américains peintres et sculpteurs a l'Ecole des Beaux-Arts dans la deuxième moitié du XIXe siècle." *Le voyage de Paris, les américains dans les écoles d'art 1868–1918.* Blérancourt, pp. 33–46.

Guiffrey, J. J. 1910. "Histoire de l'Académie de Saint-Luc." *Archives de l'art français,* n.p. 4, pp. 32–47.

Guiffrey, J, and P. Marcel. 1907–21. *Inventaire général des dessins du Musée du Louvre et du Musée de Versailles. Ecole française.* 9 vols. Paris.

Hall, A. Rupert. 1983. *The Revolution in Science, 1500–1750.* London and New York.

Hambourg, M. M., and C. Phillips. 1989. *The New Vision: Photography between the World Wars.* New York.

Hamilton, G. H. 1954. *Manet and His Critics.* New Haven.

Hankins, J. 1990. "Cosimo de' Medici and the 'Platonic Academy.' " *JWCI* 53: 144–62.

— 1991. "The Myth of the Platonic Academy of Florence." *Renaissance Quarterly* 44, no. 3:429–75.

Hanson, A. C. 1977. *Manet and the Modern Tradition.* New Haven and London.

Harris, A. Sutherland. 1977. *Andrea Sacchi.* Princeton.

Harris, A. Sutherland, and E. Schaar. 1967. *Die Handzeichnungen von Andrea Sacchi und Carlo Maratta.* Düsseldorf.

Harris, M. E. 1987. *The Arts at Black Mountain College.* Cambridge, Mass.

Hart, J. 1982. "Reinterpreting Wölfflin: Neo-Kantianism and Hermeneutics." *AJ* 42:292–300.

Hasenmueller, C. 1978. "Panofsky, Iconology, and Semiotics." *Journal of Aesthetics and Art Criticism* 36:289–301.

Haskell, F. 1963. *Patrons and Painters: A Study in the Relations between Italian Art and Society in the Age of the Baroque.* New Haven and London.

Haskell, F., and N. Penny. *Taste and the Antique: The Lure of Classical Sculpture, 1500–1900.* New Haven and London.

Haverkamp-Begemann, E. 1969. "Rembrandt as a Teacher." In *Rembrandt after Three Hundred Years.* Chicago, pp. 21–30.

— 1988. *Creative Copies: Interpretive Drawings from Michelangelo to Picasso.* New York.

Hayum, A. 1989. *The Isenheim Altarpiece: God's Medicine and the Painter's Vision.* Princeton.

Held, J. 1966. "Goya's Akademiekritik." *Münchner Jahrbuch der Bildenden Kunst* 17:214–24.

Held, J., and D. Posner. n.d. *Seventeenth- and Eighteenth-Century Art.* Englewood Cliffs, N.J.

Henry, S. L. 1989. "Paul Klee's Pictorial Mechanics, from Physics to the Picture Plane." *Pantheon* 47:147–65.

Herbert, R. L., ed. 1968. *Modern Artists on Art:*

Ten Unabridged Essays. New York, London, Toronto, Sydney, and Tokyo.

Herding, K. 1991. *Courbet: To Venture Independence.* New Haven and London.

Hermann, L. 1968. "The Drawings by Sir Joshua Reynolds in the Herschel Album." *BM* 110: 650–8.

Hermann, W. 1958. "Antoine Desgodets and the Académie Royale d'Architecture." *AB* 40: 23–53.

Hess, T. 1967. "Some Academic Questions." In *The Academy: Five Centuries of Grandeur and Misery, from the Carracci to Mao Tse-tung (Art News Annual, 33)*, ed. T. B. Hess and J. Ashbery. New York, pp. 8–10.

Higonnet, A. 1990. *Berthe Morisot.* New York.

 1992. *Berthe Morisot's Images of Women.* Cambridge, Mass.

Hilles, W. H. 1936. *The Literary Career of Sir Joshua Reynolds.* Cambridge.

Hofmann, H. 1967. *Search for the Real.* Ed. S. T. Weeks and B. H. Hayes, Jr.

Hofrichter, F. Fox. 1983. "The Academy and the Art." In *Haarlem: The Seventeenth Century.* New Brunswick, N.J., pp. 36–49.

 1989. *Judith Leyster: A Woman Painter in Holland's Golden Age.* New York.

Hogarth, W. 1955. *The Analysis of Beauty.* Ed. J. Burke. Oxford.

Hollander, E. 1971. "Working Models." *AiA*, pp. 152–4.

Holly, M. A. 1984. *Panofsky and the Foundation of Art History.* Ithaca and London.

Homer, W. I. 1992. *Thomas Eakins: His Life and Art.* New York.

Honour, H. 1968. *Neo-Classicism.* Harmondsworth and Baltimore.

Hope, A. M. 1988. *The Theory and Practice of Neoclassicism in English Painting: The Origins, Development, and Decline of an Ideal.* New York and London.

Howitt, M. 1886. *Friedrich Overbeck: Sein Leben und Schaffen. Nach seinen Briefen und anderen Documenten des handschriftlichen Nachlass.* Ed. F. Binder. 2 vols. Freiburg.

Hughes, R. 1990. *Nothing If Not Critical: Selected Essays on Art and Artists.* New York.

Hutchison, S. C. 1968. *The History of the Royal Academy.* London.

 1989. "The Royal Academy of Arts in London: Its History and Activities." *Academies of Art between Renaissance and Romanticism*, pp. 451–63.

Hutt, W. 1964. *Die Düsseldorfer Malerschule 1819–69.* Leipzig.

Huyghe, R. 1932. "Manet peintre." *L'amour de l'art* 13:165–84.

Ireland, J. 1798. *Hogarth Illustrated.* London.

Irwin, D. 1966. *English Neoclassical Art: Studies in Inspiration and Taste.* London.

 1972. *Winckelmann: Writings on Art.* London.

Itten, J. 1964. *Design and Form: The Basic Course at the Bauhaus.* London.

Iturburu, C. 1958. *La pintura argentina del siglo XX.* Buenos Aires.

Ivins, W. M., Jr. 1930. *Notes on Prints.* New York.

 1953. *Prints and Visual Communication.* Cambridge, Mass., and London.

Jack, M. A. 1976. "The Accademia del Disegno in Late Renaissance Florence." *The Sixteenth-Century Journal* 7, no. 2:3–20.

Jacques-Louis David, 1748–1825. 1989. Paris.

Jameson, F. 1984. "Postmodernism, or the Cultural Logic of Late Capitalism." *New Left Review* 146:53–92.

Janson, H. W. 1986. *History of Art.* 3d ed., revised and expanded by A. F. Janson. New York.

 1985. *Nineteenth-Century Sculpture.* New York.

Janssen, P. Huys, and W. Sumowski. 1992. *Rembrandt's Academy.* The Hague.

Jay, M. 1993. *Downcast Eyes: the Denigration of Vision in Twentieth-Century French Thought.* Berkeley, Los Angeles, and London.

Jencks, C. 1977. *The Language of Post-Modern Architecture.* New York.

Jenkyns, R. 1992. *Dignity and Decadence: Victorian Art and the Classical Inheritance.* Cambridge, Mass.

Johns, E. 1983. *Thomas Eakins: The Heroism of Modern Life.* Princeton.

Johnson, D. 1993. *Jacques-Louis David: Art in Metamorphosis.* Princeton.

Johnson, E. H. 1983. "Order and Chaos: From the Diaries of Eva Hesse." *AiA* 71:110–18.

Jombert, C. A. 1755. *Méthode pour apprendre le dessein.* Paris (reprint of 1740).

Jones, P. M. 1993. *Federico Borromeo and the Ambrosiana: Art Patronage and Reform in Seventeenth-Century Milan.* Cambridge and New York.

Jordan, J. M. 1977. "The Structure of Paul Klee's Art in the Twenties: From Cubism to Constructivism." *AM* 52:152–7.

Josef Albers, a Retrospective. 1988. New York.

Jouin, H. 1883. *Conférences de l'Académie Royale de Peinture et de Sculpture.* Paris.

—— 1889. *Charles Le Brun et les arts sous Louis XIV.* Paris.

Justi, C. 1943. *Winckelmann und seine Zeitgenossen.* 4th ed. Leipzig.

Kandinsky, W. 1947. *From Point and Line to Plane.* New York.

Kant, E. 1952. *Critique of Aesthetic Judgment.* Trans. J. Meredith. Oxford.

Kauffmann, G. 1960. *Poussin-Studien.* Berlin.

Kemp, M. 1969. "J.-L. David and the Prelude to a Moral Victory for Sparta." *AB* 51:178–83.

—— 1987. " 'A Chaos of Intelligence': Leonardo's 'Traité' and the Perspective Wars in the Académie Royale." In *Il se rendit en Italie. Etudes offertes à André Chastel.* Paris, pp. 415–26.

—— 1990. *The Science of Art: Optical Themes in Western Art from Brunelleschi to Seurat.* New Haven and London.

Kendall, R. 1993. *Degas Landscapes.* New Haven and London.

Kenneth Noland, a Retrospective. 1977. New York.

Kirchner, T. 1991. *L'Expression des passions. Ausdruck als Darstellungsproblem in der französischen Kunst und Kunsttheorie des 17, und 18. Jahrhunderts.* Mainz.

Kitson, M. 1968. "Hogarth's 'Apology for Painters.' " *The Walpole Society* 41:46–111.

Klee, P. 1948. *Paul Klee: On Modern Art.* Trans. P. Finlay, foreword by H. Read. London.

—— 1961. *Paul Klee Notebooks. Volume 1, The Thinking Eye.* Ed. J. Spiller, trans. R. Manheim. London and New York.

—— 1973. *Paul Klee Notebooks. Volume 2, The Nature of Nature.* Ed. J. Spiller, trans. H. Norden. New York.

Klingsohr, C. 1986. "Die Kunstsammlung der Académie Royale de Peinture et de Sculpture in Paris." *ZfKg* 49:556–78.

Kluver, B., and J. Martin. 1971. "A Short History of Modeling." *AiA,* pp. 156–63, 183.

Kozloff, M. 1968. "Robert Rauschenberg." In his *Renderings.* New York, pp. 212–16.

Kraus, R. 1979. "Grids." *October,* pp. 51–64.

Kris, E., and O. Kurz. 1979. *Legend, Myth, and Magic in the Image of the Artist: An Experiment.* New Haven and London.

Kristeller, P. O. 1962. "The Modern System of the Arts." *Journal of the History of Ideas.*

Reprinted in *Ideas in Cultural Perspective,* ed. P. Wiener and A. Noland. New Brunswick, N.J., pp. 145–206.

Kupferberg, F. 1971. *Der Mensch.* Mainz and Berlin. Translated into English as *Oskar Schlemmer Man: Teaching Notes from the Bauhaus,* ed. H. Kuchling, trans. J. Seligman. Cambridge, Mass.

Lambert, S. 1987. *The Image Multiplied: Five Centuries of Printed Reproductions of Paintings and Drawings.* New York.

Langheit, K. 1962. *Florentinische Barockplastik.* Munich.

Lapauze, H. 1924. *L'Histoire de l'Académie de France à Rome (1666–1801).* Paris.

Lauter, P. 1991. *Canons and Contexts.* New York.

Lavin, I. 1993. "Picasso's Lithograph(s) 'The Bull(s)' and the History of Art in Reverse." In his *Past – Present: Essays on Historicism in Art from Donatello to Picasso.* Berkeley, Los Angeles, and Oxford, pp. 203–60.

Le Brun, C. *Livre d'antiques tirés d'après celles qui sont à Rome.* Bibliothèque Nationale, Ms. fran 17217. Paris.

L'Ecorché. 1977. Rouen.

Lee, R. W. 1967. *Ut Pictura Poesis: The Humanistic Theory of Painting.* New York.

Le Nouveau Mercure galant, contenant tout ce qui c'est passé de curieux au mois de avril de l'année 1678. 1678. Paris.

Leonardo da Vinci. *Trattato della pittura.* 1882. Ed. H. Ludwig. 3 vols. Vienna.

—— 1651. *Traité de la Peinture de Léonard de Vinci.* Trans. R.F.S.D.C. [Roland Fréart]. Paris.

—— 1939. *The Literary Works of Leonardo da Vinci.* Ed. J. P. Richter and I. A. Richter. London and New York.

Levey, M. 1993. *Painting and Sculpture in France, 1700–1789.* New Haven and London.

Levin, T. Y. 1988. "Walter Benjamin and the Theory of Art History: An Introduction to 'Rigorous Study of Art.' " *October* 47:77–83.

Lewis, M. T. 1989. *Cézanne's Early Imagery.* Berkeley, Los Angeles, and London.

Lindinger, H., ed. 1991. *Ulm Design: Hochschule für Gestaltung, Ulm 1953–1968.* Cambridge, Mass.

Lipman, J., and R. Marshall. 1978. *Art about Art.* New York.

Lippard, L. 1976. *Eva Hesse.* New York.

—— 1981. *Ad Reinhardt.* New York.

Lippincott, L. 1976. "Thomas Eakins and the

Academy." In *In This Academy: The Pennsylvania Academy of the Fine Arts, 1805–1976*. Philadelphia, pp. 162–87.

"A List of the students of the Royal Academy who have obtained Premiums of Gold and Silver Medals in Painting, Sculpture, & Architecture, the Subjects, Sketches & c. and the Year when given." Uncatalogued ms. Royal Academy, London.

Long, R. C. Washton. 1986. "Expressionism, Abstraction, and the Search for Utopia in Germany." In *The Spiritual in Art: Abstract Painting, 1890–1985*, organized by M. Tuchman. Los Angeles and New York, pp. 201–17.

Loquin, H. 1912. *La Peinture d'histoire en France de 1747 à 1785*. Paris.

Lorenzoni, A., ed. 1912. *Carteggio artistico inedito di D. Vincenzo Borghini*. Florence.

Losee, L. 1977. *An Historical Introduction to the Philosophy of Science*. Oxford.

Lugt, F. 1949. *Musée du Louvre. Inventaire général des dessins des écoles du nord, école Flamand*. Paris.

Lyman, J. 1968. "Matisse as a Teacher." *Studio International* 176:2–5.

Lyotard, F. 1984. *The Postmodern Condition: A Report on Knowledge*. Minneapolis and London.

MacDonald, S. 1970. *The History and Philosophy of Art Education*. London.

Mahon, D. 1947. *Studies in Seicento Art and Theory*. London.

 1960. "Poussin au carrefour des années trente." *Actes du colloque Nicolas Poussin* (Paris), 1:237–63.

 1962. "Poussiniana." *GBA* 60:1–135.

Mai, E. 1989. "Die Berliner Kunstakademie zwischen Hof und Staatsaufgabe. 1696–1830 – Institutionsgeschichte im Abriss." *Academies of Art between Renaissance and Romanticism*, ed. Boschloo et al. pp. 320–9.

Mainardi, P. 1973. "Quilts: The Great American Art." *Feminist Art Journal* (Winter), pp. 1–2.

 1993. *The End of the Salon: Art and the State in the Early Third Republic*. Cambridge and New York.

Maison, K. E. 1960. *Art Themes and Variations: Five Centuries of Interpretations and Re-Creations*. New York.

Major Themes in Roman Baroque Art from Regional Collections. 1974. Amherst, Mass.

Malraux, A. 1947. *Le Musée imaginaire (La psychologie de l'art)*. Geneva.

1953. *The Voices of Silence*. Trans. S. Gilbert. New York.

Malvasia, C. C. 1678. *Felsina pittrice, vite de' pittori bolognesi*. 2 vols. Bologna.

Manet, 1832–1883. 1983. Catalogue by F. Cachin, C. S. Moffett, and M. Melot. New York.

Manovich, L. 1991. Review of F. Saint-Martin, *Semiotics of Visual Language*, and G. Sönesson, *Pictorial Concepts: Inquiries into the Semiotic Heritage. AB* 73:500–2.

Marek, M. J. 1985. *Ekphrasis und Herrscherallegorie*. Worms.

Marx, K. 1973. *Grundrisse*. Harmondsworth.

McClellan, A. 1994. *Inventing the Louvre: Art, Politics, and the Origins of the Modern Museum in Eighteenth-Century Paris*. Cambridge and New York.

Mead, Ch. C. 1991. *Charles Garnier's Paris Opera*. Cambridge, Mass., and London.

Melion, W. 1990. "Hendrick Goltzius's Project of Reproductive Engraving." *AH* 13:458–87.

Mémoires pour servir à l'histoire de l'Académie Royale de Peinture et de Sculpture depuis 1648 jusqu'en 1664. 1853. Ed. A. de Montaiglon. Paris.

Mendelsohn, L. 1982. *Paragoni: Benedetto Varchi and Cinquecento Art Theory*. Ann Arbor.

Mérot, A. 1987. *Eustache Le Sueur, 1616–1655*. Paris.

Mersenne, M. 1625. *La Vérité des sciences, contre les septiques ou Pyrrhoniens*. Paris.

Michel, R. 1989. *Le Beau Idéal, ou l'art du concept*. Paris.

Middleton, R., ed. 1982. *The Beaux-Arts and Nineteenth-Century French Architecture*. Cambridge, Mass.

Miller, J. Hillis. 1992. *Illustration*. Cambridge, Mass.

"Minutes of the General Assemblys of the Academicians of the Royal Academy." N.d. Manuscript. Royal Academy, London.

Missirini, M. 1823. *Memorie per servire alla storia della Romana Accademia di San Luca fino alla morte di Antonio Canova*. Rome.

Mitchell, C. 1942. "Three Phases of Reynolds' Method." *BM* 80:35–40.

Mitchell, W. J. T. 1986. *Iconology: Image, Text, Ideology*. Chicago.

Monrad, K. 1989. "Abildgaard and the Copenhagen Art Academy at the End of the 18th Century." *Academies of Art between Renaissance and Romanticism*, pp. 549–59.

Montagu, J. 1963. "The Early Ceiling Decorations of Charles Le Brun." *BM* 105:395–408.

——— 1976. "Charles Le Brun and His Sculptors: A Reconsideration in the Light of Some Newly Identified Drawings." *BM* 118:88–94.

——— 1989. *Roman Baroque Sculpture: The Industry of Art*. New Haven and London.

——— 1992. "The Theory of the Musical Modes in the Académie Royale de Peinture et de Sculpture." *JWCI* 55:233–48.

——— 1994. *The Expression of the Passions: The Origin and Influence of Charles Le Brun's 'Conférence sur l'expression générale et particulière.'* New Haven and London.

Monty, J. R. 1961. *La Critique littéraire de Melchior Grimm*. Geneva and Paris.

Morel d'Arleux, L. J. M. 1806. *Dissertation sur un traité de Charles Le Brun concernant les rapports de la physiognomie humaine avec celle des animaux*. Paris.

Morris, W. 1899. *Arts and Crafts Essays*. London.

Mosby, D. 1991. *Henry Ossawa Tanner*. Philadelphia.

Mostra di disegni dei fondatori dell'Accademia delle Arti del Disegno nel IV centenario della fondazione. 1963. Florence.

Mouilleseaux, J.-P. 1990. "David: A Classical Painter against the Academy and a Teacher of the French School." In *The French Academy, Classicism and Its Antagonists*, ed. J. Hargrove. Newark, Del., pp. 131–9.

Muller, J. M. 1982. "Rubens's Theory and Practice of Imitation." *AB* 64:229–47.

Nachbilder. Vom Nutzen und Nachteil des Zitierens für die Kunst. 1979. Hanover.

Natur und Antike in der Renaissance. 1986. Frankfurt am Main.

Naylor, G. 1971. *The Arts and Crafts Movement: A Study of Its Sources, Ideals and Influences on Design Theory*. Cambridge, Mass.

Nemser, C. 1970. "An Interview with Eva Hesse." *Artforum* 8:59–63.

Newcome, M., ed. *Strictly Academic: Life Drawing in the Nineteenth Century*. 1974. Binghamton, N.Y.

Newman, J. 1986. "Reynolds and Home: 'The Conjuror' Unmasked." In *Reynolds*, ed. N. Penny. New York, pp. 344–54.

Nochlin, L. 1971. "Why Have There Been No Great Women Artists?" *Art News* 69:22–39, 67–71.

Nochlin, L., and A. Sutherland Harris. 1976. *Women Artists, 1550–1950*. New York.

Noehles, K. 1969. *La chiesa dei SS. Luca e Martina*. Rome.

Norden, L. 1992. "Getting to 'Ick': To Know What One Is Not." In *Eva Hesse, a Retrospective*, exh. cat. ed. H. A. Cooper. New Haven and London, pp. 51–74.

Oakley, F. 1992. *Community of Learning: The American College and the Liberal Arts Tradition*. Oxford.

O'Malley, J. 1979. *Praise and Blame in Renaissance Rome: Rhetoric, Doctrine, and Reform in the Sacred Orators of the Papal Court, c. 1450–1521*. Durham, N.C.

"Ordini dell'Accademia de' pittori et scultori di Roma." 1609. Manuscript. Rome, Archivio dell'Accademia di San Luca.

"Ordini e statuti dell'accademia del disegno de' pittori, scultori, e architetti di Roma. . . ." 1716. Manuscript. Rome, Archivio dell'Accademia di San Luca.

Oursel, H. 1989. "L'Académie des arts de Lille au 18e siècle." In *Academies of Art between Renaissance and Romanticism*, ed. Boschloo et al., pp. 244–53.

Owen, C. 1992. *Beyond Recognition: Representation, Power, and Culture*, ed. S. Bryson, et al. Berkeley, Los Angeles, and Oxford.

Panofsky, E. 1953. "Artist, Scientist, Genius: Notes on the 'Renaissance Dammerung.' " In *The Renaissance: Six Essays,* ed. W. Ferguson. New York, pp. 123–82.

——— 1955. "Iconography and Iconology: an Introduction to the Study of Renaissance Art." In his *Meaning in the Visual Arts,* New York, pp. 26–54.

——— 1960a. *Renaissance and Renascences in Western Art*. New York.

——— 1960b. *Idea: A Concept in Art Theory*. New York.

——— 1962a. "The Neoplatonic Movement in Florence and North Italy." In his *Studies in Iconology: Humanistic Themes in the Art of the Renaissance*. New York, pp. 129–69.

——— 1962b. "Father Time." In *Studies in Iconology: Humanistic Themes in the Art of the Renaissance*. New York, pp. 69–93.

——— 1962c. "Blind Cupid." *Studies in Iconology: Humanistic Themes in the Art of the Renaissance*. New York, pp. 95–128.

Parker, R., and G. Pollock. 1981. *Old Mistresses: Women, Art, and Ideology*. New York.

Passeri, G. B. 1934. *Die Kunstlerbiographien von Giovanni Battista Passeri*. Ed. J. Hess. Leipzig.

Paulson, R. 1971. *Hogarth: His Life, Art, and Times*. New Haven.

1975. *Emblem and Expression: Meaning in English Art of the Eighteenth Century*. Cambridge, Mass.

1989. *Breaking and Remaking: Aesthetic Practice in England, 1700–1820*. New Brunswick and London.

Payant, R. 1979. "Bricolage pictural: l'art à propos de l'art. 1 – La question de la citation." *Parachute* 16:5–8.

1980. "Bricolage pictural: l'art à propos de l'art. 2 – *Citation et intertexualitè*." *Parachute* 18:25–32.

Paz, O. 1959. "Tamayo in Mexican painting." In *Tamayo*, exh. cat. Mexico City.

1961. *The Labyrinth of Solitude: Life and Thought in Mexico*. New York.

1988. *Sor Juana, or the Traps of Faith*. Cambridge, Mass.

1993. "Re/Visions: Mural Painting." *Essays on Mexican Art*. New York.

Penny, N., ed. 1986. *Reynolds*. New York.

Perini, G. 1988. "Sir Joshua Reynolds and Italian Art and Art Literature: A Study of the Sketchbooks in the British Museum and Sir John Soane's Museum." *JWCI* 51:141–68.

Perlingieri, I. S. 1992. *Sofonisba Anguissola: The First Great Woman Artist of the Renaissance*. New York.

Pérouse de Montclos, J.-M. 1984. *Les Prix de Rome, concours de l'Académie Royale d'Architecture au XVIIIe siècle*. Paris.

Perrault, C. 1668. *La Peinture, poëme*. Paris.

1673. *Les Dix Livres d'architecture de Vitruve*. Paris.

Perrier, F. 1638. *Segmenta nobilium signorum et statuarum que temporis dentem invidium evase*. Rome and Paris.

Peteghem, L. J. van. 1868. *Histoire de l'enseignement du dessin*. Brussels.

Pevsner, N. 1940. *Academies of Art, Past and Present*. Cambridge. Reprinted New York, 1973.

1968a. *The Sources of Modern Architecture and Design*. New York and Washington, D.C.

1968b. *Pioneers of Modern Design: From Morris to Gropius*. Harmondsworth.

Pirotta, L. 1964. "Contributo alla storia della Accademia Nazionale di San Luca. Alunni delle scuole accademiche premiati nel secolo XVII." *L'Urbe* 23:5–9.

Plato. 1973. *The Collected Dialogues of Plato including the Letters*. Ed. E. Hamilton and H. Cairns. Bollingen Series 71. Princeton.

Pleynet, M. 1977. *Painting and System*. Trans. Sima N. Godfrey. Chicago and London.

Pliny the Elder. 1938–62. *Natural History*. Trans. H. Rackham, W. S. Jones, and D. E. Eicholz. 10 vols. London and Cambridge.

Podro, M. 1982. *The Critical Historians of Art*. New Haven and London.

Pointon, M. 1990. *Naked Authority: The Body in Western Painting 1830–1908*. Cambridge.

Poling, C. V. 1983. "Kandinsky: Russian and Bauhaus Years, 1915–1933." *Kandinsky: Russian and Bauhaus Years 1915–1933*. New York, pp. 36–56.

1986. *Kandinsky's Teaching at the Bauhaus: Color Theory and Analytical Drawing*. New York.

Pool, P. 1963. "Degas and Moreau." *BM* 105:251–56.

Pope-Hennessy, J. 1970. *Raphael*. New York.

1985. *Cellini*. New York.

Popkin, R. H. 1979. *The History of Skepticism from Erasmus to Spinoza*. Berkeley and Los Angeles.

Posner, D. 1971. *Annibale Carracci: A Study in the Reform of Italian Painting around 1590*. 2 vols. London.

Postle, M. 1991. "The Artist's Model from Reynolds to Etty." In *The Artist's Model: Its Role in British Art from Lely to Etty*, catalogue by I. Bignamini and M. Postle. Nottingham and Kenwood, pp. 16–24.

Potts, A. 1978. "Winckelmann's Interpretation of the History of Ancient Art in Its Eighteenth-Century Context." Ph.D diss., University of London.

Poudra, N. M. 1864. *Oeuvres de Desargues réunies et analysées par M. Poudra*. Paris.

Preziosi, D. 1989. *Rethinking Art History: Meditations on a Coy Science*. New Haven and London.

Prinz, W. 1966. "Vasari's Sammlung von Kunstlerbildnissen." *Mitteilungen des Kunsthistorisches Institutes in Florenz* 12:5–158.

Procès-verbaux de l'Académie Royale de Peinture et de Sculpture. 1875. Ed. A. de Montaiglon. Paris.

Procès-verbaux de l'Académie Royale d'Architecture. 1911–29. Ed. H. Lemonnier. Paris.

Prokopoff, S. 1985. *The New Spirit in American Photography*. Urbana-Champaign.

Prown, J. D. 1966. *John Singleton Copley*. Cambridge, Mass.

Puttfarken, T. 1985. *Roger de Piles' Theory of Art*. New Haven and London.

Puvis de Chavannes, 1824–1898. 1976. Paris.

Quatremère de Quincy, A. C. 1823. *Essai sur la nature, le but et les moyens de l'imitation dans les beaux-arts*. Paris.

1824. *Histoire de la vie et des ouvrages de Raphaël*. Paris.

Rabinbach, A. 1990. *The Human Motor: Energy, Fatigue, and the Origins of Modernity*. New York.

Radycki, J. D. 1982. "The Life of Lady Art Students: Changing Art Education at the Turn of the Century." *AJ* 42:9–13.

Raphaël et l'art français. 1983. Paris.

Read, H. 1956. *The Art of Sculpture*. Princeton.

Redon, O. 1922. *A soi-meme*. Paris.

Reff, T. 1964. "Copyists in the Louvre." *AB* 46:552–9.

1969. "Manet's Sources: A Critical Evaluation." *Artforum* 8:40–8.

1975. *Manet: Olympia*. New York.

Regnault, H. 1873. *Correspondance*. Ed. A. Duparc. Paris.

Reinhardt, A. 1975. *Art as Art: The Selected Writings of Ad Reinhardt*. Ed. B. Rose. New York.

Rewald, J. 1946. *Paul Cézanne: Letters*. Oxford.

1973. *The History of Impressionism*. 1973. New York.

Reynolds, Sir Joshua. 1975. *Discourses on Art*. Ed. R. R. Wark. New Haven and London.

Reynolds, T. 1974. "The Accademia del Disegno in Florence: Its Formation and Early Years." Ph. D. diss., Columbia University.

Reznicek, E. K. J. 1963. "Realism as a 'Side Road or Byway' in Dutch Art." In *The Renaissance and Mannerism: Studies in Western Art (Acts of the Twentieth International Congress of the History of Art)*, 2: 247–53. Princeton.

Richardson, J. 1967. *Manet*. 2d ed. 1958. London and New York.

Richman, M. 1976. *Daniel Chester French: An American Sculptor*. New York.

Richter, S. 1992. *Laocoön's Body and the Aesthetics of Pain: Winckelmann, Lessing, Herder, Moritz, Goethe*. Detroit.

Roman, Cynthia E. 1984. "Academic Ideals of Art Education." In *Children of Mercury: The Education of Artists in the Sixteenth and Seventeenth Centuries*. Providence, Rhode Island pp. 81–95.

Rosand, D. 1970. "The Crisis of the Venetian Renaissance Tradition." *L'Arte* 10:5–53.

Rose, M. 1979. *Parody/Metafiction*. London.

Rosenberg, H. 1970. "Teaching of Hans Hofmann." *AM* 45, no. 3:17–19.

1973. "Educating Artists." In *New Ideas in Art Education*, ed. G. Battcock. New York, pp. 91–102.

Rosenberg, P., and J. Thuillier. 1988. *Laurent de la Hyre, 1606–1656, l'homme et l'oeuvre*. Geneva.

Rosenblum, R. 1967. *Transformations in Late Eighteenth-Century Art*. Princeton.

1986. "Reynolds in an International Milieu." In *Reynolds*, ed. N. Penny. New York, pp. 43–53.

Rosenblum, R., and H. W. Janson. 1984. *Nineteenth-Century Art*. Englewood Cliffs, N.J. and New York.

Rossi, P. 1970. *Philosophy, Technology and the Arts in the Early Modern Era*. New York.

Rossi, S. 1984. "La compagnia di San Luca nel cinquecento e la sua evoluzione in accademia." *Ricerche per la storia religiosa di Roma* 5. Rome.

Rouchette, J. 1959. *La Renaissance que nous a legué Vasari*. Bordeaux.

Rowell, M. 1972. "On Albers' Color." *Artforum*, pp. 26–37.

Roworth, W. W. 1992. *Angelica Kauffmann, a Continental Artist in Georgian England*. London.

Rubin, J. H. 1977. *Eighteenth-Century French Life-Drawing: Selections from the Collection of Mathias Polakovits*. Princeton.

1992. "Concepts and Consequences in Eighteenth-Century French Life-Drawing." In *Drawing: Masters and Methods, Raphael to Redon*, ed. D. Dethloff. New York and London, pp. 7–18.

Rubin, W. 1988. "La Genèse des Demoiselles d'Avignon." In *Les Demoiselles d'Avignon*, ed. H. Seckel. Paris, 2:367–487.

Ruskin, J. 1907. *The Seven Lamps of Architecture*. London and New York.

1987. *Modern Painters*. Ed. D. Barrie. New York.

Saabye, M. 1989. "The Royal Danish Academy of Fine Arts under the Leadership of A. G. Moltke and J.-F. Saly." *Academies of Art*

between Renaissance and Romanticism, ed. Boschloo et al., pp. 530–2.

Said, E. 1978. *Orientalism.* New York.

Saint-Martin, F. 1990. *Semiotics of Visual Language.* Bloomington and Indianapolis.

Salling, E. 1989. "The Creation of an Art Collection at the Danish Academy." *Academies of Art between Renaissance and Romanticism,* pp. 533–46.

Sandblad, N. G. 1954. *Manet: Three Studies in Artistic Conception.* Lund.

Sandler, I. 1973. "Hans Hofmann: The Pedagogical Master." *AiA* 6:48–54.

1982. "The School of Art at Yale, 1950–1970: The Collective Reminiscences of Twenty Distinguished Alumni." *AJ* 42:14–21.

Sarabianov, D. 1990. *Russian Art from Neoclassicism to the Avant-Garde: 1800–1917.* New York.

Sauer, M. 1990. *L'Entrée des femmes à l'Ecole des Beaux-Arts 1880–1923.* Paris.

Savage, N. 1988. "The Academicians' Library." *Apollo* 128:258–63.

Schapiro, B. J. 1983. *Probability and Certainty in Seventeenth-Century England.* Princeton.

Schapiro, M. 1969. "On Some Problems in the Semiotics of Visual Art." *Semiotica* 1:223–42.

1973. *Words and Pictures.* The Hague.

Schnapper. A. 1990. "The Debut of the Royal Academy of Painting and Sculpture." In *The French Academy: Classicism and Its Antagonists,* ed. J. Hargove. Newark, Del., pp. 27–36.

Schnapper, A., and H. Guicharnaud. N.d. *Louis de Boullogne 1654–1733.* Paris.

Schneider, P. 1984. *Matisse.* New York.

Schwarzenberg, E. 1969. "From the Alessandro Morente to the Alexandre Richelieu: The Portraiture of Alexander the Great in Seventeenth-Century Italy and France." *JWCI* 32:398–405.

Schweizer, N. 1972. *The Ut Pictura Poesis Controversy in Eighteenth-Century England and Germany.* Bern.

La Sculpture française au XIXe siècle. 1986. Paris.

Sheriff, M. 1990. *Fragonard: Art and Eroticism.* Chicago and London.

Shiff, R. 1984. *Cézanne and the End of Impressionism: A Study of the Theory, Technique, and Critical Evaluation of Modern Art.* Chicago and London.

Shoemaker, I. H., and E. Broun. 1981. *The Engravings of Marcantonio Raimondi.* Lawrence, Kansas, and Chapel Hill, N.C.

Silver, K. 1989. *Esprit de corps: The Art of the Parisian Avant-Garde and the First World War, 1914–1925.* Princeton.

Six, Jan. 1925–6. "La famosa accademia di Eeulenborg." *Jaarboek der Koninklijke Akademie van Wetenschappen te Amsterdam,* pp. 229–41.

Skovgaard, B. 1961. *Maleren Abildgaard.* Copenhagen.

Slive, S. 1953. *Rembrandt and His Critics, 1630–1730.* The Hague.

Smith, B. H. 1988. *Contingencies of Value: Alternative Perspectives for Critical Theory.* Cambridge, Mass.

Snyder, J. 1989. "Benjamin on Reproducibility and Aura: A Reading of 'The Work of Art in the Age of Its Technical Reproducibility.' " In *Benjamin, Philosophy, History, Aesthetics,* ed. G. Smith. Chicago and London, pp. 158–72.

Solomon-Godeau, A. 1991. "The Armed Vision Disarmed: Radical Formalism from Weapon to Style." In her *Photography at the Dock: Essays on Photographic History, Institutions and Practices.* Minneapolis, pp. 52–84.

Sönesson, G. 1989. *Pictorial Concepts: Inquiries into the Semiotic Heritage and Its Relevance to the Analysis of the Visual World.* Lund.

Souchal, F. 1977. *French Sculptors of the Seventeenth and Eighteenth Centuries: The Reign of Louis XIV.* Vol. 1, A–F. Oxford.

Soussloff, C. 1989. "Imitatio Buonarotti." *Sixteenth-Century Journal* 20, no. 4:581–602.

Spengler, O. 1926. *The Decline of the West: Form and Actuality.* Trans. C. F. Atkinson. New York.

Stafford, B. 1980. "Beauty of the Invisible: Winckelmann and the Aesthetics of Imperceptibility." *ZfKg* 43:65–78.

Stansky, P. 1985. *Redesigning the World.* Princeton.

Steinberg, L. 1972a. "The Algerian Women and Picasso at Large." In his *Other Criteria: Confrontations with Twentieth-Century Art.* London, Oxford, and New York, pp. 125–234.

1972b. "Other Criteria." In *Other Criteria: Confrontations with Twentieth-Century Art.* London, Oxford, and New York, pp. 55–91.

1978. "The Glorious Company." In J. Lipman and R. Marshall, *Art about Art*. New York, pp. 8–28.

Sterling, C. 1956. "La Peinture française du XVIIe siècle." In *Le XVIIe siècle européen*, exh. cat. Rome, pp. 42–51.

Stix, A. 1925. *H. F. Füger*. Vienna.

Stone, D. 1991. *Guercino, Master Draftsman: Works from North American Collections*. Bologna and Cambridge, Mass.

Suhre, T., et al. 1990. *Moholy-Nagy: A New Vision for Chicago*. Springfield and Chicago.

Suleiman, S. R., ed. 1986. *The Female Body in Western Culture*. Cambridge, Mass.

Summers, D. 1969. "The Sculptural Program of the Capella di San Luca in the Santissima Annunciata." *Mitteilungen des Kunsthistorisches Institutes in Florenz* 14:67–90.

———. 1981. *Michelangelo and the Language of Art*. Princeton.

———. 1991. "Real Metaphor: Towards a Redefinition of the Conceptual Image." In *Visual Theory, Painting and Interpretation*, ed. N. Bryson, M. A. Holly, and K. Moxey. New York, pp. 231–59.

Taft, L. 1903. *The History of American Sculpture*. New York.

Teyssèdre, B. 1965. *Roger de Piles et les débats sur le coloris au siècle de Louis XIV*. Paris.

Thieme, U., and F. Becker. 1907–50. *Allgemeines Lexicon der bildenden Kunstler*, Leipzig.

Thomson, R. 1988. *Degas: The Nudes*. London.

———. 1992. "The Creative Copy in Late Nineteenth-Century French Art." In *Drawing: Masters and Methods, Raphael to Redon*, ed. D. Dethloff. New York and London, pp. 19–37.

Thuillier, J. 1957. "Polémiques autour de Michel-Ange au XVIIe siècle." *XVIIe siècle, Bulletin de la Société d'Etudes au XVIIe siècle* 36–7:352–91.

———. 1960. "Pour un 'Corpus Pussinianum.'" *Actes du colloque Nicolas Poussin, Paris*. 2:49–238.

———. 1964. "Académie et classicisme en France: Les débuts de l'Académie Royale de Peinture et de Sculpture." In *Il mito del classicismo nel seicento*, ed. S. Bottari. Messina and Florence, pp. 181–209.

———. 1967. "Temps et tableau: La théorie des 'péripéties' dans la peinture du XVIIe siècle." *Stil und Uberlieferung in der Kunst des Abendländes. International Congress for Art History*, (1964, Bonn), 3:191–206. Berlin.

———. 1983. "Raphaël et la France: Présence d'un peintre." In *Raphaël et l'art français*. Paris, pp. 11–36.

———. 1990. *Vouet*. Paris.

Thuillier, J., and A. Châtelet. 1964. *La Peinture française, de Le Nain à Fragonard*. Geneva.

Tomkins, C. 1968. *The Bride and the Bachelors: Five Masters of the Avant-Garde*. New York.

Tower, B. S. 1981. *Klee and Kandinsky in Munich and at the Bauhaus*. Ann Arbor.

"Transcripciones. 1975. Las escuelas de dibujo del Consulado de Buenos Aires." *Anuario 3, Academia Nacional de Bellas Artes*, 41–9.

Treasures of the Royal Academy: An Exhibition of Paintings, Drawings, Sculpture and other Possessions Earlier Than About 1850. 1963. London.

Triska, E.-M. 1979. "Die Quadratbilder Paul Klees – ein Beispiel für das Verhältnis seiner Theorie zu seinem Werk." *Paul Klee: Das Werk der Jahre 1919–33*, exh. cat. Kunsthalle Köln, pp. 45–78.

Tufts, E. 1985. *Luis Melendez: Eighteenth-Century Master of the Spanish Still Life*. Columbia, Mo.

Turner, N. 1973. "Four Academy Discourses by Giovanni Battista Passeri." *Storia dell'arte* 19:231–48.

Twenty Artists: Yale School of Art, 1950–1970. 1981. New Haven.

Ulm Design: The Morality of Objects. c. 1991. Cambridge, Mass.

Vallery-Radot, J. 1953. *Le Dessin français au XVIIe siècle*. Lausanne.

Van Gogh, V. 1978. *The Complete Letters of Vincent Van Gogh*. 2d ed. New York.

Van Tieghem, P. 1955. "Diderot à l'école des peintres." *Actes du Ve congrès international de langues et littératures modernes*. Florence, pp. 255–63.

Vasari, G. 1568. *Le vite de' più eccellenti pittori, scultori, ed architetti*. Ed. G. Milanesi. 9 vols. Florence, pp. 1878–85.

———. 1960. *Vasari on Technique*. Trans. L. S. Maclehose. New York.

———. 1965. *The Lives of the Artists*. Vol. 1. Trans. G. Bull. Baltimore.

———. 1987. *The Lives of the Artists*. Vol. 2. Trans. G. Bull. Baltimore.

Vitet, L. 1861. *L'Académie Royale de Peinture et de Sculpture*. Paris.

Vitzthum, W. 1971. *I disegni dei maestri: il barocco a Roma*. Rome.

Volk, M. C. 1977. *Vicencio Carducho and Seventeenth-Century Castilian Painting.* New York and London.

Von Erffa, H., and A. Staley. 1986. *The Paintings of Benjamin West.* New Haven and London.

Wagner, A. M. 1986. *Jean-Baptiste Carpeaux, Sculptor of the Second Empire.* New Haven and London.

Walpole, H. 1876. *Anecdotes of Painting in England.* Ed. R. N. Wornum. London.

Ward, M. A. Jack. "The 'Accademia del Disegno' in Sixteenth-Century Florence: A Study of an Artists' Institution." Ph.D diss., University of Chicago.

Wartofsky, M. 1979. "Picturing and Representing." In *Perception and Pictorial Representation,* ed. C. F. Nodine and D. F. Fisher. New York.

Watson, J. C. 1992. "Romney's theatrical Portraiture: Mrs. Siddons and Tryphasa Jane Wallis." *Apollo* 136:147–51.

Waźbiński, Z. 1978. "La prima mostra dell'Accademia del Disegno a Firenze." *Prospettiva* 14:47–57.

 1985. "Lo studio – la scuola fiorentina di Federico Zuccari." *Mitteilungen des Kunsthistorischen Institutes in Florenz* 29:275–341.

 1987. *L'Accademia medicea del disegno a firenze nel cinquecento: idea e istituzione.* Florence.

Weber, N. F. 1985. *The Woven and Graphic Art of Anni Albers.* Washington, D.C.

Weil-Garris, K. 1981. "Bandinelli and Michelangelo: A Problem of Artistic Identity." In *Art the Ape of Nature: Studies in Honor of H. W. Janson,* ed. M. Barasch and L. Freeman Sandler. Englewood Cliffs, N.J., pp. 223–51.

Weinberg, B. 1991. *The Lure of Paris: Nineteenth-Century American Painters and Their French Teachers.* New York.

Wellmer, A. 1991. *The Persistence of Modernity: Essays on Aesthetics, Ethics, and Postmodernism.* Cambridge, Mass.

Welsh, R. 1970. "Abstraction and the Bauhaus." *Artforum* 8, no. 7:46–51.

Weltge, S. W. 1993. *Women's Work: Textile Art from the Bauhaus.* San Francisco.

Westfal, U. 1991. *The Bauhaus.* New York.

Whinney, M. 1964. *Sculpture in Britain, 1530–1830.* Harmondsworth.

White, C. 1987. *Peter Paul Rubens: Man and Artist.* New Haven and London.

White, H. 1973. *Metahistory: The Historical Imagination in Nineteenth-Century Europe.* Baltimore and London, 1973.

Whitfield, S. 1968. *The Academic Tradition, an Exhibition of Nineteenth-Century Figure Drawings.* Bloomington, Ind.

Whitford, F. 1986. *Bauhaus.* London.

Whitley, W. T. 1928. *Artists and Their Friends in England.* London.

Wilkin, K. 1990. *Kenneth Noland, a Retrospective.* New York.

Wilson, J. M. 1981. *The Painting of the Passions in Theory, Practice, and Criticism in Later Eighteenth-Century France.* New York and London.

Winckelmann, J. 1987. *Gedanken über das Nachahmung der griechischen Werke in der Malerei und Bildauerkunst.* 1755. Dresden. Translated into English as *Reflections on the Imitation of Greek Works in Painting and Sculpture,* trans. E. Heyer and R. C. Norton. La Salle, Ill.

Wind, E. 1930–1. "Hume and the Heroic Portrait." In *Hume and the Heroic Portrait: Studies in Eighteenth-Century Imagery,* ed. J. Anderson. Oxford, 1986, pp. 1–52. Originally published as "Humanitätsidee und heroisiertes Portrait in der englischen Kultur des 18. Jahrhunderts," *Vorträge der Bibliothek Warburg,* pp. 156–229.

 1937–8a. "The Maenad under the Cross: Comments on an Observation by Reynolds." *JWCI* 1:70–1.

 1937–8b. "Charity: The Case History of a Pattern." *JWCI* 1:322–30.

 1938–9. "Borrowed Attitudes in Reynolds and Hogarth." *JWCI* 2:182–5. Reprint 1986. *Hume and the Heroic Portrait: Studies in Eighteenth-Century Imagery.* Ed. J. Anderson. Oxford, pp. 69–73.

Wingler, H. 1969. *The Bauhaus: Weimar, Dessau, Berlin, Chicago.* Cambridge, Mass.

Winner, M. 1962. "Gemälte Kunsttheorie. Zu Gustave Courbet's 'Allégorie réelle' und der Tradition." *Jahrbuch der Berliner Museen* 4:150–85.

 1968. "Federskizzen von Benvenuto Cellini." *Zeitschrift für Kunstgeschichte* 31:293–304.

Wittkower, R. 1958. *Art and Architecture in Italy, 1600–1750.* Harmondsworth.

 1965. "Imitation, Eclecticism, and Genius." In *Aspects of the Eighteenth Century,* ed. E. R. Wasserman. Baltimore, pp. 153–61.

 1963. "The Role of Classical Models in Ber-

nini's and Poussin's Preparatory Work." In *Studies in Western Art: Latin American Art and the Baroque Period in Europe* (*Acts of the Twentieth International Congress of the History of Art*, Vol. 3). Princeton. Reprinted in R. Wittkower, *Studies in the Italian Baroque*. 1975. London. pp. 104–14.)

Wittkower, R., and M. Wittkower. 1964. *The Divine Michelangelo*. London.

Wolff, J. 1993. *The Social Production of Art*. 1993. 2d ed. New York.

Wölfflin, H. N.d. *Principles of Art History: The Problem of the Development of Style in Later Art*. Trans. M. D. Hottinger. New York.

Wornum, R. N., ed. 1848. *Lectures on Painting by Barry, Opie, and Fuseli*. London.

Wosk, J. 1992. *Breaking Frame: Technology and the Visual Arts in the Nineteenth Century*. New Brunswick, N.J.

Wright, C. 1985. *The French Painters of the Seventeenth Century*. Boston.

Wrigley, R. 1993. *The Origins of French Art Criticism, from the ancien régime to the Restoration*. Oxford.

Yates, F. 1947. *The French Academies of the Sixteenth Century*. London.

Zemsz, A. 1967. "Les Optiques cohérentes (La peinture est-il langage?)." *Revue d'ésthetique* 20:40–73.

Zola, E. 1927. *Correspondance, 1858–71*. Ed. M. le Blond. Paris.

Zorpette, G. 1993. "Anatomy of an Art School." *Art News* 92:84–9.

INDEX